**The Year the Stars Fell: Lakota
Winter Counts at the
Smithsonian**

THE YEAR THE STARS FELL

SMITHSONIAN NATIONAL MUSEUM
OF NATURAL HISTORY
Washington D.C.

SMITHSONIAN NATIONAL MUSEUM
OF THE AMERICAN INDIAN
Washington D.C.

UNIVERSITY OF NEBRASKA PRESS
Lincoln and London

The Year the Stars Fell

LAKOTA WINTER COUNTS AT THE SMITHSONIAN

EDITED BY CANDACE S. GREENE

AND RUSSELL THORNTON

Library of Congress Cataloging-in-Publication Data

The year the stars fell : Lakota winter counts at the

Smithsonian / edited by Candace S. Greene and Russell

Thornton.

 p. cm.

Includes bibliographical references and index.

ISBN-13: 978-0-8032-2211-3 (cloth : alk. paper)

ISBN-10: 0-8032-2211-4 (cloth : alk. paper)

1. Dakota history. 2. Dakota calendar. 3. Dakota art.

4. Picture-writing—Great Plains. 5. Winter—Great

Plains—Folklore. I. Greene, Candace S. II. Thornton,

Russell, 1942– III. National Museum of Natural History

(U.S.) IV. National Museum of the American Indian (U.S.)

E99.D1.Y43 2007

978.004′975244—dc22 2006024419

Set in Quadraat and Scala Sans by

Tseng Information Systems, Inc.

Designed by Richard Hendel.

CONTENTS

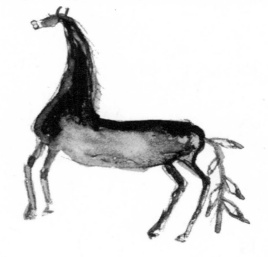

Preface

CANDACE S. GREENE

On a chilly morning in November 2001, I shook my husband awake at 3:30 a.m. "Come on, we don't want to miss it." The Leonid meteor shower was anticipated to make a particularly spectacular appearance (officially described as a meteor storm!), and 4:30–6:00 a.m. would be the peak time for our location in the mid-Atlantic region. With skies near our house obscured by tall trees and the ever-present light pollution of the metropolitan area, I had determined that we should drive out of town for prime viewing. Within minutes we were in the car speeding west, sipping hot cocoa from a thermos prepared the night before. Traveling west from Washington DC quickly takes one into the foothills of the Blue Ridge Mountains, aptly named for the blueish haze that often enshrouds them. Avoiding low areas filled with swirling fog, we finally found a country lane that climbed to an area clear enough for good viewing of the open sky. The sight was awesome, unlike anything I had imagined. The sky was alive with streaks of light darting this way and that. Occasional clouds drifted across the sky and interrupted our view, like irritating late arrivals at the theater. By dawn we were pretty well socked in, the show definitely over.

With some longing, I imagined what the experience would have been like where we used to live in central Oklahoma. Our house there was outside of town on a treeless wind-swept hill, and we often spent hot summer nights reclining in lawn chairs set among the tussocks of bluestem grass, watching for the occasional shooting star, swatting mosquitoes. The sky was immense and seemed very close. Little of it was obscured by trees or buildings, and since we knew nothing of astronomy, celestial events were always a serendipitous surprise. Although at some level I knew that "shooting stars" were cosmic debris burning through the earth's atmosphere, this knowledge never reduced the sheer wonder of such rare and special moments.

Such was the sky that generations of Native people of the Great Plains experienced, and it is small wonder that it figures large in their religion and mythology. Among the tribes that kept calendars, like the Lakota, celestial

events such as eclipses and meteors were regularly chosen as markers for the years in which there were notable occurrences. In all the calendars that I have encountered, regardless of tribal origin, the winter of 1833–34 is known as "The Year the Stars Fell," or in other translations "The Storm of Stars." The Leonid meteor storm of that year was a spectacular one owing to the conjunction of its line of passage with the earth's orbit, and evidently there were clear skies over much of the country. Already at work on this project, I had wanted to share that experience, in however attenuated a form. The title of this volume was inspired by that experience.

My second pilgrimage associated with this project was to the northern plains. Although I had lived in Oklahoma for many years and worked with several tribes there, I had never been to Sioux country. In the summer of 2002, Russ Thornton, Christina Burke, and I visited several reservations, discussing this project. Our goal was to let people know more about the winter counts in our collections, to find out what they were interested in, and to discuss plans for publication. We learned that many Lakota people feel a strong connection to the historic winter counts (one woman told me she had gotten her husband up at 3 a.m. to drive out to see the meteor storm), although few have been able to travel to Washington to examine them, or to find the now-rare books in which some of them have been published. Winter counts embody the voices and knowledge of their forebears, and they were enthusiastic about plans to make them more available. This book is part of an ongoing effort to make the collections of the Smithsonian's Department of Anthropology more widely accessible, both to the communities in which they originated and to a more general audience interested in learning about other cultures.

The Lakota winter counts are a particularly important component of the Smithsonian collections. Lakota counts consisted of two linked components — the "count" itself (the list of year names and associated explanations) and the pictorial mnemonic device that supported it. Not only are our collections large, with information on many counts, but, more importantly, they include both visual records and extensive explanatory texts provided by their original makers. All studies of other winter counts build to some extent on this foundation of information, and many studies of Lakota history have been enriched by it. Much information about the winter counts now in the National Anthropological Archives was published by Garrick Mallery in the 19th century. Periodic reprinting of those classic works attests to a continuing interest in winter counts, and this seems an appropriate time to make that information more fully and easily accessible to modern readers. The current volume includes not only the early materials that Mallery made famous but also more recent Smithsonian acquisitions, including the largely unpublished winter counts of the National Museum of the American Indian.

The collections of the National Anthropological Archives, within the National Museum of Natural History, and of its sister institution, the National Museum of the American Indian, are open by appointment to any serious student. While several hundred visiting researchers use these collections each year, this represents but a small fraction of those who would like to come but are unable to. Even for those who do study materials firsthand, the very size and complexity of the collections can make them hard to use. Preparing the winter counts for publication brought home to us very clearly the amount of work required to make sense of resources scattered among numerous boxes, files, and drawers in two museums, sorting through multiple copies and versions, however well cataloged and indexed. Even the seemingly simple question, How many winter counts do we have? turned out to be hard to answer.

This book is intended to make primary materials, both visual and verbal, easily available for study. Defining primary materials has been particularly difficult for the winter counts, and we chose to be broadly inclusive. As actively used documents, regularly handled and added to, winter counts were frequently copied onto new materials as the old ones wore out or the record outgrew the space available. All versions might be considered "copies" of previous records. Freely extending this concept, we chose

to include not only counts drawn by Native people but also replications made by others, including tracings and even photographic copies. Primary texts were similarly difficult to sort out, particularly as Mallery's notes often seem incomplete. The most original sources available have therefore been relied on: sometimes this was Mallery's published work, sometimes the notes that he received from collectors in the field, and in other instances texts recorded by unknown hands.

The opening chapter, *"Waniyetu Wówapi:* An Introduction to the Lakota Winter Count Tradition," by Christina Burke, provides general information on the place of winter counts in Lakota society and on the major collectors and scholars involved in their study. The second chapter, also by Burke, describes each of the Smithsonian winter counts, summarizes what is known of their history, and notes if there are multiple versions. The count referred to here as the Rosebud winter count is a new acquisition, not previously published. It is given special treatment by Russell Thornton in chapter 3.

These chapters provide the background for the following chapter, which makes the counts available in full, including both the pictures and accompanying texts. Rather than present each count separately, we have organized this section by year, since the greatest value in publishing this large collection as a whole seems to be in facilitating comparison among the various records. Where different counts record the same event, they enrich each other by providing different details. When they differ, they stimulate curiosity about why. An afterword by Emil Her Many Horses offers a contemporary perspective on winter counts. Through his reflections on the events referenced by each entry in his own winter count we gain a sense of the wealth of meaning that must similarly lie behind each entry in the historic counts.

In this volume we do not attempt to fully analyze the data or to smooth out the rough edges of the records by resolving any discrepancies. Winter counts were dynamic documents, passing through several filters of memory, explanation, and translation before arriving in the archives. Individual keepers could and did introduce changes, shifts

in emphasis, substitutions, perhaps even mistakes. Such differences might result from a lapse of memory, a failure in transmission from one keeper to another, or faulty translation from Lakota to written English. Often they must represent a shift in interpretation as the pictorial mnemonic or year name came to take on a new meaning in the light of new circumstances.

Although this volume focuses on the winter counts of the Lakota, the Smithsonian collections also contain materials on the calendric traditions of other Plains Indian tribes that we felt readers would want to know about. In the final chapter I provide a brief guide to related material, principally from the Kiowa but also from the Blackfeet and the Mandan.

The extensive bibliography assembled by Christina Burke was designed as a guide to the basic literature on Lakota winter counts, directing the reader beyond the materials covered in this volume.

This book results from the collaboration and support of many individuals. It began with Russ Thornton's interest in winter counts and his vision of making them more widely available to Native people. It was easy to sell me on the project, and I soon took on the logistics of organizing the many aspects of production. The Smithsonian's Repatriation Review Committee saw the dissemination of information about our collections as a worthwhile adjunct to their work. With their financial support we were able to engage Christina Burke, then a graduate student at Indiana University, in the lengthy task of locating our numerous resources and making sense of them. She drew on her own extensive research on the topic in preparing the sections she authored. Her many contacts in various Lakota communities helped us to establish an active consultation with Lakota people regarding their interests in the project. Travel to consult with Lakota people and learn their perspectives on this material was supported in part by the Getty Grant Program. In addition to supporting the idea of publishing this material in a book, many Lakota people encouraged us to make the information available online. At their urging we produced the Web exhibit Lakota Winter Counts, available

at http://wintercounts.si.edu. Information on the entries that appears there was drawn from this publication.

The original plan was to publish only the materials in the National Anthropological Archives, but we soon realized that the book would benefit from including the closely related materials in the collection of the National Museum of the American Indian. A special thanks is due to Bruce Bernstein and Ann McMullen of that museum for their enthusiastic support.

Assembling and organizing the extensive visual materials presented here was a substantial task involving many people. New digital photography of all materials was provided by Will Greene (NAA) and Ernest Amoroso (NMAI). Gayle Yiotis set up the database that allowed us to synthesize images and text from many sources, and also provided services as a general research assistant. Marit Munson managed the database after the initial setup and created all the output that appears here as chapter 4. The many hundreds of carefully cropped individual images that appear in that chapter are courtesy of Gayle Yiotis and Richard Muniz and their little digital scissors. Supporting photographs from the NAA were digitized by Becky Malinsky.

The term *winter count* is an evocative one that resonates for many different people. In recent years it has appeared in new contexts and taken on extended meanings. Some Lakota people today refer to many types of old drawings as forms of winter counts that recorded individual events rather than a sequence of years. Authors have similarly extended the term, using it as a metaphor for historical narratives regarding American Indians. To cite two books recently issued by the University of Nebraska Press, Colin Calloway incorporates the term in the title of his book *One Vast Winter Count*, a sweeping account of Indian history before the time of Lewis and Clark, and Lakota writer Dallas Chief Eagle chose the title *Winter Count* for a historical novel of Lakota life set in the 19th century. The extension of the term winter count to widening domains suggests a growing recognition of the richness of Native sources of historical information. This volume provides information on the Lakota pictorial records that have inspired these broader associations. We are pleased to make full information about the Lakota winter counts in the Smithsonian collections more widely available.

Preface

RUSSELL THORNTON

The beginning of this project for me occurred in 1995 at the annual California Indian Conference, held that year at UCLA. I was then chair of the Smithsonian Institution Repatriation Review Committee, a congressionally mandated committee to monitor the repatriation activities of the Smithsonian whereby American Indian human remains and certain types of cultural objects held at the Smithsonian are returned to American Indian communities. I made a presentation at the conference on repatriation in general and at the Smithsonian in particular. Afterward, a young California Indian woman approached me about tribal songs that she said had been recorded and placed in a government agency in Washington DC, perhaps the Smithsonian. She wondered whether copies could be made, since the songs had been lost among her people. I told her I thought she was referring to songs made under the auspices of the WPA program during the Great Depression, and that they were not at the Smithsonian but probably at the National Archives.

This brief conversation started a long thought process for me. It was a process whereby I extended my views of repatriation to encompass not just the human remains and cultural objects mandated by the 1990 Native American Graves Protection and Repatriation Act and the 1989 National Museum of the American Indian Act, as amended. Not only are human remains and objects held at museums and institutions important to Indian communities, I reasoned, but so is the knowledge represented in museum and other collections and artifacts. Repatriation should really be about assisting Indian communities in gaining what they have lost, where possible.

I was still thinking about this idea when I was contacted about a newly discovered Lakota winter count, as I discuss in chapter 3. It occurred to me that it would be important to restore the knowledge represented by this winter count to the Lakota people. After all, it was a primary document of their history. As I discuss in that chapter, this winter count was eventually donated to the Smithsonian's National Anthropological Archives, through the assistance of Candace Greene. I discussed

the idea of returning this knowledge with Candace and with the members of the Smithsonian Repatriation Review Committee. All agreed that returning important knowledge to Indian communities was important, even if the physical objects in which the knowledge existed — in this instance, the actual drawings of the winter counts on cloth — were not necessarily subject to repatriation.

One thing led to another. It was eventually decided by Candace and myself that it would be important to publish the winter counts in the Smithsonian's possession in order to facilitate the transfer of the knowledge contained in them back to the people whose history is represented by them. Given the magnitude of the topic and the fact that the winter count of most interest to me was a Lakota one, we decided to restrict our efforts to Sioux winter counts at the Smithsonian.

Obviously, we needed funding for the project. A proposal was eventually prepared and submitted to the repatriation review committee, requesting formal approval for our activities and some financial support. The committee was enthusiastic about the project and provided support, primarily to pay for the assistance of Christina Burke and Gayle Yiotis, whose work was eventually extremely important.

The result of my initial insight to broaden the meaning of repatriation, the support of the Repatriation Review Committee, and the efforts of Candace, Christina, Gayle, and myself is the present volume.

THE YEAR THE STARS FELL

1

Waniyetu Wówapi

AN INTRODUCTION TO THE LAKOTA WINTER COUNT TRADITION

CHRISTINA E. BURKE

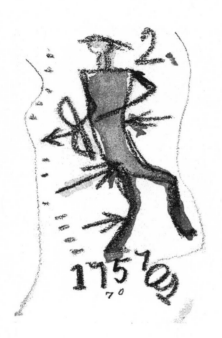

The Smithsonian Institution boasts the preeminent collection of Lakota winter counts, including materials in the National Anthropological Archives (NAA) and the National Museum of the American Indian (NMAI). These invaluable and diverse resources—pictographic calendars drawn on cloth and in sketchbooks, photographs, manuscripts, typescripts, and associated documents—include the earliest documented examples of pictographic winter counts as well as many interpretations recorded directly from the keepers of these community histories. Other relevant materials in the NAA are winter count texts listing the names of years, photographs of calendars outside the collection, and information about the creators, interpreters, and collectors of these unique resources. In addition, the NAA holds important early ethnographic and linguistic materials pertaining to the Lakota which are useful for interpreting and analyzing winter count pictographs and texts.

WINTER COUNTS: COMMUNITY HISTORIES

Winter counts are pictographic calendars in which each image represents a remarkable or unusual event of a single year. Pictographs were arranged sequentially in spirals or rows, originally on hide. Later they were drawn on cloth and paper, which became available through trade with whites, along with drawing materials such as pens, pencils, and watercolors. With these new materials and the influence of white artists like George Catlin and Karl Bodmer in the mid-1800s, the style of pictographs changed and Indians began to incorporate additional details into their images (Ewers 1957). Also, using cloth and paper as the "canvas" affected how winter counts were arranged; for instance, most counts drawn on paper are in rows across the page. Whatever the format, the most important factor was maintaining the sequence of pictographs and thus the chronology of events as they occurred.[1]

The term *winter count* comes from the Lakota name for these pictographic calendars: *waniyetu wówapi*.[2] The first word is glossed as "winter" and refers either to the sea-

son or to the span of a year from first snow to first snow, as reckoned by the Lakota. Although seasons and lunar months were also considered meaningful units of time, calendars marked only the passing of a year. Because a Lakota "winter" encompassed the end of one Gregorian calendar year and the beginning of another, there are sometimes differences of a year or two in relating the date of a pictograph. For instance, the first event depicted on the Lone Dog winter count, the killing of 30 Lakota, may have occurred in late 1799 or early 1800. A further consideration is that the event depicted may have occurred at any time during the span of the "winter." For these and other reasons, it is important to correlate information recorded on winter counts with other ethnographic, linguistic, and historical sources.

The second word (wówapi) can refer to anything that is marked and can be read or counted, from the root verb owá, meaning "to draw, paint, color, or mark." The indefinite prefix wa- (which becomes wo- before owá) means "anything," or even "something." The suffix -pi can be either a plural or a passive marker, making the whole word "something that they mark" or "something that is marked." The word wówapi is used to refer to a book, letter, flag, or anything with two-dimensional markings on it.

The images served as mnemonic devices for community members and for the winter count keeper, who was responsible for recording and remembering events. Using the calendar as his guide, the keeper could "read" the images and recite the narratives of remarkable occurrences. The earliest winter counts noted by non-Indians consisted of simple pictographic images on animal hide drawn with a bone brush dipped in vegetal and mineral paints.[3] The pictographs recorded events that affected a community or band of Lakota who camped together. In general, it was only unusual or unexpected events that were documented, including natural phenomena (floods, fires, epidemics, and astronomical occurrences) and cultural events (battles, peace treaties, and the deaths of leaders).

It is believed that each band had a tribal historian who was responsible for keeping the chronicle and its stories. In consultation with a council of elder men, he would choose a single event to mark the year that had passed (Mallery 1886:91). The winter count keeper was charged with adding it both to the calendar and to his verbal repertoire. Often winter counts covered over 100 years, more than the lifespan of one keeper. In such a case, the calendar and the responsibility for its maintenance were passed down to a male apprentice (usually a son or nephew) who would carry on the tradition of recording and reciting the band's stories (Sandoz 1967). While an apprentice may have inherited the winter count itself, it is more likely that he created his own copy from an original kept by his mentor, since such personal effects as calendars might be buried with their owner. We do not know when such a copy was made, but probably while the elder keeper was still alive so that he could instruct the younger man on the stories each image depicted. The younger keeper then simply added new pictographs for events that occurred thereafter. Sometimes a winter count was sold to another Indian who was not a relative; the new owner then took on the responsibility of marking subsequent events (Howard 1968).

Often there were multiple copies of a winter count in a band, and more often there were closely related versions kept by bands that were closely allied. This is probably why Lone Dog, The Flame, The Swan, and Major Bush are all so similar to each other; they were collected from bands of Lakota who lived close to each other and interacted on a regular basis. By the end of the 19th century, many related winter counts were circulating throughout the northern plains. Winter count texts even appeared in Iapi Oaye (The Word Carrier), a Dakota-language newspaper published by the Presbyterian Church from 1871 to 1939. Other sociopolitical changes affected the production of winter counts. Most significantly, camps of extended families that had lived together were split into smaller family units and scattered across reservations, causing a shift in the marking of events. As the larger bands were broken up, individual families kept their own versions of the community's winter count.

By the late 1870s, copies of winter counts were being commissioned by non-Indian collectors, serving the growing market for Indian ethnographic objects. Between 1879 and 1880, American Horse, Cloud Shield, and Battiste Good were all commissioned to make copies from original calendars that remained in their possession. Other winter counts, including The Flame and The Swan, were copied from the originals by collectors or unknown Indians. With the large number of Lone Dog copies (at least 13 in collections throughout the world), it is clear that creating such objects became something of a cottage industry, even into the 20th century.

There is no clear information about how or when Lakota people began to keep winter counts. The Lakota have undoubtedly always maintained oral traditions about their history, and at some point they began to name years for memorable events. Specialized historians were responsible for remembering the year names and associated information. In time, these historians began to make painted records to help them keep the years in their proper sequence, employing the pictorial tradition already used to record personal events. Many scholars today think that the physical objects we call winter counts were not produced until the 19th century, although they record historical traditions that are older.

Traditionally, the keeper alone was responsible for the creation and care of the winter count. At various times throughout the year he would unroll the calendar and retell the events of his people's past (Mallery 1886:91). In this way, band members learned the group's history and could use particular dates to index events in their own lives; for example, individuals determined their age by counting back to the winter they were born. Even into the 20th century, people would talk about being born in a particular winter. In the 1930s the famed Oglala medicine man Black Elk told his biographer John Neihardt that he was born in "The Winter When the Four Crows Were Killed on the Tongue River."[4]

The production of winter counts flourished between the 1870s and 1930s; of the more than 170 counts studied, most were made during this period. However, this number is somewhat misleading because many are exact copies of one other, while others are closely related versions representing the same winter count tradition or cycle (Howard 1960b; McCoy 1983). Copies were made by the keepers and their apprentices. Sometimes copies were sold to other Indians, who continued marking events, or to non-Indian collectors. In comparing individual calendars to each other, there are only seven traditions that have been documented (McCoy 1983; Walker 1982:115). Since the 1930s, only a few have been maintained. Those that were continued became more family histories than community annals, recording births and deaths of relatives and other events pertinent to a small group of people. Occasionally new winter counts are initiated (see Afterword).

RECORD KEEPING:
PICTOGRAPHS, STORIES, AND TEXTS

For centuries, Plains Indians created pictographs to represent their experiences with the natural world and with the human and the supernatural, from petroglyphs chipped into stone to images drawn and painted on hide, cloth, and paper. Some scholars cite a connection between petroglyphs and painted pictographs, arguing that the latter are a continuation of the former (Rodee 1965; Keyser 1987). It is clear, though, that regardless of the format, pictographs functioned as meaningful records and not simply as aesthetic expressions of "art for art's sake." They were, and continue to be, part of the long legacy of plains oral and pictorial traditions.

Plains Indians created two basic types of pictographs: the calendric winter counts (described above) and biographical drawings that recorded the brave deeds of men, including war honors, successful hunts, and interactions with spirits experienced during visions. Such images were painted on tipis, tipi liners, clothing (robes, shirts, leggings), paper, and in ledger books (thus giving the genre its name).[5] Like winter counts, during the 19th century these images were created by men; unlike winter counts, they recorded the activities of individual men. Most ledger

art images revolve around warfare and the continual striving for status, including scenes of battle and the capturing of horses, weapons, and other goods. Other significant activities that were recorded include hunting and courting. By the end of the 1860s, Indian men were using new materials (cloth, paper, pens, pencils, paints) and techniques (perspective, background) to also depict scenes from reservation camp life, including children's games and social and ceremonial events.[6]

Around the same time, another change in the way Lakota people documented their lives was happening as well. In the 1830s and '40s, Protestant missionaries in Minnesota developed a system for writing the Dakota dialect of the Sioux language using the Roman alphabet and diacritical marks to represent sounds not present in English (e.g., glottal stops and nasalized vowels). The Smithsonian Institution published a dictionary and grammar of Dakota by Rev. Stephen R. Riggs in 1852. Because this government publication was easily available and widely distributed, it helped support a surge in Native literacy in the late 19th century. By the 1880s Lakota people, who speak a mutually intelligible dialect with their Dakota neighbors to the east, were reading and writing their own language in personal letters, Native-language newspapers, and ethnographic notes for non-Natives like James R. Walker, the Pine Ridge agency physician from 1896 to 1914 (Walker 1982).

With the advent of literacy, men began to add written captions to drawings of their exploits and daily activities (Howard 1968). Winter count keepers sometimes added Native-language text to their pictographic calendars, writing out the names of the winters. By the end of the 19th century, some winter counts were solely texts; pictographs were replaced by written year names as the mnemonic device of choice. As mentioned above, a few such texts were published in the Native-language newspaper *Iapi Oaye* (*The Word Carrier*) (Waktegli/Kills and Comes Back 1892; Tate/Wind 1900; Lawrence 1905; Ironhawk 1936). Translation of winter count texts requires knowledge of Lakota vocabulary and grammar, and of idiomatic phrases for things like personal names, which often defy easy interpretation. Like the earlier pictographs, the meaning of the words may not be readily apparent, and an interdisciplinary approach to translation and analysis is required.

LAKOTA LIFE ON THE NORTHERN PLAINS

The creation and use of winter counts may have begun in the mid-1800s (Mallery 1886:92; also Howard 1960b; Walker 1982:112), but it grew in the latter part of the century and then declined in the early part of the 1900s. There were probably tribal historians charged with the responsibility of remembering year events from time immemorial, but the tradition of recording them in pictographs may have developed as late as the 19th century (Ewers 1997:210). Many counts record events from the 1700s (and one, kept by John K. Bear, even marks happenings from the 1600s; see Howard 1976), but these may have begun as oral histories that were recorded in pictographs years later. We know that Battiste Good kept a winter count that originally began in the 1770s, but when the collector William Corbusier came to obtain a copy of it, Good was inspired to interview older knowledgeable Lakota who helped Good mark events beginning in 1700 (NAA Ms. 2372, Box 12).

Between the 1850s and 1950s the Lakota experienced tremendous and often devastating changes in every aspect of their lives. In the 1850s the Lakota, like other Plains Indians, were enjoying what is now referred to as the classic buffalo-hunting culture. People lived in bands of extended family groups known as tiyošpayes, which might include a man and his brothers and/or male cousins and their families. This band of about 150–300 people camped together year round.

In the summer, a tiyošpaye would move from a sheltered area out onto the open plains to join other bands in communal activities including buffalo hunts and sun dance ceremonies. The buffalo hunts provided food and materials from which people made their tipis, clothing,

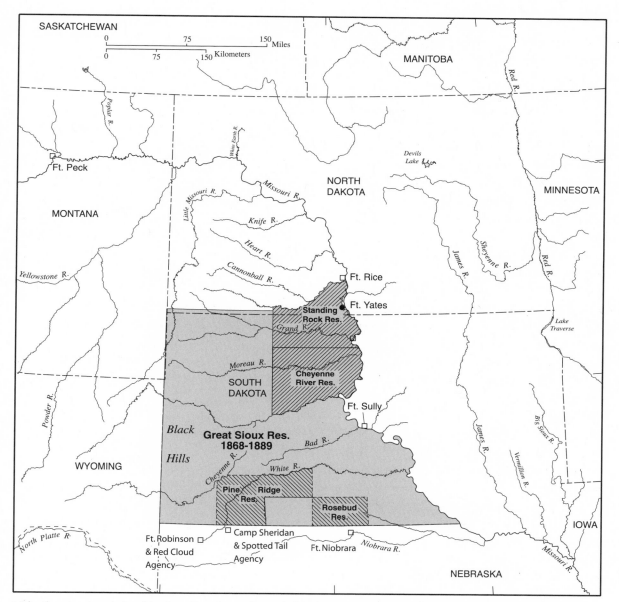

Mid-19th-century boundaries of the Great Sioux Reservation (excluding short-term additions and subtractions) and modern reservations associated with the Smithsonian winter counts and their keepers. Map based on DeMallie 2001:778, courtesy of the Handbook of North American Indians, *Smithsonian Institution.*

tools, and ritual objects. The summer was a time of so-cializing as well; marriages were arranged and friendships renewed.

When the weather grew colder with the onset of fall, each *tiyošpaye* would move, heading off the windswept plains and into the wooded areas of sheltered valleys. During the cold season, small hunting parties of men and boys would provide food for the group by hunting deer, antelope, and other animals. Women would prepare and tan hides for clothing and tipi covers, and cook food for their families and guests who might happen to visit. Winter was the time of storytelling and reflecting on the past.

COLLECTORS AND COLLECTIONS

The winter count collections in the NAA center around the materials, documents, and information gathered together by one man, Col. Garrick Mallery (1831–94). Materials on 9 of the 13 winter counts in the NAA were collected by Mallery, and he was the first to publish scholarly materials on Lakota calendars.

Garrick Mallery was born in Wilkes-Barre, Pennsyl-vania, on April 25, 1831, the son of Garrick senior (a judge and sometime state legislator) and his second wife, Catherine J. (Hall) Mallery. Both parents were concerned with their son's education, and young Garrick was pushed to excel academically. He attended private school and was tutored in preparation for entering his father's alma mater, Yale College, in 1846. During his time at Yale, Mal-lery earned honors in both mathematics and languages. He graduated in 1850 and went on to study law at the Uni-versity of Pennsylvania. In 1853 he earned his law degree and was admitted to the bar in Pennsylvania. He began his law practice in Philadelphia and kept up his interest in literature in his spare time (Fletcher 1895a, b, c; Crossette 1966; Powell 1896).

When the Civil War broke out, Mallery left his law practice and volunteered as a private in the Union army. On June 4, 1861, he was appointed captain in the 71st Pennsylvania Infantry. Just a year later, he was seriously

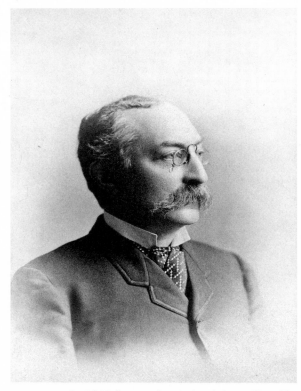

FIGURE 1.1. *Garrick Mallery was the premier scholar working with Lakota winter counts during the 19th century. His extensive papers are in the collection of the National Anthropological Archives. National Anthropological Archives, Smithsonian Institution (NAA Neg. no. 45190).*

wounded in the Battle of Peach Orchard in Virginia. Found lying on the battlefield, Mallery was captured and held at Libby Prison in Richmond. He was soon exchanged for a Confederate prisoner and sent home to recover from his extensive injuries (Fletcher 1895c:467; Powell 1896:52).

Despite his severe injuries on the battlefield, Mallery continued serving in the military after the war and was later stationed on the plains as a signal officer at Fort Rice, near present-day Bismarck, North Dakota. It was there in 1876 that his interest in Native American culture was piqued. In particular, he was struck by the complex systems of nonverbal communication created and used by Plains Indians, including smoke signals, sign language,

SIOUX POLITICAL DIVISIONS

Western (Lakota speakers)	Middle (Nakota speakers)	Eastern (Dakota speakers)
TETON	YANKTON	Various tribes
	YANKTONAI	(No winter counts known)

Oglala
Brulé (Sičáŋǧu)
Mnicónjou
Húnkpapa
Blackfeet (Sihásapa)
Two Kettle (Ó'óhenunpa)
Sans Arc (Itázipčo)

People commonly known as the Sioux are a complex association of tribes speaking closely related dialects of the widespread Siouan language family. This chart includes only the tribes and bands referred to in this volume. In the 19th century, when Mallery was writing, the term Dakota was used to refer to all of these people.

and pictography. By 1877 he was assigned to work for Maj. John Wesley Powell, another Civil War veteran, who was heading the U.S. Geological and Geographical Survey (USGGS) in Washington DC. The staff of the USGGS were not only mapping the western landscape but also gathering ethnographic and linguistic data on the Native Americans who inhabited the area.

While assigned to the USGGS, Mallery published the first scholarly study of winter counts. His "A Calendar of the Dakota Nation" appeared in a USGGS bulletin in April 1877. In it he describes a winter count painted on hide kept by a Yanktonai named Lone Dog. Soon thereafter, Mallery retired from the army and was immediately hired by Powell at the Smithsonian's newly formed Bureau of Ethnology, later known as the Bureau of American Ethnology, or BAE. As a staff ethnologist with the BAE, Mallery's job was to continue his collection and study of Indian material culture and symbolic systems.

Throughout his time in Washington, Mallery was part of an elite group of men in learned societies who researched and discussed matters of ethnology, linguistics, and literature. Like many of his peers, he was active in the Anthropological Society of Washington as well as in

the Literary Society and the Philosophical Society. In addition, he was a part of the American Association for the Advancement of Science as well as a founding member, along with Powell, of the exclusive gentleman's group the Cosmos Club.

Research conducted for his job and discussions carried on in these various societies and clubs reinforced his interest in American Indian pictography. Mallery used his position as a BAE ethnologist and his extensive connections with army personnel and others in contact with Indians on the plains to accumulate information on pictography. His major work comparing several winter counts, "Pictographs of the North American Indians," appeared in 1886 in the *Fourth Annual Report of the BAE.* In this publication, Mallery presented five related winter counts, all collected by army officers on the plains. He established the practice of naming the counts after their keepers: Lone Dog, The Swan, The Flame, and Mato Sapa (Black Bear). He did not know the keeper of the fifth winter count, and so named it for its collector, Major Joseph Bush.

All five counts were from bands of Lakota who had settled on the Cheyenne River and Standing Rock

reservations: Yanktonai, Húnkpapa, Blackfeet (Sihá-sapa), Mnicónjou, Sans Arc (Itázipčo), and Two Kettle (O'óhenunpa). The calendars are closely related, covering the same basic period of time and sharing many of the same pictographs and interpretations (see Mallery 1886:100–127 for comparisons).

Much of the research for Mallery's work was accomplished by other army officers. One was Hugh T. Reed, a 1873 graduate from the U.S. Military Academy at West Point. Reed served as a second lieutenant in the 1st Infantry from June 13, 1873, to 1879, during which time he was stationed at Fort Sully, Fort Rice, and the Lower Brule Agency, among other places.[7] Another military officer who collected winter counts and information for Mallery was William H. Corbusier, an assistant army surgeon stationed at Camp Sheridan, Nebraska, in the late 1870s.

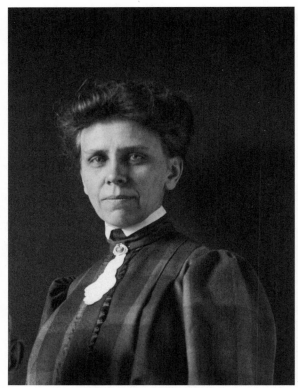

FIGURE 1.3. *Ethnomusicologist Frances Densmore collected the Swift Dog winter count. Many of the materials she collected on the Standing Rock Reservation are now in the National Museum of the American Indian, but the location of her Swift Dog winter count is unknown. National Anthropological Archives, Smithsonian Institution (NAA Neg. no. 537B1).*

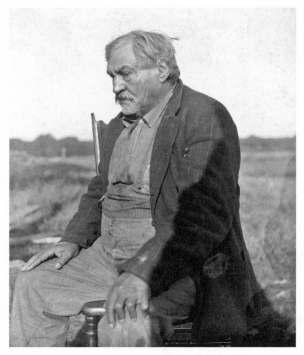

FIGURE 1.2. *Interpreters such as Basil Clément, shown here, were a critical link between calendar keepers and the collectors who recorded their explanations in English. National Anthropological Archives, Smithsonian Institution (NAA 00633300).*

While at Camp Sheridan, near the Pine Ridge and Rosebud reservations in southern South Dakota, Corbusier collected three pictographic calendars from their keepers. On Pine Ridge, he obtained winter counts from the Oglalas American Horse and Cloud Shield. He also traveled to Rosebud to get a copy of Battiste Good's Sičáŋǧu calendar. Each keeper copied images for Corbusier from an original cloth calendar in their possession; through translators, they also explained the events depicted. Corbusier also collected the year names from White Cow Killer's calendar, but he did not obtain a pictographic version.

In addition to these core winter count materials col-

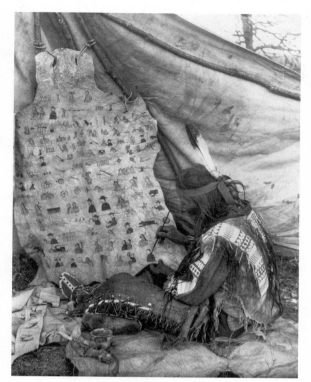

FIGURE 1.4. *This photograph of the Brulé Kills Two was made by John Anderson, the collector of the Rosebud winter count. Kills Two is carefully posed as if painting a count on a small hide. On the ground near his foot is a painted strip of cloth, which may be another winter count. Anderson titled the photograph "The Recorder" when he copyrighted it in 1929. National Anthropological Archives, Smithsonian Institution (NAA 03494000).*

terials in the early years of the 20th century, and his hobby soon became a major occupation, leading to his founding of the Museum of the American Indian in 1915. Although he hired a number of archaeologists and ethnologists to collect for him, much of the collection was assembled and cataloged by Heye himself. None of the winter counts in the NMAI has extensive collecting information associated with it, and only one is accompanied by an interpretation. However, they can all be compared to other winter counts, including many in the NAA, for interpretation.

SCHOLARLY STUDIES

Since Mallery's first article appeared in 1877, there have been dozens of publications on plains winter counts. Most of these are descriptions of individual calendars, but some compare several counts. Some papers have used multiple calendars to focus on a particular subject, including ethnohistorical descriptions of Plains Indian life (Howard 1960b), analyses of meteorological phenomena (Brandt and Williamson 1979; Chamberlain 1984), epidemic disease (Sundstrom 1997), and the impact of westward migration by non-Indians (Henning 1982). But the works of Mallery (1886, 1893), James H. Howard (1960b, 1976, 1979), Wilhelm Wildhage (1988), Ron McCoy (1983), and Raymond J. DeMallie (1982) stand out as exemplary comparative studies of winter counts in and of themselves.

Mallery's work was the first and in some ways the most groundbreaking, since he gathered information on Indian pictographs from every source he knew. During his 19 years of ethnographic work (1876–95), he accumulated and interpreted the first great collection of winter counts, which remains in the NAA to this day. He published most of his findings in the "Pictographs of the North American Indians" (1886) and followed up with additional information in "Picture-Writing of the American Indians" (1893). But while his collecting was extensive, his record keeping was not. Like many scholars of his time, Mallery threw away many of his notes and his drafts once a piece was published. Consequently, his papers (NAA Ms. 2372) con-

lected by Mallery, Corbusier, and Reed, the NAA has information from other sources. A large calendar on muslin from the Rosebud Reservation was donated by the family of frontier photographer John Anderson, while a Lakota text version of the No Ears count was found in the archives without any source of origin noted. There are also photographs of four additional calendars. The histories and collectors of each are discussed in individual entries in the next chapter.

Most of the winter counts in the NMAI were acquired by the museum's founder, George Gustav Heye, a wealthy New Yorker. Heye began collecting American Indian ma-

tain little more than what one can read in the BAE annual reports. There is, however, tantalizing information found in separate files, including Mallery's correspondence with the army officers and others who collected materials for him. Some of this information is invaluable in providing insight into who made and interpreted the winter counts in Mallery's collection. Documentation, such as original correspondence, is critical for researchers in the search for details about data collection and interpretation.

Decades after Mallery's death, another anthropologist became intrigued by winter counts. For many years James H. Howard (1925–82) collected previously unknown winter counts and worked to have them interpreted by Lakota people. His findings were published in several articles between 1955 and 1979. He described calendars of the Lakota and other tribes and published useful lists of source materials in 1976 and 1979.

Howard's contribution to winter count studies included not only his publication of newly discovered calendars but also his comparison of many calendars, and indeed many calendar traditions. His monumental "Dakota Winter Counts as a Source of Plains History," published in 1960 in BAE *Bulletin* 173, examines individual chronicles from many traditions, giving names and interpretations for the years 1785 to 1930 for 22 winter counts, including Mallery's calendars and two Swift Dogs. Howard knew the Lakota language well and worked to find knowledgeable Indian people to assist him in translating and interpreting winter count pictographs and texts (Howard 1979).

Ron McCoy also studied winter counts from many traditions. His dissertation, "Winter Count: The Teton Chronicles to 1799," submitted to Northern Arizona University in 1983, compares dozens of calendars and comes to two conclusions. First, there are but a few winter count independent traditions or "cycles"; individual calendars fall into one of these cycles based on their relative similarity in terms of pictograph content, text, and/or interpretation. Second, there was a progression of winter count types from the earliest form, pictographs painted on animal hide, through pictographs and text painted on cloth and paper, to winter counts with only text (whether handwritten, typed, or printed). Like Howard, McCoy contributed much to winter count studies by making previously unknown calendars available for further study. He was also able to elucidate some connections among calendars within certain traditions. A more recent article by McCoy (2002) describes several Lakota winter counts in the collection of the South Dakota State Historical Society, including two that are associated with Long Soldier.

Wilhelm Wildhage also wrote a dissertation on winter counts (1988), available only in his native German. His work focuses on Oglala calendars, but he includes information on over 70 Lakota counts from various traditions. Of particular importance is his extensive appendix with several previously unpublished Oglala winter count texts, some in Lakota, others in English.

In terms of relating winter counts within a particular tradition, Raymond DeMallie has done a great service by publishing his interpretation of several versions of the No Ears calendar. Not only does he provide translations of three versions, but he also carefully maps out the relationship among several others.[8] DeMallie has also contributed to winter count studies in other ways, publishing a list of relevant materials in the NAA as an appendix to the volume *The Modern Sioux* (1970) and a paper on tribal traditions in the Plains volume of the *Handbook of North American Indians* (2001).

There are many other scholars who have written on individual Lakota calendars. Comparison of these counts to one another is crucial to accurate and meaningful interpretation and analysis of these enigmatic ethnographic pieces. Sources directly relevant to the Smithsonian winter counts are noted in the individual descriptions in the following chapter. Source material relating to other counts appears in the bibliography of this volume, which is intended as a general guide to the literature on Lakota winter counts.

NOTES

1. Much of our knowledge of winter counts and their function is based on Mallery 1886. Other insightful information is given in Blish 1967.

2. Unless otherwise noted, all translations are from Buechel's *Lakota English Dictionary* (1970). Other phrases for the winter counts were *waniyetu yawapi*, literally, "winter count" or "they counted [by] winters," and *hekta yawapi*, "counting back" (Corbusier 1886:128).

3. See Ewers 1939 for a description of techniques and styles of two-dimensional design.

4. For 19th-century uses of winter counts, see Corbusier 1886:130; for 20th-century usage, see DeMallie 1984:101.

5. The NAA has hundreds of ledger drawings by Plains Indians in their collections. Many of these are by Lakota artists, and some have been published. See particularly pictographs by Sitting Bull in Stirling 1938 and Praus 1955, and the drawings by George Sword in Dorsey 1894.

6. See in particular Bad Heart Bull's work in Blish 1967.

7. Information on Reed's service record is based on Cullum 1891:220–21.

8. The No Ears material appears in Walker 1982:124–157; a more generalized overview of the Lakota winter count tradition is given in DeMallie 2001.

2

Winter Counts in
the Smithsonian

CHRISTINA E. BURKE

The Smithsonian has winter counts in two collections, the National Anthropological Archives NAA and the National Museum of the American Indian NMAI. Each repository holds six pictographic calendars, and the NAA has materials relating to an additional nine counts.

Most of the NAA materials are in Garrick Mallery's papers (NAA Ms. 2372), including five pictographic calendars with interpretations provided by their keepers: The Swan, The Flame, American Horse, Cloud Shield, and Battiste Good. Each of these was copied from a winter count in the keeper's possession. The Flame was copied onto muslin cloth. American Horse, Cloud Shield, and Good were drawn in sketchbooks. The Swan and a second copy of American Horse are on architect's linen, a tracing medium. The American Horse copy covers only part of the calendar in the sketchbook and is missing a pictograph for the year 1803–04. Documents pertaining to two other winter counts (Mato Sapa and White Cow Killer) are also in the Mallery papers, although the actual pictures and texts are not present. The most detailed descriptions of these two calendars were published by Mallery and by William H. Corbusier, respectively, in the *Fourth Annual Report of the Bureau of American Ethnology* BAE (1886). The NAA also holds two texts with no pictographs: Major Bush, which is a part of the Mallery collection, and No Ears (NAA Ms. 2261). The most recent addition to the winter count materials is a pictographic example drawn on cloth known as the Rosebud winter count (NAA Ms. 2001-10). Although there was no interpretation accompanying it, many year events can be determined by comparing it to other winter counts (see chap. 3).

Of the six pictographic winter counts in the NMAI collections, three are copies of Lone Dog, all drawn on hide. They closely follow the version published by Mallery and are labeled here as NMAI Lone Dog A, B, and C. In addition, there are two cloth calendars from the Standing Rock Reservation associated with a man named Long Soldier: one was interpreted by him and the other may have been drawn by him. The last NMAI calendar is a cloth copy of The Flame, with entries very similar to the version in the NAA. Only the example interpreted by Long Soldier has any accompanying description.

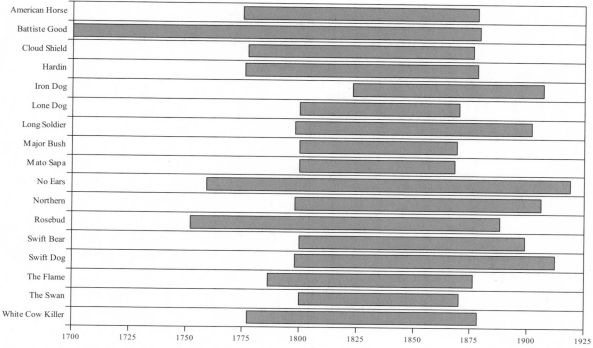

Time periods covered by the winter counts in this volume.

This chapter is organized to provide basic information about the form and history of each winter count. The counts are arranged by their relative similarity to one another, with closely related calendars grouped together. The Lone Dog copies and associated counts (Flame, Swan, Major Bush, and Mato Sapa) are listed first, followed by the two Long Soldier calendars. Next there are descriptions of the American Horse, Cloud Shield, Good, No Ears, and Rosebud winter counts.

Following the descriptions are two appendixes: Appendix 1 lists calendars for which the NAA has only photographic records (Swift Bear, Densmore's Swift Dog, Hardin, and Iron Dog). Appendix 2 lists locations of winter counts related to those in the NAA collections.

Sources of information include unpublished materials in the NAA and NMAI and Smithsonian publications. Mallery's paper in the *Fourth Annual Report of the* BAE (1886) provides the majority of the data, although interpretations of Lone Dog and Good are from Mallery's work in the *Tenth Annual Report of the* BAE (1893). At the time these papers were written, it was customary to dispose of notes and drafts once an article was published, so some of the original materials are probably long gone. There are some unpublished materials in the Mallery collection and in other BAE files as well as in the NMAI archives; where appropriate, these are cited. These materials include handwritten correspondence between Mallery and the army officers who were collecting material and information while stationed on the plains, and letters between George G. Heye and collectors with whom he was negotiating for objects. Sometimes the author of these materials is known or can be identified by distinctive handwriting, but other times it is unclear who wrote them.

Unfortunately, the collection information on the winter counts is inconsistent; for some calendars, like Lone Dog, there is a great deal of information about how it was collected, who provided the interpretation, and who else was consulted. For other examples, like the No Ears text, there is no information about who collected it or even how it came to the Smithsonian. Most of the objects, like the NMAI calendars, fall somewhere in the middle; they have some documentation but not much. In addition, it should be noted that some "interpretations" of winter counts include more information than others. A few are simply lists naming the event being depicted, while others include more details about what happened and who was involved. As Corbusier described the data he collected: "The explanations of the counts are far from complete, as the recorders who furnished them could in many instances recall nothing except the name of the year, and in others were loth [sic] to speak of the events or else their explanations were vague and unsatisfactory" (1886:130). Events far in the past were beyond anything but a simple recitation of a year event, but recent happenings were fresh in the memories of keepers, interpreters, and the collectors, so explanations are vivid and detailed. It should also be noted that most of the interpretations were collected by army officers who did not speak Lakota and so relied on interpreters to relate the keepers' narratives. Sometimes, as with the No Ears text, translations of Lakota phrases were provided by someone who did not know the language very well. However, retranslations and comparison with other winter counts can help elucidate unclear interpretations.

■

NAME: LONE DOG (See Color Plate 1)

Physical Form: Photographs of cloth copy

Photograph of re-creation on buffalo hide

Paper photostats of pictographs

Years Covered: 1800 to 1870

Format: Pictographs drawn on cloth with black and red ink;

 pictographs spiral counterclockwise from the center of the cloth out

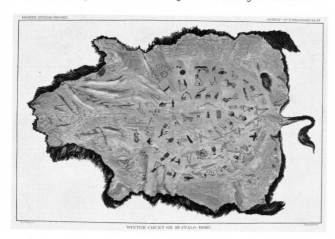

Lone Dog, as published by Mallery.

HISTORY OF PRODUCTION

The NAA does not have an original copy of Lone Dog, but only a series of photographs. All these images are based on a cloth copy of Lone Dog which was obtained in the fall of 1876 by Hugh T. Reed, a lieutenant in the 1st U.S. Infantry. At the time, Reed was stationed at Fort Sully, Dakota Territory, near present-day Pierre, South Dakota. There he met a mixed-blood trader and interpreter named Basil Clément (also known as Jacquesmarie Claymore; see DeLand 1922). Clément showed Reed a copy of a winter count on buffalo hide which the trader had acquired from the keeper, Lone Dog, a Yanktonai living near Fort Peck, Montana, around 1870. Lone Dog allowed Clément to copy his calendar onto a second buffalo hide. It is not clear from Mallery's papers who actually drew the pictographs on Clément's copy. What is clear is that Clément was familiar with some events depicted on the calendar, and collected interpretations from Lone Dog and other knowledgeable Indian people around Fort Sully. He then translated and transcribed all of this information.

HISTORY OF ACQUISITION

Having seen Clément's hide copy, Reed asked for and was granted permission to make his own copy, this time on cloth (Fig. 2.1). Reed used black ink to draw outlines of the figures, then added red ink for details, using the hide version as a guide. It is not clear how Mallery learned of Reed's copy, but Reed loaned it to him. It was never accessioned into the Smithsonian collections and was presumably returned after it was photographed.

FIGURE 2.1.

The Lone Dog winter count drawn on muslin by Lt. Hugh Reed ca. 1876. This copy formed the basis for Mallery's study as well as for an artist's reconstruction on buffalo hide, which Mallery published (see Color Plate 1). National Anthropological Archives, Smithsonian Institution (NAA Neg. no. 3524C).

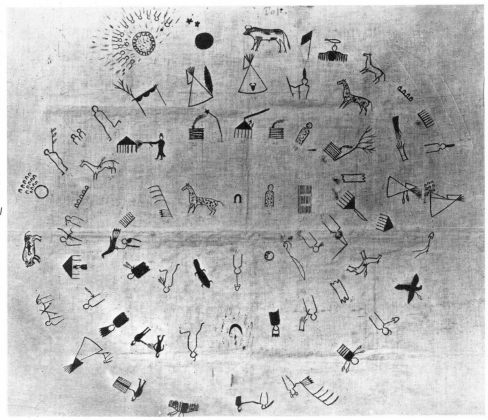

Although Mallery's Lone Dog is the best known and most copied winter count, there is no hide or cloth version in the NAA, and apparently there never was. The version on buffalo hide that Mallery published (Color Plate 1) was an artist's re-creation. It was created by superimposing a photograph of Reed's cloth copy onto a drawing of a buffalo hide to simulate Clément's copy and suggest what Lone Dog's original might have looked like. This photographic re-creation was published by Mallery in 1877 (pl. 1) and 1886 (pl. 6) and has been copied many times since.

Using Clément's interpretation as a starting point, Reed continued to elicit information about Lone Dog and his winter count. During the spring of 1877, Reed spoke with several interpreters in Dakota Territory, including Sam Brewer at Fort Rice, Alex Laravey at Fort Sully, and William Fielder at Cheyenne River Agency.[1] These men in turn consulted knowledgeable Indians in the area, including Good Wood, a Blackfoot Lakota. Good Wood was "an enlisted scout attached to the garrison of Fort Rice" who immediately recognized the cloth copy as a calendar similar to Lone Dog's, adding that he had seen yet another copy at the Standing Rock Agency, owned by Blue Thunder (Mallery 1877:4).[2] The scout was familiar with many of the events depicted and so could corroborate many of Clément's translations. Reed noted that another trader, Charles Primeau, could recount "all details from 35 years back of 1868" (Mallery 1877:4). Mallery was also busy using Reed's cloth copy

to elicit information about the calendar. While at Fort Rice in November 1876, and later in Washington DC, he showed the copy to various government officials from the Departments of War and the Interior who were familiar with Indian ethnology. However, none of them had seen or heard of this type of chronology before (Mallery 1877:3).

Undeterred, Mallery continued his quest. Following its publication in April 1877, Mallery circulated copies of his article "A Calendar of the Dakota Nation" among Indian agents, military officers, missionaries, and "other persons favorably situated," in the hopes of obtaining further interpretations of Lone Dog and perhaps even finding other winter counts (Mallery 1886:93). His efforts paid off, and over the next few years he gathered details pertaining to eight winter counts, all collected by army officers on the northern plains. These were published collectively as "The Dakota Winter Counts" in Mallery's paper "Pictographs of the North American Indians," which appeared in the *Fourth Annual Report of the* BAE (1886).

In that publication, Mallery compares five calendars, all of which cover the same basic period of time, ca. 1786–1876 (1886:100–127). Individual pictographs from Lone Dog (Yanktonai), The Flame (a Two Kettle who lived with the Sans Arc), and The Swan (Mnicónjou) are compared with one another (see pls. 7–33). There are also comments from two other winter counts "where there seems to be any additional information or suggestion in them" (Mallery 1886:99). The two calendars are known as Mato Sapa/Black Bear (Mnicónjou) and the Major Bush count (probably Yanktonai, since it is nearly identical to Lone Dog's). The current location of these winter counts is unknown, and the most information known about them is published in Mallery 1886.

BIOGRAPHY OF LONE DOG

According to Mallery, Lone Dog was a Yanktonai who lived near Fort Peck, Montana Territory, in the late 1860s. Many of the army officers contacted by Reed and Mallery claimed to know Lone Dog, or at least something about him. This information is somewhat confusing, though, because there were probably many Indian people with that name living on the plains at the time. In a letter dated April 25, 1877, Rev. Samuel D. Hinman wrote to Mallery that he knew Lone Dog, Shunka Ishnala, and could get the entire history and translations for Mallery, but not until later in the year (NAA Ms. 2372, Box 12, Folder 5). Reed noted that those who knew Lone Dog (Chin-o-sa) reported that he was with Sitting Bull in the late 1870s.[3] Perhaps such references were to a father and son; in January 1878 Reed reported that Sam Brewer, an interpreter at Fort Rice, stated that the elder Lone Dog, a Yanktonai, was at Fort Peck in Montana and the younger Lone Dog was at the Standing Rock Reservation. Another interpreter, Alex Laravey from Fort Sully, said that Lone Dog was a Mnicónjou (NAA Ms. 2372, Box 12, Folder 3). For additional information on Lone Dog, see Dodge 1882:398–405; Howard 1960b and 1979; and Morgan 1879.

COPIES AND CITATIONS

The Lone Dog winter count was the first published and remains the most duplicated, with at least 15 versions in collections around the world. Three copies on hide are in the collections of the NMAI (NMAI Lone Dog A, B, and C). There is at least one hide copy at the South Dakota State Historical Society in Pierre (Object #65.22; see Capps 1973:21–22; Cash 1971:99–106), and one at

the Deutsches Ledermuseum in Offenbach, Germany (Howard 1960b, 1979). There are at least two hide copies in Canada as well: one at the Riding Mountain Provincial Park in Manitoba (Howard 1960b, 1979) and one at the Buffalo National Park in Alberta, which was reportedly destroyed by fire (Barbeau 1960:229). A cloth copy, collected by an army officer named C. L. Gurley in 1871, is in the Galena and Jo Daviess County Historical Society in Galena, Illinois (Obj. #81.444A). Another copy in the collection of Theodore Riggs (son of the missionary Thomas L. Riggs) was destroyed by a fire following the 1906 San Francisco earthquake (Riggs 1958:250). There is also a textual interpretation of Lone Dog's calendar in the Nebraska State Historical Society in Lincoln in the papers of Susan Bettelyoun Bordeaux (Bordeaux and Waggoner 1988; Sundstrom 1997). Bettelyoun Bordeaux was the granddaughter of a man named Lone Dog, but he was Santee, who died in 1871 (Bordeaux and Waggoner 1988). Mallery's re-created image of the Lone Dog calendar on hide appears in many publications (e.g., Brotherston 1979; Chamberlain 1984:S13; Taylor 1996:286; Anonymous 1951; Warhus 1997:18), and images from Lone Dog have even been used to illustrate literary works (Glancy 1991; Robertson 1976).

Other winter counts in the Smithsonian collections that are related to Lone Dog include The Flame, The Swan, Major Bush, and Mato Sapa. Such related versions are described as being part of the same winter count tradition or "cycle" (McCoy 1983). Mallery referred to them collectively as the "Lone-Dog system of winter counts" (1886:95). While there may be some variation among them, they cover the same basic period of time and contain many of the same pictographs or interpretations for those years. For instance the pictographs for Lone Dog, The Swan, and The Flame are the same for the years 1800 to 1869, although occasionally there is a variation in interpretation. Yet, sometimes there is a difference of opinion about which enemies the Lakota fought; for 1811, Lone Dog says the Lakota battled the Gros Ventres, while The Flame claims it was the Mandans (Mallery 1886:107).

REPOSITORY IDENTIFICATION

Photographs of copies on cloth:

NAA Neg. no. 3524C (glass plate negative)

NAA SPC BAE 4420 Vol. 6, 01009200 (print from negative)

NAA Photo Lot 88-35 (print from negative)

Photographs of re-creation on buffalo hide as published:

NAA Neg. no. 3524A (glass plate negative)

NAA Neg. no. 3524B (glass plate negative)

NAA Neg. no. 3524D (glass plate negative)

Paper photostats of selected pictographs:

NAA, Ms. 2372, Box 12, Folder 5

■

NAME: NMAI LONE DOG A (See Color Plate 2)
Physical Form: Pictographs on buffalo hide
Dimensions: 106" (270 cm) by 77" (196 cm)
Years Covered: 1800 to 1870
Format: Pictographs painted in a spiral on buffalo hide

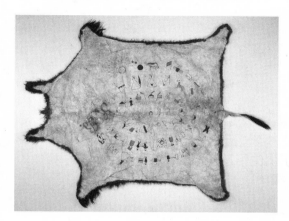

*Lone Dog, on buffalo hide
(NMAI 01/0617).*

HISTORY OF PRODUCTION

There is no information in the NMAI files about how, when, or by whom this version of the winter count was produced. This a beautifully tanned complete buffalo hide, referred to on the catalog card as a robe. However, there is no indication that winter counts were ever worn as robes.

This winter count presents a number of anomalies. The painted figures bear a remarkable similarity to the Lone Dog count as published by Mallery in 1877 and 1886, seen in this volume as Color Plate 1. Not only are the same images included, but they are almost identical in proportions and spacing, suggesting that it was based on the published image, itself a re-creation. The hide is also unusually flat. There are a number of seams around the edges where sections have been removed to reduce the unevenness usually seen in hides. All the edges have been folded over, and holes are evident where stitching has been removed, suggesting that the hide was once lined. It may have been a carriage robe of the type used by non-Indians in the late 19th century. The hide is also marked with large initials "L.B." (appearing upside down on the left), which may be a mark placed on it by a hide dealer.

HISTORY OF ACQUISITION

According to the object number, this piece was accessioned into the Heye collection in 1906. The catalog card notes that it was acquired from Stephen A. Frost, an Indian trader in New York. Frost reported that he had purchased the winter count from the Chichester family about 1880, and that it had been collected by a "Capt. Chichester," presumably while he was stationed on the plains in the late 1870s. The name on the card may be misspelled; research did not turn up a Chichester in the U.S. Army in the late 1800s, but did reveal a Capt. Walter C. Chidester, who served as assis-

tant surgeon in the Ohio volunteers during the Civil War (Heitman 1903:298). Perhaps it was his family who sold it to Frost (NMAI Archives #6, Box OC 127).

Stephen Allen Frost (b. ca. 1820) began his trading company at Fort Leavenworth, Kansas, in 1848. His son Dan joined the family business, which became known as S. A. Frost and Son, Indian Trader. Stephen retired in 1900 at the age of 80. Dan continued doing business until his retirement in 1937 at age 87. Dan died in 1943 (age 93), and his daughter, Mrs. Walter F. Wagner, auctioned off most of the family's collection. Some objects that did not sell were subsequently given to the Illinois State Museum, where they currently reside (Jonathan E. Reyman, pers. comm., 2002).

BIOGRAPHY OF LONE DOG
See biography above.

COPIES AND CITATIONS
This copy is cited and illustrated in Glubok 1975:6–7; and Nahwooksy and Hill Sr. 2000:4–5. See also Liu 1983.

REPOSITORY IDENTIFICATION
NMAI 01/0617

■

NAME: NMAI LONE DOG B (See Color Plate 3)

Physical Form: *Pictographs on cowhide*

Dimensions: *75" (190 cm) by 68" (173 cm)*

Years Covered: *1800 to 1870*

Format: *Pictographs painted in a spiral on cowhide*

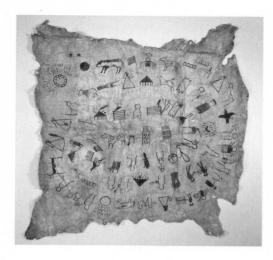

Lone dog, on cowhide
(NMAI 21/8701).

HISTORY OF PRODUCTION

There is no information about how, when, or by whom this version of the winter count was produced.

HISTORY OF ACQUISITION

The catalog card states that this piece was obtained by the NMAI in January 1952 through an exchange with Jim Anthony, an antique dealer in El Seguado, California. Anthony and George G. Heye (founder of the NMAI) corresponded in the early 1950s, bargaining over various objects to be traded, including this winter count (NMAI Archives Box FD1, File #45). It is not clear what Heye gave Anthony in exchange for the calendar. At the time this piece was acquired by the museum, it was common practice for the Heye Foundation, and other museums, to deaccession objects and trade them with other institutions and collectors.

BIOGRAPHY OF LONE DOG

See biography above.

COPIES AND CITATIONS

As noted above, there are over a dozen copies of Lone Dog. This particular one is cited in Howard 1960b and 1979, and illustrated in Amiotte 1989:115; Barbeau 1960:229; and Szabo 1994:49.

REPOSITORY IDENTIFICATION

NMAI 21/8701

■

NAME: NMAI LONE DOG C (See Color Plate 4)

Physical Form: Pictographs on deer hide (doeskin)

Dimensions: 42½" (108 cm) by 31" (79 cm)

Years Covered: 1800 to 1870

Format: Pictographs painted in a spiral on doeskin

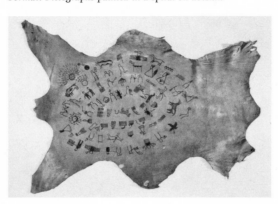

Lone dog, on deer hide (NMAI 23/0246).

HISTORY OF PRODUCTION

There is no information about the history of production in the NMAI files.

HISTORY OF ACQUISITION

The catalog card states that this is a "copy of the Winter Count Robe." It is not clear from which other piece it was copied. The card also notes that the winter count was part of the Thomas C. Watson Collection, "formed by E.W. Countryman, 1900–1940; purchased in 1947." It was in the IBM Gallery of Art & Science in New York (IBM #48) and was obtained by the NMAI as part of the IBM Gift Collection in October 1960 and accessioned in 1961.

The documentation reads that this is a "Very fine Pictograph Skin Chart. . . . The original was on a large Elk Skin, smaller ones were no doubt made for use." This piece, and presumably some of the others in the IBM Gift Collection, were originally acquired by Reuben Oldfield of Bath, New York, who worked for IBM. It is not known how he acquired this winter count.

BIOGRAPHY OF LONE DOG

See biography above.

COPIES AND CITATIONS

To the best of my knowledge, this piece has not been cited or illustrated in any publication.

REPOSITORY IDENTIFICATION

NMAI 23/0246

NAME: THE FLAME (See Color Plate 5)

Physical Form: Pictographs drawn on cloth (cotton muslin)

Dimensions: 35″ (89 cm) by 35½″ (90 cm)

Years Covered: 1786 to 1876

Format: Pictographs drawn in black and red ink on muslin in a serpentine manner, beginning at the lower
left corner; pictographs are numbered sequentially (1–91)

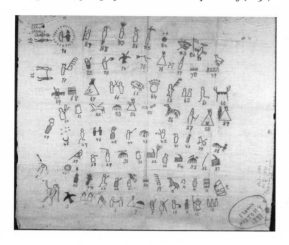

The Flame, on muslin
(NAA 08633800).

HISTORY OF ACQUISITION

This cloth copy of The Flame's winter count was traced by Lt. Reed, the collector of the Lone Dog count, probably in the late 1870s. There is no description of the material of the original winter count. On the bottom right corner he wrote: "Flame's HISTORY 1877" in black ink and "No. 1 1786, No. 91 1876. Copied by Reed" in red ink.

Descriptions of the events depicted were first collected from the keeper by Alex Laravey, the official interpreter at Fort Sully. In April 1877 Lt. Marion P. Maus, 1st U.S. Infantry, obtained this information from Laravey (Mallery 1886:93). There are two handwritten interpretations of The Flame in the NAA (Ms. 2372, Box 12, Folder 3). One of these was clearly written by Reed, but it is not known who transcribed the other.

BIOGRAPHY OF THE FLAME

The keeper, Boíde (The Flame or The Blaze) was a Sans Arc by birth, his father being a Sans Arc, yet he lived most of his life with the Two Kettle (see Mallery 1886:93, and interpretation written by H. T. Reed, NAA Ms. 2372, Box 12, Folder 3).

COPIES AND CITATIONS

Although the pictographs are arranged in a serpentine rather than spiral form, this winter count closely resembles Lone Dog's, except that it includes several more years, beginning in 1786 and continuing until 1876. The Flame's count fits into the Lone Dog tradition and is related to The Swan,

Major Bush, and Mato Sapa. The Flame has the same pictographs as Lone Dog and The Swan for the years 1800–1868, but records a more personal rather than tribal event for 1869. While Lone Dog and The Swan note a battle with the Crows in which 30 enemies were killed, The Flame documents that his son was killed by some Arikara (Mallery 1886:126 and pl. 32).

The location of the original version of The Flame is not known; however, there is another cloth copy in the NMAI (see following entry), and a second in the Denver Museum of Nature and Science (DMNS #7923). The latter is called the White Horse winter count and differs from the NAA and NMAI versions in that it continues into the 1910s (Joyce Herold, pers. comm., 2001).

REPOSITORY IDENTIFICATION
NAA Ms. 2372, Box 12; 08633800

NAME: NMAI THE FLAME (See Color Plate 6)

Physical Form: Pictographs drawn on cloth (cotton muslin)

Dimensions: 31" (79 cm) by 36" (91 cm)

Years Covered: 1786 to 1876

Format: Pictographs drawn on cloth with dark blue media; serpentine arrangement,
* beginning in the bottom left corner*

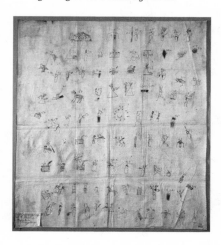

The Flame, tracing on muslin
(NMAI 24/4039).

HISTORY OF PRODUCTION

Little is known about the creation of this object. It is noted in the NMAI files that it was copied by Septima V. Koehler around 1892. This copy may be a tracing made with carbon paper. The source of the original is not recorded.

HISTORY OF ACQUISITION

Septima Koehler (1848–1918) was one of Herman A. and Aurore (Ludeling) Koehler's seven children. The family lived in Springfield, Ohio, but later moved to southeastern Indiana. Two of the four Koehler daughters, Septima and her elder sister Aurora (1846–1928), became teachers. They took up missionary work and taught on the Standing Rock Reservation and in nearby communities between 1892 and 1912 (Kelemen 1973:38). It was probably during this time that Septima created this copy.

The copy stayed in the family, passing to Septima's great-niece, Elisabeth Hutchings Zulauf Kelemen (granddaughter of Septima's sister Matilda). The NMAI acquired the winter count from the Kelemens in October 1970.

COPIES AND CITATIONS

This is an exact copy of the entries but not the layout of The Flame count in the NAA. Another version, known as White Horse, extends into the 1910s and is at the Denver Museum of Nature and Science (#7923). The NMAI Flame copy has never been published.

REPOSITORY IDENTIFICATION

NMAI 24/4039

■

NAME: THE SWAN OR LITTLE SWAN (See Color Plate 7)

Physical Form: Pictographs on cloth (architect's linen)

Dimensions: 38" (97 cm) by 21" (53 cm)

Years Covered: 1800 to 1870

Format: Pictographs drawn or traced onto architect's linen with ink and colored pencil;
* pictographs spiral clockwise from the center outward*

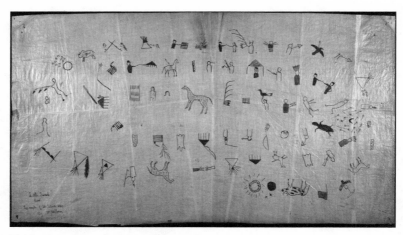

The Swan, tracing on linen (NAA 08633900).

HISTORY OF PRODUCTION

The NAA holds a copy on architect's linen of The Swan's winter count.[4] This was copied from a cloth version, itself a copy of the original painted on hide. The original count on hide was kept in The Swan's family for 70 years. Multiple cloth copies were commissioned by Dr. Washington West, an assistant surgeon in the army, when he was stationed at the Cheyenne River Agency from November 1868 to May 1870. Mallery states, "In return for favors, Dr. West obtained permission to have some copies made on common domestic cotton cloth. . . . From one of these he had a photograph taken on a small plate, and then enlarged in printing to about two-thirds of the original size and traced and touched up in Indian ink and red paint to match the original." It is not known who traced the copies, or what became of the photograph. We do know that sometime in 1868 West recorded an interpretation of the winter count from Jean Premeau, an interpreter at the agency. Although not stated directly, it is implied that The Swan provided the interpretation, which was translated by Premeau. In explaining the distinctive perspective offered by this winter count, Mallery says that "the owner and explainer of this copy of the chart was a Minneconjou" (1886:94).

HISTORY OF ACQUISITION

Soon after collecting the copies and interpretation, West sent a single cloth copy and Premeau's interpretation to a friend, Dr. John R. Patrick, in Belleville, Illinois. In 1872 Patrick sent them to Dr. Charles Rau of the Smithsonian, and it was Rau who later brought them to Mallery's atten-

tion (Mallery 1886:93–94).[5] Apparently the cotton cloth was only loaned to the Smithsonian, but a copy on architect's linen was made by a BAE employee, Walter J. Hoffman, around 1872 (DeMallie 1970:330). In the lower lefthand corner of this copy is a note reading "Little Swan's History. Facsimile of Dr. Patrick's copy by W. Hoffman." This architect's linen and a handwritten interpretation, listing years and events, are in the Mallery papers (Ms. 2372, Box 12, Folder 5). There is no notation as to who wrote the interpretation in the NAA, but it is in the same careful hand as the explanation of Major Bush (see below). The location of West's cotton copies is not known.

BIOGRAPHY OF THE SWAN

Not much is known about The Swan except that he was a member of the Mnicónjou, a northern band of Lakota who were settled primarily on the Cheyenne River Reservation in central South Dakota. His father was a well-known chief of the same name whose death was recorded not only by his son but also by Lone Dog, The Flame, Major Bush, and Mato Sapa.

COPIES AND CITATIONS

The Swan's winter count is part of the Lone Dog tradition and is closely related to The Flame, Major Bush, and Mato Sapa. There is at least one other copy of The Swan that consists of pictographs painted on buffalo hide and was sold at a Sotheby's auction (Sotheby's 1976). The hide was in the collection of George G. Frelinguysen, who owned the Wampum Trading Post in San Simeon, California, and is now presumably in another private collection. The hide copy follows The Swan (and Lone Dog and The Flame) closely, and so can be classified as belonging to the Lone Dog tradition. It is unclear why the auction catalog called this a copy of The Swan and not of Lone Dog. Despite its similarities to the NAA's The Swan, there are noticeable differences. For instance, the fourth image (representing the year 1804) looks like an elk on the hide copy but is clearly a horse on the NAA's The Swan, as well as on Lone Dog and The Flame. The interpretations clearly state that the image refers to a horse, in particular to a curly haired horse (Mallery 1886:104).

Information about The Swan's winter count has been published in Burke 2000; Howard 1960b, 1979; Mallery 1886; McCoy 1983; and Wildhage 1988. There is also a comment about a winter count, presumably The Swan's, in Dodge 1882:400.

REPOSITORY IDENTIFICATION

NAA Ms. 2372, Box 12; 08633900

■

NAME: MAJOR BUSH

Physical Form: *Text*

Dimensions: *8½" (21.5 cm) by 14" (35.5 cm)*

Years Covered: *1800 to 1869*

Format: *Handwritten text listing years and English names*
for each year written on legal-size paper (author unknown)

FIGURE 2.2. *The first page of the Major Bush manuscript, recording a count by an unknown keeper. The location of the pictorial version, which belonged to a trader at the Cheyenne River Agency, is unknown. National Anthropological Archives, Smithsonian Institution (NAA Ms. 2372, Box 12, Folder 5).*

HISTORY OF PRODUCTION

There is not much documentation on this calendar, and no pictorial copy exists in the Smithsonian collections. Because the keeper is not known, it is named for its collector, Joseph Bush, who was a major in the 22nd U.S. Infantry from September 1866 to March 1879 (Heitman 1903, vol. 1:268). In 1870 Bush collected a cloth version of this winter count from James C. Robb, a trader at the Cheyenne River Agency. There is no documentation about the keeper of this calendar or

whether it is a copy or an "original." Apparently, Bush's cloth version was loaned to Mallery, but it did not become part of the NAA collection. From Mallery's description, we know that the cloth was 1 yard by ¾ yard and had 69 pictographs drawn in a counterclockwise spiral beginning in the center (1886:94).

HISTORY OF ACQUISITION

Bush read "A Calendar of the Dakota Nation" and immediately wrote to Mallery: "I have a copy which was executed by an Indian which I obtained from Fort Rice in 1870 and I would much like to know if they are the same. The data in the Journal [USGGS Bulletin] agrees with mine. Will you be so kind as to send me the data of yours complete and greatly oblige" (April 28, 1877, NAA Ms. 2372, Box 12, Folder 5). Mallery replied on May 4, and the two men struck up a correspondence and shared information. Bush also corresponded with Reed, who apparently sent him an interpretation of The Swan. In a letter dated February 22, 1878, Bush wrote to Reed that there were several differences in interpretation between his copy and Dr. West's (NAA Ms. 2372, Box 12, Folder 5).

This carefully handwritten interpretation listing the years and their names is in Mallery's papers in the NAA. Although the writer is not known, it is written in the same hand as the interpretation of The Swan in the same folder. The interpretation is titled "Major *Joseph Bush's* copy procured in 1870 at Cheyenne [River] Agency, D[akota] T[erritory] by Mr. *James C. Robb*."

BIOGRAPHY OF THE KEEPER

The creator of this calendar collected by Major Bush is not known.

COPIES AND CITATIONS

Major Bush fits into the Lone Dog tradition except that it ends in 1869 and has a few different interpretations. In his 1886 paper Mallery cites the Major Bush calendar only where it expands on the others or differs from them.

REPOSITORY IDENTIFICATION

NAA Ms. 2372, Box 12, Folder 5

■

NAME: MATO SAPA (Black Bear)
Physical Form: References in publication only
Years Covered: 1800 to 1868
Format: Text with names of winters in English

HISTORY OF PRODUCTION

Virtually nothing is known about the creation of this winter count.

HISTORY OF ACQUISITION

A cloth copy of this winter count was collected at the Cheyenne River Agency from Mato Sapa in the late 1860s. The keeper apparently made this copy himself, drawing pictographs on cloth for Lt. Oscar D. Ladley (22nd U.S. Infantry). Ladley then showed the cloth to an ex-army friend in Washington DC, who in turn shared it with Mallery. This must have been a loan, because the cloth is not in the Mallery collection. From the *Fourth Annual Report of the* BAE we know that the copy was made on cotton cloth, 1 yard by ¾ yard, and that the pictographs were drawn in a counterclockwise spiral (Mallery 1886:94). None of Mallery's notes on this calendar have survived, and all information comes from his published work (Mallery 1886:100–127).

It is not clear whether the interpretation Mallery published was collected in the field, or whether it was developed in comparison with the other Lone Dog variants. Mallery mentions the Mato Sapa interpretation only when it provides either clarification or deviation from other winter counts.

BIOGRAPHY OF MATO SAPA

Not much is known about Mato Sapa. Mallery notes that he was Mnicónjou and refers to this calendar as "The History of the Minneconjous" (1886:94). The keeper lived at or near the Cheyenne River Agency in the late 1860s.

COPIES AND CITATIONS

Mato Sapa is part of the Lone Dog tradition but ends in 1868 and differs in some of its interpretations, as noted by Mallery. The most information on this example is in Mallery 1886.

REPOSITORY IDENTIFICATION

Published Mallery 1886.

NAME: LONG SOLDIER (See Color Plate 8)

Physical Form: Pictographs drawn on cloth

Dimensions: 69" (175 cm) by 34½" (88 cm)

Years Covered: 1798 to 1902

Format: Pictographs drawn on cloth with black and colored ink, arranged in a serpentine manner, beginning in the top left corner

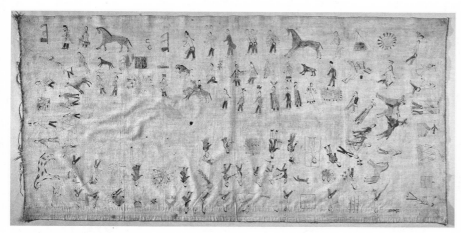

Long Soldier, on muslin (NMAI 11/6720).

HISTORY OF PRODUCTION

The NMAI records hold no information about the creation of this winter count. It is not known whether Long Soldier actually drew the pictographs, but according to the NMAI catalog card, he provided interpretations for the year events which were then translated into English by an unnamed interpreter and written down by Mrs. M. K. Squires.

HISTORY OF ACQUISITION

The catalog cards note that this was collected by Mrs. M. K. Squires at Fort Yates, North Dakota, the agency town for Standing Rock. It was collected sometime between 1902, the last year on the calendar, and 1923, when it was accessioned into the museum collections. It was presented by Mrs. Thea Heye, who was the second wife of George G. Heye, founding director of the Museum of the American Indian, Heye Foundation. The cloth is accompanied by an interpretation (a typed list of English year names for the years 1798 to 1902) provided by Long Soldier through an unnamed interpreter (Archives #OC 142.23). Presumably Mrs. Squires transcribed the English and later typed up the information.

BIOGRAPHY OF LONG SOLDIER

Long Soldier was a Húnkpapa chief who signed the 1868 Fort Laramie treaty and settled on the Standing Rock Reservation.

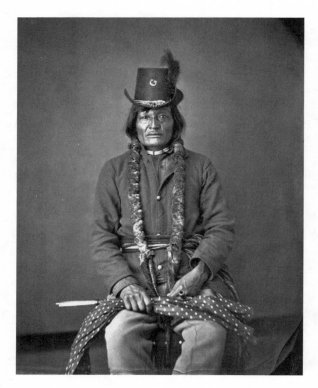

FIGURE 2.3. *Long Soldier, ca. 1880s, by D. F. Barry. The catalog identifies the sitter as Gros Ventres, but the photographer worked extensively at Fort Yates and on the Standing Rock Reservation, and this is probably the Lakota winter count keeper. Courtesy of the Denver Public Library, Western History Collection, B-17.*

COPIES AND CITATIONS

There are at least four other calendars attributed to or associated with Long Soldier: one is the "Northern" winter count in the NMAI (12/2166, see below), and two are in the collections of the South Dakota State Historical Society (#B162 and #2001.39.2, donated by Dr. Ralph Reed). These are most likely related in some way to the many Swift Dog calendars: they begin in the same year, cover the same basic period of time, and have many of the same pictographs and interpretations. Long Soldier and Swift Dog were both from Standing Rock and were in closely associated bands that may have camped together.

Although this count has never been published, there are references to it in McCoy 1983, 2002; Wildhage 1988; and Chamberlain 1984.

REPOSITORY IDENTIFICATION
NMAI 11/6720

NAME: NORTHERN (See Color Plate 9)

Physical Form: Pictographs drawn on cloth

Dimensions: 48" (122 cm) by 30½" (77 cm)

Years Covered: 1798 to 1906

Format: Pictographs drawn on cloth with black ink; images are in a spiral arrangement,
* beginning in the upper left corner and moving clockwise toward the center*

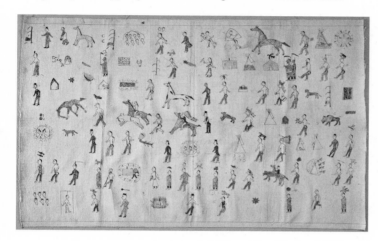

Northern count,
on muslin
(NMAI 12/2166).

HISTORY OF PRODUCTION

Nothing is known about when, where, or by whom this winter count was created. The cloth is canvas, with finished edges on top and bottom. This was standard issue on the plains during the early reservation period; the canvas was used for tipis and tents, among other things.

HISTORY OF ACQUISITION

The catalog card reads "Painted canvas strip. Teton Sioux. George H. Bingenheimer collection." It was accessioned into the museum in 1923. Bingenheimer (1861–1920) was the agent at Standing Rock from March 11, 1898, to March 31, 1903 (Tidball 1976:14). He later moved to Mandan, North Dakota, where he was a businessman and civic leader. Apparently, he had a large collection (over 190 objects), which was in the State Historical Society of North Dakota, perhaps on loan, in 1920. Other pieces he had collected were kept by his wife in their home after Bingenheimer died on December 24, 1920, in Minneapolis.

COPIES AND CITATIONS

This winter count is undoubtedly from Standing Rock and is very likely associated with the three other Long Soldier counts (NMAI #11/6720, and South Dakota State Historical Society #B162 and #2001.39.2). It begins in the same year (1798) with the same image of a ceremony using a feathered calumet. It also covers the same basic period of time (into the early 1900s) and depicts some events

unique to Standing Rock, including the last communal buffalo hunt, in 1882, which was attended by the agent at the time, Maj. James McLaughlin.

This winter count has not been published; however, references to various Long Soldier counts appear in McCoy 1983, 2002; Wildhage 1988; and Chamberlain 1984. One sold through Morning Star Gallery (1991) is now in the collection of the Minneapolis Institute of Arts.

REPOSITORY IDENTIFICATION
NMAI 12/2166

■

NAME: AMERICAN HORSE (See Color Plate 10)

Physical Form: Pictographs drawn in sketchbook; pictographs drawn on cloth (architect's linen)

Dimensions: Book: 10½" (27 cm) by 7½" (19 cm)

Cloth: 16½" (42 cm) by 15" (38 cm)

Years Covered: 1775 to 1878

Format: Sketchbook: Pictographs drawn on 12 pages of a bound book with pen and ink
in linear format moving from left to right, numbered sequentially and with years
Cloth: Pictographs traced onto architect's linen with graphite, moving left to right in
rows

HISTORY OF PRODUCTION

In 1879 William H. Corbusier provided a sketchbook into which American Horse drew a copy of his winter count, using his original as a model.[6] American Horse stated that this winter count had been kept in his family for generations, passed down from his grandfather to his father to himself (Corbusier 1886:129). Beginning in the front of the book, American Horse copied several pictographs per page on the first 12 pages of the book, which were then numbered sequentially by Corbusier. The book version spans the years 1777 to 1878.

American Horse provided the interpretation of his calendar, which was translated by an unknown interpreter (Corbusier 1886:129). It is unclear from the documents whether this process took place at Pine Ridge Agency, Dakota Territory, or in nearby Camp Sheridan, Nebraska, where Corbusier was stationed.

In addition to the sketchbook version, there is also a copy on architect's linen in the Mallery collection. This copy is virtually identical to the sketchbook version but only includes the years 1775 to 1811 and is missing an image for 1803. It is not known who drew this copy, but it was probably made by someone at the Smithsonian, perhaps Walter J. Hoffman, who had traced Dr. West's copy of The Swan (see above).

HISTORY OF ACQUISITION

Corbusier sent this book together with the Good winter count (described below) to Mallery for inclusion in the *Fourth Annual Report*. During his time at Camp Sheridan, Corbusier collected other winter counts as well. Unfortunately, all of them—and other family possessions—were destroyed in a fire following the San Francisco earthquake in 1906 (W. T. Corbusier 1961:51 n. 19, 1968:291).

BIOGRAPHY OF AMERICAN HORSE

American Horse was a well-known Oglala chief born in 1840, "The year Little Thunder killed his brothers" (Walker 1982:89). When he died in 1908, several Oglala calendars, including No Ears, marked his death for the year (Walker 1982:156). Because his father had been killed in battle when

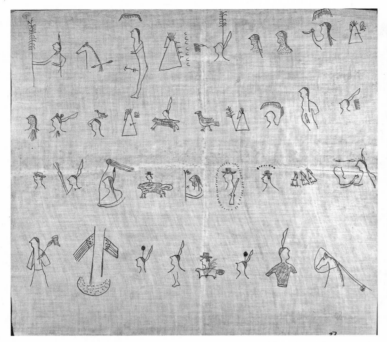

(left) FIGURE 2.4.
A partial copy of the American Horse winter count reproduced on architect's linen. National Anthropological Archives, Smithsonian Institution (NAA 08634000).

(right) FIGURE 2.5.
This photograph of American Horse was made ca. 1876, around the time that he copied his winter count into the book now in the National Anthropological Archives. National Anthropological Archives, Smithsonian Institution (NAA 00576100).

he was small, American Horse was brought up by an uncle. He received his uncle's name (American Horse) after the elder man was killed in the Battle of Slim Buttes in 1876. After his uncle's death, American Horse became recognized as a leader. His band was one of the so-called loafer bands, so named because they were on friendly terms with the whites and engaged in active trading at the post. He was closely allied with Red Cloud's band, which advocated peace with the whites. Charles Eastman writes that American Horse "was noted for his eloquence, which was nearly always conciliatory, yet he could say very sharp things of the duplicity of the whites." During the Ghost Dance, he talked his band out of joining up. Eastman also notes that American Horse was one of the early advocates of formal education for Indian children, sending his son Samuel and nephew Robert to Carlisle Indian School in Pennsylvania (Eastman 1918:165–178).

COPIES AND CITATIONS

The American Horse winter count is related to other southern Lakota counts from the Oglala of Pine Ridge (especially Cloud Shield and White Cow Killer) and the Brulé of Rosebud (particularly Good). However, even though American Horse and Cloud Shield cover the same basic period of time and are from bands that wound up on Pine Ridge, they often differ in what was recorded on their winter counts: "In a few instances the differences are in the succession of the events, but in most instances they are due to an omission or to the selection of another event." Corbusier goes on to explain that "when a year has the same name in all of [the winter counts], the bands were probably encamped together or else the event fixed upon was of general interest; and, when the name

is different, the bands were scattered or nothing of general interest occurred. Differences in succession may be due to the loss of a record and the depiction of another from memory, or to errors in copying an old one" (1886:130).

REPOSITORY IDENTIFICATION

NAA Ms. 2372, Box 12; book 08746923–0874933; cloth 08634000

■

NAME: CLOUD SHIELD (See Color Plate 11)

Physical Form: Pictographs drawn in sketchbook

Dimensions: 10½" (27 cm) by 7½" (19 cm)

Years Covered: 1777 to 1878

Format: Pictographs drawn with pen and ink in linear format on 22 pages, labeled with years

FIGURE 2.6. *Cover of the drawing book in which both American Horse and Cloud Shield copied versions of their winter counts. National Anthropological Archives, Smithsonian Institution (NAA Ms. 2372, Box 12).*

HISTORY OF PRODUCTION

Cloud Shield copied his winter count in the same sketchbook as American Horse, using 22 pages beginning from the back of the book. Again, Corbusier added sequential numbers and years to the images drawn by Cloud Shield. The keeper also provided an interpretation, which was translated by an unknown interpreter and transcribed by Corbusier. It is not known whether Corbusier collected this at Pine Ridge Agency, Dakota Territory, or at Camp Robinson, Nebraska, where he was stationed.

HISTORY OF ACQUISITION

The history is the same as for American Horse (see above).

BIOGRAPHY OF CLOUD SHIELD

Cloud Shield, an Oglala, was a close associate of Red Cloud on the Pine Ridge Reservation, where he served as a lieutenant in the Indian Police.

COPIES AND CITATIONS

The Cloud Shield winter count is related to other southern Lakota counts from the Oglala of Pine Ridge (especially American Horse and White Cow Killer) and the Brulé of Rosebud (particularly Good).

REPOSITORY IDENTIFICATION

NAA Ms. 2372, Box 12; 08746901–08746922

■

NAME: WHITE COW KILLER

Physical Form: References in publication only

Years Covered: 1777 to 1878

Format: Text with names of some years in English

FIGURE 2.7. *White Cow Killer and his wife, photographed during the period when they were associated with Buffalo Bill's Wild West Show, 1885 to ca. 1900. Courtesy of the Denver Public Library, Western History Collection, Nate Salsbury Collection, N S-79.*

HISTORY OF PRODUCTION

Information on this winter count was recorded by Corbusier. He was not able to collect a physical copy of White Cow Killer's winter count, which was drawn on unknown material, but he was able to learn the names of the winters for 1775 to 1878 (Corbusier 1886:130).

HISTORY OF ACQUISITION

Corbusier transmitted information on this count to Mallery at the BAE (see American Horse entry above).

BIOGRAPHY OF WHITE COW KILLER

Corbusier provided no information about White Cow Killer, who was presumably an Oglala living at Pine Ridge.

COPIES AND CITATIONS

White Cow Killer's winter count is related to those of American Horse, Cloud Shield, and Good.

REPOSITORY IDENTIFICATION

Published in Mallery 1886.

■

NAME: BATTISTE GOOD (See Color Plates 12 and 13)

Physical Form: Pictographs drawn in sketchbook

Dimensions: 10½" (27 cm) by 7½" (19 cm)

Years Covered: 900 to 1700 (mythical cycles), 1700 to 1879

Format: Pictographs drawn with pen and water colors in linear format on 19 pages, labeled by the keeper
 with years

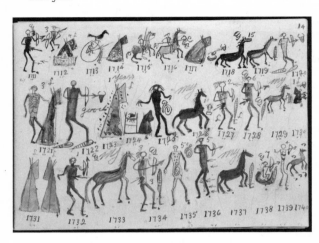

Battiste Good,
in drawing book
(NAA 08746806).

HISTORY OF PRODUCTION

One of the most unusual winter counts is that of Battiste Good. Good drew a copy into a sketchbook provided by Corbusier on May 10, 1880, on the Rosebud Reservation; like American Horse and Cloud Shield, he used his original cloth version as a model. Good's example is unique because it begins with a "generational" calendar depicting the mythological time of the Lakota (AD 900–1700). First is an image labeled "Black Hills Council Lodge" followed by 12 of his distinctive generational cycles representing mythological time. Each cycle consists of a camp circle representing 70 years, or the ideal lifespan of an old man. The latter part of the calendar follows the typical pattern of winter counts, with one pictograph per year, covering the period 1700–1879. An interpretation by Rev. William J. Cleveland, an Episcopal missionary at Rosebud, was also collected by Corbusier.

Good used five colors besides black to paint the pictographs in the sketchbook provided by Corbusier. A redrawn version of the winter count (eliminating his inscriptions) was published in black and white in the *Tenth Annual Report of the* BAE, with color plates illustrating three of the generational camp circles (Mallery 1893: pls. 21, 22, and 23).

HISTORY OF ACQUISITION

This history is the same as for American Horse (see above).

BIOGRAPHY OF BATTISTE GOOD

Good was born in 1821, the year the comet streaked across the sky making a loud noise. He was Brulé and lived on the Rosebud Reservation in the 1880s. His Lakota name was Wapóštangi, or Brown Hat.

COPIES AND CITATIONS

There are several variants of this unique winter count; some were drawn by Battiste Good himself, and others were done by his son High Hawk. These variants are in collections all across the country, including a copy on a large piece of paper at the Library of Congress in Washington; a book copy at the Sioux Indian Museum/Journey Museum in Rapid City, South Dakota; a book copy at the Denver Art Museum; and a copy on several sheets of paper at the Southwest Museum in Los Angeles (this is one by High Hawk; see Curtis 1908:159–182).

Because of its unusual inclusion of mythical time as marked by camp circles representing 70 years each, images of the Good/High Hawk calendars have been published many times: Amiotte n.d.: 160; Chamberlain 1984:S25; Frazier 1996:11; and Libhart 1970:19. Images of the Library of Congress copy, which is part of their "American Memory" exhibit, are included on their Web site (http://www.loc.gov/exhibits/treasures/trm054.html). For further reference, see DeMallie 2001; Hyde 1961; McCoy 1983; and Wildhage 1988.

REPOSITORY IDENTIFICATION

NAA Ms. 2372, Box 12; 08746801–08746819b

■

NAME: NO EARS

Physical Form: Text

Dimensions: 8½" (21.5 cm) by 14" (35.5 cm)

Years Covered: 1759 to 1919

Format: Typescript of years and names of events in Lakota with English translations on 5 pages of legal-size
paper

FIGURE 2.8. *The first page of a manuscript with an interpretation of the No Ears winter count in both Lakota and English. The unknown author of this document had only limited knowledge of the Lakota language. National Anthropological Archives, Smithsonian Institution (NAA Ms. 2261).*

HISTORY OF PRODUCTION

There is nothing known about who actually recorded or typed this winter count text, which consists of a list of years and names in Lakota with English translations. It is referred to as "No Ears" because of its similarity to other counts in the No Ears tradition, and on that basis can be recognized as an Oglala calendar from Pine Ridge.

HISTORY OF ACQUISITION

There is no documentation about when or from whom this typescript came to the NAA. There is no collection information associated with it, but it must have come to the Smithsonian sometime after 1919, the last year recorded. It was originally a part of the BAE archives collection.

The text is labeled "Oglala Sioux Names for Years From A.D. 1759 to A.D. 1919." An introduction explains that before contact with Europeans, the Sioux divided time into days, months ("moons"), and years. The years on the winter count are labeled "Oglala Names" with English "Translations" and "Years, A.D." There are no diacritical marks in the Lakota phrases, which, along with the transcriber's evidently tenuous knowledge of the language, makes interpretation or translation difficult. For instance, for the year 1862 the Lakota reads *Hoksila wan waspapi*, which is translated as "A boy scalded." Other winter counts have the image of a boy who has been scalped, suggesting that "scalded" is simply a typographical error. The year 1827 is labeled *Psa chamupi*, which is translated here as "They boiled rushes" (from the noun *psa*, a kind of rush or water grass, and perhaps a typo of *ohanpi*, "to boil"). Related pictographic winter counts mark a snowshoe, and some texts even specify *psa ohanpi* for snowshoes.[7] Using both pictographs and texts helps to determine the correct translation of the Lakota and interpretation of the event.

BIOGRAPHY OF NO EARS

John No Ears (ca. 1853–1918) was an Oglala and lived in the White Clay District of the Pine Ridge Reservation. See Haberland 1986:86 for a photograph of him.

COPIES AND CITATIONS

In the scholarly literature, this example has alternately been called the "BAE" (DeMallie 1982) and the "Anonymous" (Wildhage 1988) No Ears version. There are at least two dozen variants of the No Ears tradition, sharing many of the same pictographs or interpretations. Some are pictographic versions, while others are texts listing the years and names of winters. Many of these have been published; for a discussion of some of the versions, see Walker 1982:111–122. The many versions all begin in 1759, and some continue into the 1910s (Howard 1960a; Wildhage 1988:186–189). The longest was kept by Charles Whistler until the year 1936 (see Wildhage 1988:191–202). One of the versions most closely related to this one was published by Powers (1963).

REPOSITORY IDENTIFICATION

NAA Ms. 2261

■

NAME: ROSEBUD (See Color Plate 14)
Physical Form: Pictographs drawn on cloth
Dimensions: 69½" (176 cm) by 35" (89 cm)
Years Covered: 1752 to 1888
Format: Pictographs drawn on cloth with pen and ink (black with various color washes)

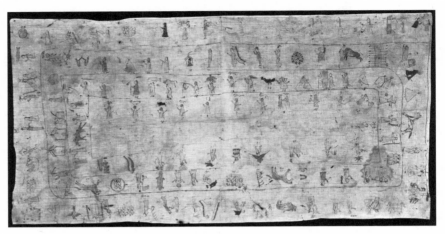

Rosebud count, on muslin (NAA Ms. 2001–10).

HISTORY OF PRODUCTION

There is no documented evidence about when, where, or by whom this was created. However, research shows that it was in the family of the photographer John A. Anderson. Most likely it was collected by Anderson on the Rosebud Reservation sometime between 1880 and 1935. Further information on its possible origin is given in chapter 3.

HISTORY OF ACQUISITION

This is the most recently acquired winter count in the NAA. It was donated by Tim Tackett in November 2000. It had been in the Anderson family for many years and upon John's death had passed to his wife, Myrtle Miller Anderson. She brought it with her when she moved in with her niece, Jean Tackett, the donor's mother, in the 1950s. It was rediscovered by Mrs. Tackett and her son in 1998 and subsequently donated to the Smithsonian.

John Anderson (1869–1949) homesteaded in Cherry County, Nebraska, where he apprenticed as a carpenter in 1883. By 1885 he had taken up photography and began working for the U.S. Army at nearby Fort Niobrara. He lived near the Rosebud Reservation for over four decades. During that time, he took hundreds of photographs of the landscape and people of Nebraska and South Dakota and assembled a collection of Indian material, now in the Sioux Indian Museum (part of the Journey Museum) in Rapid City, South Dakota.

Since there is no interpretation accompanying this pictographic winter count, the entries in chapter 4 are based on comparison with other counts in the Smithsonian and elsewhere, and on

examination of the published literature. Except for the Good/High Hawk count, this count contains the earliest entries known for the Brulé. Interpretations for these entries for which there is no comparative information are inherently speculative and provisional.

BIOGRAPHY OF THE KEEPER

The keeper of this winter count is not known. Russell Thornton, the first scholar to publish the count, established the name Rosebud winter count.

COPIES AND CITATIONS

This winter count appears to be related to the Brulé tipi cover that was photographed by Anderson around 1895. A preliminary report on it was published by Thornton (2002), and it is treated in more detail in the following chapter of this volume.

REPOSITORY IDENTIFICATION

NAA Ms. 2001–10

APPENDIX 1

Winter Counts Represented Only by Photographs in the NAA

In addition to original pictorial and text versions of winter counts, the NAA has photographs of four calendars that are not in the collection: Swift Bear, Densmore's Swift Dog, Hardin, and Iron Dog.

■

NAME: SWIFT BEAR

Physical Form: Photograph (pictographs on deer hide)

Years Covered: 1800 to 1899

Format: Pictographs painted with black ink on a black-tailed deer hide, in a spiral format, beginning in the center and moving clockwise

FIGURE 2.9.
The Swift Bear winter count, from a photograph in the National Anthropological Archives. The original calendar is now at the Denver Museum of Nature and Science. National Anthropological Archives, Smithsonian Institution (NAA Neg. no. 53,409).

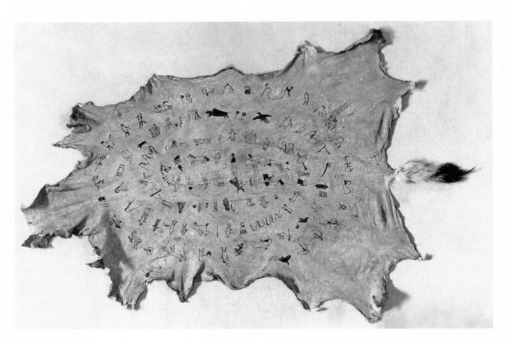

HISTORY OF PRODUCTION

This photograph is of a winter count drawn on deer hide by a Brulé named Swift Bear, who also provided an interpretation of its meaning. It is unclear whether he provided the interpretation in Lakota or in English, and whether the collector required an interpreter or understood Lakota.

HISTORY OF ACQUISITION

The winter count was collected by Jesse H. Bratley on the Rosebud Reservation around 1899. Bratley (1867–1948) was a teacher in the Indian Service who worked on several reservations and was at Rosebud from 1895 to 1899. He and his wife, Della (Ransom) Bratley, taught in day schools

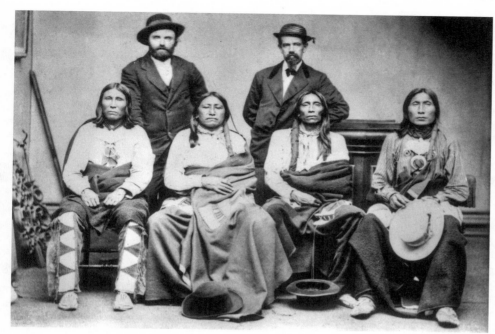

FIGURE 2.10. *Swift Bear was a part of this ca. 1870 deputation under the charge of Capt. D. C. Poole (back right). Members are identified, left to right, as Fast Bear (Brulé), Spotted Tail (Brulé), Swift Bear, and Yellow Hand (Cheyenne). Courtesy of the Denver Public Library, Western History Collection, X-31707.*

at Whirlwind Soldier's camp and Lower Cut Meat communities. Along with academic subjects, Mr. Bratley taught agriculture, blacksmithing, and carpentry. He took many photographs during his time on Rosebud, and collected many ethnographic objects. The BAE correspondence files in the NAA include a 1904 letter from Bratley with a list of the items in his collection. Bratley began writing an autobiography but died before completing it. Reutter published excerpts from a rough draft of chapter 16, spanning the Rosebud years of 1895–99, in which Bratley referred to the winter count as his favorite item in the collection (Reutter 1962:29).

Bratley's collection of photographs and artifacts remained in the family for many years. After teaching in Indian and white schools across the country, Bratley moved his family to Florida in 1910. Years later, in 1961, the collection was purchased by Mr. and Mrs. Francis V. Crane, who opened a museum in Marathon, Florida (Dolan 1977; Herold 1999). In 1962 the Cranes loaned the Bratley photographic collection to the NAA, which made reference copies of 600 items, including glass plate negatives and photographic prints made between 1895 and 1924. (The NAA had previously received some images directly from Bratley himself.) In 1977 the Cranes donated their collection of 11,000 objects, including Bratley's Swift Bear winter count, to the Denver Museum of Natural History, now the Denver Museum of Nature and Science.

BIOGRAPHY OF SWIFT BEAR

Swift Bear, a Brulé, was born around 1825 and lived until about 1900. He advocated friendly relations with whites and participated in various treaty negotiations.

COPIES AND CITATIONS

According to the literature, there are three versions of the Swift Bear winter count. One copy on a strip of cloth is in the Robinson Museum of the South Dakota State Historical Society in Pierre. A second version on deer hide is in the National Cowboy and Western Heritage Hall of Fame in Oklahoma City, Oklahoma (#92.10). Another version on black-tailed deer hide is supposed to be in the Bureau of Indian Affairs in Washington DC (Cohen 1942a, b, c; Wildhage 1988; Hyde 1961), but its location there has not been verified.

REPOSITORY INFORMATION

NAA Neg. no. 53,409

■

NAME: HARDIN

Physical Form: Photograph (pictographs on muslin)

Years Covered: 1776 to 1878

Format: Pictographs drawn with wax crayons on cloth, in a serpentine format beginning in the upper left corner of the cloth

HISTORY OF PRODUCTION

This photograph is of a winter count drawn on cloth by an unknown keeper. It is named after its collector, Dr. Leonidas M. Hardin. According to one source (McBride 1970), the creator of this history was High Hawk, the son of Battiste Good, but comparison with other High Hawk winter counts demonstrates that this attribution is not correct. High Hawk drew in a style similar to his father's and included the mythical cycles that are presented only on his and Good's winter counts (see above).

HISTORY OF ACQUISITION

Dr. Leonidas M. Hardin (1868–1937), the agency physician at the Rosebud Reservation, acquired the winter count about 1900. This photograph of it was made by Arthur E. McFatridge (b. 1867), who spent seventeen years in the Indian Service teaching in various reservation schools. From 1898 to 1905 he and his wife were on the Rosebud Reservation, first teaching school at He Dog's camp, then supervising over 20 day schools while stationed at the agency. Although a direct relationship between Hardin and McFatridge is not known, they did work on the Rosebud Reservation during the same period of time, and it can be assumed that they knew each other. Photographs of Mc-Fatridge are published in *The Vanishing American* (Dippie 1982) and in an article by his granddaughter Dorothy McFatridge McBride (1970). It was she who suggested that the author of the winter count was High Hawk.

The McFatridge photograph collection was purchased by Mr. and Mrs. Francis V. Crane, who also owned the Swift Bear count described above, for their private museum in Marathon, Florida. They subsequently sold these photographs to the Denver Art Museum. In the 1960s Norman Feder, Curator of Native Art at that museum, sent the NAA a reference copy of this photograph.

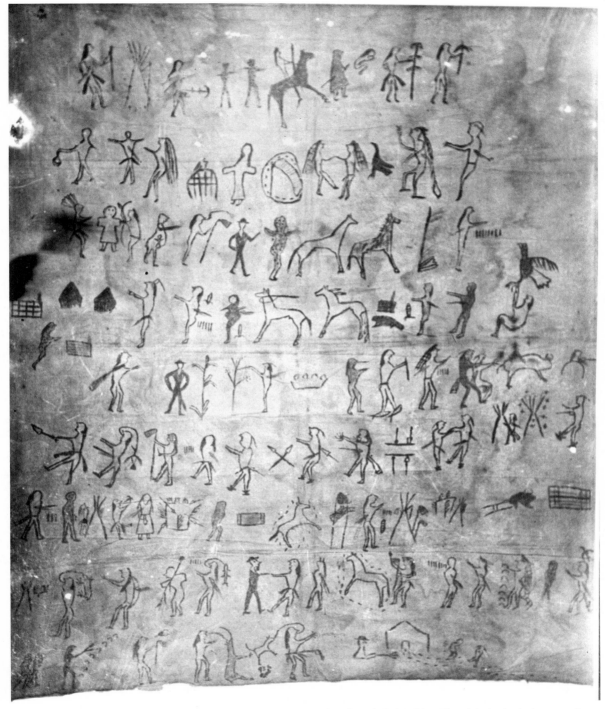

FIGURE 2.11. *The Hardin winter count, from a photograph in the National Anthropological Archives. The original calendar is now at the W. H. Over Museum in Vermillion, South Dakota. National Anthropological Archives, Smithsonian Institution (NAA Neg. no. 57,487).*

The original calendar on muslin is now owned by Hardin's daughter, Mrs. Robert Niblick, and is on long-term loan to the W. H. Over Museum at the University of South Dakota in Vermillion.

No interpretation was collected with the calendar, but one has been established and published by Finster (1968). He compared this count with several others, including those published by Mallery. Finster wrote that the maker of the calendar was unknown (1968:1) and added that although no interpretation of the count accompanied it, "an interpretation for a number of winters preceding and following it by the brother of Battiste Good . . . was among the items Mrs. Niblick loaned to the museum" (1968:2). Finster later concluded that there was a high correlation of events between the Hardin count and the Battiste Good calendar (see 1995 ed.).

COPIES AND CITATIONS

The print from which this copy was made is in the collection of the Denver Art Museum, while the original count is at the W. H. Over Museum.

REPOSITORY IDENTIFICATION

NAA Neg. no. 57,487

■

NAME: DENSMORE'S SWIFT DOG

Physical Form: Photograph (pictographs on cloth)
Years Covered: 1798 to 1912
Format: Pictographs drawn with black ink on cloth, in a spiral format
* beginning in the upper left corner and moving clockwise toward the center*

HISTORY OF PRODUCTION

A series of different names are associated with this winter count. A list of specimens prepared by the collector in 1917 describes it as a calendar by Running Dog. In terms of both style and content, it is consistent with the work of a Húnkpapa from Standing Rock known as Swift Dog, who produced other calendars as well. Running Dog is presumably an alternate translation for the same Lakota name. However, Frances Densmore also described the calendar as "owned by Black Thunder, of Eagle River" (1918:69).

HISTORY OF ACQUISITION

This winter count was collected by Frances Densmore (1867–1957) sometime between 1911 and 1913 while she was conducting fieldwork on the Standing Rock Reservation. Densmore, a noted ethnomusicologist, worked as an independent scholar and collector. She occasionally received fieldwork support from the BAE, which also published some of her research. She assembled a collection of artifacts at Standing Rock, which she loaned to the Smithsonian in 1913, where they were photographed. Many of these photographs were included as illustrations in her publication *Teton Sioux Music* (1918), including two details from the Swift Dog winter count. In August 1917 she withdrew the loan of the Standing Rock collection when the Smithsonian was unable to come up with funds

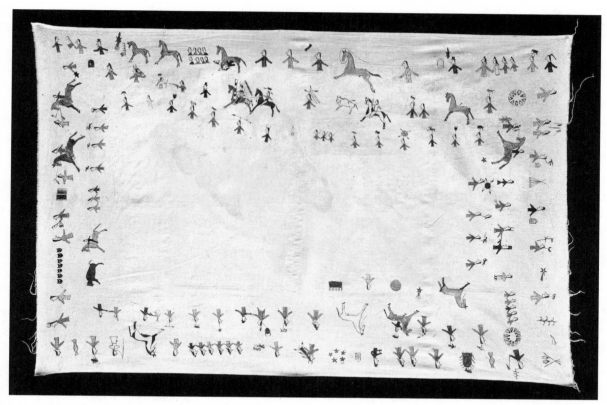

FIGURE 2.12.
*The Swift Dog
winter count, from
a photograph
in the National
Anthropological
Archives. The
location of the
original calendar is
unknown. National
Anthropological
Archives, Smithsonian
Institution (NAA Neg.
no. 3377C45).*

for its purchase, and she sold most of it to George Heye for his Museum of the American Indian (Densmore 1948). But Densmore had already withdrawn the calendar from the collection and had sold it in May of that year to Victor J. Evans, a wealthy collector living in Washington DC. Evans's collection came to the Smithsonian after his death in 1931, but the winter count was not among the items received, and its current location is unknown. The three photographs in the NAA, one showing the whole count and two showing details, are the only record of this object now available.

Densmore was an enthusiastic and tireless scholar who documented American Indian music and songs for future generations of Indians and non-Indians. Throughout her prolific career from 1905 to 1957 she received support from such institutions as the BAE and the Museum of the American Indian for collecting ethnographic objects and data from more than 75 native communities in the United States and Canada (Babcock and Parezo 1988:91). She worked with the oldest and most reliable singers, usually men over 65, and recorded not only representative examples of a tribe's musical culture but also the context in which they were used. After returning from her field trips, she would spend hours transcribing and analyzing her data at home (Frisbie 1989:54–55).

BIOGRAPHY OF SWIFT DOG

Swift Dog was a Húnkpapa from the Standing Rock Reservation. See McCoy 1994 for information about Swift Dog and his art.

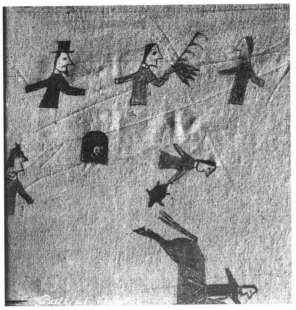

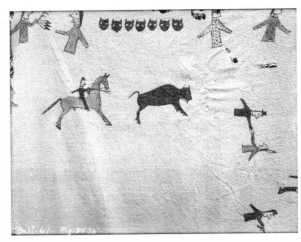

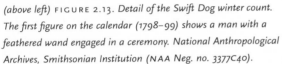

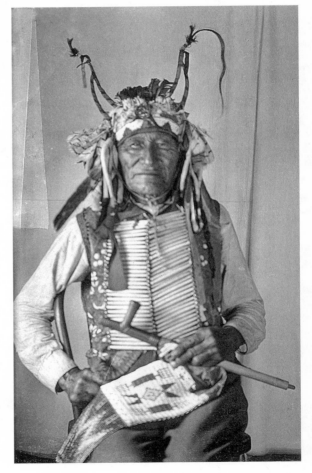

(above left) FIGURE 2.13. *Detail of the Swift Dog winter count. The first figure on the calendar (1798–99) shows a man with a feathered wand engaged in a ceremony.* National Anthropological Archives, Smithsonian Institution (NAA Neg. no. 3377C40).

(above right) FIGURE 2.14. *Detail of the Swift Dog winter count. The figure on the horse is James McLaughlin, the agent at Standing Rock who participated in the last communal buffalo hunt on the reservation in 1882–83.* National Anthropological Archives, Smithsonian Institution (NAA Neg. no. 3377C43).

(bottom) FIGURE 2.15. *Swift Dog, photographed ca. 1911 by Frances Densmore, the collector of the Swift Dog winter count.* National Anthropological Archives, Smithsonian Institution (NAA Neg. no. 3360A).

COPIES AND CITATIONS

There are many copies and variants of Swift Dog's winter count. This cloth covers the years 1798 to 1912. Like all the other known Swift Dog calendars, it consists of pictographs drawn in a spiral, beginning in the upper left corner and spiraling in toward the center. The first image on all the Swift Dog counts, representing the year 1798, is of a ceremony in which a decorated wand is used, perhaps a *hunka* (adoption) or *alowanpi* (singing [praise] for) ceremony (Densmore 1918:68–73). There are at least five other pictographic calendars drawn by Swift Dog late in his life, between 1912 and 1922, that can be used for comparison of style and content. All are drawn on cloth.

All of the Swift Dog winter counts are in public collections, and photographs of four of them have been published: two are in the collections of the North Dakota State Historical Society (Howard 1960a; Maurer 1992; McCoy 1994), a third is at the Chicago Historical Society (Mahoney 1997), and the fourth is at the Cranbrook Institute of Science (Praus 1962). The fifth calendar, although not published, is mentioned in Lovett and DeWitt (1998). It is in the collections of the Cass County Historical Society/Red River and Northern Plains Regional Museum in West Fargo, North Dakota, where it was on display as of August 1999.

REPOSITORY IDENTIFICATION

NAA Neg. no. 3377C40, 3377C43, and 3377C45

■

NAME: IRON DOG

Physical Form: Photograph (pictographs on cloth)

Years Covered: 1823 to 1906

Format: Pictographs drawn in serpentine format on strips of cloth put side by side

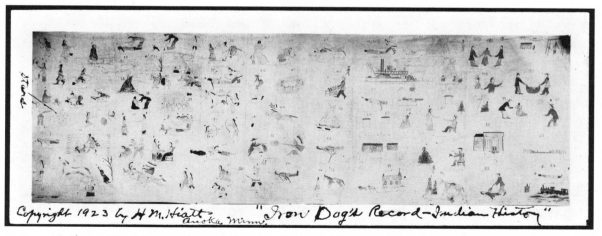

FIGURE 2.16. *The Iron Dog winter count, from a photograph in the National Anthropological Archives. The location of the original calendar is unknown. National Anthropological Archives, Smithsonian Institution (NAA Neg. no. 81-7374, Ms. 3031).*

HISTORY OF PRODUCTION

There is very little documentation on the winter count in this photograph. The identification of the keeper is based on a handwritten inscription on the print. The photo is labeled "Iron Dog's Record—Indian History," and there was a well-known man at Standing Rock named Iron Dog.

HISTORY OF ACQUISITION

The collector of this winter count, Harvey M. Hiatt, must have acquired it sometime between 1906, the last year on the calendar, and 1923, when he copyrighted a photograph of it and allowed the *Minnesota Journal* to publish it (Anonymous 1923). It is not known when or where Hiatt acquired the Iron Dog winter count, or how the print came to the NAA collections.

Harvey Marion Hiatt (1869–1953) was a pastor at a Seventh Day Adventist church in Anoka, Minnesota, where he and his wife, Edith, raised their family. In the early 1900s he worked as a teacher in Kansas, later moving to Georgia, and finally to Minnesota in 1913. He had a lifelong interest in Indians and claimed to have known people from many different tribes (Anonymous 1923).

The photograph in the NAA is quite faded and difficult to see, but what pictographs are visible indicate that it could be compared with other pictographic records from Standing Rock. Hiatt numbered the pictographs and also labeled the "Storm of Stars." An unusual photograph of Hiatt wrapped in the large painted cloth accompanies the 1923 article, which discusses the 1833 Leonid meteor shower and provides clearer perspective on at least some of the pictographs.

BIOGRAPHY OF IRON DOG

Iron Dog was a Húnkpapa leader who settled on the South Dakota side of the Standing Rock Reservation in the community of Bullhead.

COPIES AND CITATIONS

As far as has been determined, there are no other copies or versions of this winter count. A copy of the same photograph is in the Library of Congress. The winter count is otherwise known only from a short published article (Anonymous 1923).

REPOSITORY IDENTIFICATION

NAA Ms. 3031

APPENDIX 2

Winter Counts Related to Those in the Smithsonian Institution

The following is a listing of related copies or versions of Smithsonian winter counts.

LONE DOG

Deutsches Ledermuseum, Offenbach, Germany

Galena and Jo Daviess County Historical Society, Galena IL

Nebraska State Historical Society, Lincoln NE

Riding Mountain Provincial Park, Manitoba, Canada

South Dakota State Historical Society, Pierre SD

Theodore Riggs (copy lost in San Francisco Fire of 1906)

BATTISTE GOOD, INCLUDING VERSIONS BY HIS SON HIGH HAWK

Buechel Memorial Lakota Museum, St. Francis SD

Denver Art Museum, Denver CO

Library of Congress, Washington DC

Sioux Indian Museum/Journey Museum, Rapid City SD

Southwest Museum, Los Angeles CA

W. H. Over Museum, Vermillion SD

NO EARS

American Museum of Natural History, New York NY

American Philosophical Society, Philadelphia PA

Colorado Historical Society, Denver CO

Marquette University, Special Collections and Archives, Milwaukee WI

Nebraska State Historical Society, Lincoln NE

Oglala Lakota College Archives, Kyle SD

South Dakota State Historical Society, Pierre SD

State Historical Society of North Dakota, Bismarck ND

W. H. Over Museum, Vermillion SD

"Flying Hawk" version, published in McCreight 1947

"Kindle/Afraid of Soldier" version, published in Beckwith 1930

"White Buffalo Man" version, private collection

LONG SOLDIER

Minneapolis Institute of Arts, Minneapolis MN

South Dakota State Historical Society, Pierre SD

NOTES

1. Reed to Mallery, January 18, 1878, NAA Ms. 2372, Box 12, Folder 3.

2. For more information on the Blue Thunder winter counts, see Howard 1960b and 1979.

3. Reed to Mallery, May 18, 1877, NAA Ms. 2372, Box 12, Folder 5.

4. Architect's or architectural linen is a thin, translucent, handkerchief-weight, starch-coated fabric widely used for drawings and tracings by architects and engineers in the 19th century. It was commonly used by Smithsonian illustrators to make duplicate copies of drawings. While the woven fabric structure is clearly visible, the application of starch sizing produces a smooth, stiff surface resembling paper; some catalogers describe the material as cloth, while others refer to it as paper. For additional information on this material, see Page 1996.

5. Rau received the materials in 1872, several years before Mallery began working at the BAE.

6. American Horse's winter count uses the first 12 pages of this sketchbook, and Cloud Shield's is in the last 21 pages.

7. Rushes may have been used to make snowshoes, although they are normally made of wood and rawhide.

3

The Rosebud Winter Count

RUSSELL THORNTON

1769

In 1998 Jean Miller Tackett was preparing to move out of her family home in Ontario, California. Her son was helping her sort through her possessions, including an old trunk that she had had for years. They opened the trunk and found among its contents a large piece of muslin with pictures drawn on it, which the son, Timothy Tackett, a professor of history at the University of California at Irvine, immediately recognized as a winter count (Color Plate 14). However, neither he nor his mother remembered ever having seen it before.

The trunk and its contents were among the effects left to Jean Tackett by her aunt, Myrtle Miller Anderson, the widow of the well-known Rosebud Reservation photographer John A. Anderson. As a child, Jean had lived across the street from John and Myrtle Anderson in Rosebud and had even stayed with them for a year while she was in high school. In the 1950s Myrtle Anderson came to live with her niece, and she brought with her various Lakota items. When she died in 1961, the items were passed on to the family, which included Mrs. Anderson's great-nephew, Timothy.

Besides the winter count, the effects included a deteriorated Sioux woman's dress of cloth and leather, also found in the trunk and which, according to her son, Mrs. Tackett distinctly remembered having seen previously, and a "few pieces of clothing, beadwork, an arrowhead collection" (pers. comm., 2001). Also given to the Tacketts by the Andersons was an enlargement of the much-reproduced photograph of Kills Two copying the Big Missouri winter count (Figure 1.4). Professor Tackett recalls that this photograph occupied a prominent place in his family's living room when he was growing up.

After Professor Tackett and his mother found the winter count in 1998, he took possession of it. He subsequently showed it to a colleague at the University of California at Irvine, Professor Tanis Thorne, affiliated with the university's Native American Studies Program. She in turn contacted an expert on plains material culture, Michael Cowdrey of San Luis Obispo, California, for his opinion about the winter count. Meanwhile, Tackett and

Thorne discussed the possibility of donating the winter count to a museum. Thorne eventually contacted me at the Department of Anthropology at UCLA. I suggested donating it to the Smithsonian Institution, since I was familiar with its National Anthropological Archives (NAA), both as a researcher and as chair of the Smithsonian's Repatriation Review Committee since 1991. The NAA had recently received a grant from Save America's Treasures, a program administered through the Department of the Interior to preserve material designated as national treasures. I also contacted Candace Greene, a North American ethnologist with the Department of Anthropology in the Smithsonian's National Museum of Natural History (NMNH), where the NAA is housed, who then contacted Tackett directly. After some discussion, Tackett decided to donate the winter count to the Smithsonian. In the fall of 2000, it was personally delivered to Greene by Tackett, who was spending the 2000–2001 academic year on sabbatical at the National Humanities Center in North Carolina and journeyed to DC for the donation. Tanis Thorne, who was spending the fall term in DC, was also present when the winter count was delivered on a rainy fall morning. Professor Tackett chose the NAA as a repository in part because of its ability to care for materials. The Lakota winter count is now housed at the Smithsonian's Museum Support Center in Suitland, Maryland, which is specifically designed for storage and conservation.

I have previously reported on this winter count and its discovery in the scholarly journal *Ethnohistory* (Thornton 2002). At that time, I discussed the naming of the winter count. Winter counts are drawn and cared for by keepers of the winter count, typically male elders, and most are named after their keepers. However, the keeper of this newly resurfaced winter count is unknown; consequently, I decided to name it after the reservation with which it was undoubtedly associated—the Rosebud Reservation in South Dakota. If at some point in the future a keeper of the winter count is ascertained, then it should be renamed after that person.

JOHN AND MYRTLE ANDERSON

The Rosebud Reservation winter count was surely acquired by John A. Anderson or Myrtle Anderson while they were living on the Rosebud Reservation. (Tim Tackett thinks that it was most likely John, since Myrtle was against accepting such items in lieu of money, as discussed below). How and when they acquired it remain a mystery, as do the circumstances whereby the winter count ended up on the Rosebud Reservation.

John Alvin Anderson was a well-known photographer and merchant associated with the Rosebud Reservation for most of his adult life. He was born in Stockholm, Sweden, on March 25, 1869. His family emigrated from Sweden to the United States in 1870, when John was only

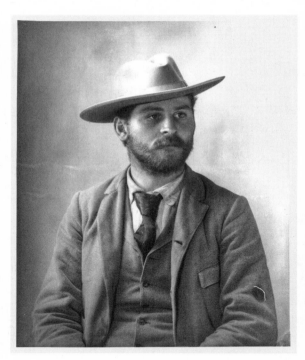

FIGURE 3.1. *John Anderson, collector of the Rosebud winter count. Anderson made an extensive photographic record of the Brulé of the Rosebud Reservation, including the images appearing here as Figures 1.4 and 3.3. Courtesy of the Nebraska State Historical Society Photograph Collections.*

a year old. The family lived in both New York and Pennsylvania, and possibly in Illinois and Missouri for brief periods of time. Anderson's mother died in Pennsylvania in 1879, and at the age of ten he went to live with his married older sister, Maggie Carlson, and her family in Williamsport, Pennsylvania. Anderson's father, a carpenter, moved again in 1884 to Cherry County, Nebraska, near Fort Niobrara (Hamilton and Hamilton 1971:3; see also Roosa 1977:388–389). John joined him there, and from then until 1936, when he moved to Rapid City, South Dakota, he lived near or on the Rosebud Reservation, with some periods of time spent in Pennsylvania and California. During one of his trips to Pennsylvania, he married Myrtle Miller, on October 13, 1895, in Williamsport. He then returned to the Rosebud Reservation with his bride.

During his early adulthood, Anderson worked not only as a photographer but also as a woodworker and a bookkeeper and clerk for Charles P. Jordan, who had a trading post at the Rosebud Agency. In 1893 Anderson bought an interest in the Jordan Trading Post, which after a fire in 1892 became the Jordan Mercantile Company, with Anderson as its manager (Hamilton and Hamilton 1971:4–9). According to his great-nephew Timothy Tackett, Anderson obtained numerous Lakota objects in payment for food and other goods purchased in the store, or as gifts for his generosity and willingness to assist the Lakota, two traits for which he was widely recognized (pers. comm., 2001; see also Hamilton and Hamilton 1971:11; Roosa 1977:390–391). Supposedly, they called him "Little White Chief" (Roosa 1977:390). Anderson's wife also apparently earned the respect of the Lakota. According to one source, "Myrtle Anderson did many charitable things for the Indian women. They loved her and she loved them" (Roosa 1977:390). Nevertheless, her great-nephew reports that "she always opposed accepting Sioux artifacts in lieu of money for goods at their general store," although "she laughed about it later, because when he [Anderson] sold most of his collection to the state in the Thirties, she had to admit that it helped get them through the Depression" (pers. comm., 2001).

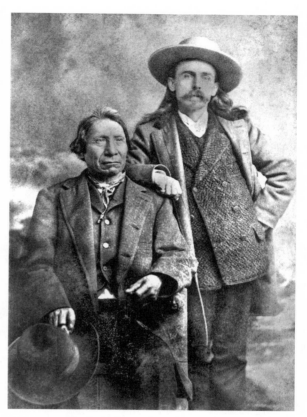

FIGURE 3.2. *Charles Jordan, trader and impresario, shown here with the Oglala leader Red Cloud. Jordan managed a trading post at the Rosebud Agency and also presented "Indian shows" at various fairs and expositions. Photograph by John Nephew, Washington DC, 1889. National Anthropological Archives, Smithsonian Institution (NAA Neg. no. 3243B2).*

After moving to Rapid City, Anderson established and managed the Sioux Indian Museum, a private museum that housed his collection of Sioux materials. In 1938 he sold the museum and much of his collection to the Bureau of Indian Affairs. It continued to be called the Sioux Indian Museum and is now incorporated in Rapid City's Journey Museum. Another pictorial record, known as the Big Missouri winter count, was included in these materials. (See Figure 1.4.) As Wilhelm Wildhage states, "John A. Anderson had been in the possession of a winter

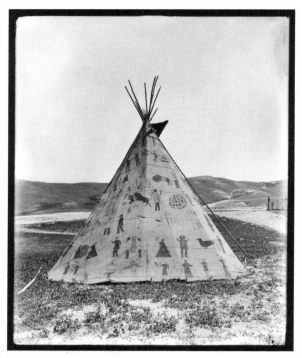

FIGURE 3.3. *A winter count painted on a Brulé tipi cover by an unknown artist. The scenes that are visible correspond closely with those on the Rosebud winter count. Photograph by John Anderson. Courtesy of the Nebraska State Historical Society Photograph Collections.*

count painted on skin; and this had . . . been acquired together with other objects by the Indian Office" of the Sioux Indian Museum (1991:39).

In addition to this well-known photograph, Anderson's work includes a photograph of another winter count, drawn on a tipi cover that Anderson photographed in 1895, in the town of Rosebud, South Dakota. It is called the Brulé Tipi Cover winter count and is known only from this photograph. Actually, Anderson photographed this tipi cover with its winter count at least twice. Although not widely recognized, a warrior's record that Anderson photographed on another occasion is covering most of the Brulé tipi with its winter count (Dyck 1971:331).

Anderson also photographed many Rosebud Lakota and reservation scenes. Prints of these are widely dis-

persed and often reproduced. In 1928, however, his home on the Rosebud Reservation burned, and many of his photographic plates were destroyed in the fire. A decade later, Anderson moved again, this time to Atascadero, California, where he died of stomach cancer in 1948. Following his death, his widow "sold the photographic plates that had been saved from the 1928 fire and most of his equipment for one hundred dollars" (Hamilton and Hamilton 1971:12). However, some glass negatives of Anderson's photographs were donated to the NAA. In 1970 the Nebraska State Historical Society received an inquiry offering for sale "some 350 original Anderson photograph negatives" that had been "taken in the late 1880s and early 1900s" (Anonymous 1970:470). The collection was quickly purchased by the Nebraska State Historical Society Foundation, and it now resides with the society.

THE ROSEBUD WINTER COUNT

As Color Plate 14 shows, the Rosebud Reservation Winter Count consists of 136 pictographs drawn on muslin with numbers added below each image. Whoever added the numbers seemingly had some difficulty in determining their order. The drawing labeled as No. 1 was originally numbered as 23, and correcting it required changes to subsequent numbers. However, the comparability of the original No. 23 with entries in other winter counts for around the same year, as discussed in chapter 4, is very high.

It is also possible that the unknown annotator made other mistakes. In some places two numbers may mark a single event. For instance, see 1784–85 and 1785–86, and 1817–18 and 1818–19.

THE PICTOGRAPHS AND THEIR ARRANGEMENT

The pictographs are mostly drawn in black ink with ink washes of red, yellow, blue, and black. The first 122 pictographs are in black ink with colored washes. Some of the later pictographs, starting with 1873–74, are done

mainly in pencil. More ink was used, however, in several pictographs between 1875–76 and 1883–84.

The pictographs are arranged in a flattened spiral, moving back and forth across the rectangular surface, starting off-center and ending in one corner. A line has been drawn connecting the pictographs, starting with the year 1752–53 and continuing through 1774–75 — and then throughout the winter count. This line is noticeably disjointed at each point along the middle of the winter count. This indicates that the line may have been drawn while the count was folded, then turned over and the other half drawn, or while it lay unfolded on a surface with a joint or depression in the middle, or while it hung over a rack.

The winter count is remarkably well preserved; some of its colors are almost vibrant. The primary blemish on the muslin is a water spot over the image for 1799–1800, part of the pictograph for 1798–99, and then into the pictographs for 1844–45 though 1846–47. This detracts little, however. Since none of the colors have bled, they are certainly ink, not watercolor. A few other minor stains and blemishes are present. The muslin on one of the shorter edges of the winter count is very slightly folded over, and there are a few rough edges on all sides of the muslin.

INTERPRETING THE CHRONOLOGY

According to the standard reckoning — ascertaining the pictograph that represents the Leonid meteor shower of November 12, 1833, (#83 in fig. 3.5) and working forward and backward — the 136 pictographs appear to cover the history of this Lakota *tiyošpaye* from a beginning date of 1752–53 for the first pictograph to an ending date of 1886–87 for the final pictograph.

However, the annotator who numbered the entries could have skipped or compressed years by accident, forgetting a designation or reading a designation as more than one, as suggested above. Or, keepers could have made mistakes due to disruptive events, like the death of one keeper of the winter count and the passing of the count on to another, the plains wars, or the movement to a reservation and the disruption it created. This provisional chronology can be checked by comparison with other counts. For example, a sequential chronology may be especially problematic for the later years of the count: Michael Cowdrey (1999) observes that the pictograph for the year 1884–85, by strict chronological reckoning, "seems to duplicate the personal glyph with which High Hawk marked his tragic loss of a child in '1887.'"

Since pictographs from the beginning to the year 1872–73 are so uniform in medium, "colors, quality of line, and general style" (Cowdrey 1999), it would seem they were drawn (rather, redrawn) at that date. This was around the time some Lakota, now known as the Upper Brulé, were required to relocate to Spotted Tail Agency, following the Fort Laramie Treaty of 1868, which established the Great Sioux Reservation.[1] On reservations, the Lakota would have "had access to a host of new materials such as drawing inks, and muslin cloth" (Cowdrey 1999), and someone may have transferred this winter count from hide to muslin, perhaps making more than one copy. If it was redrawn around 1873–74, it was before the Rosebud Agency was established. The site of the agency for the Brulé led by Spotted Tail was changed several times; in 1878 it was relocated to its present location on Rosebud Creek and its name changed to Rosebud Agency. Spotted Tail's Brulé were at the Whetstone Agency on the Missouri River in the summer of 1871 but left to hunt and did not return until the spring of 1872. Late in that same year, Whetstone was moved to a new location, "on the south bank of the White River at the mouth of Beaver Creek" (Hyde 1961:184; also Biolsi 1992:6; DeMallie 2001:794–799, 812–815). Spotted Tail and his group were hunting again at that time and did not return to Whetstone until the spring of 1873. If the winter count was copied during this period, however, it is amazing that it could have remained so well preserved as it moved around with a *tiyošpaye* during the turbulence on the northern plains in the 1870s and the relocation of the Brulé to several agencies (DeMallie 2001). Of course, the winter count could have been associated with other Lakota at this time.

The keeper may have subsequently added individual entries each year for the following six years — from 1873–

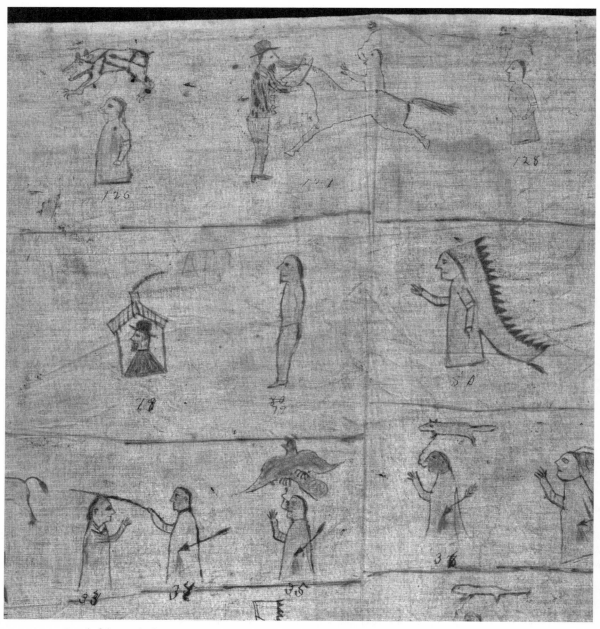

FIGURE 3.4. *Detail of the Rosebud winter count. National Anthropological Archives, Smithsonian Institution (NAA Ms. 2001–10)*

74 through 1878–79 — since the media change somewhat from year to year, although the style remains the same. At this point, 1879–80, the style changes as "a different, more-sophisticated hand assumes the helm" (Cowdrey 1999). Although the medium varies from pencil to ink, probably the same artist drew the remaining pictographs, ending at 1886–87, the point at which space on the muslin ran out. The date could have been a few years later.

THE BRULÉ TIPI COVER WINTER COUNT AND "COLONEL" CHARLES P. JORDAN

The Rosebud Reservation winter count is clearly related to a Brulé tipi cover that Anderson photographed in 1895. (See Figure 3.3.) Images on the tipi cover can be matched to the muslin winter count and were probably based on it. The Brulé tipi cover belonged to Anderson's associate at Rosebud, Charles P. Jordan, and was used in his Wild West show.[2]

Charles Philander Jordan, typically referred to by the honorary title of "colonel," was born in Piqua, Ohio, in 1851. He reportedly served at various times as the Indian agent at the Red Cloud Agency (now Pine Ridge) and the Spotted Tail Agency (now Rosebud). He also operated the Jordan Trading Post, later called the Jordan Mercantile Company, on the Rosebud Reservation. The 1880 U.S. census lists him as married and as a clerk working for the U.S. Interior Department at the Rosebud Reservation (11). His wife, Julia Walks First (*Winyan-hcaka*), was an Oglala woman, probably a member of Red Cloud's band.

Jordan was a friend of Buffalo Bill Cody, and by at least 1890, Jordan and Anderson were recruiting Indians — Brulé from the Rosebud Reservation and Oglala from the adjacent Pine Ridge Reservation — for Cody's Wild West Show. According to Henry and Jean Tyree Hamilton, a painted tipi like the one photographed by Anderson "stood just behind the Jordan Trading Post in 1892" (1971:138). Jordon's son William Red Cloud Jordon states that the tipi was used to store "many large and small trunks which contained old Indian materials, fancy bead and porcupine quill work articles . . . to be exhibited at the Chicago World's Fair in 1893" (1970:367). Some of these items were made by Jordan's wife, Julia, expressly for the fair, but in the summer of 1892 the tipi and its contents were destroyed when the Jordan Trading Post and its warehouse caught fire. Nevertheless, Jordan and his family attended the exposition and visited Buffalo Bill Cody's Wild West Show.

By 1894 Jordan had his own Indian show, and that year he took dancers from Rosebud to San Francisco's Midwinter International Exposition. The official history of the exposition contains a picture of a group of Sioux Indians who performed, and the official guide to the exposition describes "Dr. White Cloud's American Indian Village." The accompanying picture of Dr. White Cloud bears a striking resemblance to Jordan (Calfornia Midwinter Exposition 1894a:122–124, 1894b:159).

In 1895, the year the Brulé tipi cover was photographed, Jordan took dancers to the Cotton States and International Exposition in Atlanta, Georgia. He also had a "concession to exhibit a typical Sioux Indian Village" (Jordan 1970:369; also Hamilton and Hamilton 1971:133), located at Midway Heights (Dodge 1895:111). The exhibited village included "a buffalo skin lodge which required many buffalo skins to cover it" (Jordan 1970:369). The official history of the exposition states that the village also contained "a historic lodge, giving in pictures the history of the Sioux for 240 years" (Cooper 1896:91).[3] This "lodge" may have been the well-known Brulé tipi cover painted with a winter count.

The tipi cover may also have been included in the show Jordan staged in 1896 at the Zoological Garden in Cincinnati, Ohio, apparently his last show (Jordan 1970:369–370; also Hamilton and Hamilton 1971:133).[4] The show included 89 Brulé men, women, and children from the Rosebud Reservation who camped there for three months (Meyn 1992:21) "to illustrate life on the Plains with a living Indian village" (Meyn 1994:34). They traveled to Cincinnati by train from Valentine, Nebraska; "two boxcars transported their tepees and horses" (Meyn 1994:30). According to one account, "the Sicangu [Brulé] had a busy schedule. During the day Cincinnatians strolled

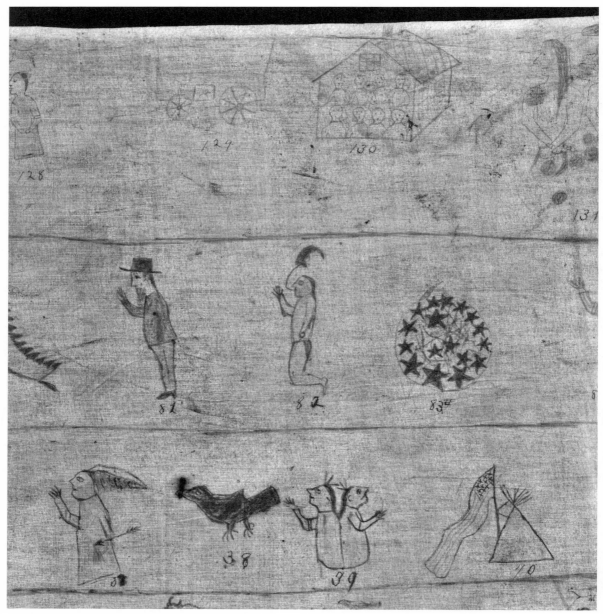

FIGURE 3.5. *Detail of the Rosebud winter count. The lower two lines of entries are by the artist who drew the majority of the record; another hand added the pictures in the top line, suggesting that a new owner took over responsibility for the count. National Anthropological Archives, Smithsonian Institution (NAA Ms. 2001–10).*

through their village and at night under electrical and chemical lighting applauded spectacular re-enactments of the Ghost Dance, the massacre of Wounded Knee, the battle of Little Big Horn, and an attack on a stagecoach" (Meyn 1992:24). (The "re-enactments" also included "the proverbial burning of the prisoner at the stake" [Meyn 1994:36]). The village they created contained "tepees . . . covered with rude pictures, showing the Indian's passion, if not his talent, for drawing" (Meyn 1994:36).

Anderson's photograph of the tipi cover records only part of the count, since it was painted in tiers around the tipi and Anderson photographed the tipi from only one angle (as far as we know). Despite this limitation, James Howard included the photograph in analyses of Lakota winter counts. He concluded that there are 47 visible pictographs, covering from about 1788–89 to 1865–66, and speculated that the entire count "probably begins ca. 1761–62 and ends ca. 1870–71" (1976:67). Howard even provides a comparison of the visible pictographs with those offered by Garrick Mallery, and he was able to identify 21 of them.

OTHER WINTER COUNTS

A comparison of the pictographs on the tipi cover with those of the Rosebud Reservation winter count indicates they are very closely related. The count on the tipi goes from right to left in the photograph, whereas the Rosebud Reservation count goes from left to right, but this could be merely a function of the negative being reversed. There are some variations in how the pictographs are drawn; for example, many of the human figures on the Rosebud winter count lack legs, whereas there are full figures on the tipi cover. However, the images are very similar to one another. (See Figures 3.3 and 3.4.) Thus, the events they represent appear to be the same, although similar pictographs can and do depict different events on different counts.

The earliest visible pictograph on the tipi cover corresponds to 1762–63 in the Rosebud Reservation winter count; the latest corresponds to 1876–77. Howard's

identifications of the 21 Brulé tipi cover pictographs correspond well with the dates offered here for the Rosebud winter count.

It seems that the tipi cover's pictographs were copied from the Rosebud Reservation winter count, or a closely related account. The Rosebud Reservation winter count seemingly spans a slightly longer period than the events on the tipi, which indicates it was not copied from the cover. Also, it was possibly created on the present muslin as early as 1873–74, which seems too early a date for the tipi cover to have been created, at least the one photographed by Anderson and perhaps also the one reportedly burned in 1892. And, most important, no other winter count on a tipi is known to have existed. If this is the case, then someone—probably Jordan or Anderson—had access to the Rosebud Reservation winter count (or one similar to it) and had it painted on a tipi, possibly as late as shortly before the 1893 World's Columbian Exposition in Chicago. This was a time when people were "constructing" Lakota artifacts and culture to present to the general public. Raymond DeMallie asserts that "during the early reservation period, as whites paid attention to winter counts, they developed from stylistically mnemonic devices to artistic presentations; on a tipi cover, aesthetic considerations called for more highly developed style" (pers. comm., 2001). Such "construction" could even explain the full figures on the tipi, since the images would have been modified for public consumption. (And, too, there was more space on the tipi cover.) Thus, the tipi cover could have been only a "showbiz prop," according to Tanis Thorne. Whether the tipi Anderson photographed was already in existence, was created at the same time, or was created again from the Rosebud Reservation winter count after the fire, perhaps in anticipation of Jordan's own entertainment venture, one cannot now say.

COMPARISON TO OTHER WINTER COUNTS

The history that the Rosebud winter count chronicles is also similar to other Sioux winter counts from various

bands, including the High Hawk, No Ears, and Lone Dog winter counts. (See chap. 4 in this volume.)

As yet, we have few matches for the first three dozen pictographs of the Rosebud Reservation winter count with other winter counts, though several counts, or some versions of them, go back to these years or further. Thus, versions of the Battiste Good and High Hawk winter counts begin a year-by-year chronology in 1700; other winter counts start around the same time as the Rosebud Reservation winter count (1752–53), such as No Ears winter count, in 1759, and White Bull winter count, in 1764 (Howard 1968). Still other winter counts start in the 1770s, for example, American Horse winter count, Cloud Shield winter count, and Hardin winter count (Finster 1968). Many of the events for the initial decades of the Rosebud count (1750s to 1780s) clearly depict wounded individuals, perhaps indicating their deaths. Other figures are intriguing but unidentified. For example, the pictograph for 1767–68 depicts an anthropomorphic half human and half buffalo, almost surely depicting a buffalo dancer, but possibly a person's name. A very similar pictograph shows up on the Blue Thunder winter count from the Standing Rock Reservation, but for a much later year, 1926–27 (Howard 1960). (No interpretation of the pictograph is given.) Two similar pictographs show up on the British Museum winter count for the years 1871–72 and 1872–73: the first event referred to is uncertain; the second is the death of "Standing Buffalo Bull" (Howard 1979).

The pictograph for 1775–76 depicts a horse with a travois, showing a transition from the use of the travois with dogs to its use with horses (as well as with dogs) by at least the mid-1770s. Indeed, the Sioux name for the horse, šuŋka wakaŋ (sacred dog), indicates its importance in replacing the dog as a beast of burden. Does the entry indicate the first acquisition of a horse by this band of Lakota? Perhaps so. Certainly, some bands of Sioux had horses before this date. The winter counts of Battiste Good and the High Hawk—both Brulé—indicate horses, apparently taken from the Omaha, for the year 1708 or 1709, although whether they actually had horses at this

early date is conjecture. Interestingly, these winter counts do not have a pictograph similar to this one in the Rosebud winter count to indicate horses, nor have I ever seen a similar pictograph on another winter count. Nevertheless, some Sioux certainly had horses by at least 1742, as observed by the explorer Pierre Gaultier de Varenes, sieur de la Vérendrye, when he was among the Teton Sioux (Wissler 1914:6).

The pictograph for the year 1787–88 possibly represents the same event as that depicted in the Cloud Shield winter count for 1786–87 ("Long Hair Killed") and/or events from the Batiste Good winter count, The Flame winter count, and the Hardin winter count for 1787–88: the leaving behind of a *heyoka* ("backward" person) who did the opposite of what he was told to do and was killed.

From 1787–88 onward, however, the Rosebud Reservation winter count correlates well with other known winter counts. As discussed in chapter 4, this includes such winter counts as the Brulé Battiste Good winter count, but particularly The Flame winter count as well as the Lone Dog winter count and The Swan winter count.

One problem in correlating this winter count with others may center on the entries for 1817–18 and 1818–19, which are drawn very closely together but which I believe represent two separate years. The picture that I have identified as 1818–19 corresponds to the "Built Trading Post" year recorded in other counts (Praus 1962).

A similar problem was encountered with the figures originally numbered as 33 and 34. I believe that these two numbers represent a single entry corresponding to 1784–85. Since this section of the record covers a period prior to any known relationships between the Rosebud Reservation winter count and other winter counts, comparisons cannot be made.

While the later years correlate well with various other winter counts, there are some unique entries for individual years or short series of years. For example, pictographs for 1883–84 through 1885–86 appear not to relate to any other winter count over this three-year period, nor does the two-year period of 1846–47 to 1847–48, or the single years of 1800–01 or 1858–59. Such differences may in-

dicate that this *tiyošpaye* spent some winters away from other groups represented by known winter counts and therefore had unique experiences.

CONCLUSIONS

The Rosebud Reservation winter count is a remarkable aesthetic, cultural, and historic object. It is a tribute to the great Sioux people who recorded their histories. Many of its colors are bright; many of its pictographs are intriguing. It is a very important chronicle of Sioux history, dating back further into the 18th century than most other Sioux winter counts known today. It also helps explain the origin of the Brulé tipi cover photographed by Anderson and likely used in Jordan's Wild West shows.

It is very curious that this winter count was not known to us earlier. By 1895 Anderson was aware of the tipi cover based on it, but he or his wife may not have actually possessed the winter count by this time, or even been aware of it. Whenever it was acquired, Anderson did not subsequently photograph it, as far as we currently know. This is particularly strange, since he photographed the Big Missouri winter count and even provided interpretations of its pictographs.

It is also curious that few of the first two dozen years of the Rosebud winter count—1752–53 through 1774–75—relate to any other known Sioux winter count. All winter counts contain some unique entries. Such a long period of mostly unique experiences, however, indicates that this *tiyošpaye* was quite isolated from other Sioux groups from the early 1750s to the latter 1780s, perhaps not even acquiring the horse until the mid-1770s. If so, it will be important to document where they lived during this time. In so doing, scholars may even be able to document the name of one of several keepers of the winter count over the decades, most likely one during the later years, and may then be able to provide a proper name for it.

I am continuing my research on the Rosebud winter count with members of the Rosebud community and hope that more information regarding its origins and significance will emerge.

ACKNOWLEDGMENTS

I gratefully acknowledge the many people who contributed to this chapter and to my earlier publication, on which portions of this chapter are based: Thomas Biolsi, Christina Burke, Raymond DeMallie, Gillian Flynn, Ron Little Owl, Ronald T. McCoy, Melissa Meyer, Joaquin Rivaya Martinez, Timothy Tackett, Phuong Tong, and Tanis Thorne. A special thanks is extended to Candace Greene and Gayle Yiotis, both of whom assisted in various ways.

NOTES

1. See Hyde 1961 for a history of the Brulé; see Utley 1963 for a more general history of the Sioux during this period.

2. However, some have stated that the tipi cover was actually owned by High Hawk, although it does not seem to have been drawn by him, since it differs significantly from another winter count attributed to him. See Dyck 1971:332, 356; McCoy 1983:88; Howard 1976:20, 67; Cowdrey 1999; and Curtis 1908:159–182, and illus. facing 158, 160, 162, and 164. Cowdrey (1999) attributes the tipi winter count to High Hawk and does not make the connection between it and the Rosebud Reservation winter count that he examined.

3. The history of the Atlanta exposition also says that "with the tribe was a medicine man with two medicine lodges covered with pictures representing the strange, unnatural objects which the medicine man had seen in his dreams" (Cooper 1896:91).

4. According to Hamilton and Hamilton (1971:131), Charles Jordan died around 1927; according to Jordan (1970:327), Julia had died earlier, in 1913.

4

Winter by Winter

CHRISTINA E. BURKE AND
RUSSELL THORNTON,
assisted by Dakota Goodhouse

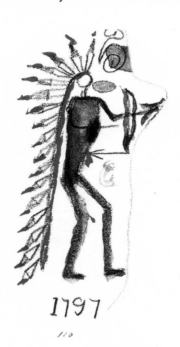

1797

110

INTRODUCTION
Candace S. Greene

Much of the research value of a collection such as the Smithsonian's comes not from the sheer quantity of material or even the high quality of particular items but from the synergy generated when these resources are brought together. Each object has the potential to shed a unique light on the next, providing new insights and possibly challenging conclusions that might seem evident from any one item examined in isolation.

This chapter brings together all the explanations recorded for the Lakota winter counts in the Smithsonian, organized by date to facilitate comparison among the various records. It includes all the information that could be located in Smithsonian records combined with interpretations published by the collectors, occasionally supplemented and clarified by reference to other sources, including winter counts in other repositories. The information in this chapter was assembled by Christina Burke, except for that relating to the Rosebud winter count. Interpretations for that count were prepared by Russell Thornton and Dakota Goodhouse. They have in some instances, especially for the early years of the winter count, provided provisional names for the years based on their reading of the pictographs alone. At other times they were able to interpret the picture by reference to other winter counts in the Smithsonian or other collections. These non-Smithsonian counts are described briefly at the end of the chapter.

The data on which this chapter is based are also available through a Web site developed at the request of Lakota educators and with support from the Smithsonian Institution Women's Committee. It is available at www.wintercounts.si.edu.

Information is organized by date, correlating the Lakota year names to the modern Western calendar. As discussed in the first chapter, the Lakota year was counted from first snow to first snow, thus spanning parts of two calendar years as designated in the Western system. Within each year the counts are organized on the basis of relative similarity, so that related events can be compared more easily. This corresponds loosely with geographical contiguity, so that the northern counts are presented first,

followed by those from more southerly Lakota bands. Since the counts cover differing periods of time, the first years are represented only by entries from the record of Battiste Good, while the last years are covered only by No Ears. Only the early and middle years of the 19th century contain information from all ten individual winter counts. In addition to the conventional yearly entries, Good made a number of entries covering more lengthy periods of time which predate his annual entries. Their presentation requires a different structure, and they therefore appear as a separate section at the end of the chapter. Two counts, Mato Sapa and White Cow Killer, are only partially known, with neither pictorial records nor complete texts. Information from these counts is therefore incorporated into the discussions of other counts where relevant.

Each entry shows the pictograph used to designate the year in that calendar. For calendars with multiple versions in the Smithsonian collections, the one with the clearest pictures was chosen for illustration. Images for the Lone Dog winter count are from the NMAI version on buffalo hide referred to here as NMAI A (#1/0617). The images on this hide are almost identical to those in the image published by Mallery, which was itself based on a photograph of a drawing on muslin. Images for The Flame count come from the muslin in the NAA rather than from the one in the NMAI collection. And the American Horse pictures are from the book drawn by American Horse himself, rather than from the copy on linen. Two counts, Major Bush and No Ears, have only written texts and so do not have illustrations in this chapter. Overall views of all versions of the counts are provided in chapter 2.

The text for each entry in this chapter has three sections: the name of the year, the original accompanying text, and commentary and explanations provided by the authors of this chapter. The year name was often given by the keeper but in other instances was extracted from the explanatory text. The year names for the Rosebud winter count are descriptive terms provided by Thornton.

The year name is followed by direct quotation of all accompanying original text, both information provided by the keeper or other knowledgeable individual and any commentary from the collector. This material is not always well written, but we have retained without comment the original form, including spelling and punctuation, except where the meaning may be obscure. Modern insertions appear in square brackets []. Brackets in the original source material now appear as { } . Citations are given for all materials from published sources. All original information on the No Ears winter count comes from NAA Ms. 2261, while the Long Soldier text comes from NMAI Archives, OC #142.23.

The spelling of tribal names in the 19th-century texts often differs from present usage, but most are easily recognized without correction, such as Ponka for Ponca. The term Ree was used at the time to refer both to the Arikara and to the related Pawnee, with whom the Arikara sometimes lived. All divisions of the Sioux were referred to by the term Dakota, including the western bands now known as the Lakota. The chart in chapter 1 lists the names of other bands.

Explanatory information providing cultural and historical context has been included for many entries. Comparisons to other entries are noted if the related events are not from contiguous years and so the connection might be missed by the reader, or if the connection between them is not apparent. The current commentary in this chapter is provided by Christina Burke, except for commentary on the Rosebud winter count, which is by Russell Thornton. The Rosebud count is the only one in the Smithsonian that is not accompanied by an original explanatory text provided by the keeper or another contemporary Native source. Thornton has thus built his commentary on comparison with other counts in the Smithsonian and other collections. Background information on the non-Smithsonian counts to which he refers is included at the end of this chapter. There is little comparative material for him to draw on for the early years of this record; in many instances the year names are based only on the images themselves.

It is our hope that this chapter will provide the basis for a richer understanding of Lakota winter counts, both as individual records and as a system of recording events. Some counts are so similar that they can be considered exact copies or closely related variants, such as the several versions of the Lone Dog winter count. Others share many of the same referents, but the keepers selected different aspects of the same event to illustrate, or they interpreted the event's significance in a distinct way. Some counts

may place the same events in different years, or "winters." Many factors could contribute to this. Each record represents a long chain of knowledge transmission—from keeper to keeper to interpreter to recorder to the present-day reader. There was much room along the way for changes due to lapses of memory or, as the No Ears count makes clear, errors in recording and translation. Many differences, however, must be the result of changes consciously introduced by the keepers, whose task it was to maintain a cultural record that was relevant and useful to their community. Their variations as well as their similarities mark them as meaningful products of active cultural traditions.

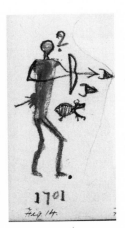

BATTISTE GOOD

1700–01

The two killed on going back to the hunting ground winter (or year).

Collector's Notes: Two Dakotas returned to the hunting ground, after the hunt one day, and were killed by enemies, of what tribe is unknown. The blood-stained arrow in the man's side signifies killed; the numeral 2 over his head, the number killed; and, the buffalo heads, the carcass of a buffalo—which had been left behind because it was too poor to eat—together with the arrow pointing toward them, the hunting-ground. The dot under the figure 2, and many of the succeeding ones, signifies, That is it. This corresponds with some gesture signs for the same concept of declaration, in which the index finger held straight is thrust forward with emphasis and repeatedly as if always hitting the same point (Mallery 1893:293).

The number "2" over his head shows how many men

were killed. The buffalo head signifies what animal they were hunting; it was too poor to eat (Mallery 1893:293).

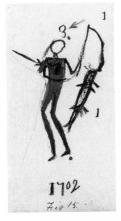

BATTISTE GOOD

1701–02

The three killed who went fishing winter.

Collector's Notes: The arrow pointing toward the 3, indicates that they were attacked; the arrow in the man's arm, and the blood stain, that they were killed; the pole, line, and fish which the man is holding, their occupation at the time (Mallery 1893:293).

Comments: The Lakota usually did not eat fish; there are few stories about fishing, and game animals were by far the preferred source of protein. However, in times of need they did eat fish, and this may have been a year when hunting for buffalo and other animals had been unsuccessful. See also Good's entry for 1748–49.

BATTISTE GOOD

1702–03

Camped cutting the ice through winter.

Collector's Notes: A long lake toward the east, near which the Dakotas were encamped, was frozen over, when they discovered about one thousand buffalo. They secured them all by driving them on the ice, through which they broke, and in which they froze fast. Whenever the people wanted meat, they cut a buffalo out of the ice. In the figure, the wave [sic] lines represent the water of the lake; the straight lines, the shore; the blue lines outside the black ones, trees; the blue patches inside, the ice through which the heads of the buffalo are seen; the line across the middle, the direction in which they drove the buffalo. The supply of meat lasted one year (Mallery 1893:293–294).

BATTISTE GOOD

1703–04

The burying winter, or many holes winter.

Collector's Notes: They killed a great many buffalo during the summer, and, after drying the meat, stored it in pits for winter's use. It lasted them all winter, and they found it all in good condition. The ring surrounding the buffalo head, in front of the lodge, represents a pit. The forked stick, which is the symbol for meat, marks the pit {Other authorities suggest that the object called by Battiste a pit, which is more generally called "cache," is a heap, and means many or much.} (Mallery 1893:294).

BATTISTE GOOD

1704–05

Killed fifteen Pawnees who came to fight winter.

Collector's Notes: The Dakotas discovered a party of Pawnees coming to attack them. They met them and killed fifteen. In this chart the Pawnee of the Upper Missouri (Arikara or Ree), the Pawnee of Nebraska, and the Omaha are all depicted with legs which look like ears of corn, but an ear of corn is symbol for the Rees only. The Pawnee of Nebraska may be distinguished by a lock of hair at the back of the head; the Omaha, by a cropped head or absence of the scalp-lock. The absence of all signs denotes Dakota. {To avoid confusion the literation of the tribal divisions as given by the translator of Battiste Good are retained, though not considered accurate.} (Mallery 1893:294).

Comments: Usually tribal affiliation is indicated in pictographs by a specific hairstyle or article of clothing. In this instance the flared tops on the moccasins identify the person as a Pawnee. Good is unusual among Lakota winter count keepers in adding a separate image (the ear of corn) to mark the person's tribe. The Pawnee and Arikara are related culturally, historically, and linguistically. In the Lakota language, the word Palani can refer to either tribe. However, the term Hewaktokta refers specifically to the Arikara, and the word Scili to Pawnee.

BATTISTE GOOD

1705–06

They came and killed seven Dakotas winter.

Collector's Notes: It is not known what enemies killed them (Mallery 1893:294).

BATTISTE GOOD

1706–07

Killed the Gros Ventre with snowshoes on winter.

Collector's Notes: A Gros Ventre (Hidatsa), while hunting buffalo on snowshoes, was chased by the Dakotas. He accidentally dropped a snowshoe, and, being then unable to get through the snow fast enough, they gained on him. The Gros Ventres and the Crows are tribes of the same nation, and are therefore both represented with striped or spotted hair, which denotes the red clay they apply to it (Mallery 1893:295).

BATTISTE GOOD

1707–08

Many kettle winter.

Collector's Notes: A man—1 man—named Corn, killed (3) his wife, 1 woman, and ran off. He remained away for a year and then came back, bringing three guns with him, and told the people that the English, who had given him these guns, which were the first known to the Dakotas, wanted him to bring his friends to see them. Fifteen of the people accordingly went with him, and when they returned brought home a lot of kettles or pots. These were the first they ever saw. Some numerical marks for reference and the written words in the above are retained as perhaps the worst specimens of Battiste's mixture of civilized methods with the aboriginal system of pictography (Mallery 1893:295).

Comments: Mallery's disparaging remarks may indicate that he believes the traditional pictographs are "tainted" by the imposition of text and numbers.

BATTISTE GOOD

1708–09

Brought home Omaha horses winter.

Collector's Notes: The cropped head over the horse denotes Omaha (Mallery 1893:295).

BATTISTE GOOD

1709–10

Brought home Assiniboin horses winter.

Collector's Notes: The Dakota sign for Assiniboine, or Hohe, which means the voice, or, as some say, the voice of the musk ox, is the outline of the vocal organs, as the Dakotas conceive them, and represents the upper lip and roof of the mouth, the tongue, the lower lip and chin, and the neck (Mallery 1893:295).

Comments: The source of Mallery's information is not known. This device indicating Assiniboine is not found on any other winter count or on any biographical pictographs known to me. Some say the Lakota term for Assiniboine (Hohe) means "stone boilers."

BATTISTE GOOD

1710–11

The warparties met, or killed three on each side winter.

Collector's Notes: A war party of Assiniboins met one of Dakotas, and in the fight which ensued three were killed on each side (Mallery 1893:295).

BATTISTE GOOD

1711–12

Four lodges drowned winter.

Collector's Notes: When the thunders returned in the summer the Dakotas were still in their winter camp on the bottom lands of a large creek. Heavy rains fell which caused the creek to rise suddenly; the bottoms were flooded, and the occupants of four lodges were swept away and drowned. Water is represented by waved lines, as before. The lower part of the lodge is submerged. The human figure in the doorway of the lodge indicates how unconscious the inmates were of their peril (Mallery 1893:296).

Comments: Another flood in which many people drowned is noted by other calendars for the year 1825–26.

BATTISTE GOOD

1712–13

Killed the Pawnee who was eagle hunting winter.

Collector's Notes: A Pawnee (Ree) was crouching in his eagle-trap, a hole in the ground covered with sticks and grass, when he was surprised and killed by the Dakotas. This event is substantially repeated in this count for the year 1806–07 (Mallery 1893:296).

by Dr. Corbusier.—It is probable that horses were not numerous among any of the Indians yet, and that this mounted attack was the first one experienced by the Brulé.) (Mallery 1893:296).

BATTISTE GOOD
1713–14
Came and shot them in the lodge winter.

Collector's Notes: The Pawnees (Rees) came by night, and, drawing aside the tipi door, shot a sleeping man, and thus avenged the death of the eagle-hunter (Mallery 1893:296).

Comments: The previous year records the event that lead to this attack.

BATTISTE GOOD
1715–16
Came and attacked on horseback and stabbed a boy near the lodge winter.

Collector's Notes: Eagle tail-feathers hang from the butt end of the lance (Mallery 1893:296).

BATTISTE GOOD
1714–15
Came to attack on horseback but killed nothing winter.

Collector's Notes: The horseman has a pine lance in his hand. It is not known what tribe came. (Note

BATTISTE GOOD
1716–17
Much pemmican winter.

Collector's Notes: A year of peace and prosperity. Buffalo were plentiful all the fall and winter. Large quantities of pemmican (wasna) were made with dried meat and marrow. In front of the lodge is seen the backbone of a buffalo, the marrow of which is used in wasna; below this is the buffalo stomach, in which wasna is packed and stored for preservation (Mallery 1893:296).

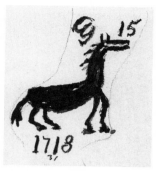

BATTISTE GOOD
1717–18
Brought home fifteen Assiniboin horses winter.

Collector's Notes: The sign for Assiniboin is above the horse (Mallery 1893:296).

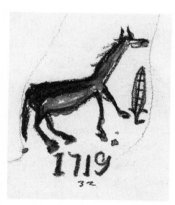

BATTISTE GOOD
1718–19
Brought home Pawnee winter.

Collector's Notes: The sign for Ree, i.e., an ear of corn, is in front of the horse (Mallery 1893:297).

Comments: As noted for 1704–05 and 1712–13, this sign and the name "Ree" may refer to either the Pawnee or the Arikara.

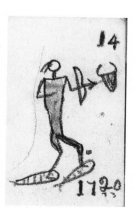

BATTISTE GOOD
1719–20
Wore snowshoes winter.

Collector's Notes: The snow was very deep, and the people hunted buffalo with excellent success (Mallery 1893:297).

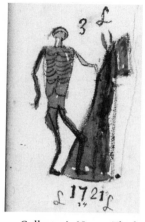

BATTISTE GOOD
1720–21
Three lodges starved to death winter.

Collector's Notes: The bare ribs of the man denote starvation. {The gesture-sign for poor or lean indicates that the ribs are visible. In the Ojibwa and Ottawa pictographs lines across the chest denote starvation.} (Mallery 1893:297).

Comments: Good's image for 1738–39 uses a similar device to show starvation.

BATTISTE GOOD
1721–22
Wore snowshoes and dried much buffalo meat winter.

Collector's Notes: It was even a better year for hunting buffalo than 1719–20 (Mallery 1893:297).

BATTISTE GOOD

1722–23

Deep snow and tops of lodges only visible winter.

Collector's Notes: The spots are intended for snow (Mallery 1893:297).

BATTISTE GOOD

1723–24

Many drying sticks set up winter.

Collector's Notes: The Lakota set up more than the usual number of racks to dry buffalo meat, hides, and entrails, indicating another successful hunt. A similar image is used for 1745–46 in this calendar (Mallery 1893:298).

Comments: Good also uses a similar device to mark a successful hunt for 1763–64.

BATTISTE GOOD

1724–25

Blackens Himself died winter.

Collector's Notes: This man was in the habit of blackening his whole body with charcoal. He died of some kind of intestinal bend as is indicated by the stomach and intestines in front of him, which represent the bowels in violent commotion, or going round and round (Mallery 1893:298).

Comments: Good is unique in portraying this type of physical ailment with an image separate from the human figure. It appears several times in this winter count. It also should be noted that, among the Lakota, men often blackened themselves in order to show they had been successful in battle and had killed one or more enemies. This image may depict a successful warrior.

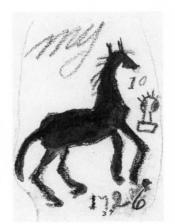

BATTISTE GOOD

1725–26

Brought home ten Omaha horses winter.

Collector's Notes: The sign for Omahas is the head, as before (Mallery 1893:298).

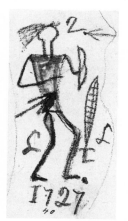

BATTISTE GOOD

1726–27

Killed two Pawnees among the lodges winter.

Collector's Notes: The Pawnees (Rees) made an assault on the Dakota Village, and these two ran among the lodges without any arrows. The sign for Ree is, as usual, an ear of corn (Mallery 1893:298).

Comments: As in other years, Good uses a numeral at the top of the figure to indicate details of the event.

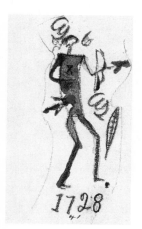

BATTISTE GOOD

1727–28

Killed six Assiniboins winter.

Collector's Notes: Two signs are given here for Assiniboin. There is some uncertainty as to whether they were Assiniboins or Arikaras so the signs for both are given (Mallery 1893:298).

Comments: Perhaps the tribal name of the enemy is not known because Good gathered the information decades after the event.

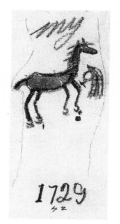

BATTISTE GOOD

1728–29

Brought home Gros Ventre horses winter.

Collector's Notes: A Gros Ventre head is shown in front of the horse (Mallery 1893:298).

BATTISTE GOOD

1729–30

Killed the Pawnees camped alone with their wives winter.

Collector's Notes: Two Pawnees and their wives, who were hunting buffalo by themselves, and living in one lodge, were surprised and killed by a war party of Dakotas (Mallery 1893:299).

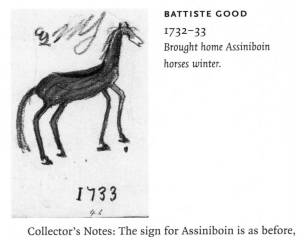

BATTISTE GOOD

1730–31

Came from opposite ways and camped together winter.

BATTISTE GOOD

1732–33

Brought home Assiniboin horses winter.

Collector's Notes: By a singular coincidence, two bands of Dakotas selected the same place for an encampment, and arrived there the same day. They had been separated a long time, and were wholly ignorant of each other's movements. The caps of the tipis face one another (Mallery 1893:299).

Collector's Notes: The sign for Assiniboin is as before, over the horse (Mallery 1893:299).

BATTISTE GOOD

1731–32

Came from killing one Omaha and danced winter.

BATTISTE GOOD

1733–34

Killed three Assiniboins winter.

Collector's Notes: This is the customary feast at the return of a successful war party. The erect arrow may stand for "one," and the Omaha is drawn at full length with his stiff short hair and painted cheeks (Mallery 1893:299).

Collector's Notes: There again is uncertainty as to whether they were Assiniboins or Arikaras, and both signs are used (Mallery 1893:299).

Comments: This uncertainty may stem from the fact that Good was collecting this information decades after the event took place. See also 1727–28.

BATTISTE GOOD
1734–35
Used them up with belly ache winter.

Collector's Notes: About fifty people died of an eruptive disease which was accompanied by pains in the bowels. The eruption is shown on the man in the figure. This was probably the first experience by the Dakotas of the smallpox, which has been so great a factor in the destruction of the Indians (Mallery 1893:300).

Comments: The figure is shown with red spots (perhaps indicating smallpox) as well as the sign for pain both inside the figure and to the right of it.

BATTISTE GOOD
1736–37
Brought home Pawnee horses winter.

Collector's Notes: This date must be considered in connection with the figure in this record for 1802–03. There is a distinction between the wild and the shod horses, but the difference in tribe is great. The ear of corn showing the husk is as common in this record for Pawnee as for Arikara (Mallery 1893:300).

Comments: See the notes accompanying Good's 1704–05 entry regarding the relationship of the Pawnee and the Arikara.

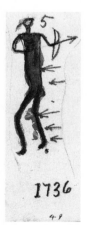

BATTISTE GOOD
1735–36
Followed them up and killed five winter.

Collector's Notes: A war party of Dakotas were chased by some enemies, who killed five of them. The arrows flying from behind at the man indicate pursuit, and the number of the arrows, each with a bloody mark as if hitting, is five (Mallery 1893:300).

BATTISTE GOOD
1737–38
Killed seven Assiniboins bringing them back to a stand under a bank winter.

Collector's Notes: The daub, blue in the original, under the crouching figure, represents the bank (Mallery 1893:300).

BATTISTE GOOD

1738–39

The four who went on the war path starved to death winter.

Collector's Notes: Starvation is indicated as before (Mallery 1893:300).

Comments: Mallery is referring to the skeletal figure with the noticeable ribs, as in the entry for 1720–21.

BATTISTE GOOD

1739–40

Found many horses winter.

Collector's Notes: The horses had thongs around their necks, and had evidently been lost by some other tribe. Hoof prints are represented above and below the horse, that is all around (Mallery 1893:301).

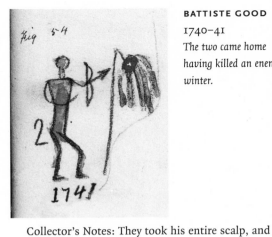

BATTISTE GOOD

1740–41

The two came home having killed an enemy winter.

Collector's Notes: They took his entire scalp, and carried it home at the end of a pole. Only a part of the scalp is ordinarily taken, and that from the crown of the head (Mallery 1893:301).

Comments: It is unclear why the entire scalp was taken in this case, but the placement of it on a pole is common. Such poles were decorated and used in ceremonies, especially the singing of victory songs to honor successful warriors upon their return. Good indicates the number of warriors with the numeral 2.

BATTISTE GOOD

1741–42

Attacked them while gathering turnips winter.

Collector's Notes: Some women, who were digging turnips (pomme blanche) near camp, were assaulted by a party of enemies, who, after knocking them down, ran off without doing them any further harm. A turnip, and the stick for digging it, are seen in front of the horseman (Mallery 1893:301).

Comments: Prairie turnips, known in Lakota as *timp-sila*, are used both fresh and dried. They are eaten in soup and pounded into flour and used in baking.

BATTISTE GOOD
1742–43
Killed them on the way home from the hunt winter.

Collector's Notes: The men were out hunting, and about 100 of their enemies came on horseback to attack the camp, and had already surrounded it, when a woman poked her head out of a lodge and said. "They have all gone on the hunt. When I heard you, I thought they had come back." She pointed toward the hunting ground, and the enemies going in that direction, met the Dakotas, who killed many of them with their spears, and put the rest to flight. Hoof-prints surround the circle of lodges, and are on the trail to the hunting ground (Mallery 1893:301).

BATTISTE GOOD
1743–44
The Omahas came and killed them in the night winter.

Collector's Notes: They wounded many, but killed only one. The Dakotas were all encamped together (Mallery 1893:301).

Comments: When Good indicates that all the Lakota were camped together, it is unclear whether he means all the Brulé or a larger group including other Lakota bands.

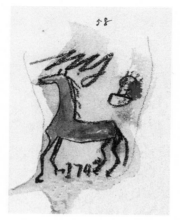

BATTISTE GOOD
1744–45
Brought home Omaha horses winter (Mallery 1893:302).

Comments: The symbol for Omaha, the head with short, stiff hair, is pictured to the right of the horse.

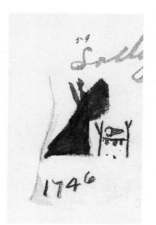

BATTISTE GOOD
1745–46
Many drying scaffolds winter.

Collector's Notes: This year was even more successful than 1723–24 (Mallery 1893:302).

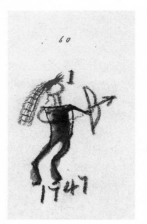

BATTISTE GOOD

1746–47

Came home having killed one Gros Ventre winter (Mallery 1893:302).

Comments: As noted for the year 1706–07, Good represents Gros Ventres and Crows with striped hair, indicating the clay they applied to their unbraided hair.

BATTISTE GOOD

1747–48

Froze to death at the hunt winter.

Collector's Notes: The arrow pointing toward the buffalo head indicates they were hunting, and the crouching figure of the man, together with the snow above and below him, that he suffered severely from cold or froze to death (Mallery 1893:302).

Comments: It is interesting that Good does not know whether the man merely suffered or actually died from exposure. The crouching figure indicates cold, a device that Good also used to indicate horses that had frozen to death. See Good's entries for 1783–84, 1852–53, and 1865–66 for other years of severe cold.

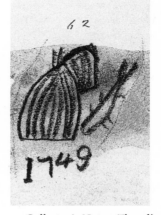

BATTISTE GOOD

1748–49

Eat frozen fish winter.

Collector's Notes: They discovered large numbers of fish frozen in the ice, and subsisted on them all winter (Mallery 1893:302).

Comments: The Lakota usually did not eat fish except in times of need; see comment on year 1701–02.

BATTISTE GOOD

1749–50

Many hole camp winter.

Collector's Notes: The same explanation as for the year 1703–04. The two figures are different in execution though the same in concept. There would, however, be little confusion in distinguishing two seasons of exceptional success in the hunt that were separated by forty-six years (Mallery 1893:302).

BATTISTE GOOD

1750–51

Killed two white buffalo cows winter.

BATTISTE GOOD

1752–53

Destroyed three lodges of Omahas winter.

Collector's Notes: (Note by Dr. Corbusier: Two white buffalo are so rarely killed one season that the event is considered worthy of record. Most Indians regard the albinos among animals with the greatest reverence. The Ojibwas, who look upon a black loon as the most worthless of birds regard a white one as sacred.) (Mallery 1893:302).

Comments: Other calendars mark a similar event for the year 1830–31.

Collector's Notes: The Dakotas went to retaliate on the Omahas, and finding three lodges of them killed them. It will be noticed that in this figure the sign for Omaha is connected with the lodge, and in the preceding figure with the arrow (Mallery 1893:303).

Comments: The previous year's entry records the event that led up to this.

BATTISTE GOOD

1751–52

Omahas came and killed two in the lodge winter.

ROSEBUD

1752–53

They killed "Red Bird."

Collector's Notes: An Omaha war party surprised them in the night, shot into the lodge, wounding two, and then fled. The two shot died of their wounds (Mallery 1893:303).

Comments: This is the first entry of the Rosebud count. Here and elsewhere we have taken the liberty of suggesting names of individuals based on their name glyphs. Thus, this glyph is of a "red bird." In these instances, the names are set in quotation marks.

BATTISTE GOOD
1753–54
Killed two Assiniboines on the hunt winter (Mallery 1893:303).

Comments: The sign for Assiniboine is shown above the figure's head, and an ear of corn to the right of his leg. The tribal identity of the enemy is not known.

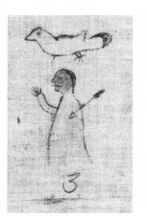

ROSEBUD
1753–54
They killed "Long Bird."

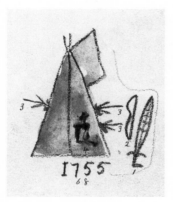

BATTISTE GOOD
1754–55
Pawnees shouted over the people winter.

Collector's Notes: The Pawnees (Rees) came at night, and standing on a bluff overlooking the Dakota village shot into it with arrows, killing one man, and alarmed the entire village by their shouts (Mallery 1893:303).

Comments: It is not clear whether Good is referring to Pawnees (usually called Palani) or their relatives the Arikara (Ree).

ROSEBUD
1754–55
They killed "Black Buffalo Bull."

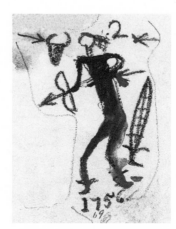

BATTISTE GOOD
1755–56
Killed two Pawnees on the hunt winter.

Collector's Notes: A war party of Dakotas surprised some Pawnee (Ree) hunters and killed two of them (Mallery 1893:303).

Comments: As in other entries in Good's count, the tribal affiliation of the hunters is not clear.

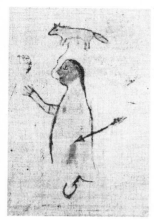

ROSEBUD

1755–56

They killed "Yellow Coyote."

Comments: The name glyph drawn in yellow could refer to a coyote, a wolf, or a fox.

ROSEBUD

1756–57

"White War Bonnet" went on war party winter.

Comments: There is nothing to suggest this person was injured or killed. The figure could be a woman. Perhaps she went on a war party, as was sometimes allowed.

BATTISTE GOOD

1756–57

The whole people were pursued and two killed winter.

Collector's Notes: A tribe, name unknown, attacked and routed the whole band. The man in the figure is retreating, as is shown by his attitude; the arrow on his bow points backward at the enemy, from whom he is retreating. The two blood-stained arrows in his body mark the number killed (Mallery 1893:303).

BATTISTE GOOD

1757–58

Went on the warpath on horseback to camp of enemy but killed nothing winter.

Collector's Notes: The lack of success may have been due to inexperience in mounted warfare as the Dakotas had probably for the first time secured a sufficient number of horses to mount a war party (Mallery 1893:304).

ROSEBUD
1757–58
They killed "Long Weasel."

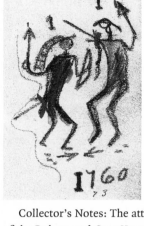

BATTISTE GOOD
1759–60
War parties met and killed a few on both sides winter.

Collector's Notes: The attitude of the opposed figures of the Dakota and Gros Ventre and the footprints indicate that the parties met; the arrows in opposition, that they fought; and the blood-stained arrow in each man that some were killed on both sides (Mallery 1893:304).

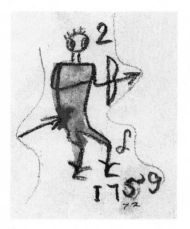

BATTISTE GOOD
1758–59
Killed two Omahas who came to the camp on war path winter (Mallery 1893:304).

NO EARS
1759–60
Bands separated in winter/Wicableca he han waniyetu.

Comments: This is the first entry of the No Ears calendar.

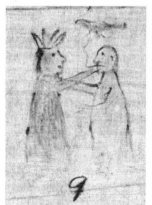

ROSEBUD
1759–60
Lakota recognize enemy and some on both sides are killed.

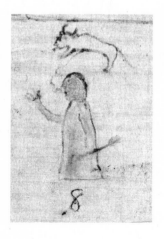

ROSEBUD
1758–59
They killed "Lean White Buffalo Bull."

Comments: This entry may correspond to the encounter with an enemy shown by Battiste Good for the

same year. The Lakota figure on the right is identified by a name glyph of a bird.

BATTISTE GOOD

1760–61

Assiniboins came and attacked the camp again winter or Assiniboins shot arrows through the camp winter (Mallery 1893:304).

BATTISTE GOOD

1761–62

Killed six Pawnees (Rees) winter.

Collector's Notes: Besides the arrow sticking in the body another arrow is flying near the head of the man figure, who has the tribal marks for Pawnee or Ree, as used in this record (Mallery 1893:304).

NO EARS

1760–61

Fishers were killed/Hokawa wica ktepi.

Comments: In general, the Lakota did not eat fish. The Lakota word *kuwa* means "to follow after, chase, or hunt" (Buechel 1970:320).

NO EARS

1761–62

Eagle Trappers killed/Wambli kuwa wica ktepi.

Comments: Several other calendars mark a similar event for 1806–07 or 1807–08. The term *kuwa* is used to refer to hunting.

ROSEBUD

1760–61

"White Bird" was killed.

ROSEBUD

1761–62

They killed "Skull" winter.

Comments: The associated name glyph appears to be a human head shown in profile.

BATTISTE GOOD
1762–63
People were burnt winter.

ROSEBUD
1762–63
"Big Yellow Fish" counted coup (struck an enemy).

Comments: The name glyph appears to be a large fish colored in yellow.

Collector's Notes: They were living somewhere east of their present country when a prairie fire destroyed their entire village. Many of their children and a man and his wife, who were on foot some distance away from the village, were burned to death, as also were many of their horses. All the people that could get to a long lake, which was near by, saved themselves by jumping into it. Many of these were badly burned about the thighs and legs, and this circumstance gave rise to the name Sican-zhu, burnt thigh (or simply burnt as translated Brulé by the French), by which they have since been known, and also to the gesture sign, as follows: "Rub the upper and outer part of the right thigh in a small circle with the open right hand, fingers pointing downward" (Mallery 1893:304–305).

Comments: This is the only winter count to give such an explanation for how the Sičáŋǧu/Brulé acquired their tribal name.

BATTISTE GOOD
1763–64
Many sticks for drying beef winter.

Collector's Notes: They had so much meat to dry that the entire village was crowded with drying racks (Mallery 1893:305).

Comments: Other years of plenty were recorded by Good for 1723–24 and 1745–46. In this image, Good does not depict a buffalo head above the drying rack as he does in previous years.

NO EARS
1762–63
The[y] swam towards a buffalo/Pte anu wanpi.

NO EARS
1763–64
No Knives/Mila wanica (or Toka mil yuke).

Comments: The word *yuke* or *yuka* occurs throughout this count. This should probably be *yuha*, a verb mean-

ing "to have." Whoever typed the year names for this count may have been working from an earlier handwritten version that was difficult to read.

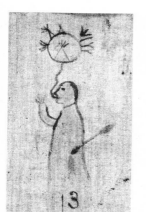

ROSEBUD
1763–64
They who talk alike fought each other winter.

Comments: The name glyph of this figure resembles Battiste Good's entry for this year, a tipi with drying poles for meat, although in this instance the whole camp circle is shown. Other winter counts indicate a "civil war" within a Lakota camp; hence the pictograph could refer to a camp circle.

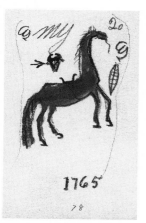

BATTISTE GOOD
1764–65
Stole their horses while they were on the hunt winter.

Collector's Notes: A Dakota war party chanced to find a hunting party of Assiniboins asleep and stole twenty of their horses. It was storming at the time and horses had their packs on and were tied. The marks which might appear to represent a European saddle on the horse's back

denote a pack or load. Hunting is symbolized as before, by the buffalo head struck by an arrow (Mallery 1893:305).

NO EARS
1764–65
Ant was killed/Tajuskala ktepi.

Comments: Ant is a person's name.

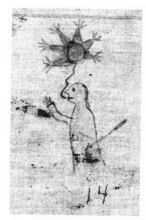

ROSEBUD
1764–65
Those who talk alike fought each other again winter.

Comments: This could refer to an escalation of the "civil war" of the previous year.

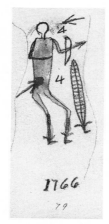

BATTISTE GOOD
1765–66
Killed a warparty of four Pawnees winter.

Collector's Notes: The four Pawnees (Rees) made an attack on the Dakota camp (Mallery 1893:305).

NO EARS
1765–66
Pouch was killed/Walegala ktepi.

ROSEBUD
1765–66
Lakota woman wounded counting coup winter.

Comments: The woman's side wound is similar to the figure in Good's entry for this year. She appears to be striking or counting coup on another figure.

BATTISTE GOOD
1766–67
Brought home sixty Assiniboin horses (one spotted) winter.

Collector's Notes: They were all the horses the Assiniboins had and were on an island in the Missouri river, from which the Dakotas cleverly stole them during a snowstorm (Mallery 1893:305).

NO EARS
1766–67
Shooting-pine was captured/Wazikutle waya yuzapi.

ROSEBUD
1766–67
"Blue Lodge" takes enemy scalp.

BATTISTE GOOD
1767–68
Went out to ease themselves with their bows on winter.

Collector's Notes: The Dakotas were in constant fear of an attack by enemies. When a man left his lodge after dark, even to answer the calls of nature, he carried his bows and arrows along with him and took good care not to go far away from the lodge. The squatting figure, etc., close to the lodge tells the story (Mallery 1893:306).

NO EARS
1767–68
They helped both sides/Anub ob iyepi.

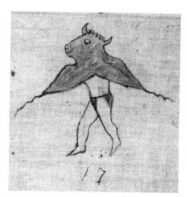

ROSEBUD
1767–68
Buffalo Bull dance held.

NO EARS
1768–69
Mixed bloods fought (among themselves)/Iyeska kicizapi.

Comments: The Lakota word *iyeska* literally means "white talkers" and historically refers to interpreters. Such translators were often mixed bloods, and so the word has come to mean mixed blood in general (Buechel 1970:210, 255).

Comments: This entry is similar to the one in the Blue Thunder winter count showing a man with a buffalo head and described as "Buffalo Head sleeping died." Another similar event is shown in the John K. Bear calendar. Bear, a Yanktonai, calls 1765 the year when the buffalo dance was performed wearing snowshoes.

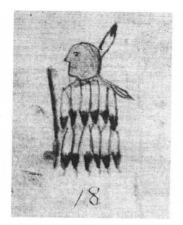

ROSEBUD
1768–69
Old "Feather Shirt" performed pipe ceremony winter.

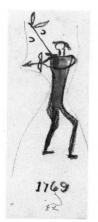

BATTISTE GOOD
1768–69
Two horses killed something winter.

Comments: The figure with a pipe and a cloak of feathers must represent a ceremony performed this year. Since the pipe is painted black, it is likely a ceremony in preparation for war. The figure has grey hair, hence he is probably old.

Collector's Notes: A man who had gone over a hill just out of the village was run down by two mounted enemies who drove their spears into him and left him for dead, one of them leaving his spear sticking in the man's shoulder, as shown in the figure. He recovered, however. (Note by Dr. Corbusier: They frequently speak of persons who have been very ill and have recovered as dying and returning to life again, and have a gesture sign to express the idea.) (Mallery 1893:306).

Comments: It appears that this man's name was Two Horses, as indicated by the two horse hoof prints above the figure.

BATTISTE GOOD
1769–70
Attacked the camp from both sides winter.

Collector's Notes: A mounted war party—tribe un-known—attacked the village on two sides, and on each side killed a woman. The footprints of the enemies' horses and arrows on each side of the lodge, which represents the village, show the mode of attack (Mallery 1893:306).

NO EARS
1769–70
Masker was killed/Iteha-kiton ktepi.

Comments: Masker can be translated as "one wearing a mask."

ROSEBUD
1769–70
"Big Brown Bird" recognized three times for bravery and was killed.

Comments: The three marks under the drawing of the name glyph could indicate three acts of bravery.

BATTISTE GOOD
1770–71
Came and killed the lodges winter.

Collector's Notes: The enemy came on horseback and assailed the Dakota lodges, which were pitched near together, spoiling some of them by cutting the hide coverings with their spears, but killing no one. They used spears only, but arrows are also depicted, as they symbolize attack. No blood is shown on the arrows, as only the lodges were "killed" (Mallery 1893:306).

NO EARS
1770–71
The great mystery was crazy/Wakan tanka knaskinye.

Comments: This might alternatively be translated as "The Great Mystery (Spiritual Being/Creator) was angry," with *wakan* meaning "sacred, holy, or mysterious" and *tanka* meaning "great or large."

ROSEBUD
1770–71
Swam in the river and got buffalo.

Comments: The blue drawing above the figure's head could indicate water instead of being a name glyph. If so, this could indicate what other winter counts report: retrieving dead buffalo from a flooded river.

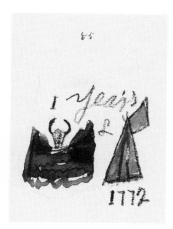

BATTISTE GOOD
1771–72
*Swam after the buffalo
winter.*

Collector's Notes: In the spring the Dakotas secured a large supply of meat by swimming out and towing ashore buffalo that were floating past the village and which had fallen into the river on attempting to cross on the weak ice (Mallery 1893:306).

NO EARS
1771–72
They burnt the Mandans out/Miwatani ohu wicayapi.

Comments: The Lakota term *Miwatani* refers to the Mandan (Buechel 1970:337, 733). This probably refers to a raid on a Mandan village during which the Lakota burned down the enemies' earth lodges.

ROSEBUD
1771–72
*"Big Eagle Woman"
carried some arrows in
a war party.*

Comments: The name glyph appears to be an eagle, grasping arrows in its claws; the figure appears to be a woman with a long braid.

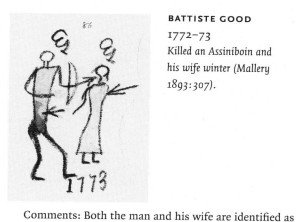

BATTISTE GOOD
1772–73
*Killed an Assiniboin and
his wife winter (Mallery
1893:307).*

Comments: Both the man and his wife are identified as Assiniboine.

NO EARS
1772–73
The wood packers killed/Cangin yamni wica ktepi.

Comments: This may refer to some Lakota who were out of the village gathering wood when they were killed by enemies.

ROSEBUD
1772–73
*Medicine Man performs
Yuwipi ceremony.*

Comments: A sacred Yuwipi or conjuring ceremony is indicated by the figure being colored blue and wrapped up, as medicine men are during the ceremony.

BATTISTE GOOD

1773–74
Killed two Pawnee boys while playing winter.

Collector's Notes: A war party of Dakotas surprised two Pawnee (Ree) boys who were wrestling and killed them while they were on the ground (Mallery 1893:307).

NO EARS

1773–74
Dogs also snow blind/Sunka ko ista niyanpi.

Comments: Most likely this was a severe winter with blowing snow which made everyone, including the dogs, blind.

ROSEBUD
1773–74
Carried home a tree.

Comments: This image was originally marked as number 23, but that number was crossed through and changed to number 1. It is not clear why the person who numbered the images made the change. The picture was drawn in line between the years identified here as 1772–73 and 1774–75. It is similar to entries in Cloud Shield for 1777–78 and Battiste Good for 1784–85 in which trees are shown, probably indicating the first time they arrived in the Black Hills.

BATTISTE GOOD

1774–75
Assiniboins made an attack winter.

Collector's Notes: They were cowardly, however, and soon retreated. Perhaps the two arrows of the Assiniboins compared with the one arrow of the attacked Dakotas suggests the cowardice (Mallery 1893:307).

Comments: Good's entry for 1775–76 records the sequel to this event.

NO EARS

1774–75
Masquerader killed/Hokekagela ktepi.

ROSEBUD

1774–75

*"Red Dragonfly"
counted coup with
bow on a Crow.*

Comments: The enemy appears to be a Crow Indian, judging by the hairstyle and red forehead, but he could be a member of another tribe.

AMERICAN HORSE

1775–76

Standing Bull, great-grandfather of the present Standing Bull, discovered the Black Hills.

Collector's Notes: He carried home with him a pine tree of a species he had never seen before. (In this count the Dakotas are usually distinguished by the braided scalp lock and the feather they wear at the crown of the head, or by the manner in which they brush back and tie the hair. It will be noticed that the profile of most of the faces is given, whereas Battiste Good gives the full face. The Dakotas have of late years claimed the Black Hills, probably by right of discovery in 1775–'76; but the Crows were the former possessors.) This is also the first winter of White Cow Killer's count and is called "Two-warriors-killed winter" (Corbusier 1886:130).

Comments: This is the first entry of the American Horse winter count.

BATTISTE GOOD

1775–76

Assiniboins went home and came back mad to make a fresh attack winter.

Collector's Notes: They were brave this time, being thoroughly aroused. They fought with bows and arrows only (Mallery 1893:307).

Comments: This attack was in retaliation for the event Good recorded for the previous year, when they were not as brave.

NO EARS

1775–76

Two who went on a hill were killed/Pahata I nonp wica ktepi.

Comments: This could refer to scouts, who were up on a hill to search for prey or an enemy, or to people who were on a hill to seek a vision.

ROSEBUD

1775–76

Spent winter in no particular place.

Comments: Horses began to appear in a number of winter counts during the 1770s, although Battiste Good recorded them a decade earlier. No Ears recorded the death of a man named Went Home for 1776–77, which the travois for transporting goods might be meant to suggest. However, the year name probably means that they moved their camp several times during the winter.

NO EARS
1776–77
Went-home killed/Kiglela hi.

Comments: Rosebud 1775–76 may record the same event, since the travois suggests a person traveling or going somewhere.

AMERICAN HORSE
1776–77
Horses were killed.

Collector's Notes: Many of their horses were killed by some of their own people, who were jealous because they were fatter than their own (Corbusier 1886:130).

ROSEBUD
1776–77
Many pregnant women died.

Comments: A similar figure appears in several other counts between 1792 and 1800 to mark a year in which many pregnant women died, perhaps from puerperal fever, an infection related to childbirth.

BATTISTE GOOD
1776–77
Killed with war club in his hand winter.

Collector's Notes: A Dakota war club is in the man's hand and an enemy's arrow is entering his body (Mallery 1893:307).

AMERICAN HORSE
1777–78
It was an intensely cold winter, and the Man-who-has-no-skin-on-his-penis froze to death.

Collector's Notes: The sign for snow or winter, i.e., a cloud with snow falling from it, is above his head. A haka-stick, which, in playing that game, they cast after a ring, is

represented in front of him. Battiste Good's record is that a Dakota named Skinned-Penis was killed in a fight with the Pawnees, and his companions left his body where they supposed it would not be found, but the Pawnees found it, and as it was frozen stiff, they dragged it into their camp and played haka with it (Corbusier 1886:131).

Comments: This event is recorded by Good (1778–79), Cloud Shield (1779–80), and No Ears (1780–81).

CLOUD SHIELD
1777–78

A war party brought in the lone pine tree from the enemy's country.

Collector's Notes: They met no enemies while out (Corbusier 1886:131).

Comments: This is the first entry of the Cloud Shield winter count.

BATTISTE GOOD
1777–78

Spent the winter in no particular place winter.

Collector's Notes: They made no permanent camp, but wandered about from place to place (Mallery 1893:307).

Comments: The keeper offers no explanation for this. No Ears marks a related event for 1779–80.

NO EARS
1777–78

Assiniboins came/Hohe ahi.

Comments: The Lakota term Hohe refers to the Assiniboine, who were traditional enemies of the Lakota (Buechel 1970:181, 733).

ROSEBUD
1777–78

"Blue Cloud" takes an enemy scalp and displays it for all to see.

Comments: The figure with a name glyph of a blue patch, perhaps indicating a body of water or a cloud, is displaying an enemy scalp on a long pole, denoting a successful war party.

AMERICAN HORSE
1778–79

The Ponkas came and attacked a village, notwithstanding peace which had just been made.

Collector's Notes: The people [Lakota] repulsed and followed them, killing sixty. Some elk-hair and a feather represent Ponka. Horse tracks are used for horses. Attack is indicated by signs which were said to represent bullet marks, and which convey the idea that the bullet struck. The sign seems to be derived from the gesture-sign for "it struck" (Corbusier 1886:131).

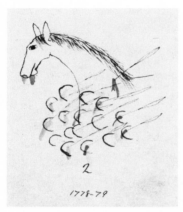

CLOUD SHIELD

1778–79

Many of their horses were killed.

Collector's Notes: Many of their horses were killed, but by whom is not known (Corbusier 1886:131).

Comments: American Horse recorded this event for the year 1776–77.

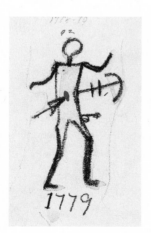

BATTISTE GOOD

1778–79

Skinned Penis used in the game of haka winter.

Collector's Notes: A Dakota named as mentioned was killed in a fight with the Pawnees and his companions left his body where they supposed it would not be found,

but the Pawnees found it and as it was frozen stiff they dragged it into their camp and played haka with it. The haka stick which, in playing the game, they cast after a ring, is represented on the right of the man. This event marks 1777–'78 in the Winter Count of American Horse and 1779–'80 in that of Cloud Shield. The insult and disgrace made it remarkable (Mallery 1893:308).

Comments: This event is also recorded in No Ears (1780–81).

NO EARS

1778–79

Club carrier was killed/Canksa-yuka ktepi.

Comments: The Lakota probably should read *Chanksa-yuha ktepi. Yuha* is a verb meaning "to have or possess."

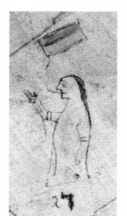

ROSEBUD

1778–79

"Drum" did something important.

Comments: The name glyph appears to be a drum, but alternatively it could be a colored blanket.

AMERICAN HORSE

1779–80

Long-Pine was killed in a fight with the Crows.

BATTISTE GOOD

1779–80

Smallpox used them up winter.

Collector's Notes: The absence of his scalp denotes that he was killed by an enemy. The wound was made with the bow and arrow (Corbusier 1886:131).

Collector's Notes: The eruption and pains in the stomach and bowels are shown as before (Mallery 1893:308).

Comments: The device for pain, as in Good 1734–35, is not used here. Other southern Lakota counts also mark a two-year outbreak of smallpox around 1780–83.

CLOUD SHIELD

1779–80

Skinned His Penis was used in the ring-and-pole game (Corbusier 1886:131).

NO EARS

1779–80

Place of winter camp forgotten/Tukti el wani tipi taninsni.

Comments: This event is recorded by American Horse (1777–78), Battiste Good (1777–78), and No Ears (1780–81).

ROSEBUD

1779–80

"Long Fox" did something important.

Comments: The name glyph appears to be a fox, but another animal of a similar type could be indicated.

AMERICAN HORSE
1780–81
*Many died of small-pox (Corbusier
1886:131).*

Comments: Several other winter counts note smallpox around this time. Many calendars denote smallpox and measles with a full human figure covered by red spots, but American Horse only shows a bust.

BATTISTE GOOD
1780–81
Smallpox used them up again winter.

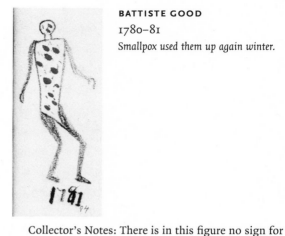

Collector's Notes: There is in this figure no sign for pain but the spots alone are shown. An attempt to discriminate and distinguish the year-devices is perceived (Mallery 1893:308).

CLOUD SHIELD
1780–81
*"The policeman" was killed by the
enemy (Corbusier 1886:131).*

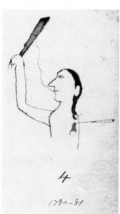

Comments: This pictograph suggests that this person's Lakota name may have been something like Has a Club (*Chanksa Yuha*), a phrase that later came to be used for policeman.

NO EARS
1780–81
Penis' body struck by wand/Slukela haka iwoto.

Comments: Other southern calendars note a similar event: American Horse (1777–78), Battiste Good (1777–78), Cloud Shield (1779–80).

ROSEBUD
1780–81
Stabber froze to death.

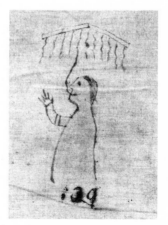

Comments: This entry is similar to ones in American Horse (1777–78, 1782–83, and 1791–92), all indicating

men freezing during a winter storm. The man's name is
obtained from other winter counts.

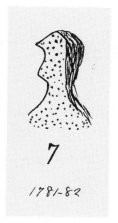

AMERICAN HORSE
1781–82
*Many died of small-pox (Corbusier
1886:131).*

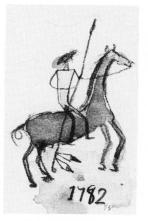

BATTISTE GOOD
1781–82
*Came and attacked on horseback
for the last time winter.*

Collector's Notes: The name of the tribe is not known,
but it is the last time they ever attacked the Dakotas
(Mallery 1893:308).

NO EARS
1781–82
Horses came rushing/Sunka wakan natan ahi.

Comments: It is unclear what is being recorded this
year.

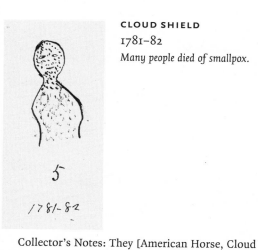

CLOUD SHIELD
1781–82
Many people died of smallpox.

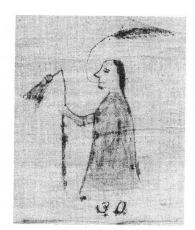

ROSEBUD
1781–82
*"Black Feather" takes
an enemy scalp and
waves it for all to see.*

Collector's Notes: They [American Horse, Cloud
Shield, White Cow Killer, Good] all record two successive
winters of small-pox, but [American Horse] makes the
first year of the epidemic one year later than that of Battiste Good, and [Cloud Shield] makes it two years later
(Corbusier 1886:131).

Comments: This entry is similar to the one for 1777–
78, but the figure carrying the victory pole has a different
name glyph, perhaps representing a feather.

AMERICAN HORSE
1782–83
A Dakota named Stabber froze to death.

Collector's Notes: The sign for winter is the same as before (Corbusier 1886:131).

Comments: The year is marked by an event that happened in the winter, as indicated by the depiction of a cloud with snow falling from it.

BATTISTE GOOD
1782–83
Killed the man with the scarlet blanket on winter.

Collector's Notes: It is not known what tribe killed him (Mallery 1893:309).

Comments: The man was wearing a red blanket; this may have been his name.

CLOUD SHIELD
1782–83
Many people died of smallpox again (Corbusier 1886:131).

NO EARS
1782–83
The measles/Nawicasli.

Comments: On pictographic calendars measles and smallpox are both depicted with red spots on a human figure, but there are distinct Lakota terms for each disease. Measles is *nawicasli*, from the word *nasli* (to swell and form sores, to ooze out), infixed with the word *wica* (human) (Buechel 1970:359, 576). Smallpox is *wicagangan*, again using the word *wica* for "human" and a reduplication of the word *han* or *gan*, which means "scabby" (Buechel 1970:192).

ROSEBUD
1782–83
"Yellow Bird Flying" was shot and killed.

Comments: The streaks emanating from the tail feathers seemingly indicate motion or flying.

AMERICAN HORSE
1783–84
The Mandans and Rees made a charge on a Dakota village.

Collector's Notes: The Dakotas drove them back, killed twenty-five of them, and captured a boy. An eagle's tail, which is worn on the head, stands for Mandan and Ree (Corbusier 1886:131).

CLOUD SHIELD
1783–84
The Stabber froze to death.

Collector's Notes: The man's name is suggested by the spear in the body over his head, which is connected with his mouth by a line (Corbusier 1886:131).

Comments: White Cow Killer calls it "Big-fire winter," possibly because big fires were required to keep them warm during a cold winter (Corbusier 1886:131).

BATTISTE GOOD
1783–84
Soldier froze to death winter.

Collector's Notes: The falling snow and the man's position with his legs drawn up to his abdomen, one hand in an armpit and the other in his mouth, are indicative of intense cold (Mallery 1893:309).

Comments: The crouching figure indicates cold, a device that Good also used to indicate horses that froze to death (1852–53 and 1865–66).

NO EARS

1783–84

Man with a red robe killed/Sina luta inwan ktepi.

Comments: The Lakota could also be translated as "Man wearing a red shirt." *Sina* can be a robe, blanket, or shawl, usually worn around the shoulders. Good marks this event for 1782–83.

ROSEBUD

1783–84

"Big Red Buffalo" was shot and killed.

AMERICAN HORSE

1784–85

A young man with small-pox shot himself.

Collector's Notes: A young man who was afflicted with the small-pox, and was in his tipi, off by himself, sang his death-song and shot himself. Suicide is more common among Indians than is generally suspected, and even boys sometimes take their own lives. A Dakota boy at one of the agencies shot himself rather than face his companions after his mother had whipped him, and a Pai-Ute boy at Camp McDermit, Nevada, tried to poison himself with the wild parsnip because he was not well and strong like the other boys. The Pai-Utes usually eat the wild parsnip when bent on suicide (Corbusier 1886:131–132).

Comments: It is not known whether he shot himself because of pain or some feeling of shame (see Deloria 1988:50).

CLOUD SHIELD

1784–85

An Omaha woman, living with the Oglala, attempted to run away and they killed her.

Collector's Notes: A war between the two tribes was the result (Corbusier 1886:132).

Comments: This event prompted the events Cloud Shield records in the following year.

BATTISTE GOOD

1784–85

The Oglala took the cedar winter.

Collector's Notes: During a great feast an Oglala de-
clared he was wakan and could draw a cedar tree out of
the ground. He had previously fastened the middle of a
stick to the lower end of a cedar with a piece of elastic
ligament from the neck of the buffalo and then planted
the tree with the stick crosswise beneath it. He went to
this tree, dug away a little earth from around it and pulled
it partly out of the ground and let it spring back again,
saying "the cedar I drew from the earth has gone home
again." After he had gone some young men dug up the
tree and exposed the shallow trick (Mallery 1893:309).

Comments: No Ears notes this event for the following
year.

NO EARS
1784–85
A marshal froze/Akicita cuwi ta.

Comments: The Akicita were a type of fraternal society
who policed the camp and were in charge of ensuring
orderly conduct, especially on the hunt and whenever the
camp was moving. These men could mete out punish-
ments for various infractions and unacceptable behavior.
The Lakota term *cuwita* refers to cold or feeling cold but
can only modify living things (Buechel 1970:135). The verb
t'a means "to die" (Buechel 1970:503).

ROSEBUD
1784–85
A wounded Lakota struck a Pawnee enemy.

Comments: This picture of one man striking another
must represent a single year entry, although it was marked

with two separate numbers on the muslin. The enemy
appears to be a Pawnee, judging by the hairstyle with
tufts; however, it could be an Arikara, close relatives of
the Pawnee.

AMERICAN HORSE
1785–86
*Bear's-Ears, a Brulé, was
killed in an Oglala village
by the Crows (Corbusier
1886:132).*

CLOUD SHIELD
1785–86
*The Oglalas killed
three lodges of
Omahas (Corbusier
1886:132).*

Comments: This may have been the result of the kill-
ing of an Omaha woman by the Oglalas the previous year,
as recorded by Cloud Shield. In both entries, the Omaha is
indicated with a red spotted shirt and blue skirt.

BATTISTE GOOD

1785–86

The Cheyennes killed Shadow's father winter.

ROSEBUD

1785–86

"Broken Leg Bird" was killed.

Collector's Notes: The umbrella signifies, shadow; the arrow which touches it, attacked; the three marks under the arrow (not shown in the [original] copy), Cheyenne; the blood-stained arrow in the man's body, killed. Shadow's name and the umbrella in the figure intimate that he was the first Dakota to carry an umbrella. The advantages of the umbrella were soon recognized by them, and the first they obtained from the whites were highly prized. It is now considered an indispensable article in a Sioux outfit. They formerly wore a wreath of green leaves or carried green boughs, to shade them from the sun. The marks used for Cheyenne stand for the scars on their arms or stripes on their sleeves, which also gave rise to the gesture-sign for this tribe (Mallery 1893:309).

Comments: The device of stripes on the sleeves is used to identify Cheyenne in other years as well. No Ears notes this event for 1787–88.

Comments: American Horse records an incident involving a man with a bird name in the following year, while Cloud Shield notes a similar event for 1789–90.

THE FLAME

1786–87

Represents an Uncpapa chief who wore an "iron" shield over his head.

Collector's Notes: It is stated that he was a great warrior, killed by the Rees. This word is abbreviated from the word Arikaree, a corrupt form of Arikara. This year in the Anno Domini style is ascertained by counting back from several well-known historical events corresponding with those on the charts (Mallery 1886:100).

Comments: This is the first entry in The Flame's winter count.

NO EARS

1785–86

Oglalas took a cedar/Oglala kin rante wan icupi.

Comments: This probably refers to the event that Good recorded for 1784–85.

AMERICAN HORSE
1786–87
*Broken-Leg-Duck, an Oglala, went
to a Crow village to steal horses and
was killed.*

Collector's Notes: A line connects the name with the
mouth (Corbusier 1886:132).

Comments: American Horse's entry for 1787–88
records the results of this year's event.

CLOUD SHIELD
1786–87
Long Hair was killed.

Collector's Notes: To what tribe he belonged is not
known (Corbusier 1886:132).

Comments: Several winter counts note a similar event.

BATTISTE GOOD
1786–87
*Iron Head Band killed on war
path winter.*

Collector's Notes: They formerly carried burdens on
their backs, hung from a band passed across the forehead.
This man had a band of iron which is shown on his head.
So said the interpreter [Rev. William J. Cleveland], but
probably the band was not of the metal iron. The word so
translated has a double meaning and is connected with
religious ideas of water, spirit, and the color blue (Mallery
1893:310).

NO EARS
1786–87
Iron ornament killed while scouting/Peici-maza-zuyapktepi.

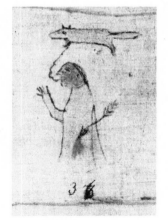

ROSEBUD
1786–87
"Red Fox" was killed.

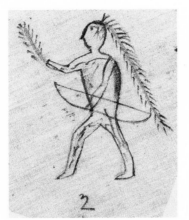

THE FLAME
1787–88
A clown, well known to the Indians; a mischief maker. A Minneconjou.

Collector's Notes: The interpreter could not learn how he was connected to this year. His accoutrements are fantastic. The character is explained by Battiste Good's winter count for the same year (Mallery 1886:100).

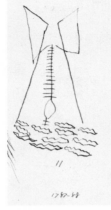

CLOUD SHIELD
1787–88
A year of famine.

Collector's Notes: They lived on roots, which are represented in front of the tipi (Corbusier 1886:132).

Comments: Cloud Shield not only records a lean year but also explains how people dealt with it.

AMERICAN HORSE
1787–88
They went out in search of Crows in order to avenge the death of Broken-Leg-Duck.

Collector's Notes: They did not find any Crows, but chancing on a Mandan village, captured it and killed all the people in it (Corbusier 1886:132).

Comments: American Horse recorded the death of Broken-Leg-Duck for the previous year.

BATTISTE GOOD
1787–88
Left the heyoka man behind winter.

Collector's Notes: A certain man was heyoka—that is, his mind was disordered and he went about the village bedecked with feathers singing to himself, and, while so, joined a war party. On sighting the enemy the party fled, and called to him to turn back also; as he was heyoka, he construed everything that was said to him as meaning the very opposite, and therefore, instead of turning back, he went forward and was killed. If they had only had sense enough to tell him to go on, he would then have run away, but the thoughtless people talked to him just as if he had been in an ordinary condition and of course were respon-

sible for his death. The mental condition of this man and another device for the event are explained by other records (Mallery 1893:310).

Comments: The Lakota word *heyoka* describes a contrarian, one who does everything, including dressing, backward.

NO EARS
1787–88
Shade's father killed by Cheyennes/Chanzi atkuku Saheyela ktepi.

Comments: The Lakota word for Cheyenne is usually spelled Shahiyela. Good notes this event for 1785–86.

ROSEBUD
1787–88
A Heyoka joins a war party and was killed by not turning back.

Comments: Other counts include the figure of a heyoka with a flowing headdress for this year, while Cloud Shield records the death of a man with long hair in the previous winter.

THE FLAME
1788–89
Very severe winter with much suffering among the Indians.

Collector's Notes: Crows were frozen to death, which is a rare occurrence. Hence the figure of the crow. Battiste Good says: "Many crows died winter." Cloud Shield says: The winter was so cold that many crows froze to death. White Cow Killer calls the preceding year, 1787–'88, "Many-black-crows-died winter." For the year 1789–'90, American Horse says: "The cold was so intense that crows froze in the air and dropped dead near the lodges." This is an instance of where three sets of accounts refer to the same severe cold, apparently to three successive years; it may really not have been three successive years, but that all charts referred to the same season, the fractions of years not being regarded (Mallery 1886:100).

AMERICAN HORSE
1788–89
Last-Badger, an Oglala, was killed by the Rees (Corbusier 1886:132).

CLOUD SHIELD
1788–89
The winter was so cold that crows froze to death.

ROSEBUD
1788–89
So cold the crows froze.

BATTISTE GOOD
1788–89
Many crows died winter.

Collector's Notes: Other records for the same year give as the explanation of the figure and the reason for its selection that the crows froze to death because of the intense cold (Mallery 1893:310).

NO EARS
1788–89
Two Masqueraders killed/Heyoka kaga nonp wica ktepi.

Comments: Good and The Flame refer to heyokas for 1787–88.

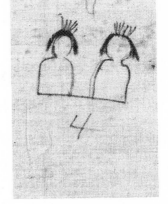

THE FLAME
1789–90
Two Mandans killed by Minneconjous.

Collector's Notes: The peculiar arrangement of the hair distinguishes the tribe. The Mandans were in the last century one of the most numerous and civilized tribes of the Siouan stock. Lewis and Clark, in 1804, say that the Mandans settled forty years before, i.e., 1764, in nine villages, 80 miles below their then site (north of Knife River), seven villages on the west and two on the east side of the Missouri. Two villages, being destroyed by the small-pox and the Dakotas, united and moved up opposite to the Arickaras, who probably occupied the same site as exhibited in the counts for the year 1823–24 (Mallery 1886:101).

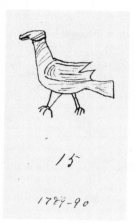

AMERICAN HORSE
1789–90
The cold was so intense that crows froze in the air and dropped dead near the lodges (Corbusier 1886:132).

NO EARS
1789–90
Many crows died/Kangi ota tapi.

Comments: This refers to birds, not the Crow tribe.

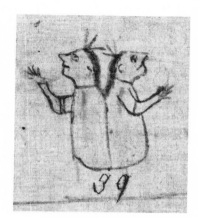

ROSEBUD
1789–90
Two Mandan killed on ice.

CLOUD SHIELD
1789–90
White Goose was killed in an attack made by some enemies.

Comments: The hairstyle indicates the enemy were Mandan, as noted in The Flame.

Collector's Notes: White Cow Killer calls it "Goose-Feather-killed winter" (Corbusier 1886:132).

THE FLAME
1790–91
The first United States flag in the country brought by United States troops.

BATTISTE GOOD
1789–90
Killed two Gros Ventres on the ice winter (Mallery 1893:31).

Collector's Notes: So said the interpreter. No special occasion or expedition is noted. . . . White Cow Killer says "All the Indians see the flag winter" (Mallery 1886:101).

AMERICAN HORSE
1790–91
*They could not hunt on account
of the deep snow.*

Collector's Notes: They could not hunt on account
of the deep snow and were compelled to subsist on any-
thing they could get, as herbs (pézi) and roots (Corbusier
1886:132–133).

Comments: The year 1844–45 is depicted in a similar
manner by The Flame, Lone Dog, and The Swan.

CLOUD SHIELD
1790–91
Picket Pin went against the Cheyennes.

Collector's Notes: A picket-pin is represented in front
of him and is connected with his mouth by the usual line.
The black band across his face denotes that he was brave
and had killed enemies. The cross is the symbol for Chey-
enne. The mark used for Cheyenne stands for the scars on
their arms, or stripes on their sleeves, which also gave rise
to the gesture sign for this tribe, given in Sign Language
among the North American Indians, etc., First Annual
Report of the Bureau of Ethnology, p. 465, viz.: Draw
the extended right index, or the inner edge of the open

right hand, several times across the base of the extended
left index or across the left forearm at different heights
(Corbusier 1886:132).

Comments: See American Horse 1798–99 for a similar
image.

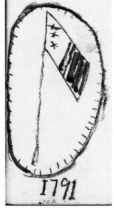

BATTISTE GOOD
1790–91
Carried a flag about with them winter.

Collector's Notes: They went to all the surrounding
tribes with the flag, but for what purpose is unknown
(Mallery 1893:310).

NO EARS
1790–91
*Two Mandans killed on the ice/Miwatani nonp carcokan
wica ktepi.*

Comments: The Flame, Good, and Rosebud note the
killing of two enemies around this time.

ROSEBUD
1790–91
Carried a flag about them.

Comments: Perhaps this was the first time they saw a U.S. flag, or at least owned one.

THE FLAME
1791–92
A Mandan and a Dakota met in the middle of the Missouri.

Collector's Notes: A Mandan and a Dakota met in the middle of the Missouri; each swimming half way across, they shook hands, and made peace. Mulligan, post interpreter at Fort Buford, says that this was at Fort Berthold, and is an historic fact; also that the same Mandan, long afterwards, killed the same Dakota (Mallery 1886:101).

AMERICAN HORSE
1791–92
Glue, an Oglala, froze to death on his way to a Brulé village.

Collector's Notes: A glue-stick is represented back of his head. Glue, made from the hooves of buffalo, is used to fasten arrow-heads on, and is carried about on sticks (Corbusier 1886:133).

Comments: Cloud Shield marks the death of a man with this name in 1820–21.

CLOUD SHIELD
1791–92
The Dakotas and Omahas made peace (Corbusier 1886:133).

Comments: The Omaha are depicted wearing red shirts.

BATTISTE GOOD
1791–92
Saw a white woman winter.

Collector's Notes: The dress of the woman indicates that she was not an Indian. This is obviously noted as being the first occasion when the Dakotas, or at least the bands which this record concerns, saw a white woman (Mallery 1893:311).

NO EARS
1791–92
They carried an emblem everywhere/Wowapi wan makokawin yuka yayapi.

Comments: The word *wowapi* can refer to a number of two-dimensional objects that are marked or decorated,

including flags and banners, as well as books, letters, or any piece of paper with writing on it. The name of this year refers to an American flag.

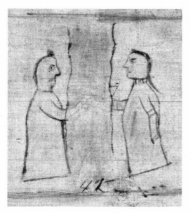

ROSEBUD
1791–92
Made peace with the Mandan.

Comments: They probably made peace with the Mandan, as indicated in some winter counts, but it could have been with another tribe.

AMERICAN HORSE
1792–93
Many women died in childbirth.

Comments: Many calendars mark a similar event as occurring in other years. Cloud Shield and Good note it for 1798–99, the year White Cow Killer calls "Many-squaws-died winter" (Corbusier 1886:133–34). The Rosebud count marks this event for 1776–77, No Ears for 1799–1800. This may have been an epidemic of puerperal fever (see Mallery 1893:312).

THE FLAME
1792–93
Dakotas and Rees meet in camp together, and are at peace.

Collector's Notes: The two styles of dwellings, viz., the tipi of the Dakotas, and the earth lodge of the Arickaras, are apparently depicted (Mallery 1886:101).

Comments: White Cow Killer calls it "Rees house winter" (Corbusier 1886:133).

CLOUD SHIELD
1792–93
The Dakotas camped on the Missouri River near the Gros Ventres and fought with them a long time.

Collector's Notes: The Dakota tipi and the Gros Ventre lodge are shown in the figure (Corbusier 1886:133).

Comments: Although both Cloud Shield and White Cow Killer note an enemy tribe, they do not agree on who it was. Note that this lodge looks quite different from the adobe building pictured by Cloud Shield for 1871–72.

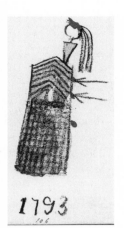

BATTISTE GOOD

1792–93

Camped near the Gros Ventres winter.

Collector's Notes: They were engaged in a constant warfare during this time. A Gros Ventre dirt lodge, with the entrance in front, is depicted in the figure and on its roof is a Gros Ventre head (Mallery 1893:311).

Comments: This house looks like the ones pictured by Good for the years 1815–16 and 1816–17.

NO EARS

1792–93

They saw a white woman / Winyan wan ska wayankapi.

Comments: It is unclear whether this phrase refers to a Caucasian woman or to a spirit woman who appeared to be white in color. The typical word for a Caucasian is *wasicun*. According to Mallery (1893:311), looking at the pictographs does not settle the matter.

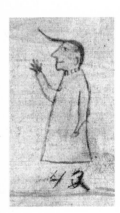

ROSEBUD

1792–93

Man with long forelock did something.

Comments: Some winter counts not in this collection say that a man named Long Forelock was killed this year.

THE FLAME

1793–94

Thin Face, a noted Dakota chief, was killed by Rees.

Collector's Notes: White Cow Killer says "Little Face killed winter." Battiste Good says in his count for the succeeding year, 1794–95, "Killed little face Pawnee winter" (Mallery 1886:101–102).

AMERICAN HORSE

1793–94

A Ponka, captured as a child by the Oglalas, was killed.

Collector's Notes: A Ponka who was captured when a boy by the Oglalas was killed while outside the village by a war party of Ponkas (Corbusier 1886:133).

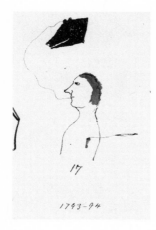

CLOUD SHIELD
1793–94
Bear's Ears was killed in a fight with the Rees (Corbusier 1886:133).

NO EARS
1793–94
A truce with the Mandans/Miwatani awicatipi.

Comments: The Lakota phrase means literally "Mandans we camped with them." The pictograph for Rosebud 1791–92 also suggests making peace with an enemy.

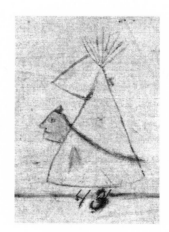

ROSEBUD
1793–94
Killed a man with long hair.

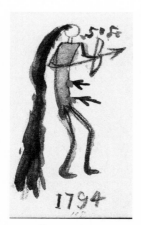

BATTISTE GOOD
1793–94
Killed a long-haired man at Rawhide Butte winter.

THE FLAME
1794–95
A Mandan chief killed a noted Dakota chief with remarkably long hair and took his scalp.

Collector's Notes: The Dakotas attacked a village of 58 lodges and killed every soul in it. After the fight they found the body of a man whose hair was done up with deerhide in large rolls, and, on cutting them open, found it was all real hair, very thick, and as long as a lodgepole. {Mem. Catlin tells of a Crow called Long Hair whose hair, by actual measurement, was 10 feet and 7 inches long.} The fight was at Rawhide Butte (now so called by the whites), which the Dakotas named Buffalo-Hide butte, because they found so many buffalo hides in the lodges (Mallery 1893:311).

Comments: Various winter counts note the killing of a long-haired enemy in the years between 1794 and 1797. See Cloud Shield (1786–87), Rosebud (1792–93 and 1793–94), Flame (1794–95), White Cow Killer (1794–95), No Ears (1795–96), and American Horse (1796–97).

Collector's Notes: White Cow Killer calls it "Long Hair killed winter" (Mallery 1886:102).

AMERICAN HORSE

1794–95

The-Good-White-Man came with two other white men.

Collector's Notes: He promised that if they would let him and his companions go undisturbed he would return and bring with him weapons with which they could kill game with but little labor. They gave them buffalo robes and dogs to pack them on and sent the party off. The sign for white man is a hat, either by itself or on a head, and the gesture-sign indicates one who wears a hat. Draw the open right hand horizontally from left to right across the forehead a little above the eyebrows, the back of the hand to be upward and the fingers pointing toward the left, or draw the index across the forehead in the same manner (Corbusier 1886:133).

Comments: Several counts note the coming of white men during the 1790s and early 1800s: American Horse (1799–1800), Long Soldier (1799–1800), Good (1800–01), Cloud Shield (1801–02), Rosebud (1801–02), and No Ears (1802–03).

CLOUD SHIELD

1794–95

Bad Face, a Dakota, was shot in the face.

BATTISTE GOOD

1794–95

Killed the little-faced Pawnee winter.

Collector's Notes: The Pawnee's face was long, flat, and narrow, like a man's hand, but he had the body of a large man (Mallery 1893:311).

Comments: The Flame and White Cow Killer place this event in 1793–94.

NO EARS

1794–95

Man with a little face killed/Ite ciqa wan ktepi.

Comments: The man may have been named Little Face.

ROSEBUD

1794–95

Camped with earth lodge people.

Comments: Several counts place this event in 1792–93, while Cloud Shield puts it in the following year. It was probably Mandan who formed the camp with the Lakota.

THE FLAME
1795–96
While surrounded by the enemy (Mandans), a Blackfeet Dakota Indian goes at the risk of his life for water for the party.

CLOUD SHIELD
1795–96
The Dakotas camped near the Rees and fought with them.

Collector's Notes: The interpreter [Alex Laravey]★ states that this was near the Cheyenne [River] Agency, Dakota Territory. In the original character there is a bloody wound at the shoulder showing that the heroic Indian was wounded. He is shown bearing a water vessel. Battiste Good gives a figure for this year recognizably the same as that in The Flame's chart, but with a different explanation (Mallery 1886:102).

Comments: White Cow Killer calls it "Water-Stomach-killed winter" (Corbusier 1886:133).

Comments: The Rees are depicted with a lodge, as opposed to a tipi like the Lakota. This lodge looks quite different from the adobe building pictured by Cloud Shield for 1871–72.

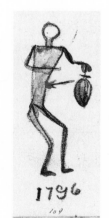

BATTISTE GOOD
1795–96
The Rees stood the frozen man up with the buffalo stomach in his hand winter.

AMERICAN HORSE
1795–96
The-Man-Who-Owns-the-Flute was killed by the Cheyennes.

Collector's Notes: His flute is represented in front of him with sounds coming from it. A bullet mark is on his neck (Corbusier 1886:133).

★This name is spelled different ways in various sources: Laravey, Larvey, and Larrabee. Mallery usually gives it as Lavary.

Collector's Notes: The body of a Dakota who had been killed in an encounter with the Rees (Pawnees), and had been left behind, froze. The Rees dragged it into their village, propped it up with a stick, and hung a buffalo stomach filled with ice on one hand to make sport of it. The buffalo stomach was in common use at that time as a water-jug (Mallery 1886:102; also 1893:312).

NO EARS
1795–96

Man with very long hair killed/Pehin hanskaska wan ktepi.

Comments: The Lakota word for long or tall is *hanska;* when it is reduplicated *hanskaska,* this means either that something was really long or tall or that many things were long or tall. See comments on Good 1793–94 for related references.

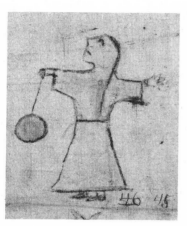

ROSEBUD
1795–96

Woman went for water and was wounded.

Comments: Other winter counts record the death of a water carrier but suggest that it was a man. The figure shown here is clearly a woman, with a long skirt and wide sleeves, who was wounded and perhaps died.

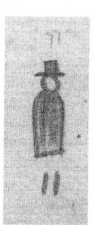

THE FLAME
1796–97

A Mandan chief, "The Man with the Hat," becomes a noted warrior.

Collector's Notes: The character is precisely the same as that often given for white man. Some error in the interpretation is suggested in the absence of knowledge whether there actually was a Mandan chief so named, in which case the pictograph would be consistent (Mallery 1886:102).

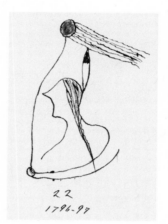

AMERICAN HORSE
1796–97

They killed a long haired man while avenging Flute-Owner's death.

Collector's Notes: They killed the long-haired man in a fight with the Cheyennes while on an expedition to avenge the death of The-Man-Who-Owns-the-Flute, who was killed by Cheyennes the year before (Corbusier 1886:133).

Comments: This event was in response to the event recorded by American Horse for the previous year. Note the scalp lock above the man's head. Scalps were taken from enemies and stretched onto small hoops, often decorated with red paint and beads. Such war trophies were brought out during the performance of a victory dance and song.

CLOUD SHIELD
1796–97
Badger, a Dakota, was killed by enemies, as shown by the absence of his scalp.

Comments: Sometimes a death is indicated by scalping, and other times it is shown by the type of injury sustained, for instance, an arrow or bullet wound.

BATTISTE GOOD
1796–97
Wears The Warbonnet died winter.

Collector's Notes: He did not die this winter, but received a wound in the abdomen from which the arrowhead could not be extracted, and he died of the "belly-ache" years after (Mallery 1893:312). White Cow Killer says: "War Bonnet killed winter." The translated expression, "killed," has been noticed to refer often to a fatal wound, though the death did not take place immediately (Mallery 1886:102).

Comments: Clearly, winter counts were recorded or modified after, perhaps even years after, events occurred.

NO EARS
1796–97
Man standing with a vessel killed/Miniyaya yuka najin wan ktepi.

Comments: This is probably the year they killed someone carrying a water bag, as noted by The Flame for 1795–96.

ROSEBUD
1796–97
Man with the warbonnet killed.

Comments: A red paw or hand above the figure may represent the man's name.

THE FLAME
1797–98
A Ree woman is killed by a Dakota while gathering "pomme blanche," a root used for food.

Collector's Notes: Pomme-blanche, or Navet de prairie, is a white root somewhat similar in appearance to a white turnip, botanically Psoralea esculenta (Nuttal), sometimes P. argophylla. It is a favorite food of the Indians, eaten

boiled down to a sort of mush or hominy. A forked stick is used in gathering these roots. It will be noticed that this simple statement about the death of the Arikara woman is changed by other recorders or interpreters into one of a mythical character (Mallery 1886:102–103).

Comments: Mallery's statement about the event's mythical character refers to the Good and Rosebud counts for 1797–98 and No Ears's entry for 1798–99.

AMERICAN HORSE
1797–98
Little-Beaver and three other white men came to trade.

Collector's Notes: Little Beaver and three other white men came to trade, having been sent by The-Good-White-Man, who had visited years before. Their goods were loaded on three sleds, each drawn by six dogs (Corbusier 1886:133).

CLOUD SHIELD
1797–98
The Wise Man was killed by enemies.

BATTISTE GOOD
1797–98
Took the God Woman captive winter.

Collector's Notes: A Dakota war party captured a woman—tribe unknown—who, in order to gain their respect, cried out, "I am a Wakan Tanka," meaning that she belonged to God, whereupon they let her go unharmed. This is the origin of their name for God (Wakan Tanka, the Great Holy, or Supernatural One). They had never heard of a Supernatural Being before, but had offered their prayers to the sun, the earth, and many other objects, believing they were endowed with spirits. {Those are the remarks of Battiste Good, who is only half correct, being doubtless influenced by missionary teaching. The term is much older and signifies mystic or unknown.} (Mallery 1893:312).

Comments: White Cow Killer calls it "Caught-the-medicine-god-woman winter" (Corbusier 1886:133). The phrase "medicine god woman" seems to be a too-literal translation of Lakota. If the woman was a human, it would probably read something like "Caught [or captured] a holy woman winter." The woman could have been a healer or a religious leader of some type, but perhaps the woman was a spirit, and so the phrase would be something like "Caught a spirit woman winter." The woman is shown wearing a long dress similar to the one Battiste Good pictures for the year 1791–92, although this one is darker.

NO EARS
1797–98
Man with a war bonnet killed/Wapaha keton wan ktepi.

Comments: Good and Rosebud note this event for the previous year.

ROSEBUD
1797–98
Captured a holy woman gathering turnips.

THE FLAME
1798–99
Blackfeet Dakotas kill three Rees (Mallery 1886:103).

LONG SOLDIER
1798–99
The time people lived at mouth of Missouri.

Collector's Notes: Pipe was given to person who was to be chief.

Comments: This is the first entry for the Long Soldier winter count.

AMERICAN HORSE
1798–99
Owns-the-Pole, leader of an Oglala war party, brought home many Cheyenne scalps.

Collector's Notes: The cross stands for Cheyenne (Corbusier 1886:133–134).

Comments: See Cloud Shield 1790–91 for a similar image.

CLOUD SHIELD
1798–99
Many women died in childbirth.

Collector's Notes: [T]he . . . mortality among the women . . . was perhaps an epidemic of puerperal fever (Mallery 1893:312).

White Cow Killer says "Many-squaws-died winter" (Corbusier 1886:133–134).

Comments: Many winter counts note this unusual illness that affected pregnant women; see American Horse 1792–93.

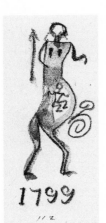

BATTISTE GOOD
1798–99
Many women died in childbirth winter.

Collector's Notes: They died of bellyache. The convoluted sign for pain in the abdominal region has appeared before (Mallery 1893:312).

NO EARS
1798–99
Found a woman the great mystery/Wakan tanka winyan wan eyeyapi.

Comments: A better translation would be "Found a holy/sacred woman." A few winter counts mark the previous year as the year the Lakota captured and released a holy woman; see The Flame's account for 1797–98.

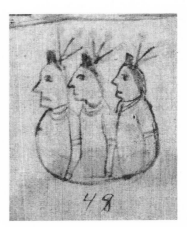

ROSEBUD
1798–99
Killed three Arikara who came in a boat to raid.

Comments: Other winter counts also indicate the enemy were Arikara.

THE FLAME
1799–1800
Uncpapas kill two Rees.

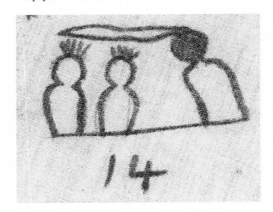

Collector's Notes: The figure over the heads of the
two Rees is a bow, showing the mode of death. The hair
of the Arickaras in this and the preceding character is
represented in the same manner (Mallery 1886:103).

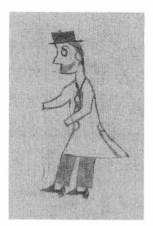

LONG SOLDIER
1799–1800
*The first white man ever seen
and who used iron etc.*

Comments: Many other calendars note encounters
with white men around this time.

AMERICAN HORSE
1799–1800
*The Good-White-Man returned
and gave guns to the Dakotas.*

Collector's Notes: The circle of marks represents the
people sitting around him, the flint lock musket the guns.
White Cow Killer says, "The-Good-White-Man-came
winter" (Corbusier 1886:134).

CLOUD SHIELD
1799–1800
*A woman who had been given
to a white man was killed
because she ran away from him.*

Comments: See American Horse 1804–05 for a similar
event.

BATTISTE GOOD
1799–1800
*Don't Eat Buffalo Heart made a
commemoration of the dead winter.*

Collector's Notes: A buffalo heart is represented above
the man. Don't Eat is expressed by the gesture sign for
negation, a part of which is indicated, and the line con-
necting the heart with his mouth. The red flag which is
used in the ceremony is employed as its symbol. The name
Don't Eat Buffalo Heart refers to the man for whom that
viand is taboo, either by gentile rules or from personal
visions (Mallery 1893:313).

Comments: White Cow Killer calls this year "Don't-
Eat-Heart-makes-a-god-house winter" (Corbusier 1886:
134). This translation should probably read "Don't Eat
Heart made a sacred lodge," referring to a place where
ceremonies were held. No Ears records this event for
1800–01. Good records several other such ceremonies

(1841–42, 1864–65, and 1875–76), depicting each with a figure holding a red flag of some sort. For similar images, see Rosebud 1810–11, 1861–62, and 1883–84, and The Flame 1867–68.

NO EARS
1799–1800
Many pregnant women died/Winyan iklusaka ota tapi.

Comments: American Horse has a similar entry for 1792–93.

ROSEBUD
1799–1800
Charred Face strikes two enemies.

Comments: The White Bull winter count (not in the Smithsonian collections) indicates that the man's name was Charred Face. This is suggested by the coloring used here.

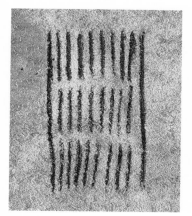

LONE DOG
1800–01
Thirty Dakotas were killed by Crow Indians.

Collector's Notes: The device consists of thirty parallel lines in three columns, the outer lines being united. In this chart, such black lines always signify the death of Dakotas killed by their enemies. The Absaroka or Crow tribe, although belonging to the Siouan [language] family, has nearly always been at war with the Dakotas proper since the whites have had any knowledge of either. They are noted for the extraordinary length of their hair, which frequently distinguishes them in pictographs (Mallery 1893:273).

Comments: This is the first entry for Lone Dog's winter count, which exists in several versions. A similar use of parallel lines appears in several counts for 1805–06, 1863–64, and 1875–76.

THE FLAME
1800–01
Thirty Dakotas were killed by Crow Indians.

Collector's Notes: The device consists of thirty parallel black lines in three columns, the outer lines being united. In this chart, such black lines always signify the death of Dakotas killed by the enemies. . . . Mato Sapa's record has nine inside strokes in three rows, the interpretation being that thirty Dakotas were killed by Gros Ventres between Forts Berthold and Union, Dakota (Mallery 1886:103).

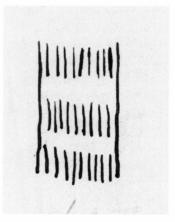

THE SWAN
1800–01
Thirty Dakotas killed by the Gros Ventres Indians between Forts Berthold and Union, Dakota [Territory].

Comments: This is the first entry for The Swan's winter count.

MAJOR BUSH
1800–01
Thirty (30) Sioux's killed by Gros Ventres between Forts Berthold and Union.

Comments: This is the first entry for the Major Bush winter count.

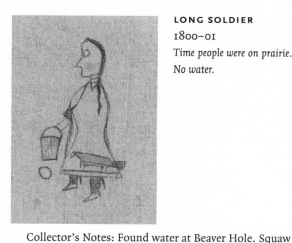

LONG SOLDIER
1800–01
Time people were on prairie. No water.

Collector's Notes: Found water at Beaver Hole. Squaw going to get water.

Comments: Other northern winter counts mention a similar event when there was no water.

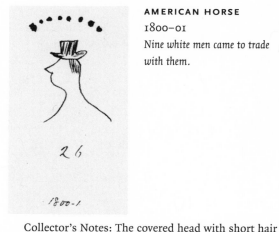

AMERICAN HORSE
1800–01
Nine white men came to trade with them.

Collector's Notes: The covered head with short hair stands for a white man and also intimates that the eight dots over it are for white men. According to this count, the first whites came in 1794–95 (Corbusier 1886:134).

CLOUD SHIELD
1800–01
The Good White Man came.

Collector's Notes: He was the first white man to trade and live with the Dakotas (Corbusier 1886:134).

Comments: American Horse marks this event for 1794–95, while others note it for various years between 1799 and 1802.

BATTISTE GOOD
1800–01
The Good White Man came winter.

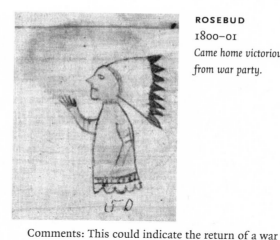

ROSEBUD
1800–01
*Came home victorious
from war party.*

Comments: This could indicate the return of a war party with the chief's hand raised in greeting.

Collector's Notes: Seven white men came in the spring of the year to their village in a starving condition; after feeding them and treating them well, they allowed them to go on their way unmolested. The Dakotas {of the recorder's band} had heard of the whites, but had never seen any before. In the fall some more came, and with them, The Good White Man, who is represented in the figure, and who was the first one to trade with them. They became very fond of him because of his fair dealings with them. The gesture made by his hands is similar to benediction, and suggests a part of the Indian gesture for "good" (Mallery 1893:313).

Comments: Several counts mark the coming of white men about this time. Some identify a man named The Good White Man, and others say that a number of traders came at that time.

LONE DOG
1801–02
Man died of smallpox.

Collector's Notes: The smallpox broke out in the tribe. The device is the head and body of a man covered with red blotches (Mallery 1893:273).

Comments: White Cow Killer calls it "All sick winter" (Mallery 1886:103).

NO EARS
1800–01
One who could not eat a heart made a vow/Tacanta yuta sni wakicaza.

Comments: Good and White Cow Killer mark this event the previous year.

THE FLAME
1801–02
Many died of small-pox.

THE SWAN
1801–02
All the Dakotas had the smallpox very bad; fatal.

MAJOR BUSH
1801–02
Sioux's had the Smallpox, very bad.

LONG SOLDIER
1801–02
Time people had no horses.

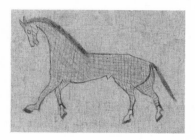

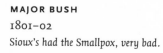

Collector's Notes: This represents first horse that people had.

Comments: Many calendars depict a horse for 1803–04.

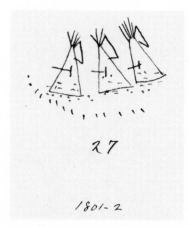

AMERICAN HORSE
1801–02
The Oglalas, Brulés, Minneconjous, Sans Arcs, and Cheyenne united in an expedition against the Crows.

Collector's Notes: They surprised and captured a village of thirty lodges, killed all the men, and took the women and children prisoners. The three tipis stand for thirty; the red spots are for blood (Corbusier 1886:134).

Comments: Other counts record 30 Lakotas killed the previous year.

CLOUD SHIELD
1801–02
A trader brought them their first guns.

Comments: American Horse says it was The Good White Man who brought them guns in 1799–1800. Others note the presence of white men among the Lakota about this time.

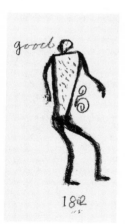

BATTISTE GOOD
1801–02
Smallpox used them up again winter.

Collector's Notes: The man figure is making a part of a common gesture sign for death, which consists substantially in changing the index from a perpendicular to a horizontal position and then pointing to the ground (Mallery 1893:313).

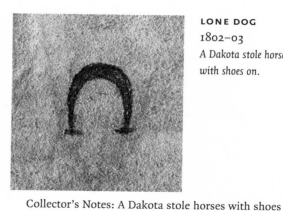

LONE DOG
1802–03
A Dakota stole horses with shoes on.

Collector's Notes: A Dakota stole horses with shoes on, i.e., stole them either directly from the whites or from some other Indians who had before obtained them from whites, as the Indians never shod their horses. The device is a horseshoe (Mallery 1893:273).

Comments: Many calendars mark this event as occurring between 1801 and 1803.

NO EARS
1801–02
Second measles/Nawicasli inonpa.

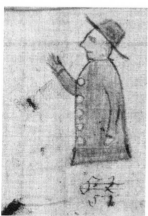

ROSEBUD
1801–02
Good White Man came.

THE FLAME
1802–03
First shod horses seen by Indians.

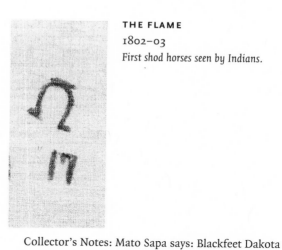

Collector's Notes: Mato Sapa says: Blackfeet Dakota stole American horses with shoes on, then first seen by them. . . . White Cow Killer calls it: "Brought in horseshoes winter" (Mallery 1886:103–104).

Comments: Most winter counts place the appearance of this trader in the previous year.

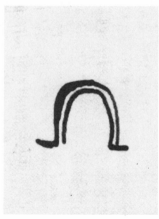

THE SWAN
1802–03
Blackfeet Dakotas stole some American horses having shoes on.

Collector's Notes: Horseshoes were seen for the first time (Mallery 1886:104).

MAJOR BUSH
1802–03
Blackfeet Sioux's stole American horses, the first horses they had ever seen, with shoes on.

LONG SOLDIER
1802–03
The first time saw shoes put on horses by traders.

Collector's Notes: Saw tracks and nail prints. First dead.

Comments: It is unclear what the phrase "first dead" means in this context.

AMERICAN HORSE
1802–03
The Ponkas attacked two lodges of Oglalas, killed some of the people, and made the rest prisoners.

Collector's Notes: The Oglalas went to the Ponka village a short time afterward and took their people from the Ponkas. In the figure an Oglala has a prisoner by the arm leading him away. The arrow indicates that they were ready to fight (Corbusier 1886:134).

CLOUD SHIELD
1802–03
The Omahas made an assault on a Dakota village.

Collector's Notes: Arrows and bullets fly back and forth (Corbusier 1886:134).

Comments: Cloud Shield records a related event for 1804–05.

BATTISTE GOOD
1802–03
Brought home Pawnee horses with iron shoes on winter.

Collector's Notes: The Dakotas had not seen horse-shoes before. This agrees with and explains Lone Dog's Winter Count for the same year (Mallery 1893:313).

Comments: Note the shoes on the horse's hooves. Other counts note this event with a simple horseshoe.

LONE DOG
1803–04
They stole some "curly horses" from the Crows.

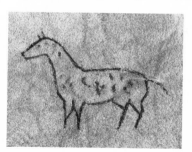

Collector's Notes: Some of these horses are still on the plains, the hair growing in closely curling tufts. The device is a horse with black marks for the tufts. The Crows are known to have been early in the possession of horses (Mallery 1893:273).

Comments: Many counts mark this as the year when they acquired curly-haired horses.

NO EARS
1802–03
Good white man came/Wasicu wan waste hi.

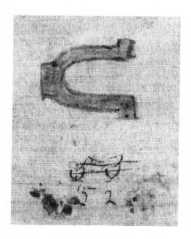

ROSEBUD
1802–03
Brought in shod horses.

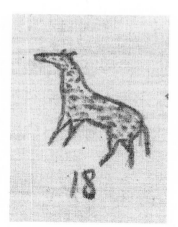

THE FLAME
1803–04
A Blackfeet [Dakota] steals many curly horses from the Assiniboines.

Collector's Notes: Mato Sapa says: Uncpapa stole from the Rees five horses having curly hair (Mallery 1886:104). White Cow Killer calls it "Plenty-of-woolly-horses winter" (Corbusier 1886:134).

THE SWAN
1803–04
Uncpapa stole five woolly horses from the Ree Indians.

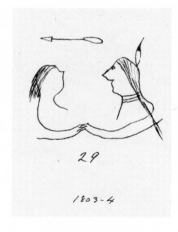

AMERICAN HORSE
1803–04
They made peace with the Gros-Ventres.

MAJOR BUSH
1803–04
Uncpapah Sioux's stole five (5) wooly horses from the Ree's.

LONG SOLDIER
1803–04
Second Chief appointed, grandchild of first chief.

CLOUD SHIELD
1803–04
Little Beaver, a white trader, came (Corbusier 1886:134).

Collector's Notes: First dead. Black Moon chief.

Comments: There are a few details that differ from the first image of a calumet in 1798–99. Here the stem is decorated with hatchmarks. These might have been painted or burned into the wood, or the stem might have been decorated with quill-wrapped strips. Other calendars have a calumet marking the year 1804–05, indicating the people were preparing to go to war. See also No Ears 1805–06 and 1846–47.

Comments: Many counts note the presence of a white man, a trader they call Little Beaver. He appears again a few years later when his trading post burns down (see Cloud Shield 1809–10). Note that even a white man is identified with a name glyph.

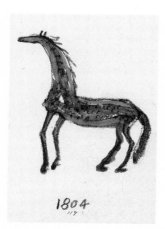

BATTISTE GOOD
1803–04
*Brought home Pawnee
horses with their hair
rough and curly winter.*

LONE DOG
1804–05
*The Dakota had a
calumet dance and
then went to war.*

Collector's Notes: The curly hair is indicated by the curved marks. Lone Dog's Winter Count for the same year records the same incident, but states that the curly horses were stolen from the Crows (Mallery 1893:314).

NO EARS
1803–04
They brought iron claws/Sake maza awicaklipi.

Comments: The phrase *sake maza* literally means "metal (or iron) claws, talons, hooves, or feet." A more accurate translation is "horseshoe." The verb *awicaklipi* means "they brought them back."

ROSEBUD
1803–04
Stole curly haired horses.

Collector's Notes: The device is a long pipe stem, ornamented with feathers and streamers. The feathers are white, with black tips, evidently the tail feathers of the adult golden eagle (Aquila chrysaetos), highly prized by the Plains Indians. The streamers anciently were colored strips of skin or flexible bark; now gayly colored strips of cloth are used. . . . Among the Indian tribes generally the pipe, when presented or offered to a stranger or enemy, was the symbol of peace, yet when used ceremonially by members of the same tribe among themselves was virtually a token of impending war. For further remarks on this point see the year 1842–43 of this Winter Count (Mallery 1893:273–274).

Comments: Several other counts also have a calumet marking a ceremony. Many interpretations say it was in preparation for going to war.

THE FLAME
1804–05
*Calumet dance.
Tall Mandan born.*

THE SWAN
1804–05
Danced calumet dance before going to war.

MAJOR BUSH
1804–05
First danced "the calumet" before going to war.

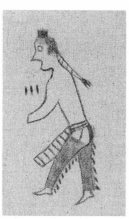

LONG SOLDIER
1804–05
War with Crows.

Collector's Notes: Killed four Crows. Blackhill killed them.

Comments: The three slashes to the left of the Crow indicate the number of other enemies who were killed (the man pictured, plus three others).

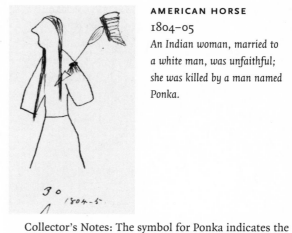

AMERICAN HORSE
1804–05
An Indian woman, married to a white man, was unfaithful; she was killed by a man named Ponka.

Collector's Notes: The symbol for Ponka indicates the name (Corbusier 1886:134).

Comments: A similar event is noted by Cloud Shield for the year 1799–00.

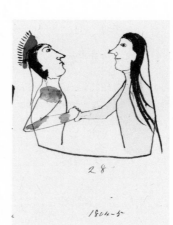

CLOUD SHIELD
1804–05
The Omahas came and made peace to get their people, whom the Dakotas held as prisoners.

Comments: Perhaps the Omaha prisoners were taken in retaliation for the Omaha attack recorded by Cloud Shield for 1802–03.

BATTISTE GOOD
1804–05
Sung over each other while on the warpath winter.

Collector's Notes: A war party while out made a large pipe and sang each other's praises (Mallery 1893:314). A memorandum is also added that the pipe here seems to indicate peace made with some other tribe assisting in the war (Mallery 1886:105).

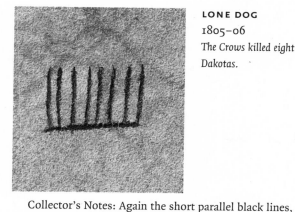

LONE DOG
1805–06
The Crows killed eight Dakotas.

Collector's Notes: Again the short parallel black lines, this time eight in number, united by a long stroke. The interpreter, Fielder, says that this character with black strokes is only used for grave marks (Mallery 1893:274).

Comments: The entry for Lone Dog 1800–01 discusses this type of image.

NO EARS
1804–05
They brought curly horses/Sungugula awicaklipi.

Comments: Many counts mark the year 1803–04 as the year they acquired curly-haired horses.

ROSEBUD
1804–05
Had a calumet dance and went to war winter.

THE FLAME
1805–06
Eight Dakotas killed by Crows.

Collector's Notes: White Cow Killer calls it "Eight Dakotas killed winter." Mato Sapa says: Eight Minneconjous killed by Crows at mouth of Powder River (Mallery 1886:105).

THE SWAN
1805–06
Eight Minneconjou Dakotas killed by Crow Indians at the mouth of Powder River.

MAJOR BUSH
1805–06
Eight (8) Minnicounjou Sioux's killed by the Crow Indians at the mouth of Powder River.

Comments: In this calendar, the Mnicónjou are mentioned far more often than any other band of Lakotas, leading to the conclusion that the Major Bush count refers primarily to events experienced by that band.

LONG SOLDIER
1805–06
Knock off Two killed two Crow Indians.

Comments: The Crows were riding together on a horse. Both were killed, so from then on, the man who killed them was called Knock Off Two.

AMERICAN HORSE
1805–06
The Dakotas had a council with the whites on the Missouri River, below the Cheyenne Agency, near the mouth of Bad Creek.

Collector's Notes: {Lewis and Clark Expedition?} They had many flags, which the Good-White-Man gave them with their guns, and they erected them on poles to show their friendly feelings. The curved line is to represent the council lodge, which they made by opening several tipis and uniting them at their sides to form a semicircle. The marks are for the people. American Horse's father was born this year (Corbusier 1886:134).

Comments: As noted by Corbusier, this may have been a meeting with the Lewis and Clark expedition. White Cow Killer notes the year 1790–91 as "All-the-Indians-see-the-flag winter," while Cloud Shield calls 1807–08 the year when "many people camped together and had many flags flying" (Corbusier 1886:132–133, 135).

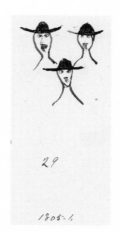

CLOUD SHIELD
1805–06
Nine white men came to trade.

Collector's Notes: The three covered heads represent the white men (Corbusier 1886:135).

Comments: American Horse notes this event as occurring in 1800–01.

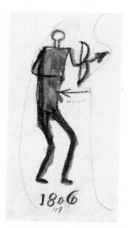

BATTISTE GOOD
1805–06
They came and killed eight winter.

Collector's Notes: The enemy killed eight Dakotas, as shown by the arrow and the eight marks beneath it (Mallery 1893:314).

NO EARS
1805–06
They did a ceremony with horses' tails/Tasinte on akici lowanpi.

Comments: The word *lowanpi* means "to sing or hold a ceremony," usually an honoring ceremony like a naming. This year name may indicate a ceremony using a decorated pipe stem or a calumet decorated with horsehair, as was often used in preparation for going to war.

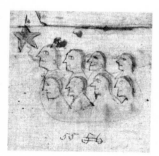

ROSEBUD
1805–06
They came and killed eight Lakota.

Comments: One man is identified by a glyph of a star.

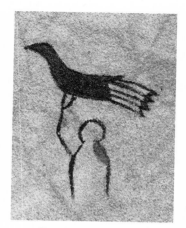

LONE DOG
1806–07
A Dakota killed an Arikara (Ree) as he was about to shoot an eagle.

Collector's Notes: The sign gives the head and shoulders of a man with a red spot of blood on his neck, an arm being extended, with a line drawn to a golden eagle. The drawing represents an Indian in the act of catching an eagle by the legs, as the Arikara were accustomed to catch eagles in their earth traps. These were holes to which the eagles were attracted by baits and in which the Indians were concealed. They rarely or never shot war eagles. The Arikara was shot in his trap just as he put his hand up to grasp the bird (Mallery 1893:274). White Cow Killer calls it "Killed while hunting eagles winter." Mato Sapa says: A Ree hunting eagles from a hole in the ground was killed by Two Kettles (Mallery 1893:105).

Comments: Several calendars mark this event for this year, although No Ears places it in 1807–08. Good marks a similar event for the year 1712–13, in which a Pawnee was killed while trapping eagles (Mallery 1893:296).

THE FLAME
1806–07
Many eagles caught.

Collector's Notes: This is done by digging a hole and baiting the eagles to the hole in which the Indian is concealed, who then catches the eagle (Mallery 1886:105).

THE SWAN
1806–07
A Ree Indian hunting eagles from a hole in the ground killed by the Two Kettles Dakotas.

Comments: The Two Kettle are also known by their Lakota name, O'óhenunpa.

MAJOR BUSH
1806–07
A Ree Indian while hunting eagles, killed by two (2) Kettle Sioux's.

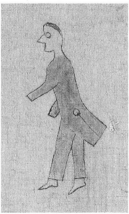

LONG SOLDIER
1806–07
Red Coat had first coat and was called "Red Coat."

Collector's Notes: Got coat from British.
Comments: The Lakota term for Canadians was "Red Coat." Canada was also referred to as "Grandmother's Country" because the Queen of England was "Grandmother." Several other calendars mark 1807–08 as the time they killed someone wearing a red shirt, or perhaps someone named Red Shirt. Also see American Horse 1810–11.

AMERICAN HORSE
1806–07
Black-Rock, a Dakota, was killed by the Crows.

Collector's Notes: A rock is represented above his head. He was killed with a bow and arrow and was scalped (Corbusier 1886:135).
Comments: This man's brother, who had taken his name, was also killed by Crows; see American Horse 1809–10.

CLOUD SHIELD
1806–07
The Dakotas killed an Omaha at night.

Comments: This may be yet another episode in the ongoing warfare between this band of Lakota and the Omaha; see Cloud Shield 1802–03 and 1804–05.

BATTISTE GOOD
1806–07
Killed them while hunting eagles winter.

Collector's Notes: Some Dakota eagle-hunters were killed by enemies (Mallery 1893:314).

NO EARS
1806–07
Eight were killed/Sagilahan ahi wica ktepi.

Comments: The Lakota word for the number eight is *shaglogan.* Other counts also mark this event for the previous year.

ROSEBUD
1806–07
Eagle hunter killed.

LONE DOG
1807–08
Red-Coat, a chief, was killed.

Collector's Notes: The figure shows the red coat pierced by two arrows, with blood dropping from the wounds (Mallery 1893:274).

Comments: Someone wearing a red shirt was killed, or perhaps the person's name was Red Shirt. Several counts record the event for this year.

THE FLAME
1807–08
Red Shirt was killed by Rees.

Collector's Notes: White Cow Killer calls it "Red shirt killed winter." Mato Sapa says: Red-shirt, an Uncpapa Dakota, was killed by Rees (Mallery 1886:104–105).

THE SWAN
1807–08
Uncpapa named Red Shirt, killed by Ree Indians.

AMERICAN HORSE
1807–08
Broken-Leg was killed by the Pawnees.

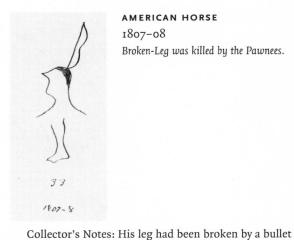

MAJOR BUSH
1807–08
An Unkpapah Sioux named "Red Shirt" killed by Rees Indians.

Collector's Notes: His leg had been broken by a bullet in a previous fight with the Pawnees (Corbusier 1886:135).

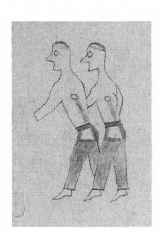

LONG SOLDIER
1807–08
Two Sioux got killed on warpath by Crows.

CLOUD SHIELD
1807–08
Many people camped together and had many flags flying.

Comments: This may mark the time when the Lewis and Clark expedition came through Lakota Territory; see American Horse 1805–06.

BATTISTE GOOD

1807–08

Came and killed man with red shirt on winter.

LONE DOG

1808–09

The Dakota who had killed the Ree shown in this record for 1806–'07 was himself killed by the Rees.

Collector's Notes: Other records say that Red Shirt killed in this year was an Uncpapa Dakota, and that he was killed by Arikaras (Mallery 1893:315).

NO EARS

1807–08

When trapping eagles they were killed/Wambli kuwaneya wica ktepi.

Comments: Several calendars mark this event for the year 1806–07.

ROSEBUD

1807–08

They shot Red Shirt.

Collector's Notes: He is represented running, and shot with two arrows, blood dripping. These two figures, taken in connection, afford a good illustration of the method pursued in the chart, which was not intended to be a continuous history, or even to record the most important event of each year, but to exhibit some one of special peculiarity. There was some incident about the one Ree who was shot when, in fancied security, he was bringing down an eagle, and whose death was avenged by his brethren the second year afterward. It would, indeed, have been impossible to have graphically distinguished the many battles, treaties, horse-stealings, big hunts, etc., so most of them were omitted and other events of greater individuality and better adapted for portrayal were taken for the year count, the criterion being not that they were of historic moment, but that they were of general notoriety, or perhaps of special interest to the recorders (Mallery 1893:274–275).

THE FLAME
1808–09
*Broken Leg (Dakotas)
killed by Rees.*

Collector's Notes: Mato Sapa says: Broken Leg, a Blackfeet Dakota, was killed by Rees (Mallery 1886:106).

LONG SOLDIER
1808–09
*One got killed on hill while
hunting buffalo during famine
while Indians were starving.*

Comments: It is unclear what is behind the figure of the man. It may be some sort of name glyph, or perhaps a cape he wore for a ceremony. Maybe it is simply the hill he was on when he was shot.

THE SWAN
1808–09
*A Blackfeet Dakota,
named Broken Leg,
killed by Ree Indians.*

AMERICAN HORSE
1808–09
*Little-Beaver's trading
house was burned down
(Corbusier 1886:135).*

MAJOR BUSH
1808–09
A Blackfoot Sioux named "Broken Leg" killed by Ree Indians.

Comments: Many other counts mark this event between 1808 and 1810; some specify that the cabin or trading post exploded with gun powder.

CLOUD SHIELD

1808–09

A Brulé was found dead under a tree which had fallen on him.

BATTISTE GOOD

1808–09

Pawnees (Rees) killed Blue Blanket's father winter.

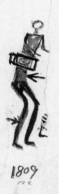

Collector's Notes: A blanket, which in the original record is blue, is represented above the arrow and across the man's body (Mallery 1893:315).

White Cow Killer calls it "Blue-Blanket's-father-dead winter" (Corbusier 1886:135).

Comments: No Ears places this event a year later.

NO EARS

1808–09

Man with red shirt intercepted/Ogle luta onwan itkop ahi ktepi.

Comments: The phrase *itkop ahi ktepi* can be glossed as "again/back again—they came—they killed" or, more freely, "they killed and came back again," referring to

those who had killed the one with the red shirt (see Buechel 1970:240). Many winter counts mark the year 1807–08 as the year someone wearing a red shirt was killed.

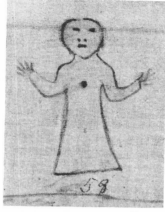

ROSEBUD

1808–09

Red Shirt died.

Comments: This entry is similar to ones for this year in the Blue Thunder and Cranbrook counts, indicating that a scout was killed on the top of a hill. This could be the same man who was shot the previous year.

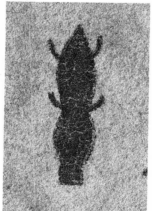

LONE DOG

1809–10

A chief, Little Beaver, set fire to a trading store, and was killed.

Collector's Notes: The character simply designates his name-totem. The other interpretations say that he was a white trapper, but probably he had gained a new name among the Indians (Mallery 1893:275). White Cow Killer says "Little-Beaver's (the white man) house-burned-down winter" (Corbusier 1886:135).

Comments: This is the white trader mentioned by Cloud Shield and others for 1803–04. Sometimes a person's name is indicated by a single pictograph, like here, and other times it is indicated with a name glyph above a human figure. Both methods are used to identify both Indians and whites who were given Indian names. Many other counts mark this event with various name signs. A few calendars, such as this one, use a single beaver, while American Horse (1808–09) shows a beaver and a man's head. Others have the image of a log house (Good 1809–10, Cloud Shield 1809–10), and one depicts a tipi with a beaver inside (Long Soldier 1811–12). No Ears says this happened in 1810–11.

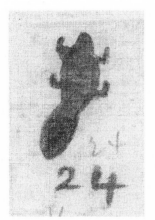

THE FLAME
1809–10
Little Beaver, a white trapper, is burnt to death by accident in his house on the White River.

Collector's Notes: He was liked by Indians (Mallery 1886:106).

THE SWAN
1809–10
White French trader, called Little Beaver, was blown up by powder on the Little Missouri River.

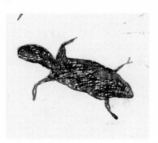

MAJOR BUSH
1809–10
White man called "Little Beaver" blown up by powder on the Little Missouri River.

LONG SOLDIER
1809–10
Caught first horse that Sioux had.

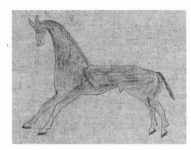

Comments: Other counts record the capture of horses between 1810 and 1812. Some accounts specify that one of the horses, or possibly more than one, had its tail decorated with feathers.

AMERICAN HORSE
1809–10
Black-Rock was killed by the Crows.

Collector's Notes: His brother, whose name he had taken, was killed by the Crows three years before (Corbusier 1886:135).

Comments: See American Horse 1806–07 and The Flame 1810–11 for related entries.

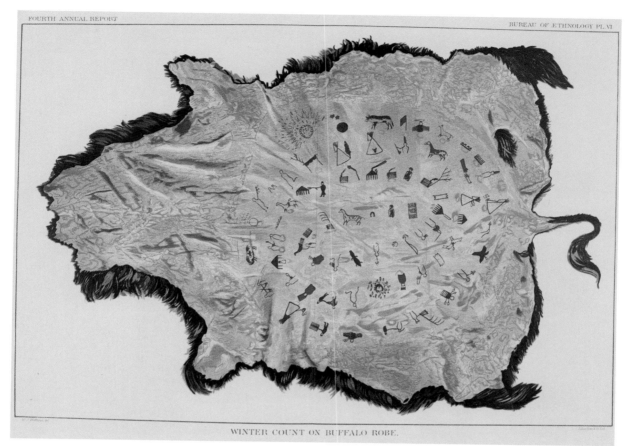

WINTER COUNT ON BUFFALO ROBE.

1. *The Lone Dog winter count as published in the* Fourth Annual Report of the Bureau of American Ethnology *(1886). This was an artist's reconstruction, made by projecting a photographic image of the muslin version (Figure 2.1) onto a drawing of a buffalo hide and tracing over the figures. National Anthropological Archives, Smithsonian Institution.*

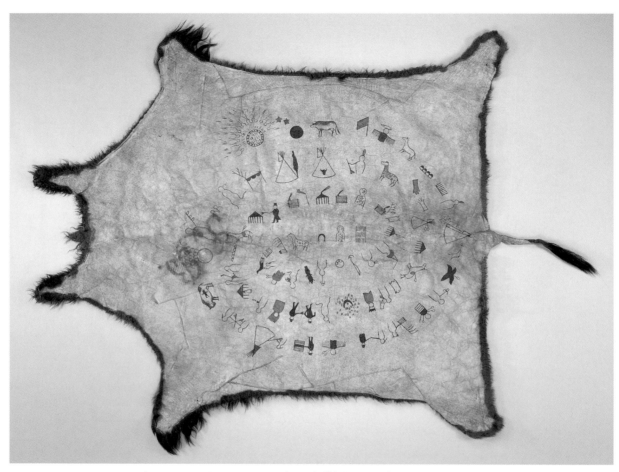

2. The Lone Dog winter count painted on a buffalo hide. The figures and their placement are almost identical to the published version (Color Plate 1) and may be based on it. Individual pictographs from this version appear in chapter 4. Courtesy National Museum of the American Indian, Smithsonian Institution (NMAI 1/0617).

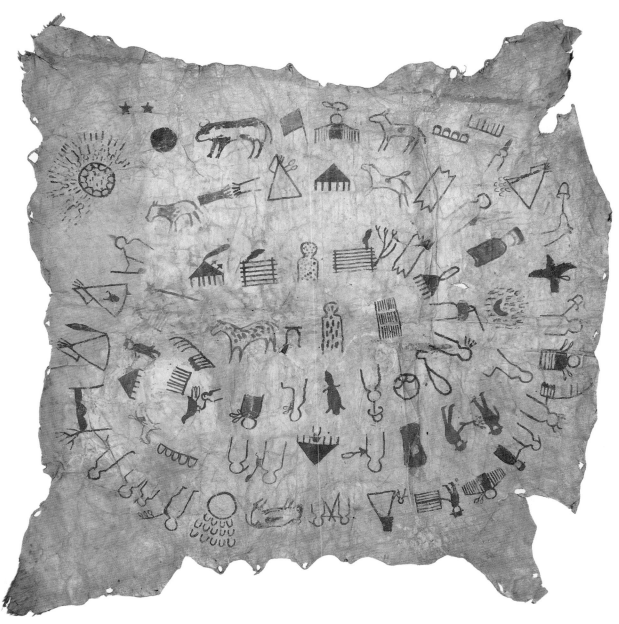

3. The Lone Dog winter count painted on cowhide. It has the same figures as other versions of the Lone Dog count illustrated here, but appears to have been drawn by a different hand. Courtesy National Museum of the American Indian, Smithsonian Institution (NMAI 21/8701).

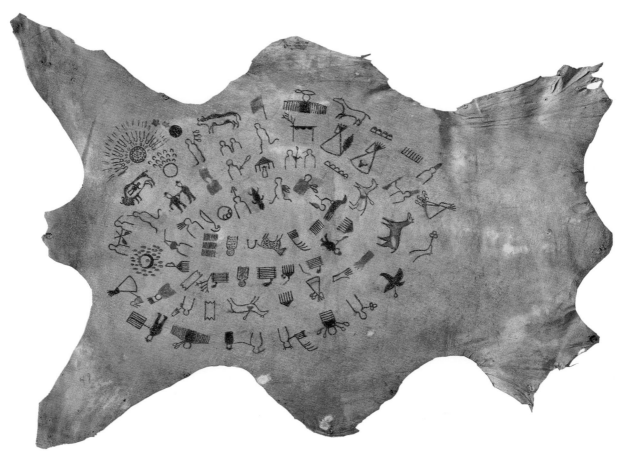

4. The Lone Dog winter count painted on deer hide. This version has the same figures as other Lone Dog copies, but with some changes in detail. Note that the buffalo head glyphs connected to two figures on the lower right have been transformed into amorphous three-lobed forms. Courtesy National Museum of the American Indian, Smithsonian Institution (NMAI 23/0246).

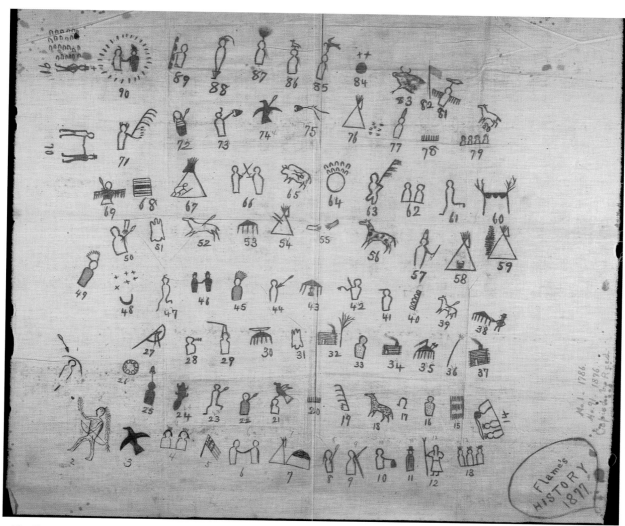

5. The Flame winter count drawn on a square of muslin. Pictographs from this version were published by Mallery in the Fourth Annual Report of the Bureau of American Ethnology (1886). Individual pictographs from this version appear in chapter 4. National Anthropological Archives, Smithsonian Institution (NAA Ms. 2372, 08633800).

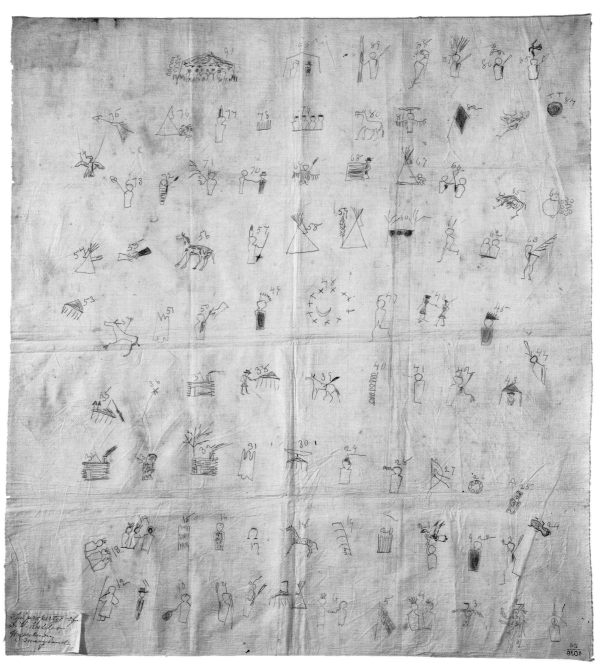

6. *Another version of The Flame winter count drawn on muslin. Although sketchily drawn, many of the figures are more detailed than those on the NAA copy of this count. Courtesy National Museum of the American Indian, Smithsonian Institution (NMAI 24/4039).*

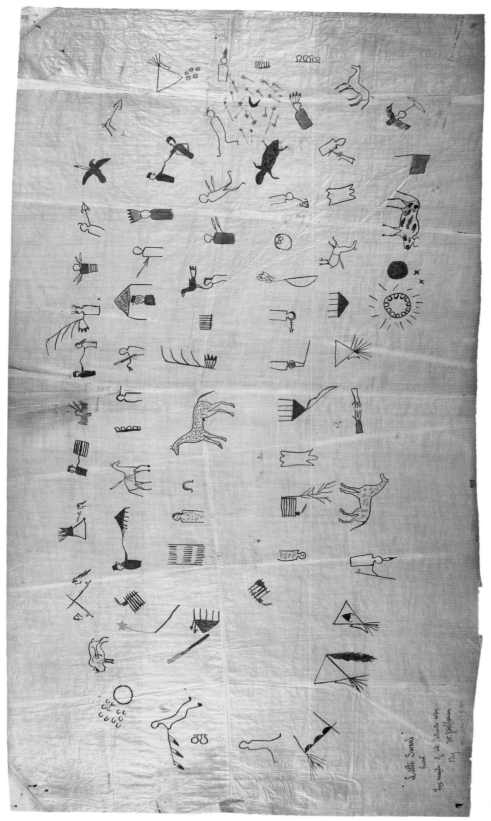

7. The Swan winter count drawn on architect's linen. Individual pictographs from this version appear in chapter 4. National Anthropological Archives, Smithsonian Institution (NAA Ms. 2372, 08633900).

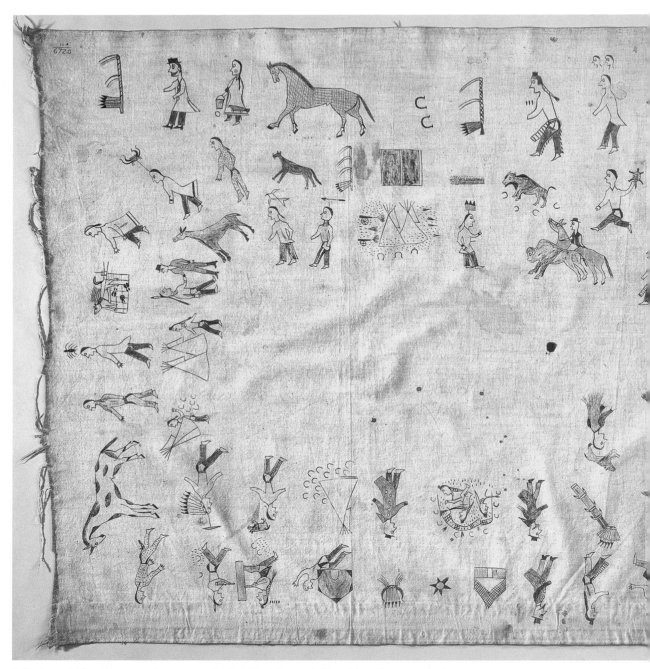

8. The Long Soldier winter count drawn on muslin. Individual pictographs from this version appear in chapter 4.
Courtesy National Museum of the American Indian, Smithsonian Institution (NMAI 11/6720).

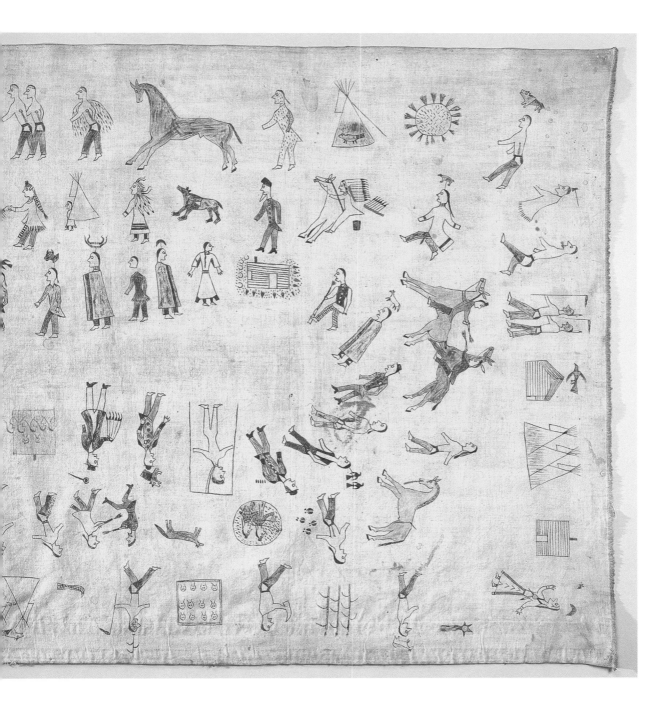

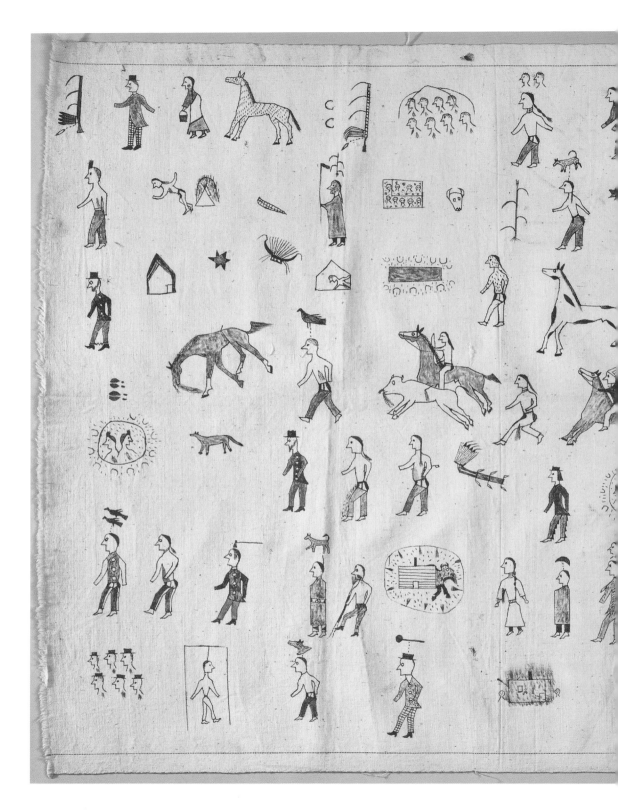

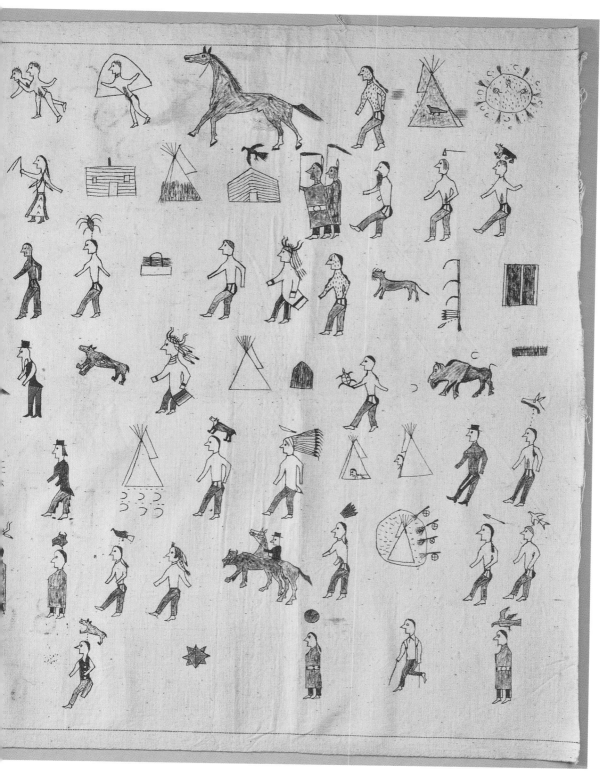

9. This winter count by an unknown keeper is very similar to the Long Soldier calendar (Color Plate 8) in both content and style of drawing. Courtesy National Museum of the American Indian, Smithsonian Institution (NMAI 12/2166).

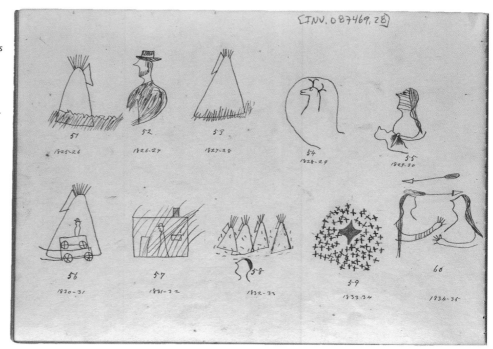

10. *Page from the American Horse winter count, covering the years 1825 to 1835, including The Year the Stars Fell. Individual pictographs from this version appear in chapter 4. National Anthropological Archives, Smithsonian Institution (NAA Ms. 2372, 08746928).*

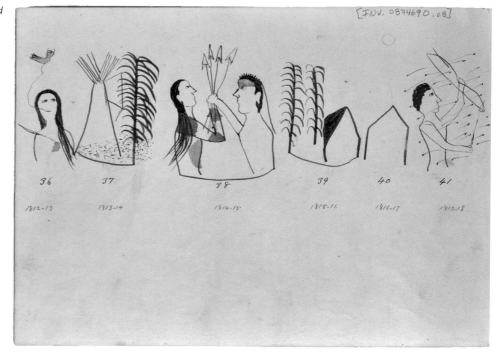

11. *Page from the Cloud Shield winter count, covering the years 1812 to 1818. Individual pictographs from this version appear in chapter 4. National Anthropological Archives, Smithsonian Institution (NAA Ms. 2372, 08746908).*

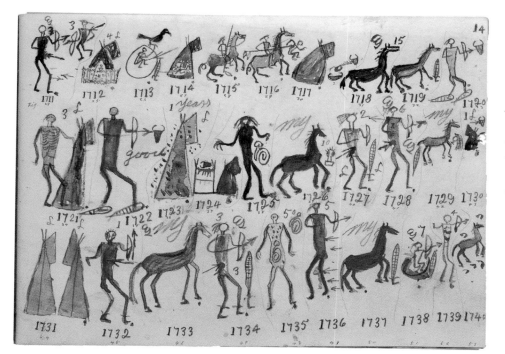

12. Page from the Battiste Good winter count, covering the years 1711 to 1740. Individual pictographs from this book appear in chapter 4. National Anthropological Archives, Smithsonian Institution (NAA Ms. 2372, 08746806).

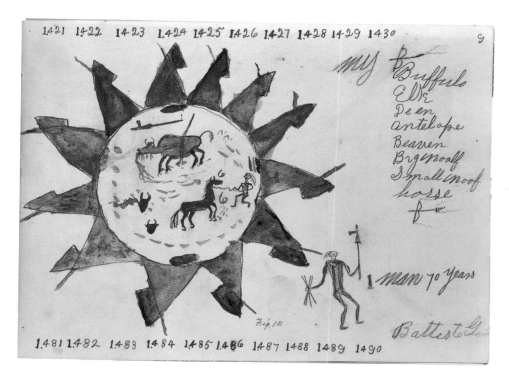

13. Page from the generational section of the Battiste Good winter count, covering the years 1421 to 1490. Individual pages from this section of the calendar appear at the end of chapter 4 (NAA Ms. 2372, 08746811).

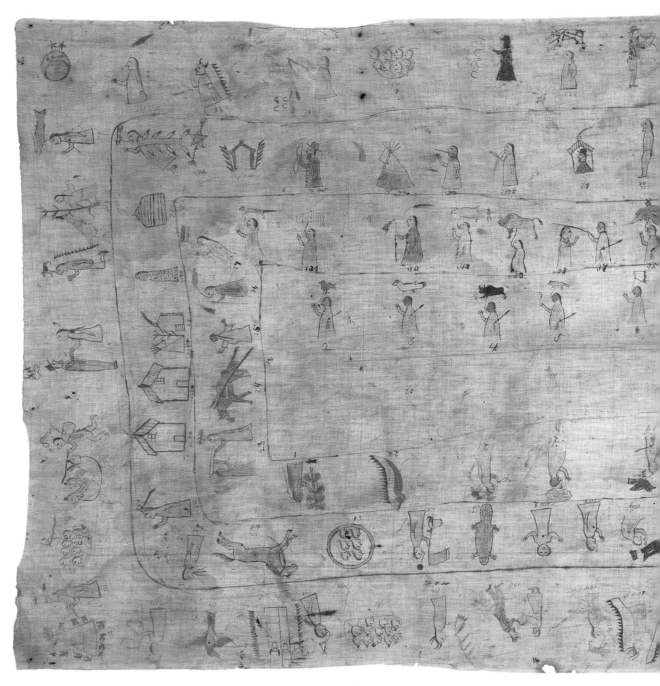

14. The Rosebud winter count drawn on a length of muslin. Individual pictographs from this calendar appear in chapter 4. National Anthropological Archives, Smithsonian Institution (NAA Ms. 2001–10).

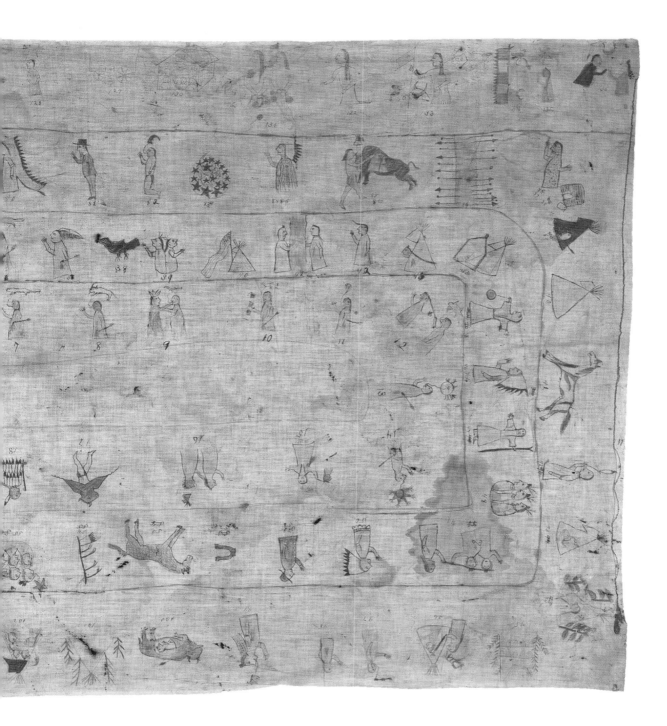

CLOUD SHIELD
1809–10
Little Beaver's house was burned.

ROSEBUD
1809–10
Little Beaver's trading post burned down.

BATTISTE GOOD
1809–10
Little Beaver's house burned winter.

LONE DOG
1810–11
Black-Stone made medicine.

Comments: Note the difference between the depiction of this structure, a log house or trading post, and the Gros Ventre earth lodge for the year 1792–93.

NO EARS
1809–10
Blue-Blanket's father killed by a Ree/Sina-to atkuku Palani ahi ktepi.

Comments: It is unclear whether the enemy was an Arikara or a Pawnee. Good notes this event for the previous year.

Collector's Notes: The expression medicine is too common to be successfully eliminated, though it is altogether misleading. The "medicine men" have no connection with therapeutics, feel no pulses, and administer no drugs, or, if sometimes they direct the internal or external use of some secret preparation, it is as a part of superstitious ceremonies, and with main reliance upon those ceremonies. Their incantations are not only to drive away disease, but for many other purposes, such as to obtain success in war, avert calamity, and were very frequently used to bring within reach the buffalo, on which the Dakotas depended for food. . . . In the ceremonial of "making medicine," a buffalo head, and especially the head of an albino buffalo, held a prominent place among the plains tribes. . . . The device in the chart is the man

figure, with the head of an albino buffalo held over his own (Mallery 1893:275).

Comments: The Swan, Major Bush, and Rosebud counts represent Black Rock making medicine, while The Flame and American Horse (1809–10) refer to the man's death.

MAJOR BUSH
1810–11
Minniconjou Sioux named "Little Tail" first made medicine with white Buffalo cow-skins.

LONG SOLDIER
1810–11
Smallpox year when a great many died.

THE FLAME
1810–11
Black Rock, a Minneconjou chief, killed.

Comments: None of the other calendars in the Smithsonian collections record an outbreak of disease at this time.

THE SWAN
1810–11
A Minneconjou Dakota, named Little Tail, first made "medicine" with a white buffalo cow-skin.

AMERICAN HORSE
1810–11
Red-Shirt, a Dakota, was killed by the Crows.

Collector's Notes: Mato Sapa says: A Minneconjou, named Little Tail, first made medicine with white buffalo cow-skin (Mallery 1886:107).

Collector's Notes: Red Shirt, a Dakota, was killed by the Crows while looking for his ponies near Old Woman's Fork (Corbusier 1886:135).

Comments: Many counts mark 1807–08 as the year someone wearing a red shirt (or perhaps called Red Shirt) was killed.

CLOUD SHIELD
1810–11

They brought in a fine horse with feathers tied to his tail.

Collector's Notes: White Cow Killer calls it "Came-with-medicine-on-horse's-tail winter" (Corbusier 1886: 135).

Comments: The medicine mentioned by White Cow Killer could simply mean that the eagle feathers tied to the horse's tail were sacred or imbued with spiritual power. Many other counts mark the capture of horses between 1810 and 1812.

NO EARS
1810–11

Little Beaver's tipi burned/Capa-ciqa ti ile.

Comments: Several other counts record this event in the previous year, although American Horse places it in 1808–09 and Long Soldier places it in 1811–12.

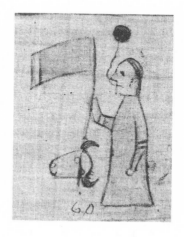

ROSEBUD
1810–11

Black Rock made medicine.

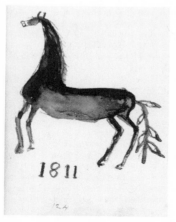

BATTISTE GOOD
1810–11

Brought home horse with his tail braided with eagle feathers winter.

Collector's Notes: They stole a band of horses beyond the South Platte. One of them was very fleet, and had his tail ornamented as described (Mallery 1893:315).

Comments: In this and the following year, Good notes two events that others may have collapsed into a single year.

LONE DOG
1811–12

The Dakota fought a battle with the Gros Ventres and killed a great many.

Collector's Notes: Device, a circle inclosing three round objects with flat bases, resembling heads severed from trunks, which are too minute in this device for decision of objects represented; but they appear more distinct in the record for 1864–'65 as the heads of enemies slain in battle. In the sign language of the plains, the Dakota are denoted by drawing a hand across the throat, signifying that they cut the throats of their enemies. The Dakota count by the fingers, as is common to most peoples, but with a peculiarity of their own. When they have gone

over the fingers and thumbs of both hands, one finger is temporarily turned down for one ten. At the end of the next ten another finger is turned, and so on to a hundred. Opawinge, one hundred, is derived from pawinga, to go around in circles, to make gyrations, and contains the idea that the round of all the fingers has again been made for their respective tens. So the circle is never used for less than one hundred, but sometimes signifies an indefinite number greater than a hundred. The circle, in this instance, therefore, was at first believed to express the killing in battle of many enemies. But the other interpretations removed all symbolic character, leaving the circle simply as the rude drawing of a dirt lodge to which the Gros Ventres were driven. The present writer, by no means devoted to symbolism, had supposed a legitimate symbol to be indicated, which supposition further information on the subject showed to be correct (Mallery 1893:275–276).

THE SWAN
1811–12
Twenty of the Gros Ventres killed by Dakotas in a dirt lodge.

Collector's Notes: They were chased into a deserted Ree dirt lodge and killed there (Mallery 1886:108).

MAJOR BUSH
1811–12
Twenty (20) Gros Ventres killed by Sioux's in a dirt lodge.

THE FLAME
1811–12
Twenty-seven Mandans surrounded and killed by Dakotas.

Collector's Notes: Mato Sapa says: Twenty Gros Ventres killed by Dakotas in a dirt lodge. In this record there is a circle with only one head (Mallery 1886:107–108).

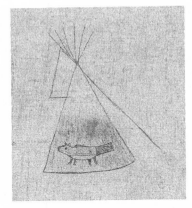

LONG SOLDIER
1811–12
Little Beaver's tent made of buckskin.

Collector's Notes: Burnt in winter.
Comments: Other calendars place this event in the years between 1808 and 1811.

AMERICAN HORSE
1811–12
They caught many wild horses south of the Platte River.

Collector's Notes: White Cow Killer calls it "Catching-wild-horses winter" (Corbusier 1886:135).

CLOUD SHIELD
1811–12
They had very little buffalo meat, as the empty drying pole indicates, but plenty of ducks in the fall.

Comments: Cloud Shield notes the scarcity of food, and how the Lakotas got by. He marks another lean year in 1813–14.

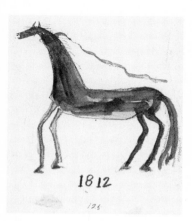

BATTISTE GOOD
1811–12
First hunted horses winter.

Collector's Notes: The Dakotas caught wild horses in the Sand Hills with braided lariats (Mallery 1893:315).

Comments: This notes the first year that they captured horses.

NO EARS
1811–12
They brought beaded tails/Sinte waksupi awicaklipi.

Comments: Several other counts note the capture of wild horses around this time, some specifying that their tails were decorated.

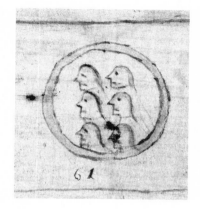

ROSEBUD
1811–12
Killed many enemies in earth lodge.

LONE DOG
1812–13
Wild horses were firt [sic] run and cought [sic] by the Dakotas.

Collector's Notes: The device is a lasso. The date is of value, as showing when the herds of prairie horses, descended from those animals introduced by the Spaniards in Mexico, or those deposited by them to the shores of Texas and at other points, had multiplied so as to extend into the far northern regions. The Dakotas undoubtedly learned the use of the horse and perhaps also that of the lasso from southern tribes, with whom they were in contact; and it is noteworthy that notwithstanding the tenacity with which they generally adhere to ancient customs, in only two generations since they became familiar with the horse they had been so revolutionized in their habits as to be utterly helpless, both in war and the chase, when deprived of that animal (Mallery 1893:276).

MAJOR BUSH
1812–13
Sioux's first made use of a lariat for catching wild horses.

LONG SOLDIER
1812–13
Crows on warpath and Sioux saw them coming so the Crow dug trenches and all 15 were killed.

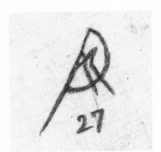

THE FLAME
1812–13
Many wild horses caught.

AMERICAN HORSE
1812–13
Big Waist's father was killed.

THE SWAN
1812–13
Lakotas first used lariat for catching wild horses.

Collector's Notes: White Cow Killer calls this "Big-Belly's-father-killed winter" (Corbusier 1886:135).

CLOUD SHIELD
1812–13
Big Owl killed.

Comments: This unusual image shows the figure with disheveled hair; it is unbraided, with one side in front of his head and the other behind.

BATTISTE GOOD
1812–13
Rees killed Big In The Middle's father winter.

Collector's Notes: Other records call this warrior Big Waist or Big Belly (Mallery 1893:316).

Comments: This figure is portrayed as having a larger stomach than other figures on this count.

NO EARS
1812–13
They killed four Rees/Palani top wica ktepi.

ROSEBUD
1812–13
Caught wild horses with lariats.

LONE DOG
1813–14
The whooping-cough was very prevalent and fatal.

Collector's Notes: The sign is suggestive of a blast of air coughed out by the man figure. The interruption in the cough peculiar to the disease is more clearly delineated in the Winter Count of The Flame for the same year . . . and still better for The Swan's Winter count (Mallery 1893:276).

THE FLAME
1813–14
Many Indians died of cold (consumption) (Mallery 1886:108).

MAJOR BUSH
1813–14
Sioux's had whooping cough, very fatal.

LONG SOLDIER
1813–14
Little Bear had trouble with his wife and left camp and was killed by Crows.

Comments: Most accounts agree that the disease was whooping cough. The discrepancy between diseases may simply be one of translation. Some diseases were new to the Indians, having been brought to North America inadvertently by Europeans. Because these were new illnesses, Indian people had no natural immunity to things like smallpox, measles, cholera, and tuberculosis.

Comments: This event may have been used as an instructive story about proper behavior. Being by oneself outside camp was always a risky situation; dangers included severe weather as well as roving enemies.

THE SWAN
1813–14
Dakotas had whooping cough, very fatal.

AMERICAN HORSE
1813–14
Many had the whooping cough.

Collector's Notes: The interruption of the cough is curiously designed. An attempt at the same thing is made in Chart 1 [The Flame], and a less-marked attempt appears in No. II [Lone Dog] (Mallery 1886:108).

Collector's Notes: The cough is represented by lines issuing from the man's mouth (Corbusier 1886:135).

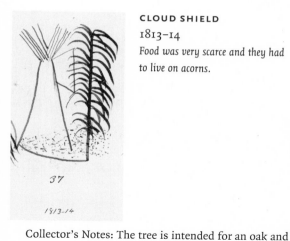

CLOUD SHIELD
1813–14
Food was very scarce and they had to live on acorns.

Collector's Notes: The tree is intended for an oak and the marks beneath it for acorns (Corbusier 1886:135).

Comments: Again Cloud Shield notes the scarcity of food and indicates how people made it through the winter; see his entry for 1811–12.

NO EARS
1813–14
Big Road's father killed by Rees/Canku-tanka atkuku Palani ktepi.

ROSEBUD
1813–14
Whooping cough.

BATTISTE GOOD
1813–14
Killed six Pawnees (Rees) winter.

Collector's Notes: Six strokes are underneath the arrow, but are not shown in this copy (Mallery 1893:316). White Cow Killer calls it "Six Rees Killed winter" (Corbusier 1886:135).

Comments: Rosebud (1811–12) and No Ears (1812–13) record similar, or perhaps the same, events.

LONE DOG
1814–15
A Dakota killed an Arapaho in his lodge.

Collector's Notes: The device represents a tomahawk or battle-ax, the red being blood from the cleft skull (Mallery 1893:276).

Comments: In most other calendars, the victim is identified as a Kiowa (see American Horse). Long Soldier depicts a similar image but gives a different explanation.

THE FLAME
1814–15
*Hunchback, a Brulé,
killed by Utes.*

Comments: Other counts say that a Kiowa was killed by Lakotas.

LONG SOLDIER
1814–15
*"Island" got killed by
Crow's hatchet while
stealing horses from
their camp.*

Comments: Many calendars depict a man being struck in the head with a hatchet for this year; most specify that it was a Kiowa who was killed.

THE SWAN
1814–15
*A Wetapahata
(a stranger Indian,
whose nationality
was not identified
by the interpreter)
Indian killed by
a Brulé Dakota,
while on a visit to
the Dakota.*

Collector's Notes: Mato Sapa says: a Wetopahata Indian was killed by a Brulé Sioux while on a visit to the Dakotas. . . . Riggs [1852] gives Wi-ta-pa-ha, the Kiowas, and Ma-qpi-ya-to, the Arapahos, in the Dakota Dictionary (Mallery 1886:109).

Comments: Buechel (1970:590) says "Witapahatu" can mean either Kiowa or Osage.

MAJOR BUSH
1814–15
*A Watahpahata Indian while on a visit to the Sioux's was killed
by a Brulé Sioux.*

AMERICAN HORSE
1814–15
*Dakotas went to a
Kaiowa village for
a peace council, but
someone clubbed a
Kiowa.*

Collector's Notes: The Dakotas met with Kaiowas (about 6 miles from Scott's Bluff [Nebraska] near the mouth of Horse Creek) to treat for peace; but their intentions were frustrated by one of their number, who drove a hatchet into a Kiowa's head. White Cow Killer calls it "Kaiowa-hit-on-head-with-axe winter." Young-Man's-Horses-Afraid, i.e., whose horses are afraid, was born this year. He is now called "Old-Man-afraid-of-his-Horses" by the whites, and his son, the present chief of the Oglalas, is known as "Young-Man-afraid-of-his-Horses." The present writer [Corbusier] has heard another interpretation about "afraid-of-his-horses," i.e., that the man valued his horses so much that he was afraid

of losing them. The present representative of the name, however, stated to the writer that the true meaning was "The-young-man-whose-horses-they-fear" (Corbusier 1886:135).

NO EARS
1814–15
A Kiowa's skull was crushed/Witapahatu wan kahuhugapi.

CLOUD SHIELD
1814–15
They made peace with the Pawnees.

ROSEBUD
1814–15
Kiowa killed with a hatchet.

Collector's Notes: The man [on the right] with the blue forehead is Pawnee, and the other is Lakota whose body is smeared with clay. The four arrows show that they had been at war, and the clasped hands denote peace (Corbusier 1886:135).

Comments: This image is an interesting change from the usual format in which the Lakota protagonist is pictured on the right of the scene.

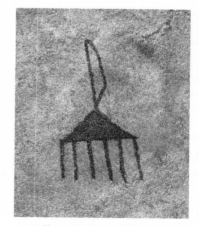

LONE DOG
1815–16
The Sans Arcs made the first attempt at a dirt lodge.

BATTISTE GOOD
1814–15
Smashed a Kiowa's head in winter.

Collector's Notes: The tomahawk with which it was done is sticking in the Kiowa's head (Mallery 1893:316).

Collector's Notes: This was at Peoria Bottom, Dakota. Crow Feather was their chief, which fact, in the absences of the other charts, seemed to explain the fairly drawn feather of that bird protruding from the lodge top, but the figure must now be admitted to be a badly drawn bow, in allusion to the tribe Sans Arc, without, however, any sign of negation. As the interpreter explained the figure to be a crow feather and as Crow Feather actually was the chief, Lone-Dog's chart with its interpretation may be independently correct (Mallery 1893:276–277).

Comments: Several winter counts note the construc-

tion of a log house this year, and most, as here, identify the Sans Arcs, or Itázipčo, as the builders.

THE FLAME
1815–16
Large dirt lodge made by Sans Arcs.

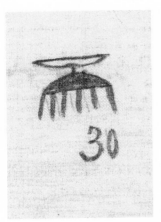

Collector's Notes: The figure at the top of the image is a bow (Mallery 1886:109).

THE SWAN
1815–16
Sans Arc Dakotas built dirt lodges at Peoria Bottom.

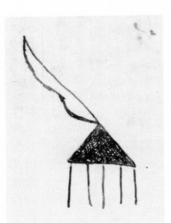

Collector's Notes: A dirt lodge is considered a permanent habitation. The mark on top of the lodge is evidently a strung bow, not a feather. . . . White Cow Killer calls it: "Made a house winter" (Mallery 1886:109).

MAJOR BUSH
1815–16
Sans Arc's Sioux's made dirt lodge at Peoria Bottom D.T. [Dakota Territory].

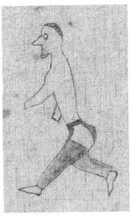

LONG SOLDIER
1815–16
Man got jaw broken while fighting at Crow's camp and trying to steal horses.

Comments: Some other northern winter counts (not in this collection) record this event, a man who was caught stealing having his jaw broken.

AMERICAN HORSE
1815–16
They lived in log houses for the first time.

Collector's Notes: The image represents a white man's house (log cabin) (Corbusier 1886:136).

CLOUD SHIELD
1815–16
Some of the Dakotas built a large house and lived in it during the winter.

ROSEBUD
1815–16
They lived in large wooden houses.

Collector's Notes: White Cow Killer calls it "Made-a-house winter" (Corbusier 1886:136).

Comments: This structure looks quite different from the adobe building that Cloud Shield pictures for 1871–72.

BATTISTE GOOD
1815–16
The Sans Arcs made large houses winter (Mallery 1893:316).

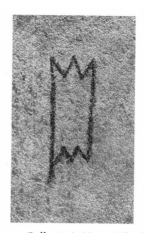

LONE DOG
1816–17
Buffalo belly was plenty.

Collector's Notes: The device rudely portrays a side of buffalo (Mallery 1893:277).

Comments: This image refers to meat being hung to dry, indicating a successful hunt. Winter counts also use a variety of other pictographs to represent years of plenty. Several counts depict pieces of meat hung on drying racks for the year 1845–46, while buffalo tracks next to a tipi are used to indicate plentiful game in Lone Dog 1861–62.

Comments: Good has clearly marked this structure as being made by the Sans Arcs ("No Bows"). This building looks more like the Gros Ventre earth lodge pictured for the year 1792–93 than the log house or trading post pictured for 1809–10 and 1817–18.

NO EARS
1815–16
No Bows [Sans Arcs] lived in a big lodge/Itazipco ti tanka otipi.

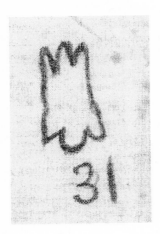

THE FLAME
1816–17
Buffalo very plenty (Mallery 1886:109).

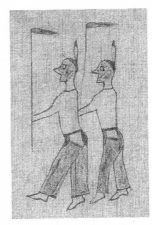

LONG SOLDIER
1816–17
2 Sioux killed 2 Crows and scalped them and blackened their own faces for gladness and came home.

Comments: Among the Sioux, warriors who were successful on the war path or while hunting painted themselves black to indicate victory. These successful warriors are also bringing home scalps on poles.

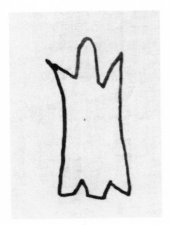

THE SWAN
1816–17
Dakotas had unusual quantities of buffalo (Mallery 1886:109).

AMERICAN HORSE
1816–17
They made peace with the Crows at Pine Bluff.

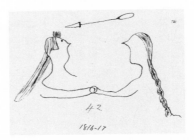

Collector's Notes: The arrow shows that they had been at war (Corbusier 1886:136).

MAJOR BUSH
1816–17
Sioux's had an immense quantity of Buffalo meat.

CLOUD SHIELD
1816–17
They lived in the same house that they did last winter.

Collector's Notes: White Cow Killer calls it "Made a house winter" (Corbusier 1886:136).

Comments: Several counts note the construction and use of these houses.

ROSEBUD
1816–17
They lived in large wooden houses again.

Comments: Several counts note the construction of a building this year. This image suggests a log or frame house rather than an earth lodge.

BATTISTE GOOD
1816–17
Lived again in their large houses winter (Mallery 1893:316).

LONE DOG
1817–18
La Framboise, a Canadian, built a trading store with dry timber.

Collector's Notes: The dryness is shown by the dead tree. La Framboise was an old trader among the Dakota, who once established himself in the Minnesota valley. His name is mentioned by various travelers (Mallery 1893:277).

Comments: Many calendars note the construction of trading posts between 1817 and 1819.

NO EARS
1816–17
Again in this lodge/Ake okitipi.

THE FLAME
1817–18
*Trading store built
at Fort Pierre.*

LONG SOLDIER
1817–18
*Buzzard had a log house
in Ree's camp near Grand
River.*

Collector's Notes: Mato Sapa says: A trading house was built on the Missouri River 10 miles above Fort Thompson [South Dakota] (Mallery 1886:109).

Collector's Notes: Had a lot of property which was distributed.

Comments: According to Indian custom, this person distributed his property among many relatives. It is not clear from the interpretation whether "property" means land or material goods.

THE SWAN
1817–18
*Trading post built
on the Missouri River
10 miles above Fort
Thompson.*

AMERICAN HORSE
1817–18
*The Oglalas had an
abundance of buffalo
meat and shared it with
the Brulés, who were
short of food.*

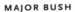

MAJOR BUSH
1817–18
*Trading Post built by Louis Laconte on Missouri river ten (10)
miles above Fort Thompson.*

Collector's Notes: The buffalo hide hung on the drying pole, with the buffalo head above it, indicates an abundance of meat. White Cow Killer calls it "Plenty-of-meat winter" (Corbusier 1886:136).

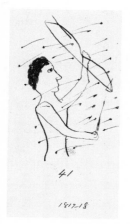

CLOUD SHIELD
1817–18
The Brave-Man was killed in a great fight.

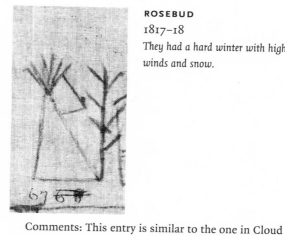

ROSEBUD
1817–18
They had a hard winter with high winds and snow.

Collector's Notes: The fight is shown by the arrows flying to and from him. Having been killed by an enemy, he is scalped (Corbusier 1886:136).

Comments: This entry is similar to the one in Cloud Shield 1813–14, indicating food was scarce and they lived on acorns from trees. The pictograph shows a tipi built among trees for protection.

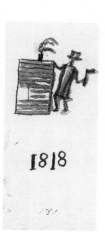

BATTISTE GOOD
1817–18
Choze built a house of dead logs winter.

LONE DOG
1818–19
The measles broke out and many died.

Collector's Notes: The house was for trading purposes. The Frenchman's name is evidently a corruption (Mallery 1893:316).

Comments: It is possible that the name "Choze" is the Lakota approximation of the first name "Joseph." Several winter counts note that this particular post was built of dry or rotten logs.

NO EARS
1817–18
They built tipis of dead branches/Can seca on ticagapi.

Collector's Notes: The device in the copy is the same as that for 1801–02, relating to the smallpox, except a very slight difference in the red blotches; and, though Lone Dog's artistic skill might not have been sufficient to distinctly vary the appearance of the two patients, both diseases being eruptive, still it is one of the few serious defects in the chart that the sign for the two years is so nearly identical that, separated from the continuous record, there would be confusion between them. Treating the document as a mere aide-de-memoire no inconvenience would arise, it probably being well known that the smallpox epidemic preceded that of the measles; but

care is generally taken to make some, however minute, distinction between the characters. It is also to be noticed that the Indian diagnosis makes little distinction between smallpox and measles, so that no important pictograph variation could be expected. The head of this figure is clearly distinguished from that in 1801–02 (Mallery 1893:277).

Comments: The Major Bush, No Ears, and Swan counts agree that this was measles, while Good, Cloud Shield, and White Cow Killer call it smallpox. The Flame says the disease was cholera.

THE FLAME
1818–19
Many Indians died of cholera.

White River, about 20 miles above the Rosebud Agency . . . Cloud Shield says: Many died of the small-pox. White Cow Killer calls it "Little smallpox winter." In Mato Sapa's drawing the head of the figure is distinguished from that of 1801–02 (Mallery 1886:109–110).

MAJOR BUSH
1818–19
Sioux's had measles, very fatal.

LONG SOLDIER
1818–19
Camp in Blackfoot Bottoms.

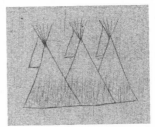

Collector's Notes: No snow. Called sand blowing year.

Comments: Notice the marks on the bottom of the tipis, indicating the blowing sand.

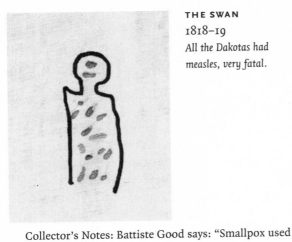

THE SWAN
1818–19
All the Dakotas had measles, very fatal.

AMERICAN HORSE
1818–19
A large house was built (Corbusier 1886:136).

Comments: Several calendars note that a trading post was built in the year 1817–18, followed by another one, made of rotten wood, a year or two later.

Collector's Notes: Battiste Good says: "Smallpox used them up again winter." They at this time lived on the Little

CLOUD SHIELD
1818–19
Many died of smallpox.

Collector's Notes: White Cow Killer calls it "Little-small-pox winter" (Corbusier 1886:136).

Comments: White Cow Killer's designation of this year as "little smallpox winter" distinguishes it from more serious outbreaks in other years.

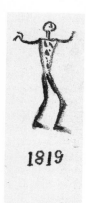

BATTISTE GOOD
1818–19
Smallpox used them up again winter.

Collector's Notes: They at this time lived on the Little White river, about 20 miles above the Rosebud agency. The two fingers held up may mean the second time the fatal epidemic appeared in the particular body of Indians concerned in the record (Mallery 1893:317).

NO EARS
1818–19
Third measles/Nawicasli iyamni.

Comments: No Ears recorded two previous measles episodes, for 1782–83 and 1801–02; he notes a fourth outbreak in 1845–46.

ROSEBUD
1818–19
Trading post built of dead wood.

Comments: This entry is similar to entries for the previous year in several counts.

LONE DOG
1819–20
Another trading store was built, this time by Louis La Conte, at Fort Pierre, Dakota.

Collector's Notes: His timber, as one of the Indians consulted especially mentioned, was rotten (Mallery 1893:277). White Cow Killer calls it "Made a house of old wood winter" (Corbusier 1886:136).

THE FLAME
1819–20
Another trading store built.

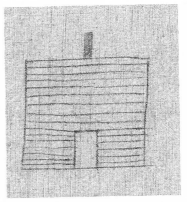

LONG SOLDIER
1819–20
At Good Creek, a man by name of Joseph built a trader's store.

Comments: This could be the man referred to elsewhere as "Choze," perhaps a Lakota pronunciation of "Joseph."

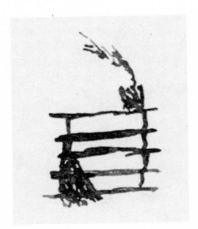

THE SWAN
1819–20
Trading post built on the Missouri River above Farm Island (near Fort Pierre).

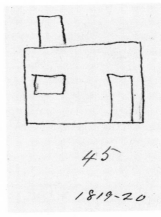

AMERICAN HORSE
1819–20
Another house was built.

Collector's Notes: The Dakotas made medicine in it (Corbusier 1886:136).

MAJOR BUSH
1819–20
Trading Post built on Missouri river near Farm Island.

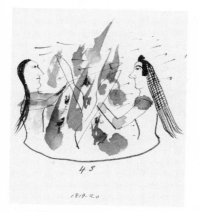

CLOUD SHIELD

1819–20

In an engagement with the Crows, both sides expended all of their arrows, and then threw dirt at each other.

Collector's Notes: A Crow is represented on the right, and is distinguished by the manner in which the hair is worn (Corbusier 1886:136).

BATTISTE GOOD

1819–20

Choze built a house of rotten wood winter.

Collector's Notes: Another trading house was built (Mallery 1893:317).

Comments: The poor quality of the logs is indicated by their yellow color.

NO EARS

1819–20

Joseph built a house of rotten wood/Cauze can punpun on ticage.

Comments: The word *punpun* means "rotten" (Buechel 1970:445). *Ticage* can be translated as "built a house,"

from *ti* (a house or tent) and the verb *kaga*, "to build or make" (Buechel 1970:487).

ROSEBUD

1819–20

Many died of measles or smallpox.

Comments: Several counts record an episode of disease in the previous year.

LONE DOG

1820–21

The trader, La Conte, gave Two Arrow a war dress for his bravery.

Collector's Notes: So translated an interpreter, and the sign shows the two arrows as the warrior's name-totem; likewise the gable of a house, which brings in the trader; also a long strip of black tipped with red streaming from the roof, which possibly may be the piece of parti-colored material out of which the dress was fashioned. This strip is not intended for sparks and smoke, which at first sight was suggested, as in that case the red would have been nearest the roof instead of farthest from it (Mallery 1893:277–278). White Cow Killer calls it "Two arrows made a war bonnet winter" (Corbusier 1886:136).

Comments: Note the difference between this structure and the ones Lone Dog shows for 1817–18 and 1819–20.

THE FLAME

1820–21

Large dirt lodge made by Two Arrow.

Collector's Notes: The projection at the top extends downward from the left, giving the impression of red and black cloth streamers (Mallery 1886:110–111).

Comments: All the interpretations specify that it was a man named Two Arrow, and not the Two Arrow band.

THE SWAN

1820–21

A Minneconjou Dakota, named Two Arrows, built himself a dirt medicine lodge.

Collector's Notes: This the interpreter calls, rather inaccurately, a headquarters for dispensing medicines, charms, and nostrums to the different bands of Dakotas. The black and red lines above the roof are not united and do not touch the roof (Mallery 1886:111).

MAJOR BUSH

1820–21

A Minniconjou Sioux named "two (2) Arrows" made medicine in a dirt lodge.

LONG SOLDIER

1820–21

Dreams of the moon year.

Collector's Notes: Next day had a sun dance.

Comments: This is one of the few winter counts that marks a Sun Dance. These communal feasts of sacrifice and thanksgiving were annual events, including many bands of Lakota who came together for the ceremony and to participate in communal buffalo hunts, arrange marriages, and visit family and friends. Because this was a regular event, it is usually not marked.

AMERICAN HORSE

1820–21

The Dakotas attacked a Crow village.

Collector's Notes: The Dakotas assaulted and took a Crow village of a hundred lodges. They killed many and took many prisoners (Corbusier 1886:136).

CLOUD SHIELD
1820–21

A Dakota, named Glue, froze to death.

Comments: American Horse notes the death of a man named Glue in 1791–92, specifying that he was an Oglala on his way to a Brulé village.

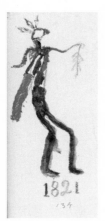

BATTISTE GOOD
1820–21

They made bands of strips of blanket in the winter.

Collector's Notes: The bands were of mixed colors and reached from the shoulders to the heels. They also made rattles of deer's hoofs by tying them to sticks with bead-covered strings. The man has a sash over his shoulders and a rattle in his hand (Mallery 1893:317).

Comments: This type of sash was used by the Miwatani warrior society (Blish 1967:106–107; Densmore 1918:326–329; Wissler 1911).

NO EARS
1820–21

Two Arrows had a magical tipi fastener/Wan nublala wicicaske kicagapi.

Comments: This may be an inaccurate translation of the Lakota. Other calendars note that a man named Two Arrows made sashes or performed some sort of ceremony.

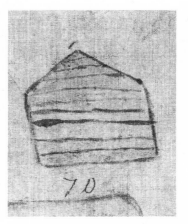

ROSEBUD
1820–21

Another trading post built with dead wood.

Comments: Several counts record this event for the previous year. As there, the wood is colored yellow.

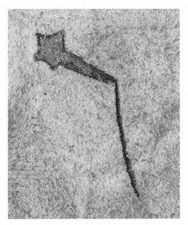

LONE DOG
1821–22

The character represents the falling to earth of a very brilliant meteor.

Comments: Many winter counts mark this astronomical event, mentioning that the comet made a loud roaring noise as it streaked across the sky.

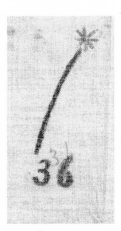

THE FLAME
1821–22
Large ball of fire with hissing noise (aerolite).

Collector's Notes: Red Cloud said he was born in that year. . . . White Cow Killer calls it "One star made a great noise winter" (Mallery 1886:111).

Comments: This event is distinguished from the Leonid meteor shower of 1833 both in imagery and interpretation.

LONG SOLDIER
1821–22
Rock Creek. Time comet fell on the ground with loud noise.

Comments: It is interesting that this keeper notes the location, probably his own community, and says that the meteor fell to the ground. No other calendar indicates this.

THE SWAN
1821–22
Dakota Indians saw an immense meteor passing from the southeast to northwest which exploded with great noise (in Dakota Territory).

MAJOR BUSH
1821–22
Saw very large meteor going S.E. to N.W.

AMERICAN HORSE
1821–22
They had all the mni wakhan (spirit water or whiskey) they could drink.

Collector's Notes: They never had any before. A barrel with a waved or spiral line running from it represents the whiskey, the waved line signifying spirit (Corbusier 1866:136).

Comments: The word *mni* is "water"; *wakhan* means "mysterious, sacred, or holy."

CLOUD SHIELD
1821–22
A large roaring star fell.

Collector's Notes: It came from the east, and shot out sparks of fire along its course. Its track and the sparks are shown in the figure (Corbusier 1886:136).

BATTISTE GOOD
1821–22
Star passed by with loud noise winter.

Collector's Notes: In the figure the meteor, its pathway, and the cloud from which it came are shown (Mallery 1893:317; cf. Corbusier 1886:137).

Comments: This is the year Battiste Good was born.

NO EARS
1821–22
A moving star roared/Wicahpi wan hoton hiyayeci.

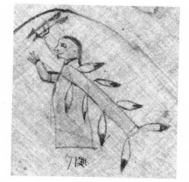

ROSEBUD
1821–22
Two Arrows made medicine in lodge.

Comments: Several counts record this event for the previous year.

LONE DOG
1822–23
Another trading house was built which was by a white man called Big Leggings, and was at the mouth of the Little Missouri or Bad river.

Collector's Notes: The drawing is distinguishable from that for 1819–20 (Mallery 1893:278).

THE FLAME
1822–23
Trading store built at Little Missouri, near Fort Pierre (Mallery 1886:111).

THE SWAN
1822–23

Trading post built at the mouth of Little Missouri River (Mallery 1886:111).

MAJOR BUSH
1822–23

Trading Post built at the mouth of Little Missouri River.

LONG SOLDIER
1822–23

Dog Ghost quarrels with wife and goes away and freezes to death.

AMERICAN HORSE
1822–23

Dog, an Oglala, stole seventy horses from the Crows.

Collector's Notes: Each of the seven tracks stands for ten horses. A lariat, which serves the purpose of a long whip, and is usually allowed to trail on the ground, is shown in the man's hand (Corbusier 1886:137).

CLOUD SHIELD
1822–23

A Brulé, who had left the village the night before, was found dead in the morning.

Collector's Notes: A Brulé, who had left the village the night before, was found dead in the morning, outside the village and the dogs were eating his body. The black spot on the upper part of the thigh shows he was a Brulé (Corbusier 1886:137).

Comments: The man's band affiliation is marked by a black patch on his thigh indicating that he is a Brulé, which is French for "burned." The Lakota term for this band is Sičáŋǧu, which translates as "burnt thighs."

BATTISTE GOOD
1822–23

Peeler froze his leg winter.

Collector's Notes: Peeler was a white trader, and his leg was frozen while he was on his way to or from the Missouri river. The name is explained by White Cow Killer's record as follows: "White-man-peels-the-stick-in-his-hand broke his leg winter." He was probably a Yankee, addicted to whittling (Mallery 1893:317).

NO EARS
1822–23

Pealing [sic] froze his legs/Wakula hu span.

ROSEBUD
1822–23

Moving star made loud noise.

Comments: Several counts record this event for the previous year.

LONE DOG
1823–24

White soldiers made their first appearance in the region.

Collector's Notes: So said the interpreter, [Basil] Clement, but from the unanimous interpretation of others the event portrayed is the attack of the United States forces accompanied by Dakotas upon the Arikara villages. . . . The device represents an Arikara palisaded village and attacking soldiers. Not only the remarkable character and triumphant result of this expedition, but the connection that the Dakotas themselves had with it, made it a natural subject for the year's totem. All the winter counts [in this report] refer to this expedition (Mallery 1893:278). White Cow Killer [says] "Old-corn-plenty winter" (Corbusier 1886:137).

Comments: Many other calendars note this event for this year. Some, as here, depict a white man shooting into an earth lodge. Mallery (1886:111–113) reports that Mato Sapa's calendar showed a human figure with a military cap, beard, and goatee. Other counts use pictures of or references to corn, representing the dried corn that was collected by the Lakota as spoils of the battle. White Cow Killer's reference to "old" corn may be a translation of the Lakota term *sheca*, meaning "dried, dead, or rotten" (Buechel 1970:461).

THE FLAME
1823–24
Whites and Dakotas fight Rees.

THE SWAN
1823–24
United States troops fought Ree Indians.

MAJOR BUSH
1823–24
United States Forces went to fight the Ree Indians.

LONG SOLDIER
1823–24
Rees driven from camp and Sioux and white men feast on corn from their fields.

Comments: Some winter counts have an image of corn or corn stalks for this year, indicating what was left for the Sioux after a combined attack on the Arikara by Gen. Leavenworth and Sioux warriors in 1824. The year is sometimes referred to as the year of much dried corn.

AMERICAN HORSE
1823–24
They had an abundance of corn, which they got at a Ree village (Corbusier 1886:137).

CLOUD SHIELD
1823–24
They joined the whites on an expedition up the Missouri River against the Rees.

BATTISTE GOOD
1823–24
Gen. [Leavenworth] first appeared and the Dakotas aided in an attack on the Rees winter.

Collector's Notes: Also "Much corn winter." The gun and the arrow in contact with the ear of corn show that both whites and Indians fought the Rees. This refers to Gen. Leavenworth's expedition against the Arikara in 1823, when several hundred Dakotas were his allies. This expedition is mentioned several times in this work (Mallery 1893:318).

NO EARS
1823–24
Much corn was bad/Wagummeza seca ota.

Comments: The translation should probably be "There was much bad/dried corn," after the Lakota word *sheca*, meaning "dried, dead, or rotten" (Buechel 1970:461).

ROSEBUD
1823–24
Lived on dried corn.

Comments: Several counts record this event.

LONE DOG
1824–25
Swan, chief of the Two-Kettle tribe, had all of his horses killed.

Collector's Notes: Device, a horse pierced by a lance, blood flowing from the wound (Mallery 1893:278).

THE FLAME
1824–25
All the horses of Little Swan's father are killed by Indians through spite.

Collector's Notes: Mato Sapa says: Swan, a Minneconjou chief, lost twenty horses killed by a jealous Indian. Major Bush says the same (Mallery 1886:113).

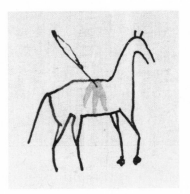

THE SWAN
1824–25
Swan, a Minneconjou Indian, had twenty horses killed by a jealous Indian.

MAJOR BUSH
1824–25
The "Swan" a Minneconjou Sioux had twenty (20) horses killed by a jealous Indian.

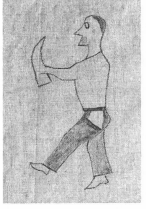

LONG SOLDIER
1824–25
Yellow Ree, a medicine man, painted buffalo horn white to make it snow so they could hunt.

Collector's Notes: It snowed.

Comments: Other winter counts have similar images and explanations about a "calling the buffalo" ceremony (see Rosebud 1825–26), which requires that a buffalo horn be painted white; this is the only count that mentions snow. Some northern winter counts have similar pictographs for 1843–44, marking an event when the Lakota made medicine to bring the buffalo, as indicated by the buffalo head in the tipi.

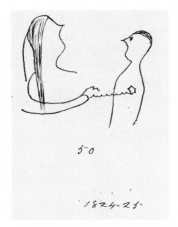

AMERICAN HORSE
1824–25
Cloud-Bear (Dakota) killed another Dakota by throwing a bullet and striking him in the heart.

Collector's Notes: Cloud-Bear, a Dakota, killed a Dakota who was a long distance off, by throwing a bullet from his hand and striking him in the heart. The spiral line is again used for wakan. The gesture-sign for wakan (holy, supernatural) is: With its index-finger extended and pointing upward, or all the fingers extended, back of hand outward nearly to arm's length from left to right (Corbusier 1886:137).

Comments: Cloud Shield and No Ears give other explanations of this event.

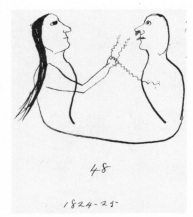

CLOUD SHIELD
1824–25
Cat Owner was killed with a spider web thrown at him by a Dakota.

Collector's Notes: The spider web is shown reaching to his heart from the hand of the man who threw it. The blood issuing from his mouth and nose indicates that he bled to death. It is a common belief among them that certain medicine men possess the power of taking life by shooting needles, straws, spider webs, bullets, and other

objects, however distant the person may be against whom they are directed (Corbusier 1886:137).

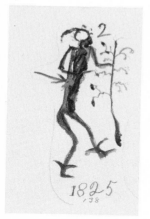

BATTISTE GOOD
1824–25
Killed two picking plums winter.

Collector's Notes: A Dakota war party surprised and killed two Pawnees who were gathering plums (Mallery 1893:318). White Cow Killer calls it "Killed the women picking cherries winter" (Corbusier 1886:137).

NO EARS
1824–25
Thrower killed by exhaustion/Yeyela hun ktepi.

Comments: Other counts note events involving throwing for this year.

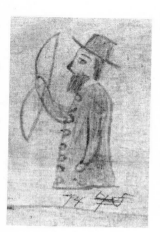

ROSEBUD
1824–25
White man came.

Comments: Several counts record this event for the previous year.

LONE DOG
1825–26
There was a remarkable flood in the Missouri river and a number of Indians were drowned.

Collector's Notes: With some exercise of fancy the symbol may suggest heads appearing above a line of water, and this is more distinct in some of the other charts (Mallery 1893:278). White Cow Killer calls it "Great flood and many Indians drowned winter" (Corbusier 1886:137–138).

Comments: Many other calendars mark this same event.

THE FLAME
1825–26
River overflows the Indian camp; several drowned.

Collector's Notes: The Flame, the recorder of this count, born. In the original drawing the five objects above the line are obviously human heads. . . . All the winter counts [in this report] refer to this flood (Mallery 1886:113).

THE SWAN

1825–26

Thirty lodges of Dakota Indians drowned by a sudden rise of the Missouri River.

Collector's Notes: Thirty lodges of Dakota Indians drowned by a sudden rise of the Missouri River about Swan Lake Creek, which is in Horsehead Bottom, 15 miles below Fort Rice. The five heads are more clearly drawn than in No. II [Lone Dog] (Mallery 1886:113).

MAJOR BUSH

1825–26

Sudden rise in Missouri river destroyed thirty (30) lodges of Sioux Indians at Rotch Point above Swan lake.

LONG SOLDIER

1825–26

Year that ice broke causing flood and nearly half of camp drowned.

AMERICAN HORSE

1825–26

Dakotas living south of Whetstone Agency killed when the Missouri River flooded.

Collector's Notes: Some of the Dakotas were living on the bottomlands of the Missouri River, below the Whetstone, when the river, which was filled with broken ice, unexpectedly rose and flooded their village. Many were drowned or else killed by the floating ice. Many of those that escaped climbed on cakes of ice or into trees (Corbusier 1886:137).

Comments: Note the similarity between this image and American Horse's depiction of deep snow in 1827–28. Good's picture for 1711–12 records another flood.

CLOUD SHIELD

1825–26

Many of the Dakotas were drowned in a flood caused by a rise in the Missouri River, in a bend of which they camped.

Collector's Notes: The curved line is the bend in the river; the waved line is the water, above which the tops of the tipis are shown (Corbusier 1886:137–138).

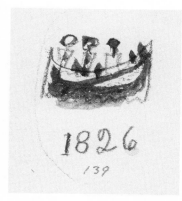

BATTISTE GOOD
1825–26
Many Yanktonais drowned winter.

Collector's Notes: The river bottom on a bend of the Missouri river, where they were encamped, was suddenly submerged, when the ice broke and many women and children were drowned (Mallery 1893:318).

Comments: Many counts mark this event, but Good is one of the few who specifies the band (Yanktonai) involved.

NO EARS
1825–26
They drowned/Mini wicata.

ROSEBUD
1825–26
They painted buffalo horn and camp flooded.

Comments: The painted horn was to attract the buffalo.

LONE DOG
1826–27
An Indian died of the dropsy.

Collector's Notes: So Basil Clement said. It was at first suggested that this circumstance was noted because the disease was so unusual in 1826 as to excite remark. Baron de La Hontan, a good authority concerning the Northwestern Indians before they had been greatly affected by intercourse with whites, specifically mentions dropsy as one of the diseases unknown to them. Carver, op. cit., also states that this malady was extremely rare. The interpretations of other charts explained, however, that some Dakotas on the warpath had nearly perished with hunger when they found and ate the rotting carcass of an old buffalo on which the wolves had been feeding. They were seized soon after with pains in the stomach, their abdomens swelled, and gas poured from the mouth. This disease is termed tympanites, the external appearance occasioned by it much resembling that of dropsy (Mallery 1893:278–279).

Comments: Several other calendars show a similar image, adding that a hunting or war party was stricken with food poisoning and died emitting a loud whistling noise. In comparing the texts with the pictographs, it seems clear that they all record a person who is sick, with something issuing from his mouth.

THE FLAME

1826–27

All of the Indians who ate of a buffalo killed on a hunt died of it, a peculiar substance issuing from the mouth.

LONG SOLDIER

1826–27

"Goose" went on warpath with Ree and brought back Ree scalp.

Collector's Notes: Near Farm School.

Comments: This should read that Goose went on the warpath *against* the Ree. It may represent the event noted in other records for 1823–24.

THE SWAN

1826–27

Dakota war party killed a buffalo; having eaten of it they all died.

AMERICAN HORSE

1826–27

The brother of Good-White-Man came (Corbusier 1886:138).

MAJOR BUSH

1826–27

A War party killed a buffalo, having eaten heartily of it all died.

CLOUD SHIELD
1826–27
Held a commemoration of the dead.

Collector's Notes: The pipe stem and the skull indicate this (Corbusier 1886:138).

Comments: Perhaps this commemoration was performed in remembrance of those who drowned in the flood that Cloud Shield recorded for the previous year.

BATTISTE GOOD
1826–27
Ate a whistle and died winter.

Collector's Notes: Six Dakotas on the war path (shown by bow and arrow) had nearly perished with hunger, when they found and ate the rotting carcass of an old buffalo, on which the wolves had been feeding. They were seized soon after with pains in the stomach, the abdomen swelled, and gas poured from mouth and anus, and they died of a whistle or from eating a whistle. The sound of gas escaping from the mouth is illustrated in the figure (Mallery 1893:318). White Cow Killer calls it "Long whistle sick winter" (Mallery 1886:113–114).

Comments: Good uses his unique device to indicate

pain, both inside and outside the figure. If his account is accurate, we can assume that the war party was quite desperate for food to have eaten from a carcass already set upon by wolves.

NO EARS
1826–27
Kaiwayo died coming back/Kaiwayo chamupi.

Comments: Perhaps the individual named here was part of the hunting party that died after eating rotten meat, as recorded in other counts for this year.

ROSEBUD
1826–27
They died whistling from eating rotten meat.

LONE DOG
1827–28
Dead-Arm was stabbed with a knife or dirk by a Mandan.

Collector's Notes: The illustration is quite graphic, showing the long-handled dirk in the bloody wound and withered arm (Mallery 1893:279).

Comments: The withered arm may indicate that the man survived his injury but was disfigured by it.

THE FLAME
1827–28
A Minneconjou is stabbed by a Gros Ventre, and his arm shrivels up (Mallery 1886:114).

LONG SOLDIER
1827–28
Year they made snow shoes and killed buffalo which were stuck in the snow.

Comments: Other calendars mark this as a year with a severe winter and deep snow, but do not mention hunting buffalo.

THE SWAN
1827–28
A Minneconjou Dakota wounded with a large knife by a Gros Ventre.

AMERICAN HORSE
1827–28
The snow was very deep.

Collector's Notes: The large knife was a sword, and the Indian who was wounded was named, afterwards, Lame Shoulder. This is an instance of a change of name after a remarkable event in life (Mallery 1886:114).

Collector's Notes: White Cow Killer calls it "Snowshoe making winter" (Corbusier 1886:138).

MAJOR BUSH
1827–28
A Minniconjou Sioux was wounded in the shoulder with a sabre in the hands of a Gros Ventre.

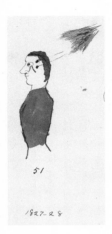

CLOUD SHIELD
1827–28
In a fight with the Mandans, Crier was shot in the head with a gun.

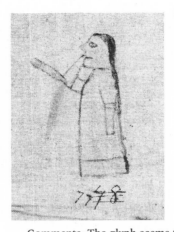

ROSEBUD
1827–28
Lakota stabbed in arm and it withered.

Comments: The glyph seems to show a person being stabbed in the right elbow.

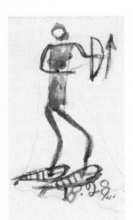

BATTISTE GOOD
1827–28
Wore snowshoes winter.

Collector's Notes: The snow was very deep (Mallery 1893:318).

NO EARS
1827–28
They boiled rushes/Psa chamupi.

Comments: On pictographic calendars, the image is of a snowshoe, *psachumpi* in Lakota. The explanation in this calendar is probably a mistranslation of the Lakota. Judging from other winter counts, it should read "They made snowshoes," marking a winter of deep snow.

LONE DOG
1828–29
A white man named Shadron, who lately, as reported in 1877, was still living in the same neighborhood, built a dirt lodge.

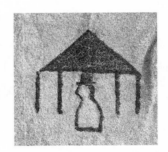

Collector's Notes: The hatted head appears under the roof. This name should probably be spelled Chadron, with whom [George] Catlin hunted in 1832, in the region mentioned (Mallery 1893:279).

Comments: The town of Chadron, Nebraska, is named after this trader. It is located about 40 miles southwest of the Pine Ridge Reservation.

THE FLAME
1828–29
Chardran, a white man, builds a house at forks of the Cheyenne River.

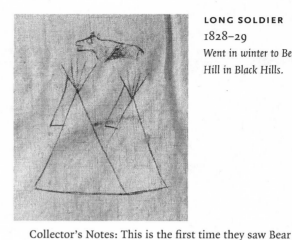

LONG SOLDIER
1828–29
Went in winter to Bear Hill in Black Hills.

Collector's Notes: This name should probably be spelled Chadron, with whom Catlin hunted in 1832, in the region mentioned (Mallery 1886:114).

Collector's Notes: This is the first time they saw Bear Hill.

Comments: This is probably Bear Butte, a sacred place for the Lakota and other tribes, just northeast of the Black Hills.

THE SWAN
1828–29
Trading post opened in a dirt lodge on the Missouri River a little below the mouth of the Little Missouri River (Mallery 1886:114).

AMERICAN HORSE
1828–29
They had much antelope meat; hunted by driving the animals into a corral.

MAJOR BUSH
1828–29
Trading Store built near Little Mo. [Missouri] River.

Collector's Notes: They provided themselves with a large supply of antelope meat by driving antelope into a corral, in which they were easily killed (Corbusier 1886:138).

CLOUD SHIELD
1828–29
They drove many antelope into a corral and then killed them.

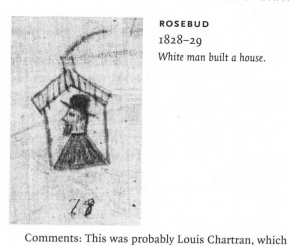

ROSEBUD
1828–29
White man built a house.

Comments: This was probably Louis Chartran, which became corrupted to Chadron, as noted in The Flame.

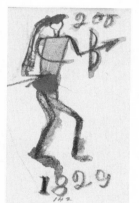

BATTISTE GOOD
1828–29
Killed two-hundred Gros Ventres (Hidatsas) winter (Mallery 1893:319).

Collector's Notes: White Cow Killer calls it "Many-Rees killed winter" (Corbusier 1886:138).

NO EARS
1828–29
They killed many Mandans/Miwatani ota wica ktepi.

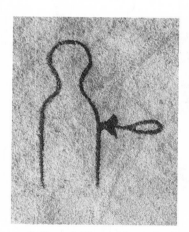

LONE DOG
1829–30
A Yanktonai Dakota was killed by Bad-Arrow Indians.

Collector's Notes: The Bad-Arrow Indians is a translation of the Dakota name for a certain band of Blackfeet Indians (Mallery 1893:279).

Comments: The winter counts for this year, which use essentially the same illustration but give different stories, are a good example of the ambiguity inherent in some interpretations; often we know the characters but are not sure who has done what to whom.

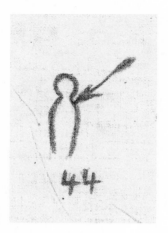

THE FLAME
1829–30
A Dakota found dead in a canoe.

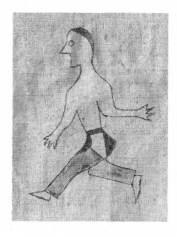

LONG SOLDIER
1829–30
Man was called to Blackfoot Sioux after he killed a Crow who was a friend of the Blackfeet, so they killed him.

THE SWAN
1829–30
A Yanktonai Dakota was killed by Bad Arrow Indians.

Collector's Notes: Mato Sapa says: a Yanktonai was killed by the Bad Arrow Indians (Mallery 1886:114).

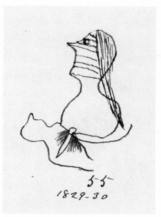

AMERICAN HORSE
1829–30
Striped-Face stabbed and killed his son-in-law for whipping his wife (Corbusier 1886:138).

MAJOR BUSH
1829–30
A Yanktonais Sioux killed by the Bad Arrow's.

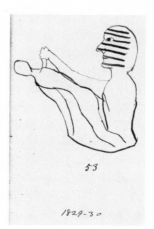

CLOUD SHIELD
1829–30
Spotted Face stabs his son-in-law for whipping his wife.

Collector's Notes: White Cow Killer calls it "Spotted Face held on long winter" (Corbusier 1886:138).

BATTISTE GOOD
1829–30
Old Speckled Face clung to his son-in-law winter.

Collector's Notes: The daughter of Speckled Face, who was coming out second best in an altercation with her husband, called to her father for help. The latter ran and grabbed his son-in-law around the waist, and, crying "That is my daughter," stabbed him. The son-in-law fell and the old man fell on top of him, and, clinging to him, begged the lookers on to put an end to him also, as he wished to bear his beloved son-in-law company to the spirit land. No one, however, was in the humor to speed him on the journey, and he remained with the living (Mallery 1893:319).

NO EARS
1829–30
Freckled-face was killed/Iteglega wa aksija.

ROSEBUD
1829–30
Man found frozen on prairie.

Comments: The figure here is painted blue, perhaps indicating that he is frozen. The British Museum winter count entry for the previous year records that a man with a blue coat and red shirt built a house. Here there is a red streak down the man's side.

LONE DOG
1830–31
Bloody battle with the Crows, of whom it is said twenty-three were killed.

Collector's Notes: Nothing in the sign denotes number, it being only a man figure with red or bloody body and red war bonnet (Mallery 1893:279).

THE FLAME
1830–31
Mandans kill twenty Crows at Bear Butte.

LONG SOLDIER
1830–31
Had war with Crows and killed 10 in war.

Collector's Notes: Near Black Hills.

THE SWAN
1830–31
Twenty Crow and one Cheyenne Indians killed by Dakotas at Bear Butte.

AMERICAN HORSE
1830–31
They saw wagons for the first time.

Collector's Notes: Mato Sapa says: One Cheyenne and twenty Crows were killed by Dakotas at Bear Butte (Mallery 1886:115).

Comments: There is some discrepancy among the calendars as to who killed whom.

Collector's Notes: Red Lake, a white trader, brought goods in the wagons (Corbusier 1886:138).

MAJOR BUSH
1830–31
One Cheyenne and Twenty Crow Indians killed by Sioux's at Bear Butte.

CLOUD SHIELD
1830–31
Killed many Crows as they attempted a sneak attack in winter.

Collector's Notes: The Crows were approaching a village at a time when there was a great deal of snow on the ground and intended to surprise it, but some herders discovering them the Dakotas went out, laid in wait for the Crows, surprised them, and killed many. A Crow's head is represented in the figure (Corbusier 1886:138).

Comments: Note the similarity between this image and those Cloud Shield uses for 1845–46 and 1857–58.

BATTISTE GOOD
1830–31
Shot many white buffalo cows winter (Mallery 1893:319).

Collector's Notes: White Cow Killer calls this year "Killed-many-white-buffalo winter" (Corbusier 1886:138).

Comments: Good notes a similar event for the year 1750–51.

NO EARS
1830–31
Many white buffaloes wounded/Ptesan ota wicaopi.

Comments: The Lakota verb *o* can mean either "to wound" or "to shoot," as with an arrow or bullet.

ROSEBUD
1830–31
Many ceremonies or bloody battle with the Crow.

Comments: The headdress is painted red, perhaps indicating a sacred ceremony; an alternative interpretation would be a bloody battle, perhaps with the Crow, as indicated in other winter counts.

LONE DOG
1831–32
Le Beau, a white man, killed another named Kermel.

Collector's Notes: Le Beau was still alive at Little Bend, 30 miles above Fort Sully, in 1877 (Mallery 1893:279).

Comments: Several other counts mark a violent interaction between white men this year.

THE FLAME

1831–32

Two white men killed by a white man at Medicine Creek, below Fort Sully (Mallery 1886:115).

LONG SOLDIER

1831–32

White man named Yellow Eyes had store and was taken prisoner because he had previously held Sioux Prisoners.

THE SWAN

1831–32

Trader named Le Beau killed one of his employees on Big Cheyenne River, below Cherry Creek (Mallery 1886:115).

MAJOR BUSH

1831–32

Fred Lafas [?], a trader killed one of his employees on the Big Cheyenne River, below Cherry Creek—cause jealousy.

AMERICAN HORSE

1831–32

Red Lake's house exploded and he was killed.

Collector's Notes: Red Lake's house, which he had recently built, was destroyed by fire, and he was killed by the accidental explosion of some powder (Corbusier 1886:138).

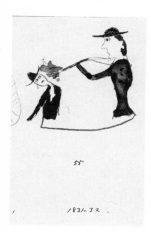

CLOUD SHIELD
1831–32

A white man, whom they called Gray-Eyes, shot and killed a man who worked for him (Corbusier 1886:138).

BATTISTE GOOD
1831–32

Killed him while looking about on the hill winter.

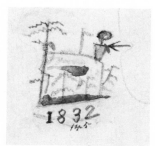

Collector's Notes: A Dakota, while watching for buffalo at Buffalo Gap, in the Black Hills, was shot by the Crows. The man is represented on a hill, which is dotted with pine trees and patches of grass. Battiste makes the grass blue. Blue and green are frequently confounded by other Indians than Battiste, and some tribes have but one name for the two colors (Mallery 1893:319).

Comments: The Lakota term *to* can be used for blue, green, or bluish green (Buechel 1970:492).

NO EARS
1831–32

Burning lake/Blestahu.

Comments: This may refer to the incident recorded by American Horse for this year.

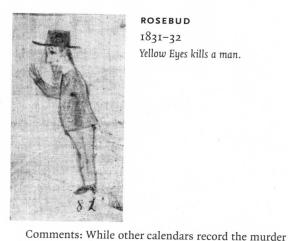

ROSEBUD
1831–32

Yellow Eyes kills a man.

Comments: While other calendars record the murder of an employee by a trader (Frederick Le Beau, aka Yellow Eyes), this man appears to be wearing an army uniform.

LONE DOG
1832–33

Lone-Horn had his leg "killed," as the interpretation gave it.

Collector's Notes: The single horn is on the figure, and a leg is drawn up as if fractured or distorted, though, not unlike the leg in the character for 1808–09, where running is depicted (Mallery 1893:279). White Cow Killer calls it "One Horn's leg broken winter."

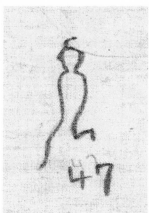

THE FLAME
1832–33
Lone Horn's father broke his leg.

Collector's Notes: In Catlin's "North American Indians," New York, 1844, Vol. 1, page 211, the author, writing from the mouth of Teton River, Upper Missouri, site of Fort Pierre, described Ha-won-je-tah, The One Horn, head chief of all the bands of the Dakotas, which were about twenty. He was a bold, middle-aged man of medium stature, noble countenance, and figure almost equalling an Apollo. His portrait was painted by Catlin in 1832. He took the name of One Horn, or One Shell, from a simple small shell that was hanging on his neck, which descended to him from his father, and which he valued more than anything else which he possessed, and he kept that name in preference to many others more honorable which he had a right to have taken, from his many exploits. On page 221, the same author states, that after being the accidental cause of the death of his only son, Lone Horn became at times partially insane. One day he mounted his war-horse, vowing to kill the first living thing he should meet, and rode to the prairies. The horse came back in two hours afterwards, with two arrows in him covered with blood. His tracks were followed, back, and the chief was found mangled and gored by a buffalo bull, the carcass of which was stretched beside him. He had driven away the horse with his arrows and killed the bull with his knife. Another account in the catalogue of Catlin's cartoons gives the portrait of The One Horn as number 354, with the statement that having killed his only son accidentally, he became deranged, wandered into the prairies, and got himself killed by an infuriated buffalo bull's horns. This was at the mouth of the Little Missouri River, in 1834 (Mallery 1886:115–116).

Comments: Mato Sapa also recorded this event as happening to Lone Horn's father. Sometimes a man would be named after his father, and they would be referred to as the younger and the elder.

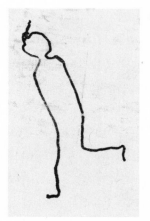

THE SWAN
1832–33
A Minneconjou Dakota, Lone Horn's father, had his leg broken while running buffalo.

Comments: Swan records a similar image and event for 1846–47.

MAJOR BUSH
1832–33
Lone Horn's father had his leg broken while running buffalo.

LONG SOLDIER
1832–33
Year of first log house.

Comments: Other counts record groups of Lakota living in log houses years earlier than this.

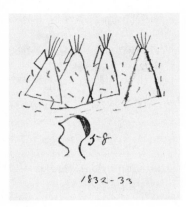

AMERICAN HORSE
1832–33
*They attacked a
Gros Ventre village
and killed many.*

Collector's Notes: He was killed in an engagement
with the Pawnees on the Platte river, in which the Brulés
killed one hundred Pawnees (Mallery 1893:319).

NO EARS
1832–33
One-horn broke his leg/Hewanjica hu kawega.

Comments: This man's name is sometimes translated
as Lone Horn.

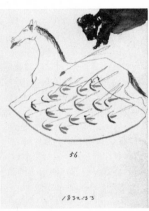

CLOUD SHIELD
1832–33
*All of Standing Bull's horses
were killed, but by whom is
unknown.*

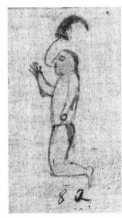

ROSEBUD
1832–33
One Horn broke his leg.

Collector's Notes: Hoof prints, blood stains, and
arrows are shown under the horse (Corbusier 1886:138).

Comments: This event is also recorded as having
happened to One (Lone) Horn's father.

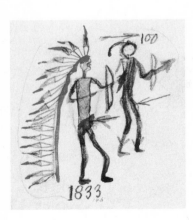

BATTISTE GOOD
1832–33
*Stiff Leg With
Warbonnet On
died winter.*

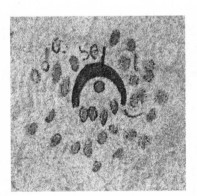

LONE DOG
1833–34
*"The stars fell," as the
Indians all agreed.*

Collector's Notes: This was the great meteoric shower
observed all over the United States on the night of Novem-

ber 12 of that year. In this chart the moon is black and the stars are red (Mallery 1893:280). White Cow Killer calls it "Plenty-stars winter" (see Corbusier 1886:138–139).

Comments: This is the definitive index event for dating winter counts and relating them to each other, since it is present in all of them.

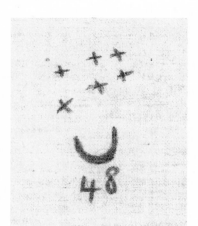

THE FLAME
1833–34
Many stars fell (meteors).

Collector's Notes: The character shows six black stars above the concavity of the moon. . . . All the winter counts [in this report] refer to this meteoric display (Mallery 1886:116).

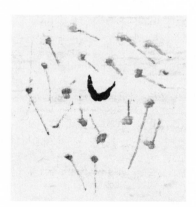

THE SWAN
1833–34
Dakotas witnessed magnificent meteoric showers; much terrified.

Collector's Notes: Battiste Good calls it "Storm of stars winter," and gives as the device a tipi, with stars falling around it. . . . The tipi is colored yellow in the original, and so represented in the figure according to the heraldic scheme. White Cow Killer calls it "Plenty stars winter." All the winter counts refer to this meteoric display (Mallery 1886:116).

Comments: The Swan and Major Bush counts are the only ones to note that this fantastic occurrence frightened people.

MAJOR BUSH
1833–34
Witnessed a magnificent meteoric shower, scared nearly to death.

LONG SOLDIER
1833–34
Stars shoots off.

Collector's Notes: Looks like stone when it fell.

AMERICAN HORSE
1833–34
The stars moved around.

Collector's Notes: All of them [American Horse, Cloud Shield, and Good] represent stars having four points (Corbusier 1886:138–139).

CLOUD SHIELD

1833–34

It rained stars.

ROSEBUD

1833–34

The year the stars fell.

BATTISTE GOOD

1833–34

Storm of stars winter.

LONE DOG

1834–35

Chief Medicine-Hide was killed.

Collector's Notes: Battiste Good calls it "Storm of stars winter," and gives as the device a tipi, with stars falling around it. . . . The tipi is colored yellow in the original, and so represented in the figure according to the heraldic scheme (Mallery 1886:116).

Comments: Most other calendars simply depict stars, but Good has portrayed a tipi surrounded by stars.

Collector's Notes: The device shows the body as bloody, but not the war bonnet, by which it is distinguished from the character for 1830–31 (Mallery 1893:280).

Comments: Several counts depict a man with a war-bonnet for this year and a few identify him as a Cheyenne.

NO EARS

1833–34

The stars fell/Wicahpi okicamna.

Comments: The verb *icamna* means "to blow, bluster, or storm" (Buechel 1970:201).

THE FLAME
1834–35
A Ree killed by a Dakota.

LONG SOLDIER
1834–35
Firts [sic] year feather hats.

Collector's Notes: Five feathers, two horses.

Comments: The comment about feathers and horses is unclear. Perhaps it relates to other counts, which mark this as the year when a man wearing a warbonnet was killed.

THE SWAN
1834–35
An Uncpapa Dakota medicine man killed by the Ree Indians.

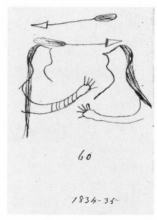

AMERICAN HORSE
1834–35
They were at war with the Cheyennes.

Collector's Notes: Mato Sapa says: An Uncpapa Dakota Medicine man was killed by Rees (Mallery 1886:116).

Collector's Notes: The Cheyenne is the one [to the left] with stripes on his arm (Corbusier 1886:139).

MAJOR BUSH
1834–35
An Unkpapah Sioux Medicine Man killed by the Ree Indians.

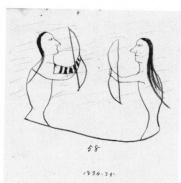

CLOUD SHIELD
1834–35
They fought with the Cheyennes.

Collector's Notes: The stripes on the arm are for Cheyenne as before (Corbusier 1886:139).

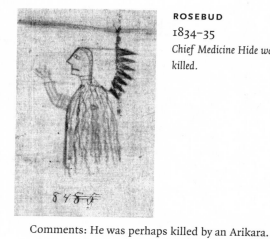

ROSEBUD
1834–35
Chief Medicine Hide was killed.

Comments: He was perhaps killed by an Arikara.

BATTISTE GOOD
1834–35
Killed the Cheyenne who came to the camp winter.

Collector's Notes: A Cheyenne who stole into the village by night was detected and killed. The village was near what is now the Pine Ridge agency (Mallery 1893:320).

NO EARS
1834–35
A returned Cheyenne killed/Sahiyela tigle wan ktepi.

Comments: The Lakota verb *tigle* indicates that the Cheyenne was returning to his village or camp (*ti*, "to dwell"; *gle*, "to return home").

LONE DOG
1835–36
Lame-Deer shot a Crow Indian with an arrow; drew it out and shot him again with the same arrow.

Collector's Notes: The hand is drawing the arrow from the first wound. This is another instance of the principle on which events were selected. Many fights occurred of greater moment, but with no incident precisely like this. Lame-Deer was a distinguished chief among the hostiles in 1876. His camp of five hundred and ten lodges was surprised and destroyed by Gen. Miles, and four hundred and fifty horses, mules, and ponies were captured (Mallery 1893:280).

THE FLAME
1835–36
Lame Deer killed by a Dakota.

LONG SOLDIER
1835–36
Rees Camp. Cannon Ball Sioux went to buy corn and Rees killed six of them as they did not want them around.

Comments: Cannon Ball is a community on the North Dakota side of the present Standing Rock Reservation. This is primarily a Dakota-speaking community, geographically close to the Arikara.

THE SWAN
1835–36
A Minneconjou chief named Lame Deer shot an Assiniboine three times with the same arrow.

AMERICAN HORSE
1835–36
They killed a very fat buffalo bull.

Collector's Notes: He kept so close to his enemy that he never let the arrow slip away from the bow, but pulled it out and shot it in again. Mato Sapa says a Minneconjou named Lame Deer shot an Assiniboine three times running with the same arrow (Mallery 1886:116–117).

MAJOR BUSH
1835–36
Minniconjou Sioux named "Lone Dear" [sic] shot an Assiniboin three (3) times with the same arrow.

Comments: Other calendars identify this man as Lame Deer.

CLOUD SHIELD
1835–36
They killed a very fat buffalo bull.

BATTISTE GOOD
1835–36
*Killed the two warparty
leaders winter.*

Collector's Notes: A Dakota war party met one of
Pawnees and killed two of their leaders, whereupon the
rest ran (Mallery 1893:320). White Cow Killer calls it
"Two-warriors-killed winter" (Corbusier 1886:139).

NO EARS
1835–36
A fat buffalo bull wounded/Tatanka wan sepa opi.

Comments: The word *sepa* should read *chepa*, meaning
"fat."

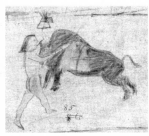

ROSEBUD
1835–36
They killed a fat buffalo bull.

Comments: The man's name glyph is a tipi with
prominent smoke flaps.

LONE DOG
1836–37
*Band's Father, chief
of the Two Kettles,
died.*

Collector's Notes: The device is nearly the same as that
for 1816–17, denoting plenty of buffalo belly. Interpreter
Fielder throws light on the subject by saying that this
character was used to designate the year when The Breast,
father of The Band, a Minneconjou, died. The Band him-
self died in 1875, on Powder river. His name was O-ye-a-
pee. The character was, therefore, the Buffalo-Breast, a
personal name (Mallery 1893:280).

THE FLAME
1836–37
*Father of the Mandans
died (Mallery 1886:117).*

Comments: Although this looks like the same figure
as The Flame's entry for 1816–17, which marked an abun-
dance of meat, the interpretation is quite different.

THE SWAN
1836–37
Two Kettle, Dakota, named The Breast died.

Collector's Notes: Mato Sapa says: A Two Kettle, named The Breast, died (Mallery 1886:117).

Comments: Although this image is virtually the same as The Swan's record for 1816–17, a very different interpretation is given.

MAJOR BUSH
1836–37
A "Two Kettle Sioux" named "Breast" died.

LONG SOLDIER
1836–37
The next year the Sioux went on warpath and Rees had moved across the river so they fought across the river and killed six Rees.

Comments: The term "Ree" often refers to the Arikaras, but here applies to the Pawnee, who are closely related to the Arikara. Many calendars record this fight with the Pawnee, usually indicating that it occurred in the winter and the two tribes fought across the ice.

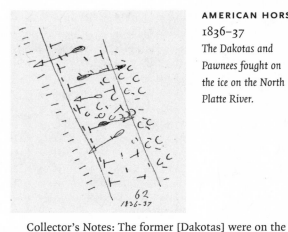

AMERICAN HORSE
1836–37
The Dakotas and Pawnees fought on the ice on the North Platte River.

Collector's Notes: The former [Dakotas] were on the north side, the righthand side in the figure, the latter [Pawnees] on the south side, the left in the figure. Horsemen and footmen on the right are opposed to footmen on the left. Both sides have guns and bows, as shown by the bullet-marks and the arrows. The red marks are for blood-stains on the ice. White Cow Killer calls it "Fight-on-the-ice winter" (Corbusier 1886:139)

CLOUD SHIELD
1836–37
They fought the Pawnees across the ice on the North Platte [River].

BATTISTE GOOD

1836–37

Fight on the ice winter.

Collector's Notes: They fought with the Pawnees on the ice, on the Platte river, and killed seven of them. The two vertical marks, which are for the banks of the river, and the two opposed arrows, signify that the tribes were on opposite sides of the river (Mallery 1893:320).

NO EARS

1836–37

They threw ice on each other/Caga a kicicininpi.

Comments: Most likely, this refers to the battle on the ice between the Lakota and Pawnee, recorded in other winter counts. *Caga* means "ice" (Buechel 1970:113).

ROSEBUD

1836–37

They fought with Pawnees across the ice.

LONE DOG

1837–38

Commemorates a remarkably successful hunt, in which it is said 100 elk were killed.

Collector's Notes: The drawing of the elk is good enough to distinguish it from other quadrupeds in this chart (Mallery 1893:280).

THE FLAME

1837–38

Many elk and deer killed.

Collector's Notes: The figure does not show a split hoof. . . . Mato Sapa says: The Dakotas killed one hundred elk at the Black Hills. His figure does not show the split hoof (Mallery 1886:117).

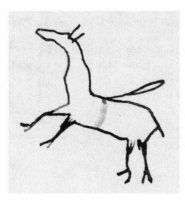

THE SWAN
1837–38
The Dakotas killed one hundred elk at the Black Hills.

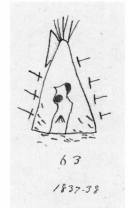

AMERICAN HORSE
1837–38
Paints His Cheeks Red and his family killed by Pawnee.

MAJOR BUSH
1837–38
Sioux's killed One hundred (100) Elk at the Black Hills.

Collector's Notes: Paints His Cheeks Red and his family, who were camping by themselves, were killed by Pawnees (Corbusier 1886:139).

Comments: Only a few Oglala calendars mark this event. White Cow Killer refers to the following year as "Paints-His-Chin's lodge all killed winter" (Corbusier 1886:139). The same event may be noted in Good (1838–39) and Rosebud (1839–40).

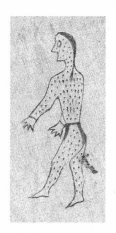

LONG SOLDIER
1837–38
Small pox year.

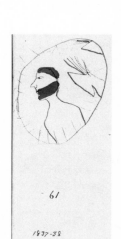

CLOUD SHIELD
1837–38
Paints-His-Face-Red, a Dakota, was killed in his tipi by the Pawnees.

BATTISTE GOOD
1837–38
Spread Out killed winter.

Collector's Notes: A Santee man, whose name is indicated by his spread hands, was killed by soldiers (Mallery 1893:320)

NO EARS
1837–38
Face-half-painted-red was killed/Itehepi-sakiya-tiapa ktepi.

ROSEBUD
1837–38
Smallpox killed them.

Comments: This outbreak of smallpox is noted in the Long Soldier, Cranbrook, and British Museum counts for the same year.

LONE DOG
1838–39
A dirt lodge was built for Iron-Horn.

Collector's Notes: The other dirt lodge (1815–'16) has a mark of ownership, which this has not. A chief of the Minneconjous is mentioned in Gen. Harney's report in 1856 under the named The-One-Iron-Horn. The word translated "iron" in this case and appearing thus several times in the charts does not always mean the metal of that name. According to Rev. J. Owen Dorsey it has a mystic significance, in some manner connected with water and with water spirits. In pictographs objects called iron are painted blue when that color can be obtained (Mallery 1893:280).

THE FLAME
1838–39
Indians built a lodge on White Wood Creek, in the Black Hills, and wintered there (Mallery 1886:117).

Comments: This pictograph represents an earth lodge and not a log cabin as in previous images.

THE SWAN
1838–39
A Minneconjou chief, named Iron Horn, built dirt lodge (medicine lodge) on Moreau River (same as Owl River).

Collector's Notes: This Minneconjou chief, Iron Horn, died a few years ago and was buried near Fort Sully. He was father-in-law of Dupuis, a French Canadian (Mallery 1886:117).

MAJOR BUSH
1838–39
A Minneconjou Sioux named "Iron Horse" [Horn?] built dirt medicine lodge on Moureau River.

LONG SOLDIER
1838–39
Year of spotted horses.

Collector's Notes: Blackfoot went on warpath with Crows and stole then [*sic*] horses and all were spotted.

Comments: Many other calendars mark the theft of horses from various tribes between 1840 and 1843.

AMERICAN HORSE
1838–39
Spotted Horse carried the pipe around and went on the warpath against the Pawnees.

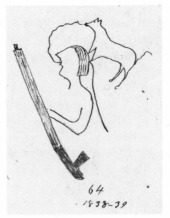

Collector's Notes: Spotted Horse carried the pipe around and took the war path against the Pawnees, to avenge the death of his uncle, Paints His Cheeks Red. When a warrior desires to make up a war party he visits his friends and offers them a filled pipe as an invitation to follow him, and those who are willing to go accept the invitation by lighting and smoking it. Any man whose courage has been proved may become the leader of a war party (Corbusier 1886:139).

CLOUD SHIELD
1838–39
Crazy Dog, a Dakota, carried the pipe around and took the war path.

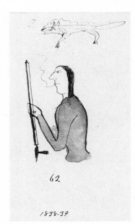

Collector's Notes: The waved or spiral lines denote crazy (Corbusier 1886:139).

BATTISTE GOOD
1838–39
Came and killed five Oglalas winter.

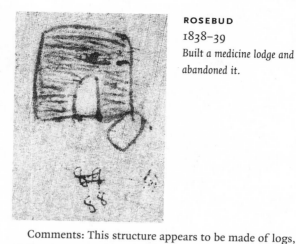

ROSEBUD
1838–39
Built a medicine lodge and abandoned it.

Collector's Notes: They were killed by Pawnees. The man in the figure has on a capote, the hood of which is drawn over his head. This garment is used here as a sign for war, as the Dakotas commonly wear it on their war expeditions (Mallery 1893:321).

Comments: Capotes were made from wool trade blankets, usually Hudson's Bay point blankets, and so would only have been worn in cold weather. This may be the same event noted in 1837–38, when Paints His Face Red and his family were killed by enemies.

Comments: This structure appears to be made of logs, while other counts indicate that an earth lodge was built. The door of the lodge is on the ground away from the opening, apparently indicating abandonment.

NO EARS
1838–39
Son of Crazy-Horse was killed/Sunknaskiinyan einca wan ktepi.

Comments: The second Lakota word should probably be *cinca*, meaning "son."

LONE DOG
1839–40
The Dakotas killed an entire village of Snake or Shoshoni Indians.

Collector's Notes: The character is the ordinary tipi pierced by arrows (Mallery 1893:281).

THE FLAME

1839–40

*Dakotas killed twenty
lodges of Arapahos.*

Collector's Notes: Mato Sapa says: A Minneconjou Dakota named The Hard killed seven lodges of the Blue Cloud Indians (Mallery 1886:117–118).

Comments: The Lakota word for Arapaho is Mahpiya To, or Blue Cloud (Buechel 1970:733).

THE SWAN

1839–40

*A Minneconjou
Dakota, named
The Hard (with
band), killed seven
lodges of Blue
Cloud Indians.*

Collector's Notes: The Blue Clouds are the Arapaho, so styled by the Dakotas, originally Maqpiyato (Mallery 1886:117–118).

MAJOR BUSH

1839–40

A Minnicounjou Sioux named "Hand" destroyed seven lodges of the "Blue Cloud" Indians.

LONG SOLDIER

1839–40

*Year Dirty Skin was killed by some of
his own people who were mad at him.*

AMERICAN HORSE

1839–40

*Left-Handed-Big-Nose was killed
by the Shoshoni.*

Collector's Notes: His left arm is represented extended, and his nose is very conspicuous. American Horse was born in the spring of 1840 (Corbusier 1886:140).

Comments: This figure, unlike most others, is presented facing forward rather than in profile.

CLOUD SHIELD
1839–40
They killed a Crow and his wife who were found on a trail.

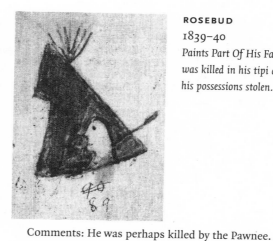

ROSEBUD
1839–40
Paints Part Of His Face was killed in his tipi and his possessions stolen.

Comments: He was perhaps killed by the Pawnee.

BATTISTE GOOD
1839–40
Came home from the starve-to-death-warpath winter.

LONE DOG
1840–41
The Dakotas make peace with the Cheyennes.

Collector's Notes: All the Dakota tribes united in an expedition against the Pawnees. They killed one hundred Pawnees, but nearly perished with hunger (Mallery 1893:321).

Comments: This may be the event that White Cow Killer calls "Large war party hungry eat Pawnee horses winter" (Corbusier 1886:140).

Collector's Notes: The symbol of peace is the common one of the approaching hands of two persons. The different coloration of the two hands and arms shows that they belonged to two different persons, and in fact to different tribes. The mere unceremonial hand grasp or "shake" of friendship was not used by the Indians before it was introduced by Europeans (Mallery 1893:281).

NO EARS
1839–40
Starving on the warpath/Wicakinkan watapi ai.

THE FLAME

1840–41

Red Arm, a Cheyenne, and Lone Horn, a Dakota, made peace (Mallery 1886:118).

THE SWAN

1840–41

Dakotas made peace with the Cheyenne Indians (Mallery 1886:118).

MAJOR BUSH

1840–41

Sioux's made peace with the Cheyenne Indians.

LONG SOLDIER

1840–41

Year Chief Spider Elk died.

Comments: Several other northern winter counts (not in this collection) also mark the death of this man.

AMERICAN HORSE

1840–41

Sitting-Bear, American Horse's father, and others, stole two hundred horses from the Flatheads.

Collector's Notes: A trailing lariat is in the man's hand (Corbusier 1886:140).

Comments: The theft of horses from various tribes appears on several winter counts between 1838 and 1843.

CLOUD SHIELD

1840–41

They stole many horses from the Snakes [Shoshoni].

BATTISTE GOOD
1840–41
Came and killed five of Little Thunder's brothers winter or Battiste alone returns winter.

Collector's Notes: The five were killed in an encounter with the Pawnees. Battiste Good was the only one of the party to escape. The capote is shown again (Mallery 1893:321). White Cow Killer calls it "Little Thunder's brothers killed winter" (Corbusier 1866:140)

Comments: Mallery's comment about the depiction of the capote refers to Good 1838–39.

NO EARS
1840–41
They killed two of Little-Thunder's brothers/Wakinyan-ciqa gonkaka nonp wica ktepi.

ROSEBUD
1840–41
They camped with the Red Lodges.

Comments: This entry may relate to the one in the Big Missouri count for the same year, which records that they camped on a hill. The Mnicónjou are called "Red Lodges."

LONE DOG
1841–42
Feather-in-the-Ear stole 30 spotted ponies.

Collector's Notes: The spots are shown red, distinguishing them from those of the curly horse in the character for 1803–04. A successful theft of horses, demanding skill, patience, and daring, is generally considered by the Plains Indians to be of equal merit with the taking of scalps. Indeed, the successful horse thief is more popular than a mere warrior, on account of the riches gained by the tribe, wealth until lately being generally estimated in ponies as the unit of value (Mallery 1893:281).

THE FLAME
1841–42
Feather In The Ear steals horses from the Crows.

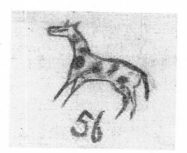

Collector's Notes: Mato Sapa says: A Minneconjou named Feather in the Ear stole nineteen spotted horses from the Crow Indians (Mallery 1886:118).

THE SWAN
1841–42
A Minneconjou Dakota, named Feather in his Ear, stole nineteen spotted horses from the Crow Indians.

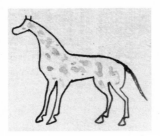

MAJOR BUSH
1841–42
A Minniconjou Sioux named "Feather in the ear" stole (9) nine spotted horses from the Crow Indians.

LONG SOLDIER
1841–42
Year snow was deep and they had no wood so they cut wood on the hills and loaded it on sleds and dogs pull it into camp.

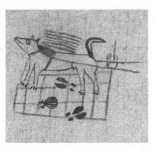

Comments: Note the three buffalo hoofprints under the dog.

AMERICAN HORSE
1841–42
The Oglalas engaged in a drunken brawl and the Kiyuksa band separated from the others.

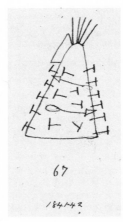

Collector's Notes: The Oglalas engaged in a drunken brawl, the Kiyuksa (Cut-Offs) separating from the others (Corbusier 1886:140–141).

CLOUD SHIELD
1841–42
The Oglalas got drunk on Chug Creek, and engaged in a quarrel among themselves.

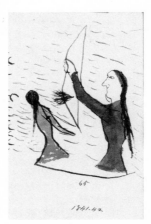

Collector's Notes: The Oglalas got drunk on Chug Creek, and engaged in a quarrel among themselves, in which Red Cloud's brother was killed, and Red Cloud killed three men. Cloud Shield (Mahpiya-Wahcanka) was born (Corbusier 1886:140–141).

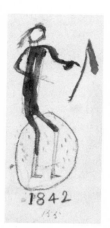

BATTISTE GOOD
1841–42
*Pointer made a commemoration
of the dead winter.*

Collector's Notes: Also "Deep snow winter." The extended index denotes the man's name, the ring and spots deep snow (Mallery 1893:321).

Comments: Good depicts many such ceremonies, each with a figure holding a red flag; see his entries for 1799–1800, 1864–65, and 1875–76.

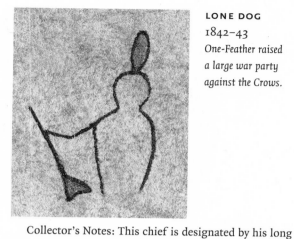

LONE DOG
1842–43
*One-Feather raised
a large war party
against the Crows.*

Collector's Notes: This chief is designated by his long solitary red eagle feather, and holds a pipe with black stem and red bowl, alluding to the usual ceremonies before starting on the warpath. . . . The Red-War-Eagle-Feather was at this time a chief of the Sans Arc (Mallery 1893:281).

NO EARS
1841–42
Captured many brown eared horses/Sunknakpogi eta te wicayapi.

Comments: The second Lakota word should be *ota* (many, several).

ROSEBUD
1841–42
Feather in the Ear stole many spotted horses from the Crow.

THE FLAME
1842–43
*A Minneconjou chief tries
to make war.*

Collector's Notes: The tip of his feather is black. No red in it (Mallery 1886:118).

THE SWAN
1842–43
Feather in the Ear made a feast, to which he invited all the young Dakota braves, wanting them to go with him.

Collector's Notes: A memorandum is added that he failed to persuade them. . . . Mato Sapa says: The same man (referring to last year), Feather in the Ear made a feast inviting all Dakota young men to go to war (Mallery 1886:118).

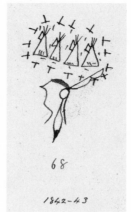

AMERICAN HORSE
1842–43
Feather-Ear-Rings was killed by the Shoshoni.

Collector's Notes: The four lodges and the many blood-stains intimate that he was killed at the time the four lodges of the Shoshoni were killed (Corbusier 1886:141).

MAJOR BUSH
1842–43
"Feather in the ear" gave a great feast, to which he invited all the young braves, wanted them to go to war with him.

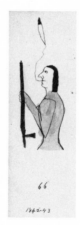

CLOUD SHIELD
1842–43
Lone Feather said his prayers, and took the warpath to avenge the death of some relatives.

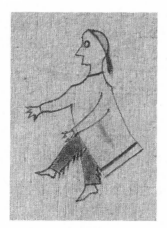

LONG SOLDIER
1842–43
Year Poplar Indian was scalped and afterward was killed.

Comments: The term Poplar Indian probably refers to a person from the area of present-day Poplar, Montana, on the southern edge of the Fort Peck Reservation; the person might be an Assiniboine.

BATTISTE GOOD
1842–43
Killed four lodges of Shoshone and brought home many horses winter (Mallery 1893:321).

Comments: Several other calendars note a successful horse raid between 1838 and 1843; the accounts differ regarding from whom the horses were taken.

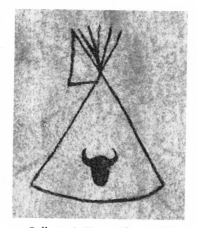

LONE DOG
1843–44
Sans Arcs made medicine to bring the buffalo.

Collector's Notes: The medicine tent is denoted by a buffalo's head drawn on it, which in this instance is not the head of an albino buffalo (Mallery 1893:281).

NO EARS
1842–43
Feather-ear-rings killed a horse herder/Wiyaka owin sunkyuka najin wan kte.

Comments: The transcriber has written *-yuka* when it probably should be *-yuha*, "to have."

ROSEBUD
1842–43
Lone Feather tries to make war.

THE FLAME
1843–44
Buffalo is scarce; an Indian makes medicine and brings them to the suffering.

Collector's Notes: Mato Sapa says: Dakotas were starving; made medicine to Great Spirit by painting buffalo head on their lodges; plenty came (Mallery 1886:118–119).

THE SWAN
1843–44
No buffalo; Indians made medicine to the Great Spirit by painting a buffalo's head on lodge; plenty came.

Comments: The Lakota had several different techniques to attract buffalo, including painting buffalo heads on their tipi covers.

MAJOR BUSH
1843–44
Scarcity of buffalo meat, made medicine to the "Great Spirit" by painting buffalo heads upon the lodges. Immense droves came immediately.

LONG SOLDIER
1843–44
Indian Chief named Four Horns went to war with Crows and [they] thought he was killed, so they left him and next year he came home.

Comments: This probably refers to Sitting Bull's relative named Four Horns. He is mentioned again in Lone Dog 1856–57.

AMERICAN HORSE
1843–44
The great medicine arrow was taken from the Pawnees by the Oglalas and Brulés and returned to the Cheyennes, to whom it rightly belonged.

Collector's Notes: White Cow Killer calls it "The Great-medicine-arrow-comes-in winter" (Corbusier 1886:141).

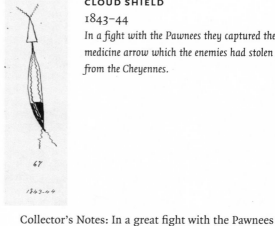

CLOUD SHIELD
1843–44
In a fight with the Pawnees they captured the medicine arrow which the enemies had stolen from the Cheyennes.

Collector's Notes: In a great fight with the Pawnees they captured the great medicine arrow which had been taken from the Cheyennes, who made it, by the Pawnees. The head of the arrow projects from the bag which contains it. The delicate waved lines (intended probably for spiral lines) show that it is sacred (Corbusier 1886:141).

BATTISTE GOOD
1843–44
Brought home the magic arrow winter.

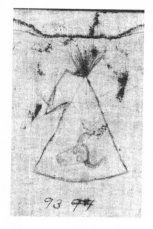

ROSEBUD
1843–44
They made medicine to bring the buffalo.

Collector's Notes: This arrow originally belonged to the Cheyennes, from whom the Pawnees stole it. The Dakotas captured it this winter from the Pawnees and the Cheyennes then redeemed it for one hundred horses (Mallery 1893:322). The upper part of the body is sable or black, the feathers on the arrow are azure or blue, and the shaft, gules or red. The remainder of the figure is of an undecided color not requiring specification (Corbusier 1886:141).

Comments: "Gules" is a heraldic term referring to the color red.

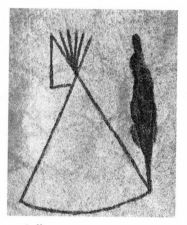

LONE DOG
1844–45
The Minneconjous built a pine fort.

NO EARS
1843–44
Captives brought/Wayaka akilipi.

Comments: A *wayaka* is a prisoner, one taken captive in war (Buechel 1970:563); the verb *aklipi* or *aglipi* means "they returned home" (Buechel 1970:57).

Collector's Notes: Device, a pine tree connected with a tipi. Another account explains that they went to the woods and erected their tipis there as affording some protection from the unusually deep snow. This would account for the pine tree (Mallery 1893:281).

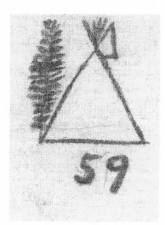

THE FLAME
1844–45
Mandans wintered in Black Hills.

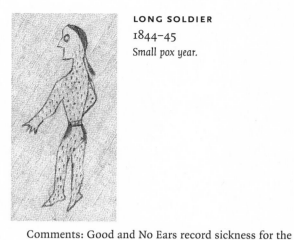

LONG SOLDIER
1844–45
Small pox year.

Collector's Notes: Probably the Indians went into the woods and erected their tipis there as protection from the snow, thus accounting for the figure of the tree (Mallery 1886:119).

Comments: Good and No Ears record sickness for the following year.

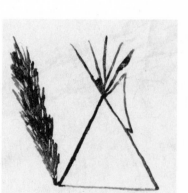

THE SWAN
1844–45
Unusually heavy snow; had to build corrals for ponies.

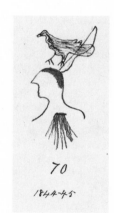

AMERICAN HORSE
1844–45
Male Crow [He Crow], an Oglala, was killed by the Shoshoni (Corbusier 1886:141).

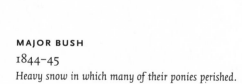

MAJOR BUSH
1844–45
Heavy snow in which many of their ponies perished.

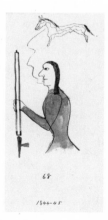

CLOUD SHIELD
1844–45
Crazy Horse said his prayers and goes on the warpath.

Collector's Notes: The waved lines are used again for crazy (Corbusier 1886:141).

ROSEBUD
1844–45
They camped among the pine trees.

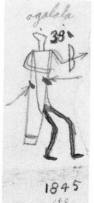

BATTISTE GOOD
1844–45
The Crows came and killed thirty-eight Oglalas winter.

Collector's Notes: The Oglalas were on the warpath, as indicated by the capote (Mallery 1893:322). White Cow Killer notes "White-Buffalo-Bull-killed-by-the-Crows winter" (Corbusier 1886:141).

Comments: Capotes were made of wool blankets and would only have been used in the winter.

LONE DOG
1845–46
Plenty of buffalo meat, which is represented as hung upon poles and trees to dry.

Collector's Notes: This device has become the conventional sign for plenty and frequently appears in the several charts (Mallery 1893:282).

Comments: There are two devices that Lakotas used to indicate successful hunts and plenty of meat: one is this image of strips of meat on a drying rack, and the other is of a "buffalo belly," as pictured for several counts in 1816–17. Some counts include a related event for 1861–62.

NO EARS
1844–45
He-Crow killed/Kanga-bloka ahin ktepi.

Comments: The name Male Crow, or more properly He Crow, should read *Kangi Bloka*.

THE FLAME
1845–46
Dakotas have much feasting at Ash Point, 20 miles above Fort Sully (Mallery 1886:199).

THE SWAN

1845–46

Immense quantities of buffalo meat (Mallery 1886:119).

MAJOR BUSH

1845–46

Plenty of buffalo meat.

LONG SOLDIER

1845–46

Year they killed seven wildcats, man eaters.

Comments: This event is noted on other northern winter counts (not in the Smithsonian collections); often the year event is depicted with seven cat heads.

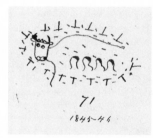

AMERICAN HORSE

1845–46

White Bull and 30 other Oglala were killed by the Crow and Shoshoni (Corbusier 1886:141).

Comments: White Cow Killer noted White Bull's death in the previous year (see Good 1844–45).

CLOUD SHIELD

1845–46

White Bull and many others killed in a fight with Shoshoni.

Comments: Note the similarity between this image and those depicted by Cloud Shield for 1830–31 and 1857–58.

BATTISTE GOOD

1845–46

Broke out on faces had sore throats and camped under the bluff winter.

Collector's Notes: "Also had bellyache." The position of the camp is shown, also suggestive attitude of the man (Mallery 1893:322).

Comments: Note how Good depicts a bluff in this entry and in his image for 1856–57. A few other calendars note an outbreak of disease around this time.

NO EARS
1845–46
Fourth measles/Nawicasli itopa.

Comments: No Ears records the first three episodes of measles in 1782–83, 1801–02, and 1818–19.

ROSEBUD
1845–46
Plenty of buffalo meat.

LONE DOG
1846–47
Broken-Leg died.

Collector's Notes: Rev. Dr. [John P.] Williamson says he knew him. He was a Brulé. There is enough difference between this device and those for 1808–09 and 1832–33 to distinguish each (Mallery 1893:282).

Comments: Several counts record many broken legs in 1847–48, probably due to snow and ice.

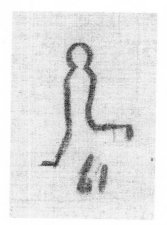

THE FLAME
1846–47
Broken Leg dies.

Collector's Notes: Mato Sapa says: A Minneconjou named Broken Leg died (Mallery 1886:119).

THE SWAN
1846–47
A Minneconjou Dakota named Broken Leg died.

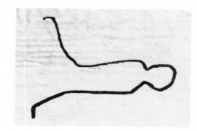

MAJOR BUSH
1846–47
Minneconjou Sioux named "Broken Back" killed by Crow Indians near Black Hills.

LONG SOLDIER
1846–47
*Man named Harvey Bull
was made chief.*

Comments: For similar pictographs noting the making of a chief, see Long Soldier 1798–99 and 1803–04.

AMERICAN HORSE
1846–47
Big-Crow and Conquering-Bear had a great feast and gave many presents (Corbusier 1886:142).

72
1846–47

CLOUD SHIELD
1846–47
Long Pine, a Dakota, was killed by Dakotas.

70
1846–47

Collector's Notes: He was not killed by an enemy, as he has not lost his scalp (Corbusier 1886:142).

Comments: There is no real consistency in terms of scalping indicating death at the hands of an enemy; many pictographs mark a Lakota's death yet the figures are not scalped.

BATTISTE GOOD
1846–47
Winter Camp broke his neck winter.

1847

Collector's Notes: He was thrown from his horse while on a hunt. The red on his neck is the break (Mallery 1893:322). White Cow Killer calls it "Diver's-neck-broken winter" (Corbusier 1886:142).

NO EARS
1846–47
Man with white testicles killed/Susu ska wan ktepi.

Comments: Some counts record the man's name as White Testicles.

ROSEBUD

1846–47

"Lean Buffalo" counts coup with a pipe.

Comments: The name glyph of the man with the pipe is a white buffalo marked with dark stripes, indicating thinness or starvation. Other counts mark the death of a man named White (Buffalo) Bull for the previous year.

LONE DOG

1847–48

Two-Man was killed.

Collector's Notes: His totem is drawn, two small man figures side by side. Another interpretation explains the figure as indicating twins (Mallery 1893:282).

THE FLAME

1847–48

Mandans kill two Minneconjous.

THE SWAN

1847–48

Two Minneconjou Dakotas were killed by the Assiniboine Indians (Mallery 1886:119).

MAJOR BUSH

1847–48

Wife of an Assiniboin Chief named "Big Thunder" had twins.

LONG SOLDIER

1847–48

Year that they gave nothing but blankets.

Comments: Several counts mark this event in 1851–52. It represents the 1851 Fort Laramie treaty, when the people received blankets.

AMERICAN HORSE
1847–48
There were many accidents; some broke their legs because the ground was covered with ice.

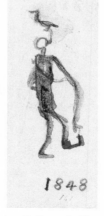

BATTISTE GOOD
1847–48
The Teal broke his leg winter.

Collector's Notes: White Cow Killer calls it "Many-legs-broken winter" (Corbusier 1886:142).

Comments: Several entries in 1846 and 1847 identify individuals who broke their legs around this time.

Collector's Notes: His arm is lengthened to direct attention to his leg (Mallery 1893:322).

NO EARS
1847–48
Crow-eagle stabbed/Kangi-wambli capapi.

CLOUD SHIELD
1847–48
Many were thrown from their horses while surrounding buffalo in the deep snow, and some had their legs broken.

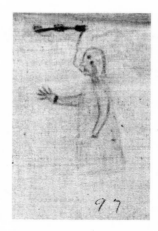

ROSEBUD
1847–48
Lakota shot in the cheek.

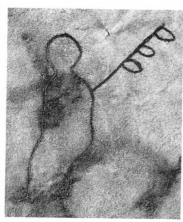

LONE DOG
1848–49
Humpback was killed.

THE SWAN
1848–49
A Minneconjou Dakota named Broken Back was killed by the Crow Indians at Black Hills.

Collector's Notes: An ornamented lance pierces the distorted back. Other records name him Broken-Back. He was a distinguished chief of the Minneconjous (Mallery 1893:282).

MAJOR BUSH
1848–49
An Unkpapah brave named "Hollow Back" shot by a Ree Indian with a three (3) feathered arrow.

THE FLAME
1848–49
Humpback, a Minneconjou, killed.

LONG SOLDIER
1848–49
No good hay this year.

Collector's Notes: Major Bush says: A Minneconjou, Broken Back, was killed by Crows (Mallery 1886:119–120).

Comments: Mallery's reference does not fully agree with the original Major Bush manuscript entry given below.

Collector's Notes: Ground bare.

AMERICAN HORSE

1848–49

American-Horse's father captured a Crow man dressed as a woman and killed him.

covered that she was an hermaphrodite and killed her (Corbusier 1886:142).

BATTISTE GOOD

1848–49

Killed the hermaphrodite winter and Big horse stealing winter.

Collector's Notes: American-Horse's father captured a Crow who was dressed as a woman, but who was found to be an hermaphrodite and killed her. White Cow Killer calls it "Half man and half woman killed winter." It is probable that this was one of those men, not uncommon among the Indian tribes, who adopt the dress and occupation of women (Corbusier 1886:142).

Comments: Corbusier notes that this practice was sometimes compulsory, if the man had failed to successfully endure an ordeal (1886:142). In Lakota, the word for such men is *winkte*. This was an accepted, although powerful and dangerous, social role among the Lakota. For the following year (1849–50), many counts note that the Crows took revenge by stealing many horses.

Collector's Notes: They captured a Crow who pretended to be a woman, but who proved to be a man, and they killed him. . . . Eight hundred horses were stolen from the Dakotas, but seven hundred of them were recovered. The Crows killed one Dakota, as is indicated by the arrow in contact with the red spot in the hoof print (Mallery 1893:323).

Comments: Other counts place the second event in the following year.

CLOUD SHIELD

1848–49

American Horse's father captured a Crow woman, who was really a hermaphrodite.

NO EARS

1848–49

A hermaphrodite was killed/Winkte wan ktepi.

Comments: More properly, the Lakota term *winkte* refers to a man who dressed and acted like a woman.

Collector's Notes: American Horse's father captured a Crow woman and gave her to the young men, who dis-

ROSEBUD
1848–49
Humpback was killed by the Crows.

THE FLAME
1849–50
Crows steal all the Dakotas' horses (Mallery 1886:120).

LONE DOG
1849–50
The Crows stole a large drove of horses (it is said eight hundred) from the Brulés.

Collector's Notes: The circle is a design for a camp or corral from which a number of horse-tracks are departing (Mallery 1893:282).

Comments: This theft was in response to the killing of a Crow hermaphrodite the previous year.

THE SWAN
1849–50
Crow Indians stole two hundred horses from the Minneconjou Dakotas near Black Hills.

Collector's Notes: Interpreter A[lex] Lavary says: Brulés were at the headwaters of White River, about 75 miles from Fort Laramie, Wyoming. The Dakotas surprised the Crows in 1849, killed ten, and took one prisoner, because he was a man dressed in woman's clothes, and next winter the Crows stole six hundred horses from the Brulés (Mallery 1886:120).

MAJOR BUSH
1849–50
Crow Indians stole two hundred horses from Minneconjou Sioux.

LONG SOLDIER
1849–50
Year they went hunting buffalo and while they were hunting the Crows came in on them and fought them.

Comments: They must have been hunting buffalo on horseback because four horse hoof marks, distinct from buffalo hoofprints, are shown.

CLOUD SHIELD
1849–50
Making The Hole stole many horses from a Crow tipi.

Collector's Notes: The index points to the hole, which is suggestive of the man's name (Corbusier 1886:142).

AMERICAN HORSE
1849–50
Many died of the cramps.

Collector's Notes: The cramps were those of Asiatic cholera, which was epidemic in the United States at that time, and was carried to the Plains by the California and Oregon emigrants. The position of the man is very suggestive of cholera. White Cow Killer calls it "The-people-had-the-cramps winter" (Corbusier 1886:142).

BATTISTE GOOD
1849–50
Brought the Crows to a stand winter.

Collector's Notes: This was done at Crow Butte, near Camp Robinson, Nebraska. It is said that a party of Crows, who were flying from the Dakotas, took refuge on the Butte about dark and that the Dakotas surrounded them, confident of capturing them the next morning, but the Crows escaped during the night, very much to the chagrin of the Dakotas. The Crow's head is just visible on the summit of the hill, as if the body had gone down (Mallery 1893:323).

NO EARS
1849–50
Cramps/Nawicatipa.

ROSEBUD
1849–50
They captured a Crow half-man and half-woman.

Comments: This figure has the distinctive hairstyle of the Crow tribe with upright forelock and netted extension. His name glyph is of a buffalo hoofprint. Conflicts with the Crow are noted in various counts for both this and the previous year. Other winter counts indicate it was probably a *winkte* or berdache, for example, No Ears (1848–49).

LONE DOG
1850–51
Buffalo cow was killed and an old woman found in her belly.

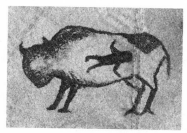

Collector's Notes: [Basil] Clément translated that "a buffalo cow was killed in that year and an old woman found in her belly;" also that all the Indians believed this. Good-Wood, examined through another interpreter, could or would give no explanation except that it was "about their religion." The Dakotas have long believed in the appearance from time to time of a monstrous animal that swallows human beings. This superstition was perhaps suggested by the bones of mastodons, often found in the territory of those Indians; and, the buffalo being the largest living animal known to them, its name was given to the legendary monster, in which nomenclature they were not wholly wrong, as the horns of the fossil Bison latifrons are 10 feet in length (Mallery 1893:282–283).

Comments: Some recorders of winter counts have rejected this spiritual or miraculous explanation in favor of one more in keeping with Western concepts of historical events. The woman may have been seeking shelter from the cold inside a buffalo carcass. It is notable that they did not question the occurrence of the event, merely its interpretation.

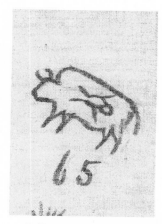

THE FLAME
1850–51
Cow with old woman in her belly.

Collector's Notes: Cloven hoof not shown (Mallery 1886:120).

THE SWAN
1850–51
A Minneconjou Dakota, having killed a buffalo cow, found an old woman inside of her.

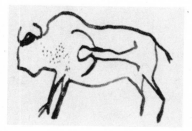

Collector's Notes: Memorandum from the interpreter [Jean Premeau]: A small party of Dakotas, two or three young men, returning unsuccessful from a buffalo hunt, told this story, and it is implicitly believed by the Dakotas (Mallery 1886:120).

MAJOR BUSH
1850–51
Minneconjou Sioux killed a Buffalo Cow, and found in her what was supposed to be a woman.

Collector's Notes: Major Bush suggests that perhaps some old squaw left to die sought the carcass of a buffalo for shelter and then died. He has known this to occur (Mallery 1893:282–283).

LONG SOLDIER
1850–51
Year Chief Catching Turtle died.

Comments: Other northern winter counts not in this collection mark the death of this man.

AMERICAN HORSE
1850–51
Wolf Robe was killed by the Pawnees (Corbusier 1886:142).

Comments: The man's name is indicated by a large figure, not just a name glyph. The Pawnee identity is quite obvious from the scalp-lock hairstyle.

CLOUD SHIELD
1850–51
Many died of the smallpox.

Collector's Notes: White Cow Killer calls this "All-the-time-sick-with-the-big-smallpox winter" (Corbusier 1886:142).

Comments: White Cow Killer distinguishes this outbreak from the "little smallpox" in 1818–19 (Corbusier 1886:136).

BATTISTE GOOD
1850–51
The big smallpox winter (Mallery 1893:323).

NO EARS
1850–51
Small-pox/Wicahanhan.

ROSEBUD
1850–51
Buffalo cow with old woman in her belly.

Comments: This image correlates to other counts, which record that a woman was found inside a buffalo that had been shot. In this image, however, the figure inside the buffalo resembles a calf rather than a human.

LONE DOG
1851–52
Peace with the Crows.

Collector's Notes: Two Indians, with differing arrangement of hair, showing two tribes, are exchanging pipes for a peace smoke (Mallery 1893:283).

Comments: Although Lakota figures are usually pictured on the right, this image has the Crow enemy (with the long hair) in that position. This pictograph marks the signing of the 1851 Fort Laramie treaty. Some counts mark the event with peace pipes, while others use the image of a blanket to indicate that goods were distributed.

THE FLAME
1851–52
Peace made with the Crows.

Collector's Notes: The Treaty of Fort Laramie was in 1851 (Mallery 1886:120–121).

THE SWAN
1851–52
Dakotas made peace with the Crows.

Collector's Notes: It was, as usual, broken immediately (Mallery 1886:121).

MAJOR BUSH
1851–52
Minneconjou Sioux made peace with the Crow Indians.

LONG SOLDIER
1851–52
Year Sitting Bull was made chief because he made peace with the Crows.

Comments: This event is connected to the 1851 Fort Laramie treaty.

AMERICAN HORSE
1851–52
They received their first annuities at the mouth of Horse Creek.

Collector's Notes: A one-point blanket is depicted and denotes dry-goods. It is surrounded by a circle of marks which represent the people (Corbusier 1886:42). White Cow Killer calls this "Large issue of goods on the Platte River winter" (Corbusier 1886:142).

CLOUD SHIELD
1851–52
Many goods were issued to them at Fort Laramie.

Collector's Notes: They were the first received. The blanket which is represented stands for the goods (Corbusier 1886:142).

BATTISTE GOOD
1851–52
First issue of goods winter.

Collector's Notes: The colored patches outside the circle are at the four cardinal points, the colored patches inside the circle are meant for blankets and the other articles issued, and the circle of strokes the people sitting. The Dakotas were told that fifty-five years after that issue they would have to cultivate the ground, and they

understood that they would not be required to do it before (Mallery 1893:323).

NO EARS
1851–52
Great distribution/Wakpanini pi tanka.

Comments: The Lakota word should read *wakpamni.*

ROSEBUD
1851–52
They camped among the pine trees again.

Comments: A similar entry appears in this count for 1844–45. It is similar to one in the Hardin count for 1856–57, indicating a trader camped in trees, perhaps Jim Bordeaux.

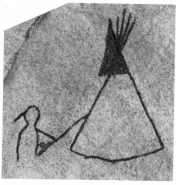

LONE DOG
1852–53
The Nez Perces came to Lone-Horn's lodge at midnight.

Collector's Notes: The device shows an Indian touching with a pipe a tipi, the top of which is black or opaque, signifying night. Touch-the-Clouds, a Minneconjou, son of Lone-Horn, when this chart was shown to him by the present writer, designated this character as being particularly known to him from the fact of its being his father's lodge. He remembered all about it from talk in

his family, and said it was the Nez Perces who came (Mallery 1893:283). Mato Sapa says: Several strange Indians came into the Dakota camp, were saved from being killed by running into Lone Horn's lodge (Mallery 1886:121).

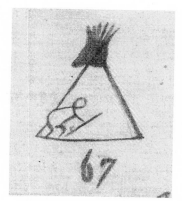

THE FLAME
1852–53
A Crow chief, Flat Head, comes into the tipi of a Dakota chief, where a counsel was assembled, and forces them to smoke the pipe of peace.

Collector's Notes: This was a daring act, for he was in danger of immediate death if he failed (Mallery 1886:121).

THE SWAN
1852–53
An enemy came into Lone Horn's lodge during a medicine feast and was not killed.

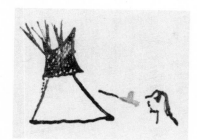

Collector's Notes: (The enemy numbered about fourteen and had lost their way in a snow storm.) The pipe is not in the man's hand, and the head only is drawn with the pipe between it and the tipi (Mallery 1886:121).

MAJOR BUSH

1852–53

An enemy came into "Lone Horn's" Lodge during a feast and was not killed.

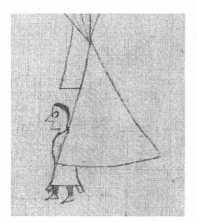

LONG SOLDIER

1852–53

Camp in winter. Woman was killed by intent by husband who was mad.

Comments: The picture could indicate that she was killed inside the tent.

AMERICAN HORSE

1852–53

The Cheyennes carry the pipe around to invite other tribes to war against the Pawnees (Corbusier 1886:142).

CLOUD SHIELD

1852–53

A white man made medicine over the skull of Crazy Horse's brother.

Collector's Notes: He holds a pipe stem in his hand. This probably refers to the custom of gathering the bones of the dead that have been placed on scaffolds and burying them (Corbusier 1886:142).

BATTISTE GOOD

1852–53

Deep snow used up the horses winter.

Collector's Notes: The spots around the horses represent snow (Mallery 1893:323). White Cow Killer calls it "Great-snow winter" (Corbusier 1886:142).

Comments: Other southern counts note a similar event, but at different times. Good uses the same kind of device as here—a crouched figure—to indicate people who had frozen (1747–48 and 1783–84).

NO EARS

1852–53

Winter of deep snow/Wasma waniyetu.

ROSEBUD

1852–53

Four enemies came to One Horn's lodge at night and were not killed.

Comments: The owner of the tipi, shown on the left, is identified by his name glyph. Lone Dog identified the enemies as Nez Perces, while The Flame said that they were Crows. Both tribes were distinguished by the pompadour or upright forelock hairstyle shown here.

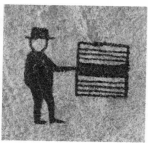

LONE DOG

1853–54

Spanish blankets were first brought to the country.

Collector's Notes: A fair drawing of one of those striped blankets is held out by a white trader (Mallery 1893:283).

Comments: The receipt of blankets is noted in several counts for 1851–52 and 1858–59.

THE FLAME

1853–54

Spanish blankets introduced by traders.

Collector's Notes: The blanket is represented without the human figure (Mallery 1886:121).

THE SWAN

1853–54

Dakotas first saw the Spanish blankets.

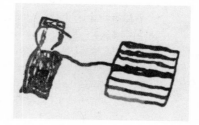

MAJOR BUSH

1853–54

First saw the Spanish Blankets.

LONG SOLDIER
1853–54
Crow Indian has on a Sioux hat and is killed by Sioux.

Collector's Notes: Is called "Year four horned Crow was killed."

Comments: The enemy is shown wearing a capote, a wool coat made from trade blankets, suggesting that this event took place in the winter. The Crow may have been called Four Horns, as indicated by his headdress.

AMERICAN HORSE
1853–54
Antelope-Dung broke his neck while surrounding buffalo (Corbusier 1886:143).

Collector's Notes: White Cow Killer calls this year "Oak-wood-house winter" (Corbusier 1886:143).

CLOUD SHIELD
1853–54
Antelope Dung broke his neck while running antelope.

Comments: His severed head is the only part of his body shown.

BATTISTE GOOD
1853–54
Cross Bear died on the hunt winter.

Collector's Notes: The travail [travois] means they moved; the buffalo, to hunt buffalo; the bear with mouth open and paw advanced, Cross Bear; the stomach and intestines, took the bellyache and died. The gesture sign for bear is made as follows: Slightly crook the thumbs and little fingers, and nearly close the other fingers; then, with their backs upward, hold the hands a little in advance of the body or throw them several times quickly forward a few inches. The sign is sometimes made with one hand only (Mallery 1893:324).

NO EARS
1853–54
A bear raped a virgin/Mato wan wisan manu.

Comments: Some calendars record that a man named Bear assaulted a woman, while others indicate that it was an animal.

ROSEBUD
1853–54
Man wearing four-horned war bonnet was killed.

THE FLAME
1854–55
Brave Bear was killed by Blackfeet (Mallery 1886:121).

Comments: The British Museum and Cranbrook counts record the death of a man with a four-horned bonnet this year. Other counts, including this one, record events relating to a Lakota warrior named Four Horns for 1856–57. The Long Soldier entry for this year shows a Crow warrior with a similar headdress who was killed.

THE SWAN
1854–55
A Minneconjou Dakota named Brave Bear was killed by the Upper Blackfeet (Satsika?).

LONE DOG
1854–55
Brave-Bear was killed.

Collector's Notes: His extended arms are ornamented with pendent stripes (Mallery 1893:283).

Comments: This is known in the historical literature as the Mormon cow incident or the Grattan massacre (see American Horse and Good for this year). The pendant stripes are probably locks of hair. Note the similarity of this image to that for the year 1866–67, when Swan, chief of the Minneconjous, died.

Comments: Although a few calendars note this man's death at the hands of another Lakota band, it probably happened during the Grattan massacre or Mormon cow incident.

MAJOR BUSH
1854–55
Minniconjou Sioux named "Brave Bear" killed by the Upper Blackfeet Indians.

LONG SOLDIER

1854–55

Chief Bear Heart was killed.

Comments: This is probably an alternative version of the name Conquering Bear, or Brave Bear.

AMERICAN HORSE

1854–55

Conquering-Bear was killed by white soldiers, and 30 soldiers were killed in retaliation 9 miles below Fort Laramie.

Collector's Notes: The thirty black dots in the three lines stand for the soldiers, and the red stains for killed. The head covered with a fatigue-cap further shows they were white soldiers. Indian soldiers [warriors] are usually represented in a circle or semicircle. The gesture-sign for soldier means all in a line, and is made by placing the nearly closed hands with palms forward, and thumbs near together, in front of the body and then separating them laterally about two feet (Corbusier 1886:143). White Cow Killer calls this "Mato-wayuhi (or Conquering Bear) killed by white soldiers winter" (Corbusier 1886:143).

CLOUD SHIELD

1854–55

Brave Bear was killed in a quarrel over a calf.

Collector's Notes: He was killed by enemies; hence his scalp is gone (Corbusier 1886:143).

BATTISTE GOOD

1854–55

Killed five Assiniboins winter.

Collector's Notes: The Dakotas are ashamed of the part they took in the following deplorable occurrence and it is not therefore noted in the record, although it really marks the year. In consequence of a misunderstanding in regard to an old foot-sore cow, which had been abandoned on the road by some emigrants and which the Dakotas had innocently appropriated, Lieut. Grattan, Sixth U.S. Infantry, killed Conquering Bear (Mato-way'uhi, Startling Bear properly) about ten miles east of Fort Laramie, August 19, 1854. The Dakotas then, in retaliation, massacred Lieut. Grattan and the thirty men of Company G, Sixth U.S. Infantry, he had with him. The figure without the above statement tells the simple story about the killing of five

Assiniboins who are denoted by the usual tribal sign, the number being designated by the five strokes below the arrow (Mallery 1893:324).

expedition, with the delegations from nine of the bands of the Sioux, viz, the Two Kettle band, Lower Yankton, Uncpapas, Blackfeet Sioux, Minneconjous, Sans Arcs, Yanctonais (two bands), Brulés of the Platte" (Mallery 1893:283).

NO EARS
1854–55
Conquering-bear killed/Mato-wayuhi ktepi.

ROSEBUD
1854–55
Chief Brave Bear died.

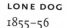

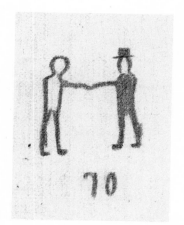

THE FLAME
1855–56
General Harney makes a treaty.

Collector's Notes: General Harney (Putin ska) makes a treaty (Mallery 1886:121).

LONE DOG
1855–56
Gen. Harney, called by the Dakota Putinska ("white beard" or "white mustache"), made peace with a number of the tribes or bands of the Dakotas.

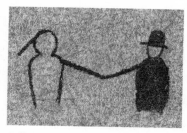

Collector's Notes: The figure shows an officer in uniform shaking hands with an Indian. Executive document No. 94, Thirty-fourth Congress, first session, Senate, contains the "minutes of a council held at Fort Pierre, Nebraska, on the 1st day of March 1856, by Brevet Brig. Gen. William S. Harney, U.S. Army, commanding the Sioux

THE SWAN
1855–56
Dakotas made peace with General Harney (called by them Putinska, white beard or moustache) at Fort Pierre, Dakota [Territory] (Mallery 1886:122).

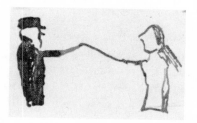

MAJOR BUSH
1855–56
Sioux made peace with General Harney at Fort Pierre D.T. [Dakota Territory].

LONG SOLDIER
1855–56
*Year White Whiskers captured
Indians and would not let them go.*

Collector's Notes: In Blackfoot Bottoms was a trader.
Comments: This refers to an incident in which Gen. Harney held some Lakota as prisoners.

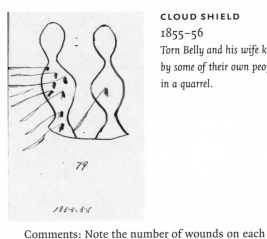

CLOUD SHIELD
1855–56
*Torn Belly and his wife killed
by some of their own people
in a quarrel.*

Comments: Note the number of wounds on each figure. Such details suggest the accuracy of winter count pictographs, as one figure is depicted with eight wounds and the other with only one.

AMERICAN HORSE
1855–56
*A war party of Oglalas killed a Pawnee;
on the way home, their feet froze.*

Collector's Notes: A war party of Oglalas killed one Pawnee—his scalp is on the pole—and on the way home froze their feet. White Cow Killer calls it "A-medicine-man-made-buffalo-medicine winter" (Corbusier 1886:143).

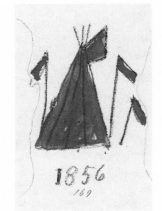

BATTISTE GOOD
1855–56
*Little Thunder and Battiste
Good and others taken
prisoners at Ash Hollow on
the Blue Creek winter.*

Collector's Notes: And one hundred and thirty Dakotas were killed by the white soldiers. Also called "Many sacrificial flags winter." The last-mentioned name for the winter is explained by other records and by Executive Document No. 94, Thirty-fourth Congress, first session, Senate, to refer to a council held on March 18, 1856, by Brevet Brig. Gen. W.S. Harney, U.S. Army, with nine of the bands of the Dakotas (Mallery 1893:324).

NO EARS

1855–56

Hornet would not give up/Wicayajipa wa aksija.

Comments: This may refer to Gen. Harney, who took Lakota prisoners about this time. Harney was sometimes called Hornet by the Lakota.

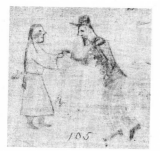

ROSEBUD

1855–56

Putinska captured women and children and made peace.

Comments: Other counts show an army officer joining hands with a Lakota to indicate agreement to a treaty of peace. In this count the Lakota is clearly a woman, who would not have been authorized to handle such an issue. The Cranbrook count records that women and children were detained by the army.

LONE DOG

1856–57

Four-Horn was made a calumet or medicine man.

Collector's Notes: A man with four horns holds out the same kind of ornamented pipe stem shown in the character for 1804–05, it being his badge of office. Four-Horn was one of the subchiefs of the Uncpapas, and was introduced to Gen. Harney at the council of 1856 by Bear-Rib, head chief of that tribe. Interpreter [Basil] Clément, in the spring of 1874, said that Four-Horn and Sitting-Bull were the same person, the name Sitting-Bull being given

him after he was made a calumet man. No other authority tells this (Mallery 1893:284).

Comments: Sitting Bull did have a relative named Four Horns, which some sources say was his uncle.

THE FLAME

1856–57

Four Horns, a great warrior.

THE SWAN

1856–57

A Minneconjou Dakota, named Red Fish's Son, danced calumet dance.

Collector's Notes: Mato Sapa says the same (Mallery 1886:122).

MAJOR BUSH

1856–57

A Minniconjou Sioux named "Red [Fish's Son, The] Ass" danced the four horned Calumet.

LONG SOLDIER

1856–57

Year half a war bonnet was torn off a Crow Indian who was determined to go to war with Sioux.

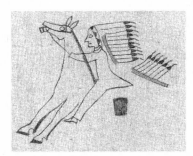

Collector's Notes: Also, Yellow Bucket, a Poplar Creek Indian was killed.

Comments: The Poplar Creek Indian may be an Assiniboine. Note that only half the horse is shown in this image.

CLOUD SHIELD

1856–57

They have an abundance of buffalo meat.

Collector's Notes: This is shown by the full drying pole (Corbusier 1886:143).

Comments: Strips hanging on a drying rack is a conventional way to depict an abundance of meat.

AMERICAN HORSE

1856–57

They received annuities at Rawhide Butte.

Collector's Notes: The house and the blanket represent the agency and the goods received. White Cow Killer calls this "White-hill-house winter" (Corbusier 1886:143).

BATTISTE GOOD

1856–57

Bad Four Bear trades with Battiste Good for furs all winter.

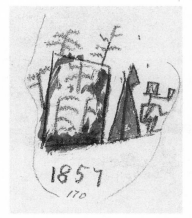

Collector's Notes: Bad Four Bear, a white trader, is represented sitting smoking a pipe in front of Battiste's tipi under a bluff at Fort Robinson, Nebraska (Mallery 1893:324).

Comments: Note how Good depicts a bluff; also see Good 1845–46.

NO EARS

1856–57

Crows with the whites/Kangi wasicu obkju.

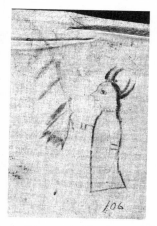

ROSEBUD

1856–57

The Ass danced the Four Horns Calumet Dance.

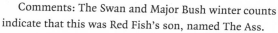

Comments: The Swan and Major Bush winter counts indicate that this was Red Fish's son, named The Ass.

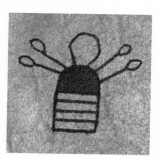

LONE DOG

1857–58

The Dakotas killed a Crow squaw.

Collector's Notes: She is pierced by four arrows, and the peace made with the Crows in 1851–52 seems to have been short lived (Mallery 1893:284).

Comments: There is no indication in the image that this figure is a woman. The explanation must have come from Lone Dog through Basil Clément.

THE FLAME

1857–58

White Robe kills a Crow woman.

Collector's Notes: There is but one arrow and one blood spot in the character. . . . Mato Sapa says: A Crow was killed by a Dakota while on a visit to the latter (Mallery 1886:122).

THE SWAN

1857–58

A party of Crow Indians, while on a visit to the Dakotas, had one of their number killed by a young Dakota.

Collector's Notes: The figure has blood from the four arrows running down each side of the body (Mallery 1886:122).

MAJOR BUSH

1857–58

During a visit of some Crow Indians to the Sioux, a Crow woman was killed by a Sioux warrior.

LONG SOLDIER
1857–58
Indian from Poplar that Sitting Bull brought back a captive and when he went to war with Crows he got his legs broken.

Collector's Notes: Little Bear was his name.
Comments: The Poplar Indian may be an Assiniboine.

CLOUD SHIELD
1857–58
They surrounded and killed ten Crows.

Comments: Note the similarities between this image and that for Cloud Shield 1830–31 and 1845–46.

AMERICAN HORSE
1857–58
Little Gay, a white trader, was killed by an exploding can of gun powder.

Collector's Notes: He was measuring out powder from the can in his wagon while smoking his pipe (Corbusier 1886:143).

BATTISTE GOOD
1857–58
Hunted bulls only winter.

Collector's Notes: They found but few cows, the buffalo composed principally of bulls. The travail [travois] is shown (Mallery 1893:324). White Cow Killer calls it "Bull-hunting winter" (Corbusier 1886:143).

NO EARS
1857–58
Crows killed ten whites/Kangi wasicu wickemna wica ktepi.

ROSEBUD

1857–58

They surrounded and killed many Crows.

THE FLAME

1858–59

Lone Horn makes medicine.

LONE DOG

1858–59

Lone-Horn, whose solitary horn appears, made buffalo "medicine," doubtless on account of the scarcity of that animal.

Collector's Notes: At such times, Indians sacrifice ponies, etc., and fast. In this character the buffalo head is black (Mallery 1886:122).

Comments: Note the similarity between this image for "making medicine" and the ones in several records for 1860–61.

Collector's Notes: Again the head of an albino bison. One-Horn, probably the same individual, is recorded as the head chief of the Minneconjous at this date (Mallery 1893:285).

Comments: The image for this ceremony is similar to that for 1810–11, when Black Stone performed this ceremony. However, both of these are quite different from the pictograph for 1843–44, which portrays a tipi with the head of a normal (not albino) buffalo.

THE SWAN

1858–59

A Minneconjou chief, named Lone Horn, made medicine with white buffalo cow skin.

Collector's Notes: Lone Horn, chief of Minneconjous, died in 1874, in his camp on the Big Cheyenne [River] (Mallery 1886:123).

MAJOR BUSH
1858–59
Minniconjou Sioux named "Lone Horn" made medicine with white buffalo cow skin.

LONG SOLDIER
1858–59
After peace was made, Crows still wanted to fight.

Collector's Notes: Sitting Bull on red horse. All Crows were killed in fight.

AMERICAN HORSE
1858–59
They made peace with the Pawnees.

Collector's Notes: The one on the left is a Pawnee. White Cow Killer calls it "Yellow-blanket-killed winter" (Corbusier 1886:143).

Comments: Note the characteristic scalp-lock hairstyle of the Pawnee.

CLOUD SHIELD
1858–59
They bought Mexican blankets from John Richard.

Collector's Notes: They bought Mexican blankets of John Richard, who bought many wagon-loads of the Mexicans (Corbusier 1886:143).

Comments: Compare this blanket with the ones shown in various counts for 1851–52 and 1853–54. This trader is also mentioned in Cloud Shield (1869–70 and 1872–73) and American Horse (1871–72).

BATTISTE GOOD
1858–59
Many Navajo blankets winter.

Collector's Notes: A Navajo blanket is shown in the figure. Several of the records agree in the explanation about the bringing of these blankets at that time (Mallery 1893:325).

NO EARS
1858–59
Yellow-blanket killed/Tasina-gi ktepi.

Collector's Notes: White Cow Killer calls it "Yellow-blanket-killed winter" (Corbusier 1886:143).

ROSEBUD
1858–59
Chief One Horn had a give away.

Comments: This was probably in honor of his dead son.

LONE DOG
1859–60
Big-Crow, a Dakota chief, was killed by the Crows.

Collector's Notes: He had received his name from killing a Crow Indian of unusual size (Mallery 1893:284).

Comments: Several northern winter counts (not in the Smithsonian collections) note the killing of a fat Crow.

THE FLAME
1859–60
Big Crow was killed.

Collector's Notes: Mato Sapa says: Big Crow, a Minneconjou, was killed by Crows (Mallery 1886:123).

THE SWAN
1859–60
A Minneconjou Dakota, named Big Crow, was killed by the Crow Indians.

Collector's Notes: He had received his name from killing a Crow Indian of unusual size (Mallery 1886:123).

MAJOR BUSH
1859–60
Minniconjou Sioux named "Big Crow" killed by Crow Indians.

LONG SOLDIER
1859–60
Chief Tied Braid was killed by Crows in war.

AMERICAN HORSE
1859–60
Broken-Arrow fell from his horse while
running buffalo and broke his neck
(Corbusier 1886:143).

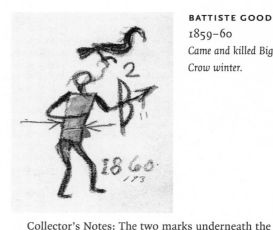

BATTISTE GOOD
1859–60
Came and killed Big
Crow winter.

Collector's Notes: The two marks underneath the
arrow indicate that two were killed (Mallery 1893:325).

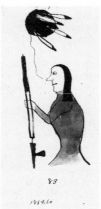

CLOUD SHIELD
1859–60
Black Shield says prayers and takes
the warpath.

NO EARS
1859–60
Big-crow killed/Knagi-tanka ktepi.

Comments: The man's name should read *Kangi tanka*.

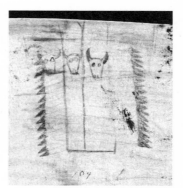

ROSEBUD
1859–60
Chief One Horn makes
medicine.

Collector's Notes: Black Shield says prayers and takes
the warpath to avenge the death of two of his sons who
had been killed by the Crows. White Cow Killer calls it
"Black Shield's two boys go hunting and are killed by the
Crows winter" (Corbusier 1886:143).

Comments: A number of counts record the making of
buffalo medicine for the previous year. The row of buffalo
skulls suggest that this entry is also related to a buffalo
ceremony.

LONE DOG
1860–61

The elk made you understand the voice while he was walking.

THE FLAME
1860–61

The Elk Who Shows Himself When He Walks made medicine.

Collector's Notes: Device, the head and neck of an elk, similar to that part of the animal for 1837–'38, with a line extending from its mouth at the extremity of which is the albino buffalo head. The interpreter persisted in this oracular rendering. This device and its interpretation were unintelligible to the writer until examination of Gen. Harney's report, above referred to, showed the name of a prominent chief of the Minneconjous set forth as "The Elk that Holloes Walking." It then became probable that the device simply meant that the aforesaid chief made buffalo medicine, which conjecture, published in 1877, was verified by the other records subsequently discovered. Interpreter A. Lavary said, in 1867, that The-Elk-that-Holloes-Walking, then chief of the Minneconjous, was then at Spotted-Tail's camp. His father was Red-Fish. He was the elder brother of Lone-Horn. His name is given as A-hag-a-hoo-man-ie, translated The Elk's Voice Walking; compounded of he-ha-ka, elk, and omani, walk; this according to Lavary's literation. The correct literation of the Dakota word meaning elk is heqaka; voice, ho; and to walk, walking, mani. Their compound would be heqaka-ho-mani, the translation being the same as above given (Mallery 1893:284–285).

Comments: This is an example of an image of an animal representing a person's name, rather than the person being identified by the depiction of a human figure with a name glyph. The elk is shown without antlers, just as the buffalo head is more or less stylized in different calendars.

THE SWAN
1860–61

A Minneconjou Dakota, named Red Fish's Son, made medicine with white buffalo cow skin.

Collector's Notes: Mato Sapa's record agrees (Mallery 1886:123).

MAJOR BUSH
1860–61

Minniconjou Sioux named "Red [Fish's son, The] Ass" made medicine with white buffalo cow skin.

Collector's Notes: Major Bush says the same, adding, after the words "Red Fish's Son," "The Ass" (Mallery 1886:123).

LONG SOLDIER

1860–61

Blackfeet Sioux had a great many fine race horses, and killed each others horses at night for jealousy.

AMERICAN HORSE

1860–61

Two Face, an Oglala, was badly burnt by the explosion of his powder horn.

CLOUD SHIELD

1860–61

They capture a great many antelope by driving them into a pen.

BATTISTE GOOD

1860–61

Broke out with rash and died with pains in the stomach winter (Mallery 1893:325).

Comments: Good again uses his unique device to denote pain. He does not specify whether this was smallpox, measles, or some other disease.

NO EARS

1860–61

Many babies died/Hoksicala ota tapi.

Collector's Notes: White Cow Killer calls it "Babies-all-sick-and-many-die winter" (Corbusier 1886:144).

Comments: This may have been German measles or scarlet fever.

ROSEBUD

1860–61

Chief Big Crow was killed.

Comments: Several counts record Big Crow's death for the previous year.

LONE DOG
1861–62
Buffalo were so plentiful that their tracks came close to the tipis.

Collector's Notes: The cloven-hoof mark is cleverly distinguished from the tracks of horses in the character for 1849–50 (Mallery 1893:285).

Comments: An abundance of buffalo was often depicted with strips of drying meat hung on racks; see how the year 1845–46 is marked on several counts.

MAJOR BUSH
1861–62
Sioux's had an abundance of Buffalo.

LONG SOLDIER
1861–62
Eagle Crow was killed when he went to capture buffalo robes which had been taken by Poplar Indians from Louis Primeau.

Comments: "Poplar Indians" may refer to Assiniboines. Louis Primeau was an interpreter at Standing Rock Agency. Note the four buffalo hoofprints to the right of this figure.

THE FLAME
1861–62
Buffalo very plentiful (Mallery 1886:123).

AMERICAN HORSE
1861–62
Spider was killed (stabbed) in a fight with Pawnees (Corbusier 1886:144).

THE SWAN
1861–62
Dakotas had an unusual abundance of buffalo (Mallery 1886:124).

CLOUD SHIELD
1861–62
*Young Rabbit, a Crow, was killed in a battle
by Red Cloud.*

NO EARS
1861–62
Spotted-horse killed/Sunkgleska ktepi.

ROSEBUD
1861–62
*Elk's Voice Walking
made medicine.*

Collector's Notes: White Cow Killer calls it "Crow-
Indian-Spotted-Horse-stole-many-horses-and-was-killed
winter" (Corbusier 1886:144).

Comments: Note that even some enemies are identified
with name glyphs when their names were known.

Comments: Several counts record this event for the
previous year.

BATTISTE GOOD
1861–62
Killed Spotted Horse winter.

LONE DOG
1862–63
*Red-Feather, a Minneconjou,
was killed.*

Collector's Notes: Spotted Horse and another Crow
came and stole many horses from the Dakotas, who fol-
lowed them, killed them, and recovered their horses
(Mallery 1893:325). White Cow Killer calls it "Crow Indian
Spotted Horse stole many horses and was killed winter"
(Corbusier 1886:144).

Comments: Note the horse tracks leading away from
the human figure.

Collector's Notes: His feather is shown entirely red,
while the "one-feather" in 1842–43 has a black tip. It is
to be noted that there is no allusion to the great Minne-
sota massacre, which commenced in August, 1862, and
in which many of the Dakotas belonging to the tribes
familiar with these charts were engaged. Little-Crow was
the leader. He escaped to the British possessions, but was
killed in July 1863. Perhaps the reason of the omission of

any character to designate the massacre was the terrible retribution that followed it (Mallery 1893:285).

Comments: Mallery brings up a good point in suggesting that perhaps the Minnesota uprising (and the resulting backlash against the eastern Dakota) is not mentioned because it was a particularly painful event. However, the eastern Dakota did not keep winter counts, nor did their neighbors to the west mark events of relevance to those in Minnesota. This omission probably has more to do with tribalism than with a desire not to remember.

THE SWAN
1862–63
A Minneconjou Dakota killed an Assiniboine named Red Feather.

Collector's Notes: Mato Sapa says: Minnoconjous kill an Assiniboine named Red Feather (Mallery 1886:124).

MAJOR BUSH
1862–63
An Assiniboin named "Red Feather" killed by the Minniconjou Sioux.

THE FLAME
1862–63
Red Plume kills an enemy.

Collector's Notes: It is to be noted that there is no allusion to the great Minnesota massacre, which commenced in August, 1862, and in which many of the Dakotas belonging to the tribes familiar with these charts, were engaged. Little Crow was the leader. He escaped to the British possessions, but was killed in July, 1863. Perhaps the reasons for the omission of any character to designate the massacre, was the terrible retribution that followed it, beginning with the rout by Colonel Sibley, on September 23, 1862. The Indian captives amounted in all to about eighteen hundred. A military commission sentenced three hundred and three to be hanged and eighteen to imprisonment for life. Thirty-eight were actually hanged, December 26, 1862, at Camp Lincoln (Mallery 1886:124).

LONG SOLDIER
1862–63
Year 20 Indians from Poplar Creek came on warpath and at Cannon Ball there was a battle and they hid behind large boulders.

Comments: Poplar Creek Indians may refer to Assiniboines.

AMERICAN HORSE
1862–63
Crows scalped an Oglala boy alive.

Collector's Notes: White Cow Killer calls this "Crows scalp boy winter" (Corbusier 1886:144).

Comments: Other counts (not in the Smithsonian collections) mark this event; most specify that it was Crows who scalped a boy. Some say the boy was out trapping foxes or coyotes when he was scalped, suggesting a connection to the Long Soldier entry for 1863–64.

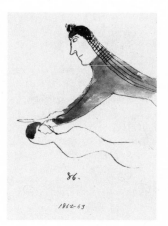

CLOUD SHIELD
1862–63
Some Crows came to their camp and scalped a boy.

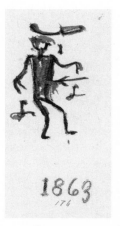

BATTISTE GOOD
1862–63
Cut up the boy in the camp winter.

Collector's Notes: The Crows came to the lodges and cut up the boy while the people were away. The knife above his head shows that he was cut to pieces (Mallery 1893:325).

NO EARS
1862–63
A boy scalded/Hoksila wan waspapi.

Comments: The interpretation should be that a boy was scalped.

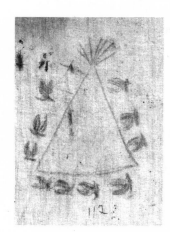

ROSEBUD
1862–63
Plenty buffalo.

Comments: Several counts record this event for the previous year.

LONE DOG

1863–64

Eight Dakotas were killed.

Collector's Notes: Again the short, parallel black lines united by a long stroke. In this year Sitting-Bull fought General Sully in the Black Hills (Mallery 1893:285).

Comments: Other counts record this event for this year, although the Rosebud calendar marks it for 1864–65. Similar images are used in 1800–01 and 1805–06 in this and other calendars.

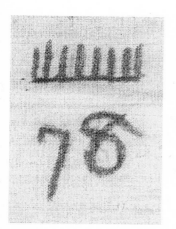

THE FLAME

1863–64

Crows killed eight Dakotas on the Yellowstone [River].

Collector's Notes: White Cow Killer calls it "Dakotas and Crows have a big fight eight Dakotas killed winter" (Corbusier 1886:144).

THE SWAN

1863–64

Eight Minneconjou Dakotas killed by Crow Indians.

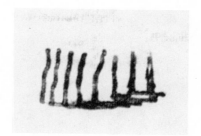

MAJOR BUSH

1863–64

Eight (8) Minniconjou Sioux's killed by the Crow Indians.

LONG SOLDIER

1863–64

Year when Poplar Creek Indian was killed by Blackfoot Sioux while trapping coyotes.

Comments: The "Poplar Creek Indian" may have been an Assiniboine. This event is mentioned in other counts for the previous year.

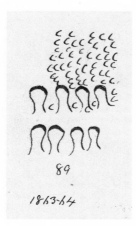

AMERICAN HORSE
1863–64
Oglalas and Minneconjous took the warpath against the Crows and stole 300 horses.

BATTISTE GOOD
1863–64
Crows came and killed eight winter.

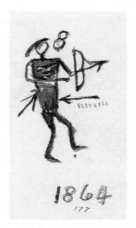

Collector's Notes: The Crows followed them and killed eight of the party (Corbusier 1886:144).

Comments: Cloud Shield and Good also mark this event, which may have been in retaliation for the Lakota boy who was scalped by Crows the previous year.

Collector's Notes: Some of the eight were Cheyennes. The marks below the arrow represent the [number] killed (Mallery 1893:325).

NO EARS
1863–64
Eight were killed/Saklogan ahi wica ktepi.

Comments: This count does not indicate who was killed, Lakotas or enemies. It does suggest that those killed were on their way somewhere, as *ahi* means "to arrive (in a group)."

CLOUD SHIELD
1863–64
Eight Dakotas were killed by the Crows.

ROSEBUD
1863–64
Red Feather was killed.

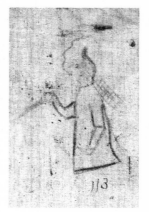

Collector's Notes: Here eight long marks represent the number killed (Corbusier 1886:144).

Comments: Several counts record this event for the previous year.

LONE DOG
1864–65
The Dakotas killed four Crows.

Collector's Notes: Four of the same rounded objects, like severed heads, shown in 1825–26, but these are bloody, thus distinguishing them from the cases of drowning (Mallery 1893:285).

THE FLAME
1864–65
Four Crow caught stealing horses from the Dakotas were tortured to death.

Collector's Notes: Shoulders shown (Mallery 1886: 124).

THE SWAN
1864–65
Four Crow Indians killed by the Minneconjou Dakotas.

Collector's Notes: Necks shown (Mallery 1886:124).

MAJOR BUSH
1864–65
Four (4) Crow Indians killed by the Minniconjou Sioux.

LONG SOLDIER
1864–65
First fight with white men.

Collector's Notes: Sitting Bull and white who was taking lands.

AMERICAN HORSE
1864–65
Bird, a white trader, went to trade with Cheyennes and was killed.

Collector's Notes: Bird, a white trader, went to Powder River to trade with the Cheyennes. They killed him and appropriated his goods (Corbusier 1886:144). White Cow Killer calls this "Big-Lips-died-suddenly winter" (Corbusier 1886:144).

CLOUD SHIELD
1864–65
Bird, a white trader, was burned to death by the Cheyennes.

Collector's Notes: He is surrounded by flames in the picture (Corbusier 1886:144).

BATTISTE GOOD
1864–65
Roaster made a commemoration of the dead winter.

Collector's Notes: A piece of roasted meat is shown on the stick in the man's hand. The Dakotas roast meat on a stick held in front of the fire (Mallery 1893:325).

Comments: Other commemorations are depicted with a red flag; see Good 1799–1800, 1841–42, and 1875–76. For similar images, see Rosebud 1810–11, 1861–62, and 1883–84; and The Flame 1867–68.

NO EARS
1864–65
Four crows were killed/Psa loka top wica ktepi.

Comments: The Lakota referred to the Crow Indians either as Kangi (also the word for the bird) or as Psaloka, a Lakota pronunciation of the tribe's word for themselves, Absaroka.

ROSEBUD
1864–65
Eight Lakota were killed.

Comments: Several counts record this event for the previous year.

LONE DOG
1865–66
Many horses died for want of grass.

Collector's Notes: The horse here drawn is sufficiently distinct from all others in the chart (Mallery 1893:285).

Comments: Several other calendars also record this winter as being so severe that many horses died.

THE FLAME
1865–66
Many horses died.

THE SWAN
1865–66
Dakotas lost many horses in the snow.

MAJOR BUSH
1865–66
Lost an immense number of horses in the snow.

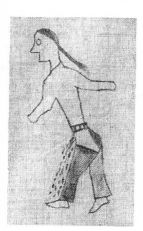

LONG SOLDIER
1865–66
Year when snow was covered with ice and Indians captured white women.

Collector's Notes: Old Crawler made capture and let women loose on ransom.

Comments: This image is of a Lakota man, not a white woman. It appears that the man is either bleeding from a wound or urinating. Comparing the image to other northern winter counts not in Smithsonian collections indicates the latter: the Lakotas experienced some kind of venereal disease that caused them to urinate often (Howard 1960b:389–390).

AMERICAN HORSE
1865–66
Gen. Maynadier made peace with the Oglalas and Brulés.

Collector's Notes: His name, the sound of which resembles the words "many deer," is indicated by the two deer's heads connected with his mouth by the lines (Corbusier 1886:144).

CLOUD SHIELD
1865–66
Many horses lost to starvation.

Collector's Notes: Many horses were lost by starvation, as the snow was so deep they couldn't get at the grass (Corbusier 1886:144).

BATTISTE GOOD
1865–66
Deep snow used up the horses winter.

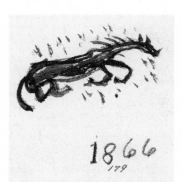

Collector's Notes: The horse is obviously in deplorable condition (Mallery 1893:326).

Comments: Good uses the same kind of image, an animal crouching, to indicate freezing in 1747–48, 1783–84, and 1852–53.

NO EARS
1865–66
All the horses died/Sunk sotapi.

Comments: The Lakota verb *sota* indicates that every single one died; the literal translation is "the horses were all used up."

ROSEBUD
1865–66
Four Crows stealing horses were killed.

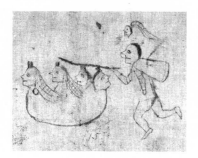

Comments: Several counts record this event for the previous year.

LONE DOG
1866–67
Swan, father of Swan, chief of the Minneconjous in 1877, died.

Collector's Notes: With the assistance of the name the object intended for his totem may be recognized as a swan swimming on the water (Mallery 1893:285).

Comments: This image is quite similar to Lone Dog's 1854–55, when Brave Bear was killed.

THE FLAME
1866–67
Little Swan, a great warrior.

Collector's Notes: Mato Sapa's record has a better representation of a swan. Interpreter Lavary says: Little Swan died in this year on Cherry Creek, 75 miles northwest of Fort Sully. Major Bush says this is historically correct (Mallery 1886:124–125).

THE SWAN
1866–67
*Minneconjou Dakota chief,
named Swan, died.*

Collector's Notes: The hats and the cap-covered head represent the whites; the red spots, the killed; the circle of characters around them, rifle or arrow shots; the black strokes, Dakota footmen [warriors on foot]; and the hoof-prints, Dakota horsemen. The Phil Kearney massacre occurred on December 21, 1866, and eighty-two whites were killed, including officers, citizens, and enlisted men. Captain W.J. Fetterman was in command of the party. White Cow Killer calls this "One-hundred white men killed winter" (Corbusier 1886:144).

Comments: American historical documents refer to this event as the Fetterman massacre.

MAJOR BUSH
1866–67
Minniconjou Sioux Chief named "the Swan" died.

LONG SOLDIER
1866–67
Gaul was stabbed by soldiers and brought back from Cannon Ball by Soldier.

CLOUD SHIELD
1866–67
Lone Bear killed in battle.

90

1866-67

Comments: Cannon Ball is on the North Dakota side of the Standing Rock Reservation, north of Fort Yates.

Comments: The Rosebud record for 1867–68 depicts a man with a bear glyph, who may be the same person noted here.

92

1866-67

AMERICAN HORSE
1866–67
They killed 100 white men at Fort Phil Kearney.

1867
180

BATTISTE GOOD
1866–67
*Beaver's Ears killed winter
(Mallery 1893:326).*

Comments: This man's identity is marked by ears added to the figure, instead of a name glyph.

NO EARS
1866–67
A hundred white men were killed/Wasicu opawings wica ktepi.

Comments: The second word should be *opawinge* (hundred).

ROSEBUD
1866–67
Many Deer (General Maynadier) made peace.

Comments: The officer is General Maynadier, known to the Lakota as Many Deer. Other counts record a peace treaty in the following year; American Horse records a peace with Maynadier in 1865–66.

LONE DOG
1867–68
Many flags were given them by the Peace Commission.

Collector's Notes: The flag refers to the visit of the Peace Commissioners, among whom were Generals Sherman, Terry, and other prominent military and civil officers. Their report appears in the Annual Report of the Commissioner of Indian Affairs for 1868. They met at Fort Leavenworth, August 13, 1867, and between August 30 and September 13 held councils with the various bands of the Dakota Indians at Forts Sully and Thompson, and also at the Yankton, Ponka, and Santee reservations. These resulted in the Dakota treaty of 1868 (Mallery 1893:285–286).

THE FLAME
1867–68
Much medicine made.

Comments: This represents the 1868 Fort Laramie (Wyoming) treaty. The Great Sioux Reservation, which had been established during the 1851 Fort Laramie treaty, was divided into smaller reservations, and "surplus" land was opened for white settlement. The red color of the flag indicates something sacred or holy. Flags were often used to mark ceremonies, as depicted by Good (1799–1800, 1841–42, 1864–65, and 1875–76) and in the Rosebud count (1810–11, 1861–62, and 1883–84).

THE SWAN
1867–68
Made peace with General Sherman and others at Fort Laramie.

Collector's Notes: Mato Sapa says: Made peace with General Sherman and others at Fort Laramie (Mallery 1886:125).

AMERICAN HORSE
1867–68
They captured a train of wagons near the Tongue River.

Collector's Notes: The men who were with it got away. The blanket represents the goods found in the wagon (Corbusier 1886:144).

MAJOR BUSH
1867–68
Made peace with General Sherman at Laramie.

LONG SOLDIER
1867–68
Year ten feather hats were made and put on ten chiefs.

CLOUD SHIELD
1867–68
Blankets were issued to them at Fort Laramie.

Comments: American Horse offers a very different explanation for how the blankets were obtained.

Comments: The headdress and sash pictured here may be a reference to the 1868 Fort Laramie treaty marked on other calendars; government officials were anxious to designate Lakota men as chiefs so that they would be granted authority to sign treaties.

BATTISTE GOOD

1867–68

Battiste Good made peace with Gen. Harney for the people winter.

Collector's Notes: This refers to the great Dakota treaty of 1868 in which other general officers besides Gen. Harney were active and other Indian chiefs much more important than Battiste took part. The assumption of his intercession is an exhibition of boasting (Mallery 1893:326).

NO EARS

1867–68

A Shoshoni that came into camp was killed/Susuni ti hi wan ktepi.

Collector's Notes: White Cow Killer calls it "Seven-Pawnees-killed winter" (Corbusier 1886:144).

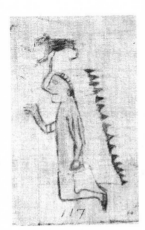

ROSEBUD

1867–68

Lone Bear killed in battle.

Comments: The figure's name glyph suggests that this was the Lone Bear whose death was noted by Cloud Shield in the previous year.

LONE DOG

1868–69

Texas cattle were brought into the country.

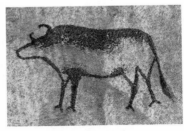

Collector's Notes: This was done by Mr. William A. Paxton, a well-known business man, resident in Dakota in 1877 (Mallery 1893:286).

Comments: This is a pictograph of a domestic cow, or spotted buffalo as the Lakota called them.

THE FLAME

1868–69

First issue of beef by Government to Indians.

THE SWAN

1868–69

Dakotas had plenty of white men's cattle (the result of peace).

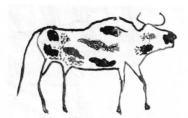

Collector's Notes: Mato Sapa agrees with No. III [Swan] (Mallery 1886:125).

MAJOR BUSH

1868–69

Winter of plenty of White men's cattle.

Comments: The cattle came as a result of the treaty the previous year.

LONG SOLDIER

1868–69

A French man, named Red Walker, came here all alone and brought gun powder and sold to Indians.

Comments: Note the red feet and tracks behind him.

AMERICAN HORSE

1868–69

People were starving and had to sell many mules and horses.

Collector's Notes: They were compelled to sell many mules and horses to enable them to procure food, as they were in a starving condition. They willingly gave a mule for a sack of flour. The mule's halter is attached to two sacks of flour (Corbusier 1886:144–145). White Cow Killer calls it "Mules sold by hungry Sioux winter" (Corbusier 1886:144–145).

Comments: The differing experiences of the widespread Lakota people are well illustrated by the entries for this year. While the northern counts record a time of plenty, the southern counts note starvation conditions.

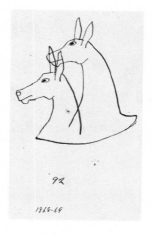

CLOUD SHIELD

1868–69

They had to sell many mules and horses to get food, as they were starving.

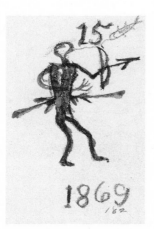

BATTISTE GOOD
1868–69
*Killed Long Fish winter and
Killed fifteen winter.*

Collector's Notes: The Crows killed fifteen Sans Arcs and Long Fish also, a Lower Brulé. The long fish is shown attached by a line to the mouth of the man figure in the manner that personal names are frequently portrayed in this paper (Mallery 1893:326).

Comments: The Rosebud figure for 1869–70 shows the name glyph even more clearly.

NO EARS
1868–69
Horned-thunder escorted/Wakinyan-heton e ihpeyapi.

Comments: The verb should be translated as "forgotten, lost" or "left behind." The meaning of this event is not known.

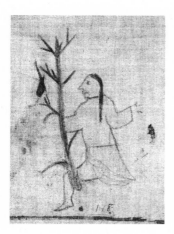

ROSEBUD
1868–69
*Old woman's leg broken
by falling tree.*

Comments: Other counts record this event for the following year.

LONE DOG
1869–70
An eclipse of the sun.

Collector's Notes: This was the solar eclipse of August 7, 1869, which was central and total on a line drawn through the Dakota country. This device has been criticised because Indians generally believe an eclipse to be occasioned by a dragon or aerial monster swallowing the sun, and it is contended that they would so represent it. An answer is that the design is objectively good, the sun being painted black, as concealed, while the stars come out red, i.e., bright, and graphic illustration prevails throughout the charts where it is possible to employ it. Dr. Washington Matthews, surgeon, U.S. Army, communicated the fact that the Dakotas had opportunities all over their country of receiving information about the real character of the eclipse and remembers that long before it occurred the officers, men, and citizens around the post told the Indians of the coming event and discussed it with them so much that they were on the tip-toe of expectancy when the day came. Two-Bears and his band were then encamped at Fort Rice, and he and several of his leading men watched the eclipse along with the whites and through their smoked glass, and then and there the phenomenon was thoroughly explained to them over and over again. There is no doubt that similar explanations were made at all the numerous posts and agencies along the river that day. The path of the eclipse coincided nearly with the course of the Missouri for over a thousand miles. The duration of totality at Fort Rice [Dakota Territory] was nearly two minutes (1′48″) (Mallery 1893:286).

THE FLAME

1869–70

Eclipse of the moon
(Mallery 1886:125).

Comments: Other counts note an eclipse of the sun, rather than the moon.

THE SWAN

1869–70

Dakotas witnessed
eclipse of the sun;
frightened terribly.

Collector's Notes: It is remarkable that the Corbusier Winter Counts [American Horse, Cloud Shield, White Cow Killer, and Good] do not mention this eclipse (Mallery 1886:126).

MAJOR BUSH

1869–70

Great eclipse in August—A white man bought one hundred (100) hides belonging to the Ogalallah and Brulé (Lower) Sioux soon after returned them, cause unknown.

Comments: This is the last entry for the Major Bush winter count.

LONG SOLDIER

1869–70

30 Crows were chasing a man and boy off Sioux [land] and came to Blackfoot Bottom where they killed the boy.

Collector's Notes: The Blackfoot Sioux saw the tracks and followed them to Cannon Ball where they hid in hill and Sioux killed all thirty of them.

Comments: This may also depict an event described in other calendars as the year when the Crows scalped a boy, although most counts mark that as occurring in 1862–63.

AMERICAN HORSE

1869–70

Tall Bull killed by white soldiers and Pawnees.

Collector's Notes: Tall Bull was killed by white soldiers and Pawnees on the south side of the South Platte River (Corbusier 1886:145).

Comments: This probably refers to the July 1869 Battle of Summit Springs, in which Tall Bull, the leader of the Cheyenne Dog Soldiers, was killed.

CLOUD SHIELD

1869–70

John Richard, a white trader, shot a white soldier.

93

1869-70

Collector's Notes: John Richard shot a white soldier at Fort Fetterman, Wyoming, and fled north, joining Red Cloud (Corbusier 1886:145).

Comments: American Horse records a different version of this event for 1871–72, or perhaps a second event involving the same man. This trader is also mentioned in Cloud Shield 1858–59 and 1872–73, and in American Horse 1871–72.

NO EARS

1869–70

Old woman killed by a tree/Winurcala wan can kate.

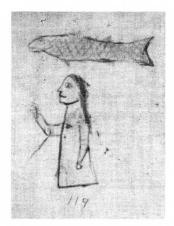

ROSEBUD

1869–70

Long Fish killed.

Comments: Good places this event in the previous year.

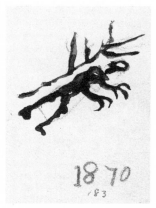

BATTISTE GOOD

1869–70

Trees killed them winter.

1870

Collector's Notes: A tree falling on a lodge killed a woman (Mallery 1893:326). White Cow Killer calls it "Tree fell on woman who was cutting wood and killed her winter" (Corbusier 1886:145).

LONE DOG

1870–71

The Unkpapas had a battle with the Crows, the former losing, it is said, 14, and killing 29 out of 30 of the latter, though nothing appears to show those numbers.

Collector's Notes: The central object is not a circle denoting multitude, but an irregularly rounded object, perhaps intended for one of the wooden inclosures or forts frequently erected by the Indians, and especially the Crows. The Crow fort is shown as nearly surrounded, and bullets, not arrows or lances are flying. This is the first instance in this chart in which any combat or killing is protrayed [sic] where guns explicitly appear to be used by

Indians, though nothing in the chart is at variance with the fact that the Dakotas had for a number of years been familiar with firearms. The most recent indications of any weapon were those of the arrows piercing the Crow squaw in 1857–58, and Brave-Bear in 1854–55, while the last one before those was the lance used in 1848–49, and those arms might well have been employed in all the cases selected, although rifles and muskets were common. There is an obvious practical difficulty in picturing, by a single character, killing with a bullet, not arising as to arrows, lances, dirks, and hatchets, all of which can be and are shown in the chart projecting from the wounds made by them. Other pictographs show battles in which bullets are denoted by continuous dotted lines, the spots at which they take effect being sometimes indicated and the fact that they did hit the object aimed at is expressed by a specially invented symbol. It is, however, to be noted that the bloody wound on the Ree's shoulder (1806–07) is without any protruding weapon, as if made by a bullet. More distinct information regarding this fight [1870–71], the record of which concludes the original Lone-Dog chart, has been kindly communicated by Mr. Luther S. Kelly, of Garfield County, Colorado. The war party of Unc-papas mentioned charged upon a small trading post for the Crows on the Upper Missouri river, at the mouth of the Musselshell river. Usually this post was garrisoned by a few frontiersmen, but on that particular day there happened to be a considerable force of freighters and hunters. The Indians were afoot and, being concealed by the sage brush, got within shooting distance of the fort before being discovered. They were easily driven off, and going a short distance took shelter from the rain in a circular washout, not having any idea of being followed by the whites. Meanwhile the whites organized and followed. The surprise was complete, the leading white man only being killed. The Indians sang their song and made several breaks to escape, but were shot down as fast as they rose above the bank. Twenty-nine were killed (Mallery 1893:287).

Comments: After serving in the Civil War, Luther S. Kelly (1849–1928) was a scout for several army expeditions during the 1870s. According to his memoirs, he learned to speak Sioux while hunting and trapping along the Yellow-

stone River. Kelly wrote to the director of the Bureau of American Ethnology on June 21, 1891, with details of his knowledge concerning this battle between the Crow and Sioux (NAA Ms. 2372, Box 12, Folder 5). This is the last entry in the Lone Dog winter count.

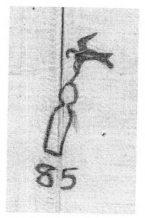

THE FLAME
1870–71
The Flame's son was killed by Rees.

Collector's Notes: The recorder, The Flame, evidently considered his family misfortune to be of more importance than the battle referred to by the other recorders (Mallery 1886:126).

THE SWAN
1870–71
A Crow war party of 30 were surprised and surrounded in the Black Hills by the Dakotas and killed.

Collector's Notes: Fourteen of the Dakotas were killed in the engagement (Mallery 1886:127).

Comments: This is the last entry for The Swan winter count.

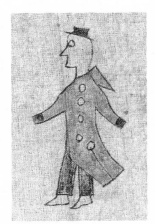

LONG SOLDIER

1870–71

Another party of 10 Frenchmen came and traded with Indians.

Collector's Notes: One picture signifies 10 in number.

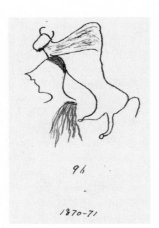

AMERICAN HORSE

1870–71

High Backbone, an Oglala, was killed by the Shoshoni.

Collector's Notes: High Backbone, a very brave Oglala, was killed by the Shoshoni. They also shot another man who died after he reached home (Corbusier 1886:145).

Comments: High Backbone was also known as Hump.

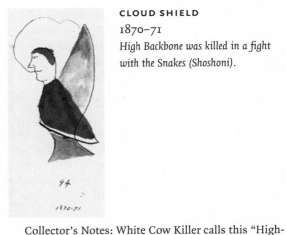

CLOUD SHIELD

1870–71

High Backbone was killed in a fight with the Snakes (Shoshoni).

Collector's Notes: White Cow Killer calls this "High-Back-Bone-killed-by-Snakes winter" (Corbusier 1886:145).

Comments: This figure appears to have been scalped as well. The Lakota term for the Shoshoni was Snake Indians.

BATTISTE GOOD

1870–71

Came and killed High Backbone winter.

Collector's Notes: He was a chief. The Crows and Shoshoni shot him at long range, and the pistol with which he was armed was of no service to him (Mallery 1893:326).

NO EARS

1870–71

High-road killed/Canku-wankatuya ahi ktepi.

Comments: "High Road" may be an erroneous transcription or translation of High Backbone or Hump,

whose death is noted on many calendars. The word *chanku* means "road," while *chantku* means "chest" (Buechel 1970:120, 126).

ROSEBUD
1870–71
Sun turns dark.

Comments: Other counts place this eclipse in the previous year.

THE FLAME
1871–72
The Flame's second son killed by Rees (Mallery 1886:127).

Comments: The Flame records a personal event, as he did in the previous year.

LONG SOLDIER
1871–72
Year Crows came in night and stole Sioux horses which were close around tents and Indians did not know of it.

Comments: Horseshoe prints are seen outside the tipi.

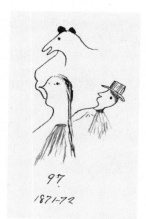

AMERICAN HORSE
1871–72
John Richard shot and killed an Oglala named Yellow Bear; Oglalas then killed Richard.

Collector's Notes: John Richard shot and killed an Oglala named Yellow-Bear, and the Oglalas killed Richard before he could get out of the lodge. This occurred in the spring of 1872. As the white man was killed after the Indian, he is placed behind him in the figure (Corbusier 1886:145).

Comments: Richard is mentioned in Cloud Shield's account for 1858–59, 1869–70, and again in 1872–73. Good's record of the death of a man named Gray Bear for this year may be related, since the Lakota words for brown or dark gray (*gi*) and for yellow (*zi*) are similar (Buechel 1970:148, 658).

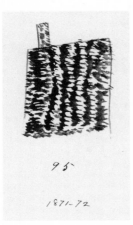

CLOUD SHIELD
1871–72
*Adobe houses were built by
Maj. J.W. Wham.*

Collector's Notes: Adobe houses were built by Maj. J.W. Wham, Indian agent (now paymaster, United States Army), on the Platte River, about 30 miles below Fort Laramie. White Cow Killer calls it "Major-Wham's-house-built-on-Platte-River winter" (Corbusier 1886:145).

Comments: This structure looks quite different from the gabled buildings Cloud Shield depicts for other years (see 1792–93, 1795–96, 1815–16, 1816–17).

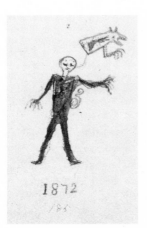

BATTISTE GOOD
1871–72
Gray Bear died winter.

Collector's Notes: He died of the bellyache (Mallery 1893:326).

Comments: Good indicates pain with his device to the right of the figure. American Horse's record of the death of Yellow Bear this year may refer to the same individual.

NO EARS
1871–72
Branches lost/Canhahaka tainsni.

Comments: The Lakota verb *taninsni* translates as "to be lost or disappeared" (Buechel 1970:479). It is not clear what this entry means.

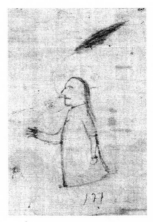

ROSEBUD
1871–72
"Crow Feather" killed.

Comments: The Cranbrook count records the death of Crow Feather in 1879 with a similar marker.

THE FLAME
1872–73
*Sans Arc John killed by Rees
(Mallery 1886:127).*

LONG SOLDIER
1872–73
Chief Turn Bear killed an Indian in his tent.

AMERICAN HORSE
1872–73
Whistler, also named Little Bull, and two other Oglalas, were killed by white hunters on the Republican River (Corbusier 1886:145).

Collector's Notes: White Cow Killer calls it "Stay at plenty ash wood winter" (Corbusier 1886:145).

CLOUD SHIELD
1872–73
Antoine Janis's two boys were killed by J. Richard.

Collector's Notes: Antoine Janis's two boys were killed by Joe (John?) Richard (Corbusier 1886:145).

Comments: Richard is mentioned in Cloud Shield for 1858–59 and 1869–70. American Horse records his death in 1871–72. This may be an example in which winter count keepers placed spring events in different years.

BATTISTE GOOD
1872–73
Issue year winter.

Collector's Notes: A blanket is shown near the tipi. A blanket is often used as the symbol for issue of goods by the United States Government (Mallery 1893:327).

NO EARS
1872–73
Anus-On-Both sides killed two Crows/Anonk-onze Pas sonp wica ktepi.

Comments: The Lakota should read *Anonk-onze Psa nonp wica ktepi.*

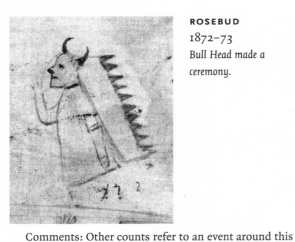

ROSEBUD
1872–73
*Bull Head made a
ceremony.*

LONG SOLDIER
1873–74
*Chief His Knife was shot through
the head by the Crows.*

Comments: Other counts refer to an event around this time involving a man named Bull Head, which the horns on the headdress might signify. See the British Museum count for 1871–72 and 1872–73, and Battiste Good and Hardin for 1875–76.

AMERICAN HORSE
1873–74
*The Oglalas killed
the Indian agent's
(Seville's) clerk.*

THE FLAME
1873–74
Brulés kill a number of Pawnee.

Collector's Notes: The Oglalas killed the Indian agent's (Seville's) clerk inside the stockade of the Red Cloud Agency, at Fort Robinson, Nebraska (Corbusier 1886:145).

Comments: Note the distinctive hairstyle and footgear.

CLOUD SHIELD
1873–74
They killed many Pawnees on the Republican River (Corbusier 1886:145).

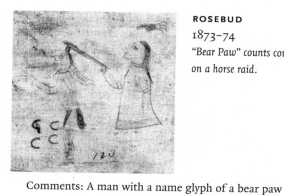

ROSEBUD
1873–74
"Bear Paw" counts coup on a horse raid.

Comments: A man with a name glyph of a bear paw is striking an enemy having the distinctive hairstyle of the Crow or Nez Perce—an upright forelock and a netted extension in the back. Horse tracks suggest that this event occurred during a horse raid. The Cranbrook count records a fight with the Crow in the following year.

BATTISTE GOOD
1873–74
Measles and sickness used up the people winter (Mallery 1893:327).

THE FLAME
1874–75
A Dakota kills one Ree (Mallery 1886:127).

Comments: Good uses his unique device to indicate pain.

NO EARS
1873–74
Two Omaha killed/Monah nonp wica ktepi.

Comments: The Lakota word for Omaha is *Oyatenunpa* (Buechel 1970:733).

LONG SOLDIER
1874–75
Time Indian Frank was surrounded by Crows and got shot while going in his tent.

Comments: The Crows must have been on horseback, as indicated by the horse hoof marks on the right of this image.

AMERICAN HORSE
1874–75
The Oglalas at Red Cloud Agency cut up the flagpole.

Collector's Notes: The Oglalas at the Red Cloud Agency, near Fort Robinson, Nebraska, cut to pieces the flag staff which their agent had had cut and hauled, but which they would not allow him to erect, as they did not wish to have a flag flying over their agency. This was in 1874. The flag which the agent intended to hoist is now at the Pine Ridge Agency, Dakota [Territory] (Corbusier 1886:145).

CLOUD SHIELD
1874–75
The Utes stole all the Brulé's horses (Corbusier 1886:145).

BATTISTE GOOD
1874–75
Utes stole horses winter.

Collector's Notes: They stole five hundred horses. The Utes are now called "black men," hence the man in the figure is represented as black. He is throwing his lariat in the direction of the hoof prints (Mallery 1893:327).

NO EARS
1874–75
Last time they went across/Ehako kowatan ai.

Comments: This refers to the last time this particular band went across the Missouri River. Afterward, they remained on the west side of the river.

ROSEBUD
1874–75
They killed many Pawnee.

Comments: Several counts record the killing of many Pawnees (denoted by the same hairstyle) in the previous year.

THE FLAME
1875–76
Council at Spotted Tail Agency (Mallery 1886:127).

Collector's Notes: The figure represents a cow or spotted buffalo, surrounded by people. The gesture sign also signifies spotted buffalo (Corbusier 1886:145).

Comments: The Lakota called domestic cattle *pte gleska*, or "spotted buffalo."

CLOUD SHIELD
1875–76
Seven of Red Cloud's band were killed by the Crows.

LONG SOLDIER
1875–76
Year the Poplar Creek Indians brought news of peace and did not want to fight anymore with the Sioux.

Comments: These may have been Assiniboine, although the hairstyle and loop necklace may indicate that they were Crow.

Collector's Notes: White Cow Killer calls it "Five-Dakotas-killed winter" (Corbusier 1886:146).

Comments: Several winter counts use similar devices in 1800–01, 1805–06, and 1863–64.

BATTISTE GOOD
1875–76
Bullhead made a commemoration of the dead winter.

AMERICAN HORSE
1875–76
The first stock cattle were issued to them.

Comments: Good often indicates ceremonies by depicting a figure holding a red flag of some sort (see 1799–1800, 1841–42, and 1864–65).

NO EARS
1875–76
Seven loafers killed/Waklure sakowan ahi wica ktepi.

Comments: The Loafer band was a group of Oglalas who "hung around the fort" and were seen by others as having acquiesced to the whites. The Lakota number seven should be written *sakowin.*

ROSEBUD
1875–76
Utes stole many Lakota horses.

Comments: Other counts record that Utes stole their horses in the previous winter. In Lakota, Utes are known as Sapa Wichasa or Black Men (Buechel 1970:733).

THE FLAME
1876–77
Horses taken by U.S. Government.

Collector's Notes: White Cow Killer calls it "General Mackenzie took the Red Cloud Indians' horses away from them winter." In the account on Lone Dog's chart, published in 1877, as above mentioned, the present writer, on the subject of the recorder's selection of events, remarked as follows: "The year 1876 has furnished good store of events for his choice, and it will be interesting to learn whether he has selected as the distinguishing event the victory over Custer, or, as of still greater interest, the general seizure of ponies, whereat the tribes, imitating Rachel, weep and will not be comforted, because they are not." It now appears that two of the counts have selected the event of the seizure of the ponies, and none of them yet seen make any allusion to the defeat of Custer. After examination of the three charts it will be conceded that, as above stated, the design is not narrative, the noting of events being subordinated to the marking of the years by them, and the pictographic serial arrangements of sometimes trivial, though generally notorious, incidents, being with special adaptation for use as a calendar. That in a few instances small personal events, such as the birth or death of the recorder or members of his family, are set forth, may be regarded as in the line of interpolations in or unauthorized additions to the charts. If they had exhibited a complete national or tribal history for the years embraced in them, their discovery would have been, in some respects, more valuable, but they are the more interesting to ethnologists because they show an attempt, before unsuspected among the tribes of American Indians, to form a system of chronology (Mallery 1886:127).

Comments: White Cow Killer calls it "General Mackenzie took the Red Cloud Indians' horses away from them winter" (Corbusier 1886:146). This is the last entry for The Flame winter count.

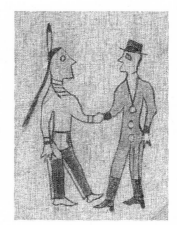

LONG SOLDIER
1876–77
Year Sitting Bull made peace with the Englishman (the red coat), man called Long Spear up above Fargo.

Comments: This refers to Sitting Bull and his followers fleeing to Canada, the land of the Red Coats, after the defeat of Custer's 7th Cavalry at the Battle of the Little Bighorn.

AMERICAN HORSE

1876–77

The Oglalas helped Gen. Mackenzie to whip the Cheyennes.

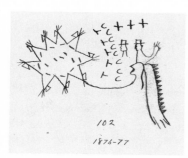

Collector's Notes: The Indian's head represents the man who was the first to enter the Cheyenne village. The white man holding up three fingers is General Mackenzie, who is placed upon the head of the Dakota to indicate that the Dakotas backed or assisted him. The other white man is General Crook, or Three Stars, as indicated by the three stars above him. {This designation might be suggested from the uniform, but General Crook did not probably wear during the year mentioned or for a long time before it the uniform either of his rank as major-general of volunteers or as brevet major-general in the Army, and by either of those ranks he was entitled to but two stars on his shoulder straps} (Corbusier 1886:146).

Comments: After their own surrender to the U.S. army, some Oglalas were recruited to serve as scouts against the Cheyenne.

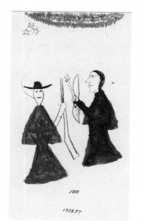

CLOUD SHIELD

1876–77

Three Stars (General Crook) took Red Cloud's young men to help him fight the Cheyennes.

Collector's Notes: A red cloud, indicating the chief's name, is represented above his head (Corbusier 1886:146).

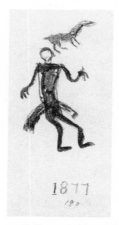

BATTISTE GOOD

1876–77

Female Elk Walks Crying died winter.

Collector's Notes: For some explanation of this figure see Lone Dog's Winter Count for 1860–61 (Mallery 1893:327).

NO EARS

1876–77

Horses taken from Red Cloud/Marpiya-luta sunkipi.

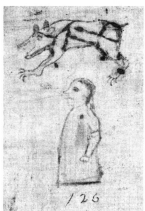

ROSEBUD
1876–77
Lean Bear was killed.

Comments: This entry is similar to the 1879–80 entry in the Red Horse Owner winter count (not in the Smithsonian) indicating that Spotted Coyote or Wolf was killed. The figure here with square muzzle and short tail more likely represents a bear.

LONG SOLDIER
1877–78
Chief Spotted Puma (Antelope) was killed by Crow.

Comments: This record is the first of three years in which Long Soldier marks the death of a leader killed by the Crows.

AMERICAN HORSE
1877–78
Crazy Horse was killed.

Collector's Notes: A soldier ran a bayonet into Crazy Horse, and killed him in the guard house, at Fort Robinson, Nebraska (September 5, 1877) (Corbusier 1886:146). White Cow Killer calls it "Crazy Horse killed winter" (Corbusier 1886:146).

Comments: Many other counts also record the death of Crazy Horse.

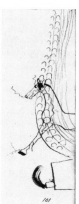

CLOUD SHIELD
1877–78
Crazy Horse's band left the Spotted Tail Agency (at Camp Sheridan, Nebraska) and went north, after Crazy Horse was killed at Fort Robinson, Nebraska.

Collector's Notes: Hoof prints and lodge pole tracks run northward from the house, which represents the Agency. That the horse is crazy is shown by the waved or spiral lines on his body, running from his nose, foot, and forehead (Corbusier 1886:146).

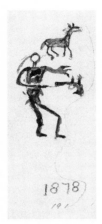

BATTISTE GOOD
1877–78
Crazy Horse came to make peace and was killed with his hands stretched out winter.

Collector's Notes: This refers to the well-known killing of the chief Crazy Horse while a prisoner (Mallery 1893:327).

NO EARS
1877–78
Crazy-horse killed/Tasunka-witka ktepi.

Comments: The name should read *Tasunka-witko.*

ROSEBUD
1877–78
Red Cloud's horses taken.

Comments: The army officer is shown grasping the bridle of a man whose name glyph consists of a red and blue streak with a black dot at the center, probably representing Red Cloud. Other counts record this event for the previous year.

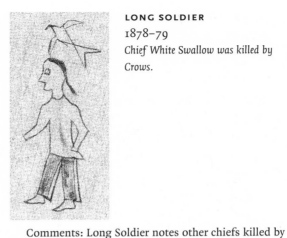

LONG SOLDIER
1878–79
Chief White Swallow was killed by Crows.

Comments: Long Soldier notes other chiefs killed by Crows in 1877–78 and 1879–80.

AMERICAN HORSE
1878–79
Wagons were given to them.

Collector's Notes: White Cow Killer calls this "Wagons-given-to-the-Dakota-Indians winter" (Corbusier 1886: 146).

Comments: This is the last entry for the American Horse winter count.

CLOUD SHIELD
1878–79
The Cheyenne who boasted that he was bullet and arrow proof was killed by white soldiers.

Collector's Notes: The Cheyenne who boasted that he was bullet and arrow proof was killed by white soldiers, near Fort Robinson, Nebraska, in the entrenchments behind which the Cheyennes were defending themselves after they escaped from the fort (Corbusier 1886:146).

Comments: This is the last entry for the Cloud Shield winter count.

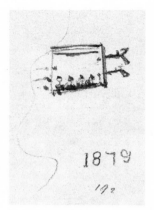

BATTISTE GOOD
1878–79
Brought the Cheyennes back and killed them in the house winter.

Collector's Notes: The Cheyennes are shown in prison surrounded by blood stains, and with guns pointing toward them. The Cheyennes referred to are those who left the Indian Territory [Oklahoma] in 1878 and made such a determined effort to reach their people in the north, and who, after committing many atrocities, were captured and taken to Fort Robinson, Nebraska. They broke from the house in which they were confined and attempted to escape January 9, 1879. Many of them were massacred in their prison by the troops (Mallery 1893:328).

NO EARS
1878–79
Cheyenne shaman killed/Sahiyela wakan wan ktepi.

Comments: This may refer to the same man whose death was noted by Cloud Shield this year.

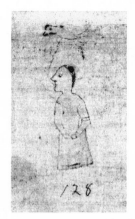

ROSEBUD
1878–79
Chief Drifting Goose came or Chief White Swallow was killed by the Crows.

Comments: It is unclear which of these two events is depicted in the pictograph. Both are indicated in other winter counts, for example, Long Soldier and the John K. Bear winter counts (not in the Smithsonian).

LONG SOLDIER
1879–80
Chief Brings Arrow killed by Crows.

Comments: This is the third of three straight years in which Long Soldier records chiefs killed by Crows.

BATTISTE GOOD

1879–80

Sent the boys and girls to school winter.

Collector's Notes: A boy with a pen in his hand is represented in the picture (Mallery 1893:328).

Comments: This is the final entry in the Battiste Good winter count.

NO EARS

1879–80

Spotted-wolf killed/Sunkmanitu-gleska ktepi.

Comments: This event is marked in other Oglala counts that are not in Smithsonian collections.

ROSEBUD

1879–80

Wagons were given.

Comments: American Horse notes this event for the previous year.

LONG SOLDIER

1880–81

Soldiers fired into Sioux and captured Indians. Infantry, artillery and cavalry represented.

NO EARS

1880–81

Man with spotted testicles killed/Susu gleska wan ktepi.

Comments: Some Oglala counts, not included in Smithsonian collections, also record this event.

ROSEBUD

1880–81

Sent boys and girls to school.

Comments: Battiste Good records this event for the previous year, as do the counts of Red Horse Owner and Wounded Bear.

LONG SOLDIER
1881–82
Chief Red Feather's hat. Died in the night, in dance charging Thunders Brother.

Comments: This explanation is unclear.

NO EARS
1881–82
Spotted-tail killed/Sinte-gleska ktepi.

Comments: Spotted Tail was a chief of the Brulés who was killed by a rival, Crow Dog.

ROSEBUD
1881–82
Lakota sent to prison.

Comments: The shackled prisoners are identified by name glyphs. The Big Missouri count uses a similar picture for 1886–87 to indicate the imprisonment of Chief Little Prairie Chicken, who refused to accept an allotment.

LONG SOLDIER
1882–83
Col. McLaughlin went out hunting buffalo with Indians.

Comments: This event is depicted on most, if not all, of the winter counts from Standing Rock. It was the last communal buffalo hunt by Standing Rock people, who were accompanied by the agent, James McLaughlin.

NO EARS
1882–83
Drum's son committed suicide/Canciga cinca wan icikte.

Comments: The verb *icikte* is reflexive, as indicated by *ici*. Suicide was uncommon among the Lakota, which is why this event merited being recorded. Three such tragedies are marked in this calendar (see 1889–90 and 1905–06).

ROSEBUD
1882–83
Chief Spotted Tail was killed.

Comments: No Ears recorded this event in the previous year.

LONG SOLDIER
1883–84
Two Crows come here after a long time had elapsed since they had seen any Crows.

Comments: Apparently this was a peaceful meeting after so many battles in previous years. Note the pompadour hairstyle and white stripes on the hair on the back of the head, which were painted on with white clay.

NO EARS
1883–84
Burnt-face broke his neck/Ite-ceguga tahu pawege.

Comments: Other calendars record broken necks in previous years; for example, Good (1846–47) and American Horse (1853–54 and 1859–60).

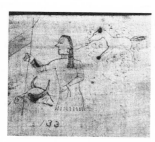

ROSEBUD
1883–84
"White Horse Running" held a Spirit Keeping ceremony.

Comments: The keepers of this count used a buffalo skull and red flag to mark ceremonies in other years as well (see 1810–11 and 1861–62); here, it probably refers

to a spirit-releasing ceremony. The British Museum count similarly records a sacred feast for the previous year. The ceremony may have been a prelude for a buffalo-calling ceremony held the following year. The man is identified by a name glyph of a white horse surrounded by many tracks.

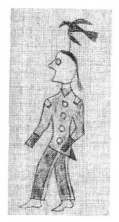

LONG SOLDIER
1884–85
Chief Kill Eagle died.

Comments: This man seems to be wearing a military uniform. Perhaps he was a scout or on the tribal police force.

NO EARS
1884–85
White-bull murdered his wife/Tatanka-ska tawicu kikte.

Comments: Other Oglala calendars not in this collection mark this event as well.

ROSEBUD
1884–85
Held a buffalo calling ceremony.

ROSEBUD
1885–86
Red Buffalo Bull or Bull Head died.

Comments: This entry along the edge of the muslin is smudged and faint. It appears to have originally shown a figure holding a decorated eagle feather staff. The dark curves at the bottom of the figure may be a buffalo skull, while the mark above his head may be a bear paw name glyph.

Comments: The smudged name glyph above the red painted figure represents a buffalo. Both of these Lakota men died about this time, as indicated in the Long Soldier and the Blue Thunder counts.

LONG SOLDIER
1885–86
Chief Bullhead or Fire Heart died.

LONG SOLDIER
1886–87
Chief Four Horns died.

Comments: This man appears to be wearing white man's clothes, as many Lakota did at this time.

Comments: This may refer to Sitting Bull's relative. Notice that the figure is wearing a wool trade blanket, perhaps indicating that he was killed during the winter. Long Soldier uses similar images for 1888–89 and 1892–93.

NO EARS
1885–86
Fire-man banished/Peta-wicasa wan ihpeyapi.

Comments: This may have been a man's name. The verb *ihpeyapi* means "to be left behind or forsaken."

NO EARS
1886–87
Turn-over accidentally killed/Yuptanyan wanu ktepi.

Comments: The word *wanu* means "by chance" or "accidentally."

ROSEBUD
1886–87
Missionaries clothed the Indians.

NO EARS
1887–88
Shaman accidentally killed/Wakan wanu ktepi.

Comments: The word *wanu* means "by chance" or "accidentally."

Comments: This is the final entry of the Rosebud count. The details of the drawing are very faint, but the figure on the right can be identified as a Crow Indian by the tribal hairstyle with netted extension. The Cranbrook count recorded a peace with the Crow a few years earlier, in 1883–84. The object above the two men resembles the horned headdress shown in the Long Soldier count for this year to indicate the death of Four Horns. It is unclear why the man is dressed in black. This could refer to the missionaries who distributed clothes and founded the St. Francis Mission at this time.

LONG SOLDIER
1888–89
Chief Black Moon died.

Comments: Black Moon was a medicine man closely associated with Sitting Bull; he had fled to Canada along with other Húnkpapas following the Battle of the Little Bighorn. Note that he is wearing a wool blanket wrapped around him, just as in the figures for 1886–87 and 1892–93.

LONG SOLDIER
1887–88
No Neck died this year.

NO EARS
1888–89
They opened packages/Wapata yublecapi.

Comments: This could be a typographical error. Other counts not in this collection have the phrase *Wapaha yublecapi,* meaning "they tore up a headdress."

Comments: This unusual depiction of the man's name is quite vivid.

LONG SOLDIER

1889–90

Indian woman crossed river followed by her husband who killed her and himself because she would not live with him.

Comments: She appears to have suffered a wound to the right arm. Long Soldier records another murder-suicide for 1891–92.

NO EARS

1889–90

Red-shirt's sister committed suicide/Okle-sa tanksitku icikte.

Comments: The reflexive verb *icikte* indicates that this woman killed herself. Suicide was uncommon among the Lakotas. Three such tragedies are recorded in this calendar (also see 1882–83 and 1905–06).

LONG SOLDIER

1890–91

Sitting Bull's cabin where he was killed by Indian police.

Comments: Note the horse hoofprints and bullets surrounding the cabin. Sitting Bull was killed in December 1890.

NO EARS

1890–91

Big-foot killed/Si-tanka ktepi.

Comments: Big Foot was the Mnicónjou leader of the group massacred at Wounded Knee on the Pine Ridge Reservation on December 29, 1890. After fleeing from the chaos following Sitting Bull's murder on Standing Rock, this group of Ghost Dancers was shot by the army in one of the bloodiest massacres in U.S. history. Over 300 Lakotas, including women and children, were killed, but only the death of Big Foot is marked, as he was the leader of this group.

LONG SOLDIER

1891–92

Indian man named Sore shot his wife and himself because his wife was living with an Indian named Goodvoiced Iron, whom he also killed.

Comments: This man is pictured wearing western clothes. See 1889–90 for another murder-suicide.

NO EARS

1891–92

Infantry enlisted/Maka mani akicita wicakagapi.

Comments: This may refer, not to the U.S. army, but to the formation of a tribal police force on the reservation.

LONG SOLDIER
1892–93
Death of Chief Iron Dog, 1892.

Comments: He is pictured wearing a wool trade blanket like the ones shown in Long Soldier 1886–87 and 1888–89.

NO EARS
1892–93
Two-sticks killed cow boys/Can-nonp yuka ptehuha eya wica kte.

Comments: The Lakota name should read Can-nunpa-yuha (Has Two Sticks). For this offense, Two Sticks was hanged two years later, as No Ears notes for 1894–95.

LONG SOLDIER
1893–94
Iron Thunder was killed by being chopped on head by White Blackbird's son, who was dumb.

Comments: This man is wearing western clothes, most likely a uniform. The black shoes and flat-topped hat were often used in pictographs to identify whites.

NO EARS
1893–94
Big school burned/Owayawa tanka ile.

Comments: In the winter of 1893 the Oglala Boarding School on Pine Ridge burned to the ground. It was later rebuilt.

LONG SOLDIER
1894–95
Gaul died a well known Indian.

NO EARS
1894–95
Two-sticks hanged/Can-nonp yuha pa nakse yapi.

Comments: This was punishment for murdering two white cowboys, as No Ears recorded for 1892–93.

LONG SOLDIER
1895–96
Death of Chief Two Crows.

NO EARS
1895–96
Big Council organized/Toka omniciye tankaka kagapi.

Comments: This was the first time there was a big meeting of Oglalas. Other Oglala counts, not in Smithsonian collections, also note this event.

LONG SOLDIER
1896–97
Murdering of Spicer family—one man, two women, three children.

Comments: The five slashes to the right of the man's shoulder indicate the number of people killed. See Long Soldier's entry for the following year for a related event.

NO EARS
1896–97
The winter of White-bird/Zintkala-ska ta waniyetu.

Comments: If the word *ta* contains an aspirated "t," it would indicate that this was White Bird's winter (*tha*, possessive). However, if there is a glottal stop after the "t" it would be the verb *t'a*, "to die." It may be that a new keeper recorded the last several years of this count, which seem to be written in a different style than the previous entries.

LONG SOLDIER
1897–98
Hanging of Holy Track and Philip Ireland.

Collector's Notes: Lynched by people.
Comments: This was the result of the killing of the Spicer family recorded for the previous year.

NO EARS
1897–98
Meat house burned/Talo tipi wan ile.

Comments: A slaughterhouse on Pine Ridge burned down this year.

LONG SOLDIER
1898–99
Policeman named Cuts the Bear's Back.

Comments: The text accompanying this count does not record what happened to this man.

NO EARS
1898–99
Fence built/Tokacunkaska kagapi.

Comments: It is unclear to what event this entry refers.

LONG SOLDIER
1899–1900
Agent Bingenheimer. Sledge hammer Indians give him a feather.

Comments: George Bingenheimer was agent from March 1898 to March 1899. It is unclear who the "Sledge hammer Indians" are.

NO EARS
1899–1900
The winter of fire/Petaga ta waniyetu.

Comments: Several Oglala counts, not in Smithsonian collections, mark this as the winter of General William P. Fire, whereas other counts identify the man as Burning Coal (Wildhage 1988:188, 211), from the Lakota *petaga*, "burning coals" (Buechel 1970:442).

LONG SOLDIER
1900–01
Indian named Blackcloud and family burned up with gasoline which he tried to burn lamp.

Comments: This image seems to be drawn by a different hand and at a different time than the previous entries.

NO EARS
1900–01
Distribution stopped/Wakepamni natakapi.

Comments: The Lakota word for distribution, referring to the distribution of rations by the government, is usually written *wakpamni* (Buechel 1970:533).

LONG SOLDIER
1901–02
Crouse, issue clerk, shot Bob Marshall while out hunting for deer.

NO EARS
1901–02
The winter of small pox/Wicahanhan waniyetu.

LONG SOLDIER
1902–03
Death of Gray Bear, whose leg was cut off by Doctor.

Comments: This is the final entry for the Long Soldier winter count.

NO EARS
1902–03
Old woman disappeared/Winurcala wan tainsni.

Comments: The verb *taninsni* means "to be lost," or "to disappear."

NO EARS
1903–04
Deer hunters were killed/Tarca hute eya wica ktepi.

Comments: Literally, this phrase reads "Deer hunters some they killed them." It is unclear whether the hunters were killed or whether they had a successful hunt and killed many deer.

NO EARS
1904–05
The winter of first allotments/Taka makiyutapi waniyetu.

Comments: Land was allotted to individuals and nuclear families with the idea that they would become self-sufficient, living off their own land by growing crops and raising livestock. This policy broke up the traditional extended family groups of the Lakota but did not succeed in making them yeoman farmers.

NO EARS
1905–06
Gray-war-bonnet's son committed suicide/Wapaha-rota sinca wan icikte.

Comments: The phrase should read *Wapaha-rota cinca*. Suicide was not a common practice among the Lakota, but three are recorded in this calendar (see 1882–83 and 1889–90).

NO EARS
1906–07
Utes captured/Sapa wicasa owicayuspapi.

Comments: The Lakota term for Ute Indians is Sapa Wicasa, or Black Men.

NO EARS
1907–08
Allottees benefits received/Makiyuta ki wahpayeca icupi.

Comments: This probably refers to a monetary payout for lands taken by the U.S. government.

NO EARS
1908–09
The winter of American Horse/Wasicu-tasunka ta waniyetu.

Comments: The verb *t'a* means "died." (See No Ears 1896–97.) The entry for 1910–11 records the death of American Horse.

NO EARS

1909–10

Red Cloud (Dec. 10, '09) died/Mahipiyu-heta to waniyetu.

Comments: The name should be written *Mahpiya Luta.* The verb should be *t'a,* "died." The next four entries have the exact same Lakota phrase, even though the deaths of various leaders are recorded in English.

NO EARS

1910–11

American Horse died/Mahipiyu-heta to waniyetu.

Comments: This should read *Wasicu tasunke ta [t'a] waniyetu. Wasicu tasunke* was the Lakota name for American Horse. See 1908–09 for a previous reference.

NO EARS

1911–12

Geo. Sword died (Nov. 18)/Mahipiyu-heta to waniyetu.

Comments: This should read *Miwakan ta [t'a] waniyetu. Miwakan* was the Lakota name for George Sword.

NO EARS

1912–13

Afraid of Bear died/Mahipiyu-heta to waniyetu.

Comments: This should read *Matokokipapi ta [t'a] waniyetu.*

NO EARS

1913–14

Little Wolf died/Mahipiyu-heta to waniyetu.

Comments: This should read *Sungmanitu-ciqa ta [t'a] waniyetu.*

NO EARS

1914–15

Winter Tomy Tyons died of yr. [sic]. Indians swore allegiance to U.S. flag during Rodman Wanamaker's expedition/Canupaqupi tawaniyetu nains.

Comments: Wanamaker was a Philadelphia businessman who owned and operated a department store. He was interested in American Indians and advocated for their citizenship. As part of this effort, he sponsored two expeditions (1914 and 1921) during which photographer Roland K. Dixon visited Indian communities and had people swear allegiance to the United States. The collection of Dixon photographs from these journeys is at the Mathers Museum of World Cultures at Indiana University, although copies of many images are in other repositories in the United States.

NO EARS

1915–16

Pine Ridge Indians adopted one general Fair association/Owakpamni el toka okininyan ke wan icage.

Comments: Apparently it was important that the community agreed on a group to organize the annual fair, a big social event including a rodeo and powwow dancing.

NO EARS

1916–17

Judge Fast Horse died (noted J[udge])/Tasunke lusahan ta waniyetu.

Comments: The Lakota should read *Tasunke luzahan ta [t'a] waniyetu.*

NO EARS

1917–18

Government drafted Indian boys 21 years old and up, into the army/Oklalakin waniyetu wickcemna nonpa sam wanje eye akicita owicawapi.

Comments: Indians were both drafted and volunteered to fight in World War I.

NO EARS
1918–19
Well known Indians died of Spanish influenza/Oklala kin wicosa wasteste flu on tapi.

Comments: This should read *Oglala kin wicasa wasteste flu un tapi [t'api].* It is interesting that the author chose to keep the English word "flu" instead of a Lakota term for the ailment.

NO EARS
1919–20
Indians at Allen, on Corn Creek, gave a big banquet and big victory dance for returned Indian soldier boys/Wakmiza wakpa oyanke el Akicita akli ca on iwakicipi tanka on hehan.

Comments: Men returning from battle in World War I were honored on the Pine Ridge Reservation. This is the last entry for the No Ears winter count.

BATTISTE GOOD'S EARLIER ENTRIES
Candace S. Greene

In addition to the individual pictures for the years 1700 to 1879, Battiste Good included a unique series of entries covering the period from 901 to 1700. He introduced this section of his calendar with a picture representing a vision he had experienced in the Black Hills, followed by 12 additional full-page images with various figures placed within or adjacent to a circle of tipis. The drawings were evidently annotated by Good himself with a series of words and numbers. Mallery edited out most of these written additions when he had the pictures redrawn for publication in 1893. The pictures are presented here in their original form.

With the exception of the earliest one, which covers 30 years, each of these calendar entries covers 70 years,

the period of time considered by the Lakota to equal a generation. Regrettably, Corbusier recorded only limited information explaining Battiste Good's unique record, describing the pages he did not understand as "valueless." Modern scholars, in contrast, find them of great value in illuminating Lakota concepts of history. See DeMallie and Parks (2001:1070–1072) for a discussion of their potential use in understanding Good's approach to history and calendar keeping.

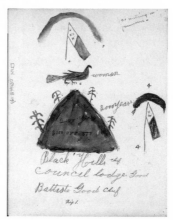

BATTISTE GOOD

Collector's Notes: [This figure] illustrates Good's introduction. He is supposed to be narrating his own experience as follows: "In the year 1856, I went to the Black Hills and cried, and cried, and cried, and suddenly I saw a bird above me, which said: 'Stop crying; I am a woman, but I will tell you something: My Great-Father, Father God, who made this place gave it to me for a home and told me to watch over it. He put a blue sky over my head and gave me a blue flag to have with this beautiful country. {Battiste has made the hill country, as well as the curve for the sky and the flag, blue in his copy.} My Great-Father, Father God (or The Great-Father, God my Father) grew, and his flesh was part earth and part stone and part metal and part wood and part water; he took from them all and placed them here for me, and told me to watch over them. I am the Eagle-Woman who tell[s] you this. The whites know that there are four flags of God; that is, four divisions of the earth. He first made the earth soft by wetting it, then cut it into four parts, one of which, containing the Black Hills, he gave to the Dakotas, and,

because I am a woman, I shall not consent to the pouring of blood on this chief house (or dwelling place), i.e., the Black Hills. The time will come that you will remember my words; for after many years you shall grow up one with the white people.' She then circled round and round and gradually passed out of my sight. I also saw prints of a man's hands and horse's hoofs on the rocks {here he brings in the petroglyphs}, and two thousand years, and one hundred millions of dollars ($100,000,000). I came away crying, as I had gone. I have told this to many Dakotas, and all agree that it meant that we were to seek and keep peace with the whites."

(Note by Dr. Corbusier: The Oglalas and Brulés say that they, with the rest of the Dakota nation, formerly lived far on the other side of the Missouri River. After they had moved to the river, they lived at first on its eastern banks only crossing it to hunt. Some of the hunting parties that crossed at length wandered far off from the rest and, re-maining away, became the westernmost bands.) (Mallery 1893:289–290.)

Comments: Battiste Good and his son High Hawk were the only winter count keepers to record events dur-ing a "mythical" Lakota past and to mark periods of time other than a single year. This count, and the other copies made by Good and High Hawk, begin with generational counts depicting events from a distant past, with each image representing a period of 30 or 70 years.

BATTISTE GOOD
901–930

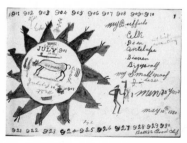

Collector's Notes: The record shown by this figure dates from the appearance of The-Woman-from-Heaven, 901 A.D.; but the Dakotas were a people long before this. The circle of lodges represents a cycle of thirty years from the year 901 to 930, and incloses the "legend" by which this period is known. All the tribes of the Dakota nation were encamped together, as was then their custom, when all at once a beautiful woman appeared to two young men. One of them said to the other, "Let us catch her and have her for our wife." The other said, "No; she may be some-thing wakan" (supernatural or sacred). Then the woman said to them, "I came from Heaven to teach the Dakotas how to live and what their future shall be." She had what appeared to be snakes about her legs and waist, but which were really braids of grass. She said "I give you this pipe; keep it always;" and with the pipe she gave them a small package, in which they found four grains of maize, one white, one black, one yellow, and one variegated. The pipe is above the buffalo. She said, "I am a buffalo, The White-Buffalo-Cow. I will spill my milk all over the earth, that the people may live." She meant by her milk maize, which is seen in the picture dropping from her udders. The colored patches on the four sides of the circle are the four quarters of the heavens (the cardinal points of the com-pass). In front of the cow are yellow and red. She pointed in this direction and said, "When you see a yellowish (or brownish) cloud toward the north, that is my breath; rejoice at the sight of it, for you shall soon see buffalo. Red is the blood of the buffalo, and by that you shall live. Pointing east {it will be noticed that Battiste has placed the east toward the top of the page}, she said, "This pipe is related to the heavens, and you shall live with it." The line running from the pipe to the blue patch denotes the relation. The Dakotas have always supposed she meant by this that the blue smoke of the pipe was one with or nearly related to the blue sky; hence, on a clear day, before smoking, they often point the stem of the pipe upward, in remembrance of her words. Pointing south, she said, "Clouds of many colors may come up from the south, but look at the pipe and the blue sky and know that the clouds will soon pass away and all will become blue and clear again." Pointing west, i.e., to the lowest part of the circle, she said, "When it shall be blue in the west, know that it is closely related to you through the pipe and the blue heavens, and by that you shall grow rich." Then she stood up before them and said, "I am The White-Buffalo-Cow; my milk is of four kinds; I spill it on the earth that you may live by it. You shall call me Grandmother. If you

young men will follow me over the hills you shall see my relatives." She said this four times, each time stepping back from them a few feet, and after the fourth time, while they stood gazing at her, she mysteriously disappeared. {It is well known that four is the favorite or magic number among Indian tribes generally, and has reference to the four cardinal points.} The young men went over the hills in the direction she took and there found a large herd of buffalo.

{Note by Dr. Corbusier: Mr. [William J.] Cleveland states that he has heard several different versions of this tradition.}

The man who first told the people of the appearance of the woman is represented both inside and outside the circle. He was thirty years old at the time, and said that she came as narrated above, in July of the year of his birth. Outside of the circle, he is standing with a pipe in his hand; inside, he is squatting, and has his hands in the position for the gesture-sign for pipe. The elm tree and yucca, or Spanish bayonet, both shown above the tipis, indicate that in those days the Dakota obtained fire by rapidly revolving the end of a dry stalk of the yucca in a hole made in a rotten root of the elm. The people used the bow and stone-pointed arrows, which are shown on the right. From time immemorial they have kept large numbers of sticks, shown by the side of the pipe, each one about as thick and as long as a lead-pencil (sic), for the purpose of counting and keeping record of numbers, and they cut notches in larger sticks for the same purpose.

{Note by Dr. Corbusier: They commonly resort to their fingers in counting, and the V of the Roman system of notation is seen in the outline of the thumb and index, when one hand is held up to express five, and the X in the crossed thumbs, when both hands are held up together to express ten.}

The bundle of sticks drawn in connection with the ceremonial pipe suggests the idea of an official recorder (Mallery 1893:290–291).

Comments: In Mallery's publication (1893) he chose not to include Good's numbers and text.

BATTISTE GOOD
931–1000

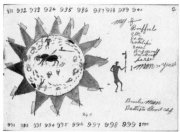

Collector's Notes: From the time the man represented in [the previous image] was seventy years of age, i.e., from the year 931, time is counted by cycles of seventy years until 1700. This figure illustrates the manner of killing buffalo before and after the appearance of The-Woman. When the Dakotas had found the buffalo, they moved to the herd and corralled it by spreading their camps around it. The Man-Who-Dreamed-of-a-Wolf, seen at the upper part of the circle, with bow and arrow in hand, then shot the chief bull of the herd with his medicine or sacred arrow; at this, the women all cried out with joy, "He has killed the chief bull!" On hearing them shout the man with bow and arrow on the opposite side, the Thunder-Bird (wakinyan, accurately translated "the flying one") shot a buffalo cow, and the women again shouted with joy. Then all the men began to shout, and they killed as many as they wished. The buffalo heads and the blood-stained tracks show what large numbers were killed. They cut off the head of the chief bull, and laid the pipe beside it until their work was done. They prayed to The-Woman to bless and help them as they were following her teachings. Having no iron or knives, they used sharp stones, and mussel shells, to skin and cut up the buffalo. They rubbed blood in the hides to soften and tan them. They had no horses, and had to pack everything on their own backs (Mallery 1893:291–292).

BATTISTE GOOD
1001–1070

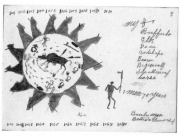

Collector's Notes: The cyclic characters that embrace the period from 1001 to 1140 illustrate nothing of interest not before presented. Slight distinction appears in the circles so that they can be identified, but without enough significance to merit reproduction (Mallery 1893:292).

BATTISTE GOOD
1071–1140

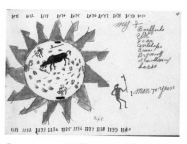

Comments: Mallery provided no information on this entry.

BATTISTE GOOD
1141–1210

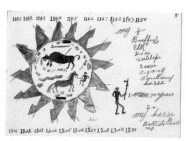

Collector's Notes: Among a herd of buffalo, surrounded at one time during this period, were some horses.

The people all cried out, "there are big dogs with them," having never seen horses before, hence the name for horse, sunka (dog) tanka (big), or sunka (dog) wakan (wonderful or mysterious). After killing all the buffalo they said "let us try and catch the big dogs;" so they cut a thong out of a hide with a sharp stone and with it caught eight, breaking the leg of one of them. All these years they used sharpened deer horn for awls, bone for needles, and made their lodges without the help of iron tools. {All other Dakota traditions yet reported in regard to the first capture of horses, place this important event at a much later period and long after horses were brought to America by the Spaniards. See this count for the year 1802–03, and also Lone Dog's Winter Count for the same year.} (Mallery 1893:292).

BATTISTE GOOD
1211–1280

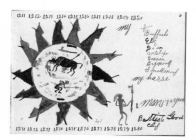

Collector's Notes: At one time during this period a war party of enemies concealed themselves among a herd of buffalo, which the Dakotas surrounded and killed before they discovered the enemy. No one knows what people, or how many they were; but the Dakotas killed them all. The red and black lodges indicate war, and that the Dakotas were successful (Mallery 1893:292).

Comments: Regrettably, Mallery viewed some of these generational cycles as redundant and recorded no information about them.

BATTISTE GOOD
1281–1350

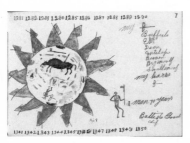

Comments: Mallery noted that "the pages of the copy which embrace the period from 1281 to 1420 are omitted as valueless" (Mallery 1893:292).

BATTISTE GOOD
1351–1420

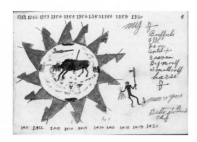

Comments: Mallery provided no information on this entry.

BATTISTE GOOD
1421–1490

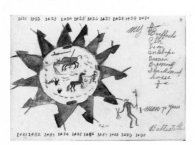

Collector's Notes: "Found horses among the buffalo again and caught six." Five of the horses are represented

by the hoof prints. The lasso or possibly the lariat is shown in use. The bundle of sticks is now in the recorder's hands (Mallery 1893:292–293).

BATTISTE GOOD
1491–1560

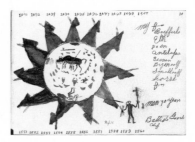

Collector's Notes: Battiste's pages which embrace the period from 1491 to 1630 are omitted for the same reason as before offered (Mallery 1893:293).

BATTISTE GOOD
1561–1630

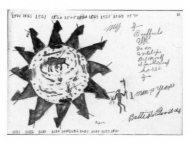

Comments: Mallery provided no information on this entry.

BATTISTE GOOD
1631–1700

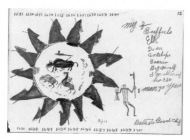

Collector's Notes: This represents the first killing of buffalo on horseback. It was done in the year 1700, inside the circle of lodges pitched around the herd, by a man who was tied on a horse with thongs and who received the name of Hunts-inside-the-lodges. They had but one horse then, and they kept him a long time. Again the bundle of count-sticks is in the recorder's hands.

This is the end of the obviously mythic part of the record, in which Battiste has made some historic errors. From this time forth each year is distinguished by a name, the explanation of which is in the realm of fact.

It must be again noted that when colors are referred to in the description of the text figures, the language (translated) used by Battiste is retained for the purpose of showing the coloration of the original and his interpretation of the colors, which are to be imagined, as they can not be reproduced by the process used (Mallery 1893:293).

NOTES ON NON-SMITHSONIAN WINTER COUNTS REFERENCED IN THE TEXT
John K. Bear Winter Count

This count is attributed to the Yanktonai chief Drifting Goose, although it is named after its last keeper, John K. Bear. The Dakota name for it is *Honkpati Oyate Waniyetu Jawapi Kin*, meaning "Winter Count of the Lower Yanktonai." It covers the years 1682–1883 and exists in text only. It "surfaced" in 1970, and two years later was turned over to the scholar James Howard for publication (Howard 1976).

Blue Thunder Winter Count

The author of this count is Blue Thunder, an Upper Yanktonai. It covers primarily the history of the Upper Yanktonai but also the history of the Blackfoot and Húnkpapa bands of the Teton Dakota; it encompasses the years 1785–86 to 1921–22. It is on white canvas, measuring 264 cm by 74 cm; it consists of pictographs done in ink, wax crayons, and paint, starting at the upper right and spiraling inward toward the left. It became known in 1913. As of 1960, it was owned by the Mandan Indian Shriners Organization and housed in their temple in Bismarck, North Dakota. There are also three variants of it, one on canvas, two on muslin. Two of the variants are owned by the North Dakota State Historical Society Museum, and the other was loaned to the museum in 1932. The count and its three variants are published in Howard 1960b. Another version of the same count is in the Heard Museum, Phoenix, Arizona. This count is related to the British Museum winter count, described below.

Big Missouri Winter Count

There are many versions of this count, one of which is depicted in the well-known photograph by John Anderson showing Kills Two (also known as Beads) (see Figure 1.4). The photograph was part of Anderson's collection, now housed in the Sioux Indian Museum–Journey Museum, Rapid City, South Dakota. It includes a different version of this count, consisting of pictographs on muslin, measuring 55 inches by 35 inches. It covers the history of a Brulé band of the Teton Dakota from 1796 to 1926. The Journey Museum version has been published in Cohen (1939), Cheney (1979), and Wildhage (1991).

British Museum Winter Count

This count is attributed to Blue Thunder (see above); it starts with the same year, 1785–86, and covers the history of the Upper Yanktonai Dakota and the same Blackfoot and Húnkpapa bands of the Teton Dakota. However, it is of a very different style from the other five versions associated with Blue Thunder and about 10 percent of the pictographs depict different events. It also ends in 1901–02, earlier than the other versions. The count, in the collections of the Department of Ethnography at the

British Museum, London, is on white cotton cloth, 122 cm by 88 cm, with pictographs arranged in a spiral, starting in the upper right-hand corner. Most of the pictographs are in black ink; however, almost 30 percent of them have watercolor additions in red, yellow, or blue. It was given to the British Museum in 1942 by a Miss Smee, who reportedly obtained it from Blue Thunder. There is no text accompanying the count, but Howard (1979) published a reconstructed textual interpretation.

Cranbrook Winter Count

This is another version of a count by Swift Dog, whose work is discussed in chapter 2. This version covers the history of a Húnkpapa band of Teton Dakota from 1798 to 1922. The count is on unbleached muslin measuring 34 inches by 35¼ inches. The pictures, arranged in spiral form beginning in the upper left corner, are outlined in brown ink, some completely filled in with the ink, others colored in red or green, probably in crayon. The count and an accompanying detailed explanation are owned by the Cranbrook Institute of Science in Bloomfield Hills, Michigan. It has been published in Praus (1962).

Hardin Winter Count

This count by an unknown keeper is discussed in detail in chapter 2.

Red Horse Owner Winter Count

This count was created by Moses Red Horse Owner and subsequently kept by his daughters, Angelique Fire Thunder and Lydia Blue Bird, who still possessed it as of 1976. It is sometimes referred to as the Fire Thunder winter count. It is the history of an Oglala band of the Teton from 1786 to 1968. It consists of pictographs in the margins of a grammar school reader along with a Lakota text, added by Ms. Fire Thunder from the explanations of her mother, Louisa Red Horse Owner. The count is published in Karol 1969. Wildhage (1988) wrote on a copy of this count that is in the archives of the American Philosophical Society, Philadelphia.

Wounded Bear Winter Count

Wounded Bear's count covers the history of an Oglala band of Teton Dakota from 1815–16 to 1896–97. It consists of pictographs done in colored ink and red pencil in a ledger arranged in a serpentine fashion starting from the upper left corner, along with several sheets of foolscap containing written Lakota interpretations by Wounded Bear. It is owned by Emmett H. Crotzer of Santa Monica, California, and is published in Feraca (1994).

5

Calendars from Other Plains Tribes

CANDACE S. GREENE

Lakota winter counts are well known and numerous, but people of other tribes kept similar records. American Indians have recorded their histories through oral traditions for untold generations. The people of the plains region, however, were particularly interested in placing events in a carefully constructed temporal sequence. Several tribes had their own systems for naming years so they could refer to the year of an event, much as Western historians refer to years by a number. Naming rather than numbering years provided a richer and more memorable context in which to frame historical narrative, but it did not ensure proper sequencing. That task was assigned to designated specialists who were responsible for memorizing the sequence of year names and for adding new names to the system as time passed.

This system of year names was probably maintained for a long time as a purely oral tradition, relying on the memory of the official keepers of such knowledge. In some instances, however, the keepers created mnemonic devices to assist them in accurately maintaining the proper order of the long sequence of years, drawing simple pictures suggestive of the year name. Such pictorial records are best known from the Lakota and the Kiowa, but they were also used by other tribes.[1] At least one pictorial calendar is known for the Mandan, and a few Plains Apache and Cheyenne pictorial calendars are still preserved in families. A Ponca elder told James Howard that such a visual record was once used in his tribe as well, although none are known to have survived. The Blackfoot evidently relied primarily on memorized oral traditions rather than pictorial devices until keepers committed their knowledge to written form in the early 20th century.[2]

In addition to the calendars that recorded a widely shared system of year names, some individuals may have maintained personal calendars recording and sequencing information of importance to them. Probably few of these survived beyond the lifetime of the individual who kept them, and even fewer can be interpreted today. The Silver Horn diary and the Mandan record described below are ex-

amples of such individual records, which offer remarkable personal views of the times in which they were created.

The Smithsonian collections include calendars of various types from three tribes in addition to the Lakota—the Kiowa, the Blackfeet, and the Mandan. These records reveal the great diversity of calendric systems on the plains.

KIOWA

Kiowa calendars record both a summer and a winter event for each year, resulting in twice as many pictures for the same period of time as Lakota winter counts. Each picture is accompanied by a seasonal marker, usually a black bar or a bare tree indicating winter and a picture of the Sun Dance pole or lodge showing summer. For years when the Sun Dance was not held, a leafy tree denotes summer.

The Smithsonian scholar James Mooney brought the Kiowa calendar system to scholarly attention in 1898 with his publication of *Calendar History of the Kiowa*. His report was based on extensive interviews and a detailed study of calendars kept by three men—Tohausen, Settan, and Anko. He concluded that the Tohausen calendar was the oldest and the model on which the others were based. It had been acquired by Lt. Hugh Scott in 1892, and Scott allowed Mooney to incorporate the notes he had acquired from its keeper into his study. The Tohausen calendar is now in the collection of the Hearst Museum of Anthropology at the University of California at Berkeley. Most of the calendar pictures in Mooney's book are from the Settan calendar, which he considered visually superior to the Tohausen record. Mooney also illustrated a monthly calendar kept by Anko.

The three calendars that Mooney published show considerable consistency in the names of the years, although they vary considerably in visual style. The Kiowa were a comparatively small tribe (with a population of about 3,000), who long occupied a common territory and who by the 1870s all lived on a single reservation in Indian Territory. The consistency among their calendars is what might

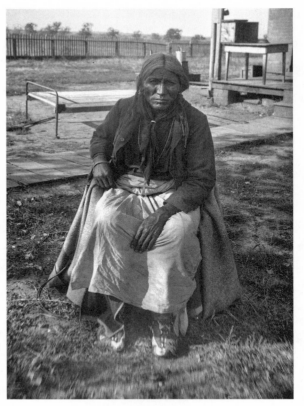

FIGURE 5.1. *Settan, or Little Bear, the aged Kiowa who gave his calendar to James Mooney. National Anthropological Archives, Smithsonian Institution (NAA Neg. no. 1394).*

be expected among people in close contact, and contrasts with the variations in winter counts found among the more numerous and widespread Lakota and Blackfoot.

Mooney worked extensively on the Kiowa Reservation over a number of years, interviewing many people about tribal history and culture. He found the calendar to be a point of reference that people commonly used to give temporal order to their oral history, fitting individual stories into this shared framework. He applied the same principle in his *Calendar History of the Kiowa*, organizing a vast amount of historical information around the simple pictorial record. Like Garrick Mallery, he used The Year the Stars Fell (the winter of 1833–34) as an index point to correlate the Kiowa calendar with Western year desig-

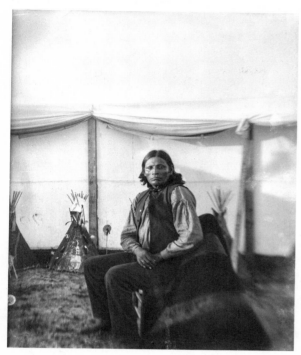

FIGURE 5.2. *Anko, one of the Kiowa calendar keepers with whom Mooney worked. In the background are a model tipi and shield, another project on which Mooney engaged Anko's services. National Anthropological Archives, Smithsonian Institution (NAA Neg. no. 1407).*

nations and to juxtapose Kiowa perspectives and white records on many of the same events.

Regrettably, none of Mooney's notes on Kiowa calendars have been preserved. In keeping with practices of the time, they were evidently discarded once the book was published.[3] A few years later, while engaged in other studies, Mooney discovered that his regular Kiowa artist Silver Horn also kept a calendar. He commissioned Silver Horn to copy it on the blank leaves of a bound volume and made extensive notes on the faces of the drawings, but he never published anything on this record.

There were only a few calendar keepers among the Kiowa when Mooney began his studies, but several people began keeping calendars in later years, inspired in part by the copies of Mooney's book, which he distributed widely

within the community (Greene 2001:165). Some of these later calendars are now in the Smithsonian collections. In 1909, while collecting for the Museum of the American Indian, Mark Harrington obtained a pictorial calendar and explanatory text from Silver Horn's brother Haba. In the 1970s the Kiowa historian Linn Pauahty allowed the NAA to photograph a calendar painted on cloth that was on loan to him, and the museum taped a brief interview with him about it. The Smithsonian's Department of Anthropology has since acquired two additional calendars that record events into the 1920s.

Other unique calendric records by Silver Horn are in the NAA. One is a pictorial diary in which Silver Horn marked the passage of days and weeks over a four-year period in the 1890s. Similar pictorial notes appear on the margins of some of the drawings that Silver Horn made while he was employed by James Mooney. Mooney paid him for the number of days worked, and Silver Horn evidently adapted this pictorial calendar system to keep a log of pay due.

BLACKFEET

Blackfeet winter counts, like those of the Lakota, recorded a single event for each year. In this tribe the calendar keepers appear to have maintained their records primarily in oral form, each keeper relying on careful memorization to keep the events in sequence (Wissler 1911:45; Dempsey 1965). Only two pictorial counts are reported for the Blackfeet, both consisting of pictures painted on hide. Neither hide has survived, but in 1912 pictures from the Bull Plume winter count were copied into a journal now at the Fort McLeod Museum in Alberta, Canada. The count covers the years 1764–1924, and reproductions of the pictures and their explanations have been published by Paul Raczka (1979). A number of the oral winter counts have been committed to writing at various times. The earliest one, the Bad Head record covering the period from 1810 to 1883, has been published by Hugh Dempsey (1965). Others begin at later dates and con-

tinue well into the 20th century. Entries in the later years typically record the names of women who sponsored the Sun Dance, the deaths of leading chiefs, or the places where the keeper resided (Wissler 1912:47; Dempsey 1965:4). Winter counts are known from all three divisions of the Blackfeet—the Blackfeet proper, the Blood, and the Piegan (Chamberlain 1984:s9).

The NAA has a Blackfeet winter count in text form which was recorded on the Blood Reserve in Canada. It differs substantially from events given in the published records of Bad Head and Bull Plume and thus provides another, independent account.

MANDAN

Only two Mandan winter counts have been reported, each constructed like the Lakota calendars with a single entry for each year. One was kept by Butterfly, who dictated an explanation for his calendar to the Hidatsa interpreter Edward Goodbird in 1911. In 1929 another keeper, Foolish Woman, worked with Martha Beckwith to record the text, pictures, and year designations for his calendar (Howard 1960c; Beckwith 1934). Both of these winter counts begin with the year that "many stars fell down to the ground" and continue into the 1870s.

The NAA recently acquired photographs of another Mandan document that appears to be calendric in nature, although it is not a winter count. Ron Little Owl of Fort Berthold brought to the museum a family heirloom consisting of four very old and fragile sheets of paper covered with markings, hoping that the staff might be able to tell him something about it. The many rows of crescents, some marked with additional pictures, suggested to me that this was a count of lunar months. The recurrence in various places of similar pictures at intervals of 13 crescents, the number of lunar months in a year, seems to support that interpretation. Mr. Little Owl agreed to place photographs of the document in the NAA to encourage further study of this unique record.

■

NAME: SILVER HORN

Physical Form: Pictographs in a bound notebook with explanatory annotations
Dimensions: 9½ in. (24 cm) by 6 in. (15 cm)
Years Covered: 1828 to 1904
Format: Pictographs, many with multiple figures, drawn in ink, watercolor, pencil, and crayon in a linear sequence, moving from left to right

HISTORY OF PRODUCTION

Silver Horn drew this calendar for the Smithsonian anthropologist James Mooney in 1904. It was a copy of a calendar that he was already keeping, perhaps the one now at the Sam Noble Oklahoma Museum of Natural History in Norman. While other Kiowa calendar keepers used simple, abbreviated pictures to reference each seasonal name, this calendar has more detailed images, often illustrating several events in addition to the one for which the summer or winter was named. Many births are noted by a picture of a cradleboard, while deaths are indicated by the horned owl, associated with the spirits of the dead. Silver Horn's calendar in the Oklahoma museum is much simpler than this version, with single images for each entry.

HISTORY OF ACQUISITION

James Mooney was engaged in a long-term research project among the Kiowa when he commissioned this work. Silver Horn had been employed by him as an illustrator and occasional informant since early 1902, producing drawings and models of Kiowa shields, tipis, and other items. Mooney evidently provided the government-issue notebook in which the calendar is drawn, since it is identical to the book he used for his own notes that year. There is no accompanying text, but the drawings themselves have been extensively annotated by Mooney, whose tiny, scribbled notes are difficult to decipher.

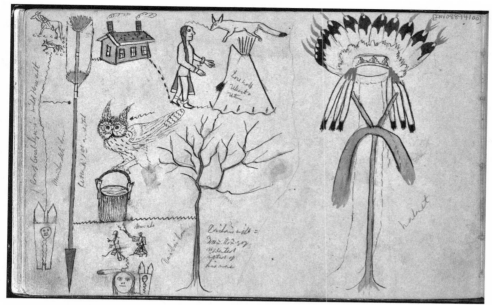

FIGURE 5.3. *A page from the Silver Horn calendar. Winters are represented by a bare tree, while summers are marked with the forked center pole of the Medicine Lodge. Lone Wolf's release from prison and Black Kettle's death are among the pictures for the winter of 1868–69; the summer of 1869 marks the capture of a warbonnet. National Anthropological Archives, Smithsonian Institution (NAA Ms. 2531, vol. 7; 08894100).*

BIOGRAPHY OF KEEPER

Silver Horn, or Haungooah (1860–1940), was the son of Agiati and his wife Seipote. Several members of his family were calendar keepers. His great-uncle the famous chief Tohausen was the first known calendar keeper among the Kiowa. Tohausen transferred his name and the responsibility for maintaining the calendar to Silver Horn's father Agiati, also known as Tohausen II. Silver Horn's half brother Haba also kept a calendar, which is described below. Extensive information about Silver Horn, his family, and his art is available in *Silver Horn: Master Illustrator of the Kiowa* (Greene 2001).

COPIES AND CITATIONS

While this calendar is related to the one his father kept, only about half of the entries reference the same events, and it is much more elaborately illustrated. It is more closely related to his brother Haba's calendar. An-other calendar by Silver Horn, covering the years 1828 to 1928, is in the collection of the Sam Noble Oklahoma Museum of Natural History. A detailed discussion of the NAA calendar is published in Greene 2001:165–172. Pages of the NAA calendar are illustrated in Merrill et al. 1997:208–212, and in Greene 2001:41, 47, 89, 168, 169, 171, and pls. 4, 33, 34. A complete copy can be viewed on the NAA Web site, as part of the online exhibit of Kiowa drawings at www.nmnh.si.edu/naa.

REPOSITORY IDENTIFICATION

NAA Ms. 2531, vol. 7; 08891700–08896700

■

NAME: HABA

Physical Form: Notebook produced to accompany pictorial
version that is now lost
Years Covered: 1828 to 1909
Format: Handwritten text, original pictographic version
described as painted in a book

HISTORY OF PRODUCTION

There is no information regarding the circumstances under which Haba produced this calendar.

HISTORY OF ACQUISITION

Mark R. Harrington, a professional collector who was often employed by George Heye to acquire material for his Museum of the American Indian, purchased this book from Haba in 1909. Working through an interpreter, Harrington recorded a detailed explanation of the calendar from Haba. Most entries are given in the Kiowa language, followed by a translation of the season name and a few additional notes or explanations. Western year designations have been added at a later time. Harrington's notes are preserved in the archives of the NMAI, although the original pictorial calendar can no longer be located. The cover sheet for the file lists the date of collecting as 1907 rather than 1909, probably because of a misreading of the date on the handwritten letter of transmittal.

BIOGRAPHY OF KEEPER

Haba, or Hill Slope (1852–1915), sometimes referred to as Habate, was the oldest son of Agiati, also known as Tohausen II, and his wife Yoete. Several members of his family were calendar keepers, including his younger half brother Silver Horn. Silver Horn's son James lived much of his early life with his uncle Haba near Mount Scott, and he believed that Haba trained Silver Horn in calendar keeping (Greene 2001:165). Like his brother, Haba assisted James Mooney with his studies of shield and tipi designs.

COPIES AND CITATIONS

While this calendar is related to that kept by his father, the choice of entries is more closely related to his brother Silver Horn's calendar. It has never been published and there are no photographs of it.

REPOSITORY IDENTIFICATION

NMAI Archives #OC 133, Folder 5, Papers of Mark R. Harrington

■

NAME: SETTAN

Physical Form: Photograph of drawing on sheet of heavy paper
Years Covered: 1833 to 1892
Format: Pictographs drawn with colored pencil in inward
clockwise spiral

HISTORY OF PRODUCTION

The Settan calendar is very similar to the Tohausen calendar, and Mooney believed that it had been inspired by that record, although it was not a direct copy. Settan reported that he had been keeping the calendar for 14 years before he gave it to Mooney in 1892. The good condition of the paper and the consistency of the drawing led Mooney to believe that the version he received had been drawn shortly before it was given to him.

HISTORY OF ACQUISITION

Mooney described his acquisition of the calendar as follows: "Settan . . . voluntarily brought in and presented the calendar without demanding any payment in return, saying that he had kept it for a long time, but that he was now old and the young men were forgetting their history, and he wanted it taken to Washington and preserved there with the other things collected from the tribe, that the white people might always remember what the Kiowa had done" (1898:145). Regrettably, the calendar has not been preserved, although an original glass plate negative is in the collection. On February 10, 1903, Mooney noted in a letter to Alfred Kroeber that the calendar had been lost when it was sent out to an artist to be reproduced for publication in his *Calendar History* (Kroeber Papers).

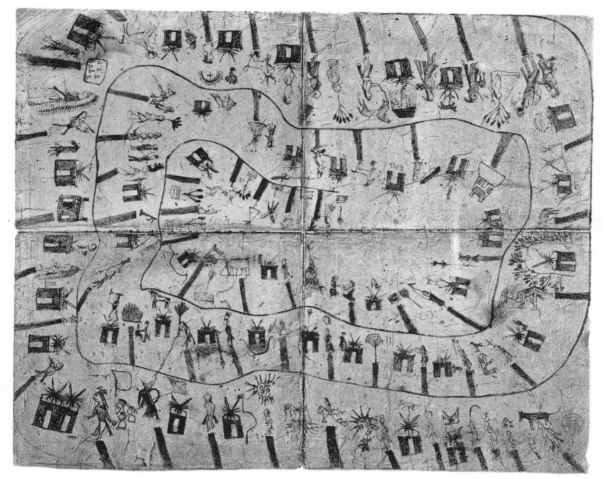

FIGURE 5.4. *The Settan calendar, as published by Mooney in his* Calendar History of the Kiowa *(1898). The original calendar was lost when it was sent out to be copied for publication. National Anthropological Archives, Smithsonian Institution (NAA Neg. no. 1465A).*

BIOGRAPHY OF KEEPER

Settan's name is translated by Mooney as Little Bear. He was a cousin of the noted war chief Gaapiatan, with whom Mooney lived near Mount Scott during his early years of work among the Kiowa.

COPIES AND CITATIONS

This calendar is published in Mooney 1898, plate 75. The content closely follows that of the Tohausen calendar, now in the collection of the Phoebe Apperson Hearst Museum of Anthropology, University of California at Berkeley, although the pictures are more carefully drawn and often more detailed.

REPOSITORY IDENTIFICATION

NAA Neg. no. 1464A; Neg. no. 1465A
print from 1465A in Photographic Lot 80-6: 06276200

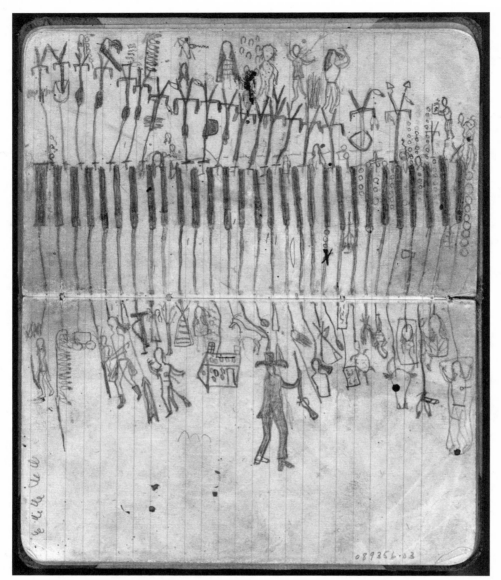

FIGURE 5.5.
The Anko calendar, as originally drawn in a small notebook. Winters are represented by black bars, and summers by the forked center pole of the Medicine Lodge. National Anthropological Archives, Smithsonian Institution (NAA Ms. 2538, Box 2; 08935603).

■

NAME: ANKO SEASONAL AND MONTHLY

Physical Form: Pictographs drawn in pencil in a small notebook; photograph of images redrawn on hide

Dimensions: 6¾" (17 cm) x 8" (20.5 cm)

Years Covered: 1864 to 1892; August 1889 to August 1892

Format: Pictographs drawn in linear fashion, left to right; monthly: counterclockwise spiral moving inward

HISTORY OF PRODUCTION

This calendar was kept by Anko in a small pocket notebook. The seasonal calendar is drawn across two facing pages. Pictures for winters are drawn on the lower page, connected by lines to a row of black bars, the usual representation for the winter season. Pictures for the summer seasons are drawn on the upper page, accompanied by images of the Sun Dance pole, with pendant lines show-

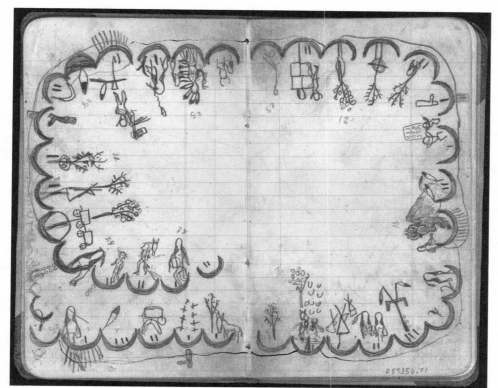

FIGURE 5.6.

The Anko monthly calendar, as originally drawn in the same small notebook as his annual calendar. Each month is marked by a crescent moon, supplemented with pictographs for various events. National Anthropological Archives, Smithsonian Institution (NAA Ms. 2538, Box 2; 08935601).

ing their position between the black bars. The crowded images fill the page from side to side with no room for additional entries. The monthly calendar consists of a series of crescents arranged in a counterclockwise spiral spread across two facing pages of the notebook. The spiral moves inward toward the center, much of which remains blank. Another page in the notebook has two parallel rows of crescents with accompanying pictures. A photograph in the NAA records the appearance of another version of the Anko calendar, which combines the seasonal and monthly calendars into a single image painted on a deer hide. This was reportedly drawn in colored ink by Anko as a copy of his original calendar at the request of James Mooney (Mooney 1898:144). The seasonal calendar is placed across the center of the hide, and the monthly calendar begins above it on the upper left moving across and down the right side in the beginning of a clockwise spiral. The final moon of the original calendar has been omitted. The pictorial figures are less crowded on this much larger surface but show little more detail than the original tiny drawings.

HISTORY OF ACQUISITION

Anko's calendar notebook was acquired by James Mooney in 1892, while he was living among the Kiowa and studying their calendar system. Mooney subsequently commissioned and supervised the production of the hide version. It was evidently sent to the Bureau of American Ethnology BAE offices in Washington to be photographed for use in his publication, but it was never received by the Smithsonian's National Museum, where other artifacts collected by Mooney were deposited, and its present location is unknown. As noted above, Mooney reported that the Settan calendar had been lost when it was sent out to be photographed for his *Calendar History*, and the Anko hide may have suffered the same fate.

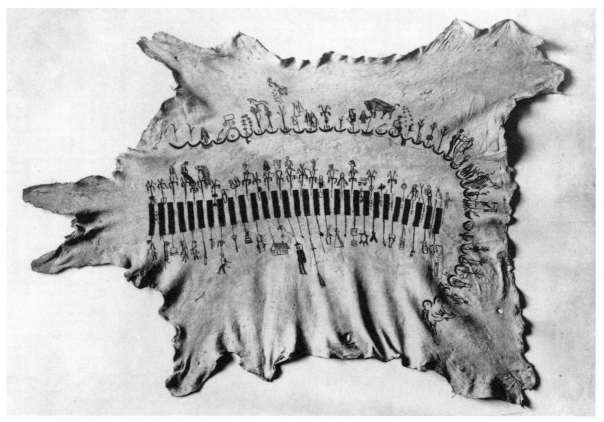

FIGURE 5.7. *The Anko calendar on buckskin, as redrawn by Anko at James Mooney's request, combining the figures from both the annual and the monthly calendars. The tiny figures from the original notebook are much larger in this version but show little more detail. National Anthropological Archives, Smithsonian Institution (NAA Neg. no. 46,856).*

BIOGRAPHY OF KEEPER

Anko was the common abbreviation for the warrior Ankopaingyadete, translated by Mooney as In the Middle of Many Tracks.

CITATIONS AND COMPARISONS

Anko's annual calendar is closely related to the Tohausen and Settan versions, as published by Mooney, but marks different events for several seasons. His monthly calendar, however, appears to be a unique personal record on which he made note of incidents in his wife's health as well as more public events. A full interpretation of it is given in Mooney 1898:373–379, and the copy painted on hide is illustrated in plate 80. A complete copy of the original version can be viewed on the NAA Web site, as part of the online exhibit of Kiowa drawings at www.nmnh.si.edu/naa.

Several artists have been inspired by the illustration published by Mooney and have painted new versions of this calendar on hide, either copying it closely or substituting some events of personal interest. A version made around 1934 by Charles E. Rowell, a descendant of Anko, is at the Haffenreffer Museum of Anthropology, Bristol, Rhode Island. It is illustrated in the *Handbook of North American Indians*, vol. 13, *Plains*, p. 1069. Another, more recent version by Rowell is in the collection of the

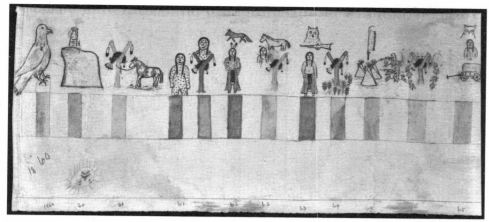

FIGURE 5.8. *Detail of the Ware calendar, from a photograph in the National Anthropological Archives. This section covers the period from 1860, when Bird Appearing died, to the winter of 1865–66, when Old Man Wagon died. National Anthropological Archives, Smithsonian Institution (NAA Ms. 7268).*

Carson County Square House Museum, Panhandle, Texas (Wunder 1989:82).

REPOSITORY IDENTIFICATION

NAA original notebook Ms. 2538, Box 2; 08935601–08935603

■

NAME: HARRY WARE

Physical Form: Color slides and black and white photographs of calendar; explanatory tape recording

Years Covered: 1860 to 1887

Format: Pictographs drawn in ink and watercolor on long strip of cotton cloth; pictographs are linear from left to right

HISTORY OF PRODUCTION

Information about the production of the calendar comes from the accompanying half-hour taped interview with Linn Pauahty, who reported that Harry Ware was the "custodian and author" of the calendar and had produced it in 1923 with the assistance of Bert Geikamah and Silver Horn. Mr. Pauahty assumed that Silver Horn had drawn the images on it, since he knew that Silver Horn was an artist. However, these images do not resemble

Silver Horn's other known drawings, and by this date he was nearly blind (Greene 2001:46). Perhaps he was an adviser on the project, describing the seasonal pictures as he remembered them rather than producing the drawings themselves.

HISTORY OF ACQUISITION

Linn Pauahty of Lawton, Oklahoma, brought the calendar to the Smithsonian in October 1977. The calendar had been loaned to the Kiowa Historical and Research Society by Harry Ware's grandson. The NAA made photographs for study purposes and tape-recorded an interview with Pauahty interpreting the calendar. Interestingly, Mr. Pauahty believed that the Kiowa calendar tradition was learned from the Kiowa-Apache (now known as the Apache Tribe of Oklahoma), and that Settan was the first calendar keeper among the Kiowa.

BIOGRAPHY OF KEEPER

Harry Ware appears on the 1901 census, Ms. 2014. Notes from interviews with him are included in notes from the Columbia University Laboratory of Anthropology summer 1935 field school (NAA Papers of Weston LaBarre, Typescript of Student Notes).

COPIES AND CITATIONS

Pauahty retained the original calendar as a part of the Kiowa Historical and Research Society, then based in Lawton, Oklahoma. Three individual entries are published in Boyd 1983:238.

REPOSITORY IDENTIFICATION

NAA Ms. 7268

■

NAME: QUITONE

Physical Form: Pictographs on loose sheets of card stock

Dimensions: 8½ in. (21.5 cm) by x 11 in. (28 cm)

Years Covered: 1825 to 1921

Format: Pictographs drawn in pencil, ink, and watercolor on 25 sheets of heavy card stock; 2 to 4 entries per page, arranged top to bottom and left to right, with years noted in pencil

HISTORY OF PRODUCTION

No information is known about the original production of this calendar. However, the pictures, although arranged in a different format, are a close match to a tracing that Wilbur S. Nye made in the 1920s of a calendar belonging to Jimmy Quitone, and this NAA calendar may be considered a variant of the Quitone calendar. Nye's tracing is in the collection of the Fort Sill Museum in Oklahoma, together with his notes about the version that he examined. He recorded that although Quitone owned the calendar when he made the tracing, it had been produced by Johnny Anko and Hauvahte (Fort Sill Museum Archives, Nye Collection, Folder 2).

HISTORY OF ACQUISITION

I deposited this calendar in the collection of the NAA in 2002. I had received it as a gift from a former professor at the University of Oklahoma, William E. Bittle. I was a doctoral student at the university when Bittle retired in 1984. When he left, he gave the calendar to another faculty member, asking him to pass it along to me because of my interest in plains drawings. At the time I assumed that the calendar was a student project, probably a copy of a published calendar, and I packed it away for future reference. Some years later, after I had become more familiar with Kiowa materials, I realized that the calendar did not follow any published works and should be considered an independent source of information. I contacted Dr. Bittle, but he recalled very little about its acquisition except that someone in Oklahoma had given it to him many years before.

William Bittle, a cultural anthropologist, taught at the University of Oklahoma from the 1950s until 1984 and directed an ethnographic field school among the plains tribes of western Oklahoma each summer for many years. His own fieldwork was primarily with the Apache Tribe of Oklahoma, then known as the Kiowa Apache, but he had friends among many tribes.

BIOGRAPHY OF KEEPER

Jimmy Quitone (Wolf Tail) was one of the elders from whom W. S. Nye recorded much information about Kiowa history. According to Nye, he was the father of George Hunt and Guy Quitone (1962:278). Hugh Corwin provides anecdotal information about Quitone, including a note that he died in 1956 at the age of 101 (1958:205). Hauvahte may be an alternate rendering of Habate, or Haba, the author of the NMAI calendar discussed above.

CITATIONS AND COMPARISONS

This document has not previously been published or studied in detail. Many of the year designations agree with the Tohausen and Settan calendars published by Mooney, but it begins a few years earlier and continues for nearly three more decades. The devices used to designate seasons—a red diamond for winter and a green or yellow bar for summer, usually with an indication of the forked Medicine Lodge pole—are similar to those employed in the muslin calendar described below.

As noted, another version of this calendar is in the collection of the Fort Sill Museum, Fort Sill, Oklahoma, cat. no. D68.39.4. It is a tracing that Wilbur S. Nye made in the 1920s from an original calendar on a long strip

Medicine Lodge TREATY

1866-67

1867-68

1867

1868

FIGURE 5.9.
Page from the Quitone calendar showing two years— the winter of 1866–67 through the summer of 1868. Winters are marked by a red diamond and a bar, summers by a green rectangle and the forked pole of the Medicine Lodge. The Medicine Lodge Treaty of 1867 was held at a place the Kiowa called Timber Hill, effectively pictured at the upper right. National Anthropological Archives, Smithsonian Institution (NAA Ms. 2002–27).

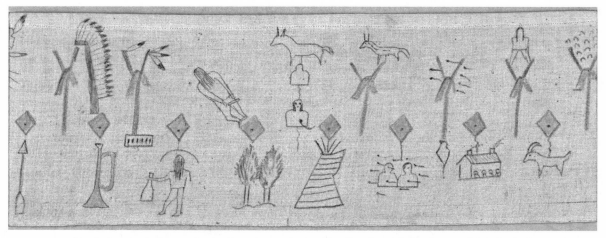

FIGURE 5.10. *Detail of a calendar by an unknown Kiowa keeper, drawn with yellow diamonds for winters and forked poles for summers. This section covers the period from winter 1868–69, when Tanguadal (represented by his lance) was killed, to summer 1876, when many horses were stolen, as referenced by their tracks. National Anthropological Archives, Smithsonian Institution (NAA Ms. 2002–28).*

of cloth. He believed that this calendar on cloth was destroyed when the Quitone home burned in the 1930s.

REPOSITORY IDENTIFICATION
NAA Ms. 2002–27

■

NAME: UNKNOWN
Physical Form: Pictographs on a strip of canvas
Dimensions: 84 in. (213 cm) by 4 in. (10 cm)
Years Covered: 1862 to 1901
Format: Entries drawn in pencil and colored pencil in a staggered linear sequence, moving from left to right

HISTORY OF PRODUCTION
No information is known about the original production of this calendar. It is drawn on a piece of coarse cotton cloth with one selvage edge and one edge machine hemmed. The entries begin near one end of the strip and stop well short of the opposite end.

HISTORY OF ACQUISITION
This calendar was purchased by the Smithsonian in March 2002 from Historical Artifacts, Inc., of Gerryowen,

Montana. They had acquired it through Butterfield's Auction House in 2000, consigned from the private collection of Rex Arrowsmith, an Indian art dealer. It was misidentified as a Sioux pictograph drawing from the 1890s, based on the accompanying history in Butterfield's catalog: "This pictograph was obtained from the family of Indian Agent Charles Lyman Ellis. Mr. Ellis was a Federal Indian Agent and spent most of his career working with the Sioux in South Dakota, first arriving there in 1904." It is not known whether this piece actually came from Ellis or whether his name was erroneously associated with the object. I have identified the piece as a Kiowa calendar.

BIOGRAPHY OF KEEPER
The keeper is unknown.

CITATIONS AND COMPARISONS
This document has not previously been published or studied in detail. Summer and winter entries alternate, with the register of summer entries drawn above the register of winter entries. A green forked pole accompanies pictures for summers when the Medicine Lodge ceremony was held. A yellow diamond outlined in blue indicates

FIGURE 5.11. *Page from the daily calendar, or diary, kept by Silver Horn for nearly four years. This page covers five weeks in April and May 1894, during which time he was enlisted in the army at Fort Sill. Large feathers divide the entries into weeks, with the figure of a longhorn steer representing the beef issue every two weeks. National Anthropological Archives, Smithsonian Institution (NAA Ms. 4252; 09063722).*

winter seasons. The entries correspond more closely with the Anko calendar than with the Tohausen record.

REPOSITORY IDENTIFICATION
NAA Ms. 2002–28

■

NAME: SILVER HORN DIARY

Physical Form: 30 pages in an Army Target Record book that also includes other drawings

Dimensions: 13½ in. (34.5 cm) by 8 in. (21 cm)

Years Covered: January 1893 to June 1897

Format: Pictographs and other symbols drawn in ink and pencil in serpentine form beginning on the upper left and continuing over 30 pages

HISTORY OF PRODUCTION

This is a unique pictorial record created by Silver Horn for his own use and maintained by him for over four years.

It correlates precisely with the Western calendar. Markers representing days are divided into seven-day weeks by large upright feathers, a reference to the Feather Dance, as the Kiowa called the Ghost Dance, which was held on Sundays during this period. Every two weeks a picture of a longhorn steer denotes ration day, when beef was issued. The picture of a flying eagle signifies the passage of each month, whether of 28, 30, or 31 days. Silver Horn was enlisted as a scout in the army when he began this diary and was paid monthly; the use of this device to mark the months may derive from the military slang for payday, "when the eagle flies." Crescent moons referencing the traditional Kiowa division of time into lunar months appear only in the first half of the diary. In addition to these regular entries, Silver Horn added tiny pictures to note other events. Many relate to military life—the guardhouse where scouts mustered, target practice, work in the post sawmill, escorting the payroll wagon. Others relate to civilian life and include the births and deaths of commu-

nity members, annuity and lease payments, and peyote meetings.

HISTORY OF ACQUISITION

The book was acquired from Silver Horn in 1897 by Lt. Hugh Scott, under whose command Silver Horn had served in the army. Scott, an able amateur ethnographer, learned of the book when he was visiting Silver Horn a few years after he had left the army, and asked him to make a copy of the calendar for him. Displaying typical Kiowa generosity, Silver Horn instead presented it to him as a gift. Recognizing the value of the book, Scott gave him $20 in return. In 1936 Scott's widow sold it to the BAE for $50. Scott recorded no information about the diary from Silver Horn and described it in museum records as "just what happened to him as a soldier."

BIOGRAPHY OF KEEPER

General information on Silver Horn is given above in the entry for his annual calendar. He served in Troop L of the 7th Cavalry, based at Ft. Sill, from 1891 to 1894.

COPIES AND CITATIONS

A detailed discussion of the diary is published in Greene 2001:172–183. Some of the 30 pages of the diary have been published in Merrill et al. 1997:228–229, and Greene 2001:173–175, pl. 35. A complete copy can be viewed on the NAA Web site, as part of the online exhibit of Kiowa drawings at www.nmnh.si.edu/naa.

REPOSITORY IDENTIFICATION

NAA Ms. 4252; 09063701–09063730

■

NAME: PERCY CREIGHTON
Physical Form: Handwritten text in spiral notebook
Dimensions: 6 in. (15 cm) by 9 in. (23 cm)
Years Covered: 1831 to 1938
Format: Text entries in English

HISTORY OF PRODUCTION

The text of this calendar was recorded on the Blood Reserve in the summer of 1939 by Harry D. Biele. Biele did not clearly record who provided the information, but Hugh Dempsey, a noted scholar who has studied the book, believes it to have been Percy Creighton (pers. comm., January 11, 2002). Other information from Creighton was recorded on the leaves of the book immediately before the calendar notes, and various entries in the calendar indicate that information was received from "P.C.," presumably referring to Creighton.

HISTORY OF ACQUISITION

The calendar came to the NAA in 1982 as a part of the papers of the anthropologist Esther Goldfrank, who published on the Blackfeet. She noted that the text and some additional notes had been recorded by Harry D. Biele on the Blood Reserve in the summer of 1939. Biele's assistance to the Columbia University Anthropological Field Laboratory research team is acknowledged in Goldfrank's publication (1945).

BIOGRAPHY OF KEEPER

Percy Creighton, whose Blackfoot name was Little Dog, was a member of the Blood tribe. He was serving on the Blood Tribal Council when Goldfrank was conducting research there, and he provided useful information to Hugh Dempsey when he was researching winter counts in the 1950s.

COPIES AND CITATIONS

This document has not been published.

REPOSITORY IDENTIFICATION

NAA Papers of Esther Goldfrank, Box 13

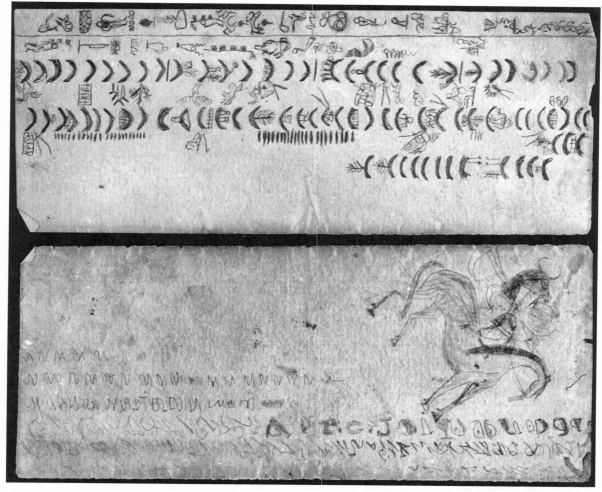

FIGURE 5.12. *Pages from a unique Mandan document. The crescents probably represent moons, or months, suggesting that it is a calendar of some sort. National Anthropological Archives, Smithsonian Institution (NAA Ms. 2003-05).*

■
NAME: MANDAN CALENDRIC CHART

Physical Form: Black and white photographs of 4 loose sheets of paper, one torn in half

Years Covered: Not determined

Format: Not determined

HISTORY OF PRODUCTION

Ron Little Owl, a member of the Three Affiliated Tribes of the Fort Berthold Reservation in North Dakota, found these pages in the bottom of a trunk that he was cleaning out in the early 1970s after his mother died. There were other papers in the trunk as well, but they fell apart when he examined them and could not be saved. He asked his father about the documents and was told that they related to the corn priests and that they came from an earlier generation, perhaps from either his grandfather William Little Owl (1861–1945) or his great-grandfather Strikes the Back, both Mandan.

HISTORY OF ACQUISITION

Ron Little Owl brought the original document to the Department of Anthropology at the Smithsonian in November 1998, when he was attending a meeting of the Smithsonian Repatriation Review Committee, of which he was a member. He showed it to a number of people and agreed for it to be photographed and the photos maintained in the archives for study. I suggested that the documents were a calendric chart of some sort, basing this suggestion on the rows of crescents, which I took to be moons.

BIOGRAPHY OF KEEPER

William Little Owl (1861–1945) and his father, Strikes the Back, were described by Mr. Little Owl as members of the Bad News clan.

CITATIONS AND COMPARISONS

This document is published in Thornton 2003.

REPOSITORY IDENTIFICATION

NAA Ms. 2003–05

NOTES

1. The term *calendar* seems to be the most useful one to apply to these varied traditions, since some were based on units of time other than the single year or winter.

2. For information on the Mandan, see Beckwith 1934. The only report of a Ponca calendar is found in Howard 1965:71. Howard's papers were deposited in the NAA after his death in 1982, but unfortunately they do not contain any information regarding this or his other research on winter counts. Information on Blackfoot winter counts comes from Dempsey 1965:3 and Wissler 1911:45.

3. A single notebook in the NAA (Mooney MS 1919) contains notes relating to the glossary he included in the *Calendar History* publication.

Afterword
Tasunka Ota Win Waniyetu Wówapi
(Her Many Horses Winter Count)

EMIL HER MANY HORSES

In 1999, when I was working on developing the Our Universes exhibition, one of four inaugural exhibitions for the National Museum of the American Indian (NMAI), John Around Him was selected to be one of the community curators representing the Oglala Lakota people. John was a Lakota language teacher at the Little Wound High School in Kyle, South Dakota. He flew into New York City, where at the time the Lakota collections were still being held at the NMAI Research Branch in the Bronx. As he and other community curators reviewed the collections to make selections for the exhibition, he came across one of the Lakota winter counts in the collections. As he studied the winter counts, John said that he wished his students could see these winter counts, so that they could understand the historical significance and perhaps be interested enough to make their own family winter counts.

In 2001 John's wish became a reality. He and several of his students were brought to Suitland, Maryland, to work with the Resources Center staff to develop a Web site program for the NMAI. Students digitally photographed the Lone Dog winter count and downloaded the images onto the computer, while John and another of the students' escorts recorded the descriptions of the images in both Lakota and English. This winter count information is now available to museum visitors and online at www.americanindian.si.edu/wintercount/.

After seeing this process, I began thinking to myself, if I were to create a winter count, what would I include? As I understand winter counts, they were made by a keeper who recorded the historical events of a *tiyóšpaye*, or community. I was living in Washington DC, miles away from my family in South Dakota, and I was single. But I come from a large extended family. I am the third oldest of a family of eight children—Leo Jr., Randy, myself, Grace, Cleve, Steve, D'Ann, and Kathy—and most of them are involved in dance and ceremonial activities. So I decided that I would contact everyone, either by phone or in person, and ask what event to include in this winter count, much like the former keepers, who consulted a group of elders when deciding on a recorded event.

I asked myself, What should I call my winter count? I

decided that I would call it *Tasunka Ota Win Wanyetu Wówapi*. *Tasunka Ota Win* means "Many Horses Woman" and was the name of my father Leo's great grandmother. The English translation became Her Many Horses. So I will call this winter count the Her Many Horses winter count, and I will include the history of my *tiyošpaye* or my extended family.

THE YEAR MANY CEREMONIES WERE HELD AT WAKPAMANI LAKE: 1999

The first event I will include is the year we conducted many ceremonies at Uncle Sidney Has No Horse's Prayer Dance at Wakpamani Lake on the Pine Ridge Reservation in South Dakota. The dance was called a Prayer Dance and not a Sun Dance because Uncle Sid and the community decided that they were still learning the responsibilities involved in conducting the Sun Dance. My younger brother Cleve decided that he wanted to give Lakota names to Vicki, his wife, and to their children: Robbie, Shawn, Rae, and Stacy. My mother, Lorna, decided to name my younger sister Kathy and my nephew Alan, D'Ann's son. My sister Grace decided to name two of her children, Wayne and Kira; her oldest son, Moses,

1999

already had his name. My brother Steve would name his daughter Stephanie.

We began preparing for the *Hunka Lowanpi*, or naming ceremony. When we give a person a name we ask a well-respected person to tie a feather on the person to be named, an eagle plume for a female and an eagle feather for a male. After the ceremony, that person is considered a family member. The names we give can be either new names or names that have been passed down from deceased family members. We began preparing several months in advance. My mother had star quilts made, and everyone began buying items that we would give away to honor the ones who were to receive their names.

My niece Rae had for several years been selected to be one of the four tree girls at the Prayer Dance. She had been dressed in white, which represented the direction of the north. The four tree girls represent virtuous young girls who made the first cuts with an ax to the Sun Dance tree. Securing this tree involves special prayers and songs. The Sun Dance tree is used to send the prayers of the people to *Wakan Tanka*, or the Great Mystery, during the four days of the Sun Dance.

It was now time for Rae to pass from childhood to womanhood. I spoke with Cleve and Vicki and asked if we could conduct two of the Lakota puberty ceremonies for Rae: the *Ishna Ta Awi Cha Lowan*, Preparing a Girl for Womanhood, and the *Tapa Wanka Yap*, The Throwing of the Ball. They agreed, and I began to prepare for the ceremonies. I also spoke with Grace, since she was one of the women Sun Dance helpers. I told her that I would prepare the materials but she would need to lead the ceremonies in the center of the *Hocoka*, or the Sun Dance circle, since these were women's ceremonies. She agreed, and I started preparing the items which would be needed to conduct the ceremonies.

Just before we were to begin the ceremonies, I started to get a little nervous because these ceremonies are rarely conducted and I did not want to do something wrong. But as I thought about it, I decided that I had been given this knowledge for a reason and that I should proceed with the ceremonies. I went to speak with my uncle Robert Two

Crow. Uncle Robert was the announcer at the Sun Dance, and I asked if he could explain to the people what we were about to do. He told the people how fortunate they were, because today they were going to witness several ceremonies there at Wakpamani Lake. He went on to explain that there are seven ceremonies associated with the sacred pipe and that the two ceremonies they were about to see were the women's puberty ceremony and The Throwing of the Ball ceremony.

At the time of the ceremony, Rae was dressed in her Sun Dance outfit, which consisted of a cloth dress with a shawl wrapped around her waist and secured with a belt. She wore her hair loose. Since red is a sacred color representing the color of the sun, I had Grace set out in the center a star quilt with a red background. Rae would stand in the middle while the ceremonies were being conducted. The first of the puberty ceremonies would be the *Ishna Ta Awi Cha Lowan*. Grace and I asked our aunt Sharon Two Crow to talk to Rae about her new responsibilities and to paint her, that is, to paint the part of her hair with red paint to indicate that the ceremony had been conducted for her.

Grace took Rae out to the center and stood her in the middle of the red star quilt at the foot of the Sun Dance tree. We had already told the grandmothers and aunts to go talk to Rae about her new responsibilities. Uncle Robert explained to the people what these women were about to do. Sitting in the Sun Dance shade, I saw Grandmother Nellie Two Bulls, known for her singing ability and knowledge of the Lakota tradition. I went up to her and asked, "Grandma Nellie, would you please go out and talk to my niece about her responsibilities as a woman?" Grandma Nellie proceeded toward the west gate of the Sun Dance circle; stopping, she took off her shoes and made a clockwise turn as she entered the circle and joined the other women surrounding my niece. Aunt Sharon spoke to Rae about her responsibilities as a Lakota woman as she painted the part of her hair red. Watching from the shade, I saw my sister-in-law facing her daughter as she spoke to her. Vicki was crying as she hugged her daughter. Vicki would later say that it was the most beautiful experi-

ence, talking to her daughter out in the center, and that she was a good daughter and very responsible.

The second ceremony was the *Tapa Wanka Yap*. The beaded ball I had made during the winter, which represented *Wakan Tanka*, or the Great Mystery, was thrown in the four cardinal directions, touched to Mother Earth, and thrown skyward. People were gathered at the four gates of the Sun Dance circle. The ball was thrown in each direction, and the person who caught it returned it to my niece, who was standing in the center. The returning of the ball represented returning back to *Wakan Tanka*. During The Throwing of the Ball, the singers sang the four-directions song. Although the people gathered at the four gates were a mixed group of both male and female participants, only women caught the ball. For catching the ball I gave each of the women a shawl, which represented the good things that would come to them.

Once these two ceremonies were completed, then came the *Hunka*, the naming ceremony. We had set out footlockers and lawn chairs and covered the chairs with star quilts and Pendleton blankets. All the people being named sat in these chairs, and the person tying the feathers and plume stood behind them. As the *Hunka* song was sung, everyone faced and prayed to the four directions, to Mother Earth, and upward to the Sky. The following names were given.

Cleve's wife and children
Vicki: *Tasunka Wakan Win* (Sacred Horse Woman)
Robbie: *Mahpiya To* (Blue Cloud)
Shawn: *Ite To Hoskila* (Blue Face Boy)
Rae: *Can Wakan Win* (Sacred Tree Woman)
Stacy: *Wi To Win* (Blue Sun Woman)
My youngest sister
Kathy: *Tehilapi Win* (They Think a Lot of Her)

D'Ann Her Many Horses and Alan Young Sr.'s son
Alan Young Jr.: *Takuni KoKipe Sni* (Afraid of Nothing)

Grace Her Many Horses and James Meek's children
Wayne: *Hante Hoksila* (Cedar Boy)
Kira: *Wahokiza Wakan Win* (Sacred Staff Woman)

Steve Her Many Horses and Dawn Marshall's daughter Stephanie: *Wicahpi Wanjila Win* (One Star Woman)

A giveaway followed, and afterward the singers sang a *Wopila*, or thank-you song. The name they used in the song was *Ho Naukpe*, The People Hear Him, which was the Lakota name of our deceased father, Leo. Cleve now carries the name. That evening Cleve and Vicki fed the people.

When I spoke to Grace after the ceremonies were completed, she said that this was such a wonderful experience that she could not wait until the next girls were ready. She said, "Let's see who's next!"

THE YEAR THE FIRST *YUWIPI* CEREMONY WAS HELD AT LOWER BRULE: 2000

This was the year that my brother Cleve held his first *Yuwipi* ceremony at Lower Brule. In the *Yuwipi* ceremony, a person is tied up in a quilt and communicates with the spirits to help heal the people. Before the ceremony, an altar is constructed, and four sticks with colored cloth flags and a tobacco offering tied to them are placed at the four corners of the altar. The colors used by my brother would be black and white. Cleve has two Lakota names. His first name is *Kokab Wosica*, which means Trouble in Front. This name was given to him at the Fourth of July Celebration at Wakpamani Lake by Lucy Brings Yellow, one of our many grandmothers. When we first heard the name we all laughed, because growing up my younger brother was often in trouble, so the name seemed appropriate. Lucy told my grandpa Dawson No Horse, who was announcing at that celebration, the meaning behind the name. It was the name of one of our relatives who was a warrior who was always the first to encounter the enemy or the first to charge into battle. I remember hearing the drum group hitting their drums with their drumsticks as a sign of approval. Cleve's second name was *Ho Naukpe*, or The People Hear Him. This name was given to him at Wakpamani Lake during one of the Prayer Dances after my father passed away. Uncle Robert Two Crow explained that important people often carry more than one name. At that time my brother was the BIA superintendent of Lower Brule tribe and a former army captain with the 82nd Airborne Division.

2000

THE YEAR PLANES FELL FROM THE SKY: 2001

This was the year terrorist planes flew into the World Trade Center in New York City and the Pentagon in Washington DC. Dawson, the son of my older brother Leo, was in school at Columbia University in New York City at the time. Dawson's Lakota name is *Wakan Tokapa*, or First Holy. He was named for Dawson No Horse, one of our grandfathers who was a Sun Dance leader and a medicine man. He was given his Lakota name by Robert Stead, a well-known Sičáŋǧu spiritual leader, at the Rosebud Fair when he was about a year old.

I myself was working in Suitland, Maryland, a Washington suburb, when the plane flew into the Pentagon. I am a curator at the NMAI. My Lakota name is *Taopi Cikala*, or Little Wound. Many family and friends called to find out whether we were safe.

2001

beaded helicopters, flags, and eagles. It won Best of Show and was purchased for exhibition by the Smithsonian's NMAI.

THE YEAR A VICTORY DANCE WAS HELD AT LOWER BRULE: 2003

This was the year Robbie, Cleve and Vicki's son, returned home, having joined the army and served in Iraq. When he returned, my brother invited the Red Leaf singers and veterans' groups from Rosebud to come to Lower Brule Fair. The Red Leaf singers sang the Lakota victory songs as the veterans and my nephew danced. Robbie had brought back a small flag, which he had secured from a school. Cleve had this flag tied to a pole in the center as the veterans and Robbie and the public danced to a sneak-up song. Uncle Robert Two Crow was the announcer, and he explained to the public that the family was very happy that Robbie had come home safely. Uncle Mike Her Many Horses was also present. A giveaway followed the Victory Dance, and gifts were given to families whose sons or daughters were actively serving in Iraq.

2002

2003

THE YEAR LAKOTA VIETNAM VETERANS WERE HONORED: 2002

This was the year I created two miniature tipis for the Northern Plains Tribal Art Show. The tipi, entitled Honoring Our Lakota Vietnam Veterans, was decorated with

2004

2005

THE YEAR OF THE CHRISTMAS *YUWIPI*: 2004

This was the year when my mother, Lorna, and all eight of her children gathered to celebrate Christmas at Cleve and Vicki's house in Lower Brule. It had been a long time since we had all been together. On Christmas night we gathered in the basement and conducted a *Yuwipi* ceremony. Steve, my youngest brother, Robbie, and Shawn had hand drums and led the singing. Everyone sang, and the room seemed to be filled with music. This was the first time we had conducted a *Yuwipi* ceremony together. The Spirits told us that we did not need a medicine man to lead the ceremony because each one of us brought a piece of the knowledge that was needed to conduct this ceremony.

THE YEAR AN HONOR DANCE WAS HELD IN DENVER: 2005

This was the year Grace held a special dance competition at the Denver March Powwow. This special dance was an honor dance or coming-out dance for Kira, my niece. Kira's Lakota name is *Wahokiza Wakan Win*, or Sacred Staff Woman, and Grace's Lakota name is *Hante Wakan Win*, or Sacred Cedar Woman. *Hante Wakan Win* is a name derived from a spiritual experience that Grandpa Dawson No Horse had. The story is that in a dream Grandpa Dawson was being chased by wolves, so to escape he went into a cedar tree. After telling this story to my dad, Grandpa Dawson said he should use it to name someone, so my dad gave this name to Grace, calling her Sacred Cedar Woman. Grace is a Fancy Shawl dancer and has been dancing since the age of 13. Kira has had many health problems since her birth. My sister was very happy that Kira's health was better and that at the age of 10 she too liked to dance. So Grace sponsored an Old Time and Contemporary Fancy Shawl contest. Grace gave away prize money and special jackets with the words "Dancing in My Mother's Footsteps" embroidered on the back to the contest winners.

BIBLIOGRAPHY

ARCHIVAL SOURCES

National Anthropological Archives, National Museum of Natural History, Smithsonian Institution, Washington DC

National Museum of the American Indian, Smithsonian Institution, Washington DC

North Dakota State Historical Society, Bismarck ND

Indiana State Historical Society, Indianapolis IN

South Dakota State Historical Society, Pierre SD

Sinte Gleska University Archives, Mission SD

PUBLISHED SOURCES

Amiotte, Arthur

n.d. Art and Indian Children of the Dakotas, Book Five: An Introduction to Art and Other Ideas. Aberdeen SD: Bureau of Indian Affairs.

1989 An Appraisal of Sioux Arts. In An Illustrated History of the Arts of South Dakota. Arthur Huseboe, ed. Pp. 109–202. Sioux Falls SD: Center for Western Studies, Augustana College.

Anderson, John A.

1896 Among the Sioux. New York: The Albertype Co.

Anderson, Myrtle Miller

1929 Sioux Memory Gems. Chicago: privately published.

Anonymous

1922? News and Comment re: death of "Ga-Be-Nah-Gewn-Wonce" or Wrinkled Meat. Minnesota History Bulletin 4:293.

1923 How the Fall of Stars Crabbed Wrinkled Meat's Act. Minneapolis Journal magazine, April 29.

1951 Winter Counts. Wi-Ihoyi 5(1).

1970 John Alvin Anderson, Frontier Photographer. Nebraska History 51(4):469–480.

1976 Announcement re: Dan Frost Trade Bead Collection at the Illinois State Museum. Bead Journal 3(1):8.

Babcock, Barbara A., and Nancy J. Parezo

1988 Daughters of the Desert: Women Anthropologists and the Native American Southwest, 1880–1980: An Illustrated Catalogue. Albuquerque: University of New Mexico.

Barbeau, Marius

1960 Indian Days on the Western Prairies. National Museum of Canada Bulletin, 163; Anthropological Series, 46. Ottawa: National Museum of Canada.

Batkin, Jonathan

1983 Plains Indian Painting and Drawing of the Nineteenth Century: A Gallery Guide. Exhibition catalog. Colorado Springs CO: Fine Arts Center.

Beckwith, Martha Warren

1930 Mythology of the Oglala Dakota. Journal of American Folklore 43(170):339–442.

1934 Mandan and Hidatsa Tales, 3rd ser. Poughkeepsie NY: Vassar College.

Berlo, Janet C.

1996 Plains Indian Drawings, 1865–1935: Pages from a Visual History. Exhibition catalog. New York: Harry N. Abrams.

Biolsi, Thomas

1992 Organizing the Lakota: The Political Economy of the New Deal on the Pine Ridge and Rosebud Reservations. Tucson: University of Arizona Press.

Blegen, Theodore C., ed.

1924? News and Comment re: H. M. Hiatt's article about the Iron Dog winter count. Minnesota History Bulletin 5:239–240.

Blish, Helen H.

1967 A Pictographic History of the Oglala Sioux: Drawings by Amos Bad Heart Bull. Lincoln: University of Nebraska Press.

Bordeaux, Susan Bettelyoun, and Josephine Waggoner

1988 With My Own Eyes: A Lakota Woman Tells Her People's History. Emily Levine, ed. Lincoln: University of Nebraska Press.

Boyd, Maurice

1983 Kiowa Voices: Myths, Legends and Folktales, vol. 2. Fort Worth: Texas Christian University Press.

Brandt, John C., and Ray A. Williamson

1979 The 1054 Supernova and Native American Rock Art. Archaeoastronomy 1:S1–S38. Supplement to vol. 10.

Brotherston, Gordon

1979 A Sioux Winter Count, 1800–1870. In Images of the New World: The American Continent Portrayed in Native Texts. Pp. 131–133. London: Thames and Hudson.

Buechel, Eugene, S.J.

1939 A Grammar of Lakota. St. Francis SD: St. Francis Mission.

1970 Lakota-English Dictionary. Paul Manhart, S.J., ed. Pine Ridge SD: Red Cloud Indian School.

Burke, Christina E.

2000 Collecting Lakota Histories: Winter Count Pictographs and Texts in the National Anthropological Archives. American Indian Art 26(1):82–103.

California Midwinter Exposition

1894a Official Guide to the California Midwinter Exposition in Golden Gate Park, San Francisco, California, Commencing January 27th, and Closing June 30th, 1894. San Francisco: George Spaulding & Co.

1894b The Official History of the California Midwinter International Exposition. San Francisco: Press of H. S. Crocker & Co.

Capps, Benjamin

1973 The Indians. The Old West series. New York: Time-Life Books.

Cash, Joseph H.

1971 The Sioux People (Rosebud). Phoenix: Indian Tribal Series.

Chamberlain, Von Del

1984 Astronomical Content of North American Plains Indian Calendars. Archaeoastronomy supplement 15(6):s1–s54.

Cheney, Roberta Carkeek

1979 The Big Missouri Winter Count: Traditional Interpretation by Kills Two. Happy Camp CA: Naturegraph.

Cohen, Lucy Kramer

1939 Big Missouri's Winter Count: A Sioux Calendar, 1796–1926. Indians at Work 6(6):16–20.

1942a Even in Those Days, Pictures Were Important (Swift Bear's Winter Count, part 1). Indians at Work 9(5):18–21.

1942b Swift Bear's Winter Count, part 2. Indians at Work 9(6):30–31.

1942c Swift Bear's Winter Count, part 3. Indians at Work 9(7):29–30.

Cooper, Walter G.

1896 The Cotton States and International Exposition and South, Illustrated, Including the Official History of the Exposition. Atlanta: The Illustrator Co.

Corbusier, William H.

1886 The Corbusier Winter Counts. In Fourth Annual Report of the Bureau of American Ethnology, 1882–1883. Pp. 127–147. Washington: Smithsonian Institution.

Corbusier, William T.

1961 Camp Sheridan, Nebraska. Nebraska History 42(1):29–53.

1968 Verde to San Carlos: Recollections of a Famous Army Surgeon and His Observant Family on the Western Frontier, 1869–1886. Tucson: Dale Stuart King.

Corwin, Hugh D.

1958 The Kiowa Indians: Their History and Life Stories. Lawton OK: privately published.

Cowdrey, Michael

1999 Letter to Timothy Tackett, January 4.

Crossette, George

1966 Founders of The Cosmos Club of Washington 1878: A Collection of Biographical Sketches and Likenesses of the Sixty Founders. Washington: Cosmos Club.

Cullum, George W.

1891 Biographical Register of the Officers and Graduates of the United States Military Academy at West Point, vol. 3. 3rd ed. Boston: Houghton Mifflin.

1901 Biographical Register of the Officers and Graduates of the United States Military Academy at West Point, vol. 4. Boston: Houghton Mifflin.

Curtis, Edward S.

1908 The North American Indian, vol. 3. Frederick W. Hodge, ed. Cambridge MA: The University Press.

Darnell, Regna

1998 And Along Came Boas: Continuity and Revolution in Americanist Anthropology. Amsterdam: John Benjamins.

DeLand, Charles

1922 Interview with Basil Clément/Claymore. South Dakota Historical Collections 11:245–389.

Deloria, Ella C.

1998[1944] Speaking of Indians. Introduction by Vine Deloria Jr. Lincoln: University of Nebraska Press. Orig. pub., New York: Friendship Press.

DeMallie, Raymond J.

1970 Appendix III: A Partial Bibliography of Archival Material Relating to the Dakota Indians. In The Modern Sioux: Social Systems and Reservation Culture. Ethel Nurge, ed. Pp. 312–343. Lincoln: University of Nebraska Press.

1976 Teton Sioux Time Concepts: Methodological Foundations for the Writing of Ethnohistory. Folklore Forum 9(15):7–17.

1982 The No Ears, Short Man, and Iron Crow Winter Counts (translations). In Lakota Society, by James R. Walker. Raymond J. DeMallie, ed. Pp. 124–157. Lincoln: University of Nebraska Press.

1984 The Sixth Grandfather: Black Elk's Teachings Given to John G. Neihardt. Lincoln: University of Nebraska Press.

2001 Teton. In Handbook of North American Indians, vol. 13: Plains, pt. 2. Raymond J. DeMallie, ed. William C. Sturtevant, gen. ed. Pp. 794–820. Washington: Smithsonian Institution.

DeMallie, Raymond J., and Douglas R. Parks

2001 Tribal Traditions and Records. *In* Handbook of North American Indians, vol. 13: Plains, pt. 2. Raymond J. DeMallie, ed. William C. Sturtevant, gen. ed. Pp. 1062–1073. Washington: Smithsonian Institution.

Dempsey, Hugh A.

1965 A Blackfoot Winter Count. Occasional Paper, 1. Glenbow Foundation: Calgary, Alberta.

Densmore, Frances

1918 Teton Sioux Music. Bureau of American Ethnology Bulletin 61. Washington: Smithsonian Institution. Repr., *Teton Sioux Music and Culture.* Lincoln: University of Nebraska Press, 1992.

1948 A Collection of Specimens from the Teton Sioux. Indian Notes and Monographs, 11(3). New York: Museum of the American Indian, Heye Foundation.

Dippie, Brian W.

1982 The Vanishing American: White Attitudes and U.S. Indian Policy. Middletown CT: Wesleyan University Press. Repr., Lawrence: University Press of Kansas, 1991.

Dodge, Richard I.

1882 Our Wild Indians: 33 Years' Personal Experience Among the Red Men of the Great West. Hartford CT: A. D. Worthington.

Dolan, Veronica

1977 Life on the Reservation. The Denver Post, Empire Magazine, November 6: 17–22.

Doll, Don, S.J., and Jim Alinder, eds.

1976 Crying for a Vision, a Rosebud Sioux Trilogy, 1886–1976: Photographs by John A. Anderson, Eugene Buechel, and Don Doll. Dobbs Ferry NY: Morgan & Morgan.

Dorsey, J. Owen

1894 A Study of Siouan Cults. *In* Eleventh Annual Report of the Bureau of American Ethnology, 1889–1890. Pp. 361–544. Washington: Smithsonian Institution.

Dyck, Paul

1971 Brulé: The Sioux People of the Rosebud. Flagstaff AZ: Northland Press.

Eastman, Charles

1918 Indian Heroes and Great Chieftains. Boston: Little Brown. Repr., Lincoln: University of Nebraska Press, 1991.

Ewers, John C.

1939 Plains Indian Painting: A Description of an Aboriginal American Art. Stanford: Stanford University Press.

1957 Early White Influence upon Plains Indian Painting: George Catlin and Carl Bodmer among the Mandans, 1832–34. Smithsonian Miscellaneous Collections 134(7):1–11.

1997 Plains Indian History and Culture: Essays on Continuity and Change. Pp. 61–81. Norman: University of Oklahoma Press.

Feraca, Stephen E.

1994[1974] The Wounded Bear Winter Count, 1815/16–1896/97. Kendall Park NJ: Lakota Books. Orig. pub., New Europe 3(4):4–10.

Finster, David

1968 The Hardin Winter Count. W. H. Over Museum News 29(3–4). Vermillion: University of South Dakota. Repr., Kendall Park NJ: Lakota Books, 1995.

Fleming, Paula Richardson, and Judith Lasky

1986 The North American Indian in Early Photographs. New York: Dorset Press.

Fletcher, Robert

1895a Brief Memoirs of Col. Garrick Mallery, U.S.A. Washington: Judd and Detweiler.

1895b Obituary of Colonel Garrick Mallery, U.S.A. American Anthropologist 8:79–80.

1895c Obituary of Garrick Mallery. Philosophical Society of Washington Bulletin 12:466–471.

Force, Roland W.

1999 Politics and The Museum of the American Indian: The Heye and Mighty. Honolulu: Mechas Press.

Frazier, Patrick, ed.

1996 Many Nations: A Library of Congress Resource Guide for the Study of Indian and Alaska Native Peoples of the United States. Washington: Library of Congress.

Frisbie, Charlotte J.

1989 Frances Theresa Densmore (1867–1957). *In* Women Anthropologists: Selected Biographies. Ute Gacs et al., eds. Pp. 51–58. Urbana: University of Illinois Press.

Gaster, Patricia

1982 Museum Collection: Nebraska State Historical Society. American Indian Art 7(2):60–72.

Glancy, Diane

1991 Lone Dog's Winter Count. Albuquerque: West End Press.

Glubok, Shirley

1975 The Art of the Plains Indians. New York: Macmillan.

Goldfrank, Esther S.

1945 Changing Configurations in the Social Organization of a Blackfoot Tribe during the Reserve Period (The Blood of Alberta, Canada). American Ethnological Society Monograph, 8. New York: J. J. Augustin.

Grange, Roger T., Jr.

1963 The Garnier Winter Count. Plains Anthropologist 8(20):74–79.

Greene, Candace S.

2000 The Artwork Collection of the National Anthropological Archives: An American Treasure. American Indian Art 26(1):54–65.

2001 Silver Horn: Master Illustrator of the Kiowa. Norman: University of Oklahoma Press.

Haberland, Wolfgang

1986 Ich, Dakota: Pine Ridge Reservation 1909, Photographien von Frederick Weygold. Berlin: Reimer.

Hamilton, Henry W., and Jean Tyree Hamilton

1971 Sioux of the Rosebud, a History in Pictures: Photographs by John A. Anderson. Norman: University of Oklahoma Press.

Hans, Frederick M.

1981 Scouting for the U.S. Army, 1876–1879: The Diary of Fred M. Hans. Michael Tate and Grace Lakota Hans Pawol, eds. South Dakota Historical Collections 40:1–174.

Hansboro News.

1921 Obituary of George H. Bingenheimer. Towner County ND. January 1–14.

Heitman, Francis B.

1903 Historical Register and Dictionary of the United States Army, vols. 1 and 2. Washington: Government Printing Office.

Henning, Elizabeth R. P.

1982 Western Dakota Winter Counts: An Analysis of the Effects of Westward Migration and Culture Change. Plains Anthropologist 27(95):57–65.

Herold, Joyce

1999 Grand Amateur Collecting in the Mid-Twentieth Century: The Mary W. A. and Francis V. Crane American Indian Collection. In Collecting Native America, 1870–1960. Shepard Krech III and Barbara A. Hail, eds. Pp. 259–291. Washington: Smithsonian Institution.

Hinsley, Curtis M.

1994[1981] The Smithsonian and the American Indian: Making a Moral Anthropology in Victorian America. Washington: Smithsonian Institution. Orig. pub., Savages and Scientists: The Smithsonian Institution and the Development of American Anthropology, 1846–1910. Washington: Smithsonian Institution.

Hoffman, Walter J.

1882 The Application of Gestures to the Interpretation of Pictographs. Abstract. Transactions of the Anthropological Society of Washington 1:58–59.

Hough, Walter

1933 Garrick Mallery. In Dictionary of American Biography, vol. 12. Dumas Malone, ed. Pp. 222–223. New York: Charles Scribner's Sons.

Howard, James H.

1955 Two Dakota Winter Count Texts. Plains Anthropologist 5:13–30.

1960a Two Teton Dakota Winter Count Texts. North Dakota History 27(2):67–79.

1960b Dakota Winter Counts as a Source of Plains History. In Bureau of American Ethnology Bulletin 173. Pp. 335–416. Washington: Smithsonian Institution.

1960c Butterfly's Mandan Winter Count: 1833–1876. Ethnohistory 7(3):28–43.

1965 The Ponca Tribe. Bureau of American Ethnology Bulletin 195. Washington: Smithsonian Institution.

1968 The Warrior Who Killed Custer: The Personal Narrative of Chief White Bull. Lincoln: University of Nebraska Press.

1976 Yanktonai Ethnohistory and the John K. Bear Winter Count. Plains Anthropologist Memoir 11, 21 (73, pt. 2): 1–78.

1979 The British Museum Winter Count. British Museum Occasional Paper, 4. London: British Museum.

Hyde, George E.

1961 Spotted Tail's Folk: A History of the Brulé Sioux. Norman: University of Oklahoma Press.

Ironhawk, F. F.

1936 Omaka Iyohi On Tiken Woyakapi. Iapi Oaye (The Word Carrier) 65(7).

Jahner, Elaine A.

1983 Introduction. In Lakota Myth, by James R. Walker. Elaine A. Jahner, ed. Pp. 1–40. Lincoln: University of Nebraska Press.

Jordan, William Red Cloud

1970 Eighty Years on the Rosebud. Henry W. Hamilton, ed. South Dakota Department of History Report and Historical Collections 35:324–383.

Karol, Joseph S., S.J.

1969 Red Horse Owner's Winter Count: The Oglala Sioux 1786–1968. Martin SD: Booster Publishing.

Kelemen, Elisabeth Zulauf

1973 A Horse-and-Buggy Doctor in Southern Indiana, 1825–1903. Madison IN: Historic Madison.

Keyser, James D.

1987 A Lexicon for Historic Plains Indian Rock Art: Increasing Interpretive Potential. Plains Anthropologist 32(115):43–71.

Keyser, James D., and Michael A. Klassen

2001 Plains Indian Rock Art. Seattle: University of Washington Press.

Kidwell, Clara Sue

1999 Every Last Dishcloth: The Prodigious Collecting of George Gustav Heye. In Collecting Native America, 1870–1960. Shepard Krech III and Barbara A. Hail, eds. Pp. 232–258. Washington: Smithsonian Institution.

Krech, Shepard III, and Barbara A. Hail, eds.

1999 Collecting Native America, 1870–1960. Washington: Smithsonian Institution Press.

Kroeber Papers

N.d. Bancroft Library. University of California, Berkeley.

Lamb, Daniel S.

1906 The Story of the Anthropological Society of Washington. American Anthropologist 8:564–579.

Lawrence, Peter M.

1905 Hunkpapaya Lakota Hca Waniyetu Yawapi. Iapi Oaye (The Word Carrier) 43(7).

Lester, Patrick D.

1995 The Biographical Directory of Native American Painters. Tulsa: SIR Publications; distributed by University of Oklahoma Press. (Rev. version of Snodgrass 1968.)

Libhart, Myles

1970 Contemporary Sioux Painting. Exhibition catalog. Rapid City SD: Tipi Shop.

Liu, Robert K.

1983 Dan Frost Bead Collection. Ornament 6(3):25–45.

Lovett, John L., and Donald L. DeWitt

1998 Guide to Native American Ledger Drawings and Pictographs in U.S. Museums, Libraries and Archives. Westport CT: Greenwood Press.

Mahoney, Olivia

1997 Go West! Chicago and American Expansion. Exhibition catalog. Chicago: Chicago Historical Society.

Mallery, Garrick

1877 A Calendar of the Dakota Nation. U.S. Geological and Geographical Survey Bulletin 3(1):3–25.

1882 Dangers of Symbolic Interpretation. Abstract. Transactions of the Anthropological Society of Washington 1:71–79.

1886 Pictographs of the North American Indians: A Preliminary Paper. In Fourth Annual Report of the Bureau of American Ethnology, 1882–1883. Pp. 1–256. Washington: Smithsonian Institution.

1893 Picture-Writing of the American Indians. In Tenth Annual Report of the Bureau of American Ethnology, 1888–1889. Pp. 266–328. Washington: Smithsonian Institution.

Mauer, Evan M., ed.

1992 Visions of the People: A Pictorial History of Plains Indian Life. Exhibition catalog. Minneapolis: Minneapolis Institute of Arts.

McBride, Dorothy McFatridge

1970 Arthur E. McFatridge: Hoosier Schoolmaster among the Sioux. Montana: The Magazine of Western History 20(4): 78–97.

McCoy, Ron

1983 Winter Count: The Teton Chronicles to 1799. Ph.D. dissertation, History and Political Science, Northern Arizona University.

1992 Short Bull: Lakota Visionary, Historian, and Artist. American Indian Art 17(3):54–65.

1994 Swift Dog: Hunkpapa Warrior, Artist and Historian. American Indian Art 19(3):68–75.

2002 Dakota Resources: "A People without History Is Like Wind on the Buffalo Grass": Lakota Winter Counts. South Dakota History 32(1):65–86.

McCreight, Major Israel

1947 Appendix: The Sioux Calendar. In Firewater and Forked Tongues: A Sioux Chief Interprets U.S. History. Pp. 163–170. Pasadena CA: Trail's End.

Mekeel, Scudder

1943 A Short History of the Teton Dakota. North Dakota Historical Quarterly 10:136–205.

Merrill, William L., Marian Kaulaity Hansson, Candace S. Greene, and Frederick J. Reuss

1997 A Guide to the Kiowa Collections at the Smithsonian Institution. Smithsonian Contributions to Anthropology, 40. Washington: Smithsonian Institution Press.

Meyn, Susan Labry

1992 Who's Who: The 1896 Sicangu Sioux Visit to the Cincinnati Zoological Gardens. Museum Anthropology: Journal of the Council for Museum Anthropology 16(2): 21–26.

1994 Mutual Infatuation: Rosebud Sioux and Cincinnatians. Queen City Heritage: The Journal of the Cincinnati Historical Society 52(1–2):30–48.

Mooney, James

1898 Calendar History of the Kiowa. In Seventeenth Annual Report of the Bureau of American Ethnology, 1895–1896. Pp. 129–460. Washington: Smithsonian Institution.

Morgan, Alfred

1879 A Description of a Dakota Calendar, With a Few Ethnographical and other Notes on the Dakota or Sioux Indians, and Their Territory. Proceedings of the Literary and Philosophical Society of Liverpool 33:233–253.

Morning Star Gallery

1991 Annual Catalog, 1. Santa Fe: Morning Star Gallery.

Nahwooksy, Fred, and Richard Hill Sr., eds.
 2000 Who Stole the Tee-Pee? Exhibition catalog. Phoenix: ATLATL.
Nye, Wilbur S.
 1962 Bad Medicine and Good: Tales of the Kiowas. Norman: University of Oklahoma Press.
Oehser, Paul Henry
 1949 Sons of Science: The Story of the Smithsonian Institution and Its Leaders. New York: Henry Schuman.
 1970 The Smithsonian Institution. New York: Praeger.
Page, Susan
 1996 Transparent Drafting Films: Profiles for Preservation. Architectural Drawings and Reprographics. The Book and Paper Group Annual, vol. 15.
Parks, Douglas R.
 1988 The Importance of Language Study for the Writing of Plains Indian History. In New Directions in American Indian History. Colin G. Calloway, ed. Pp. 153–197. Norman: University of Oklahoma Press.
Paulson, T. Emogene, and Lloyd R. Moses
 1988 Who's Who among the Sioux. Vermillion: University of South Dakota Press.
Porter, Joseph C.
 1986 Paper Medicine Man: John Gregory Bourke and His American West. Norman: University of Oklahoma Press.
Powell, John W.
 1886 Foreword. In Fourth Annual Report of the Bureau of American Ethnology, 1882–1883. Pp. v–x. Washington: Smithsonian Institution.
 1896 Obituary of Garrick Mallery. Smithsonian Institution Annual Report 1895:52–53.
Powers, William K.
 1963 A Winter Count of the Oglalas. American Indian Tradition 52:27–37. Repr., Kendall Park NJ: Lakota Books, 1994.
Praus, Alexis A.
 1955 A New Pictographic Autobiography of Sitting Bull. Smithsonian Miscellaneous Collections 123(6):1–4.
 1962 The Sioux, 1798–1922: A Dakota Winter Count. Cranbrook Institute of Science Bulletin 44. Bloomfield Hills MI: Cranbrook Institute of Science.
Pumroy, Eric
 1986 A Guide to Manuscript Collections of the Indiana Historical Society and Indiana State Library. Indianapolis: Indiana Historical Society.
Raczka, Paul M.
 1979 Winter Count: A History of the Blackfoot People. Brocket, Alberta: Oldman River Cultural Centre.

Ransom, Lena
 1910 The "Winter Counts" of the Dakotas. The Kansas Magazine (Wichita), December: 22–28.
Reutter, Winifred
 1962 Early Dakota Days: Stories and Pictures of Pioneers, Cowboys, and Indians. White River SD: privately published.
Riggs, Stephen R.
 1852 Grammar and Dictionary of the Dakota Language. Smithsonian Institution Contributions to Knowledge, 4. Washington: Smithsonian Institution.
 1893 Dakota Grammar, Texts, and Ethnography. James Owen Dorsey, ed. Contributions to North American Ethnology, 9. Washington: Government Printing Office.
Riggs, Thomas L.
 1958 Sunset to Sunset: A Lifetime with My Brothers, The Sioux. South Dakota Historical Collections 29:87–306.
Risch, Barbara
 2000 A Grammar of Time: Lakota Winter Counts, 1700–1900. American Indian Culture and Research Journal 24(2): 23–48.
Robertson, Kirk
 1976 Shooting at Shadows, Killing Crows: Working from Plains Winter Counts. Blue Cloud Quarterly 22:2–15.
Rodee, Howard
 1965 The Stylistic Development of Plains Indian Painting and Its Relationship to Ledger Drawings. Plains Anthropologist 10(30): 218–232.
Roosa, Alma Carlson
 1977 Homesteading in the 1880s: The Anderson–Carlson Families of Cherry County. Nebraska History 58(3):371–394.
Sandoz, Mari
 1967 Introduction. In A Pictographic History of the Oglala Sioux: Drawings by Amos Bad Heart Bull, by Helen H. Blish. Pp. xix–xxii. Lincoln: University of Nebraska Press.
Smith, DeCost
 1949 Red Indian Experiences. London: George Allen and Unwin.
Smith, Henry Nash
 1947 Clarence King, John Wesley Powell, and the Establishment of the United States Geological Survey. Mississippi Valley Historical Review 34(1):37–58.
Snodgrass, Jeanne O.
 1968 American Indian Painters: A Biographical Directory. New York: Museum of the American Indian. (See Lester 1995 for an updated version.)

Sotheby's
1976 Auction Catalogue: American Indian Art. Sale No. 190: George G. Frelinguysen Collection. April. New York: Sotheby's.

Starr, Frederick
1892 Anthropological Work in America. Popular Science Monthly 41(22):288–307.

Stirling, Matthew W.
1938 Three Pictographic Autobiographies of Sitting Bull. Smithsonian Miscellaneous Collections 97(5):1–56.

Sundstrom, Linea
1997 Smallpox Used Them Up: References to Epidemic Diseases in Northern Plains Winter Counts, 1714–1920. Ethnohistory 44(2):305–343.

Szabo, Joyce M.
1994 Howling Wolf and the History of Ledger Art. Albuquerque: University of New Mexico Press.

Tate/Wind
1900 Waniyetu Yawapi Wan. Iapi Oaye (The Word Carrier) 24(2).

Taylor, Allan R.
1996 Nonspeech Communication Systems. In Handbook of North American Indians, vol. 17: Languages. Ives Goddard, ed. William C. Sturtevant, gen. ed. Pp. 275–289. Washington: Smithsonian Institution.

Thornton, Russell
2002 A Rosebud Reservation Winter Count, circa 1751–52 to 1886–87. Ethnohistory 49:723–741.
2003 A Report of a New Mandan Calendric Chart. Ethnohistory 50:697–705.

Tidball, Rose
1976 Taming the Plains: A History of Corson County. Keldron SD: privately published.

True, Webster P.
1946 The First Hundred Years of the Smithsonian Institution, 1846–1946. Washington: Smithsonian Institution.

U.S. Bureau of the Census
1880 Tenth Census of the United States, June 1880. T9 Roll #113. Dakota Territory, Meyer County, Rosebud Agency. Washington.

Utley, Robert M.
1963 The Last Days of the Sioux Nation. New Haven: Yale University Press.

Waggoner, Josephine F.
1988 An Oglala Sioux Winter Count by Makula. Museum of the Fur Trade Quarterly 24(4):11–14.

Waktegli/Kills and Comes Back, Eli
1892 Waniyetu Yawapi Watapeta Kaga Kin. Iapi Oaye (The Word Carrier) 21(5).

Walker, James R.
1980 Lakota Belief and Ritual. Raymond J. DeMallie and Elaine A. Jahner, eds. Lincoln: University of Nebraska Press.
1982 Lakota Society. Raymond J. DeMallie, ed. Lincoln: University of Nebraska Press.
1983 Lakota Myth. Elaine A. Jahner, ed. Lincoln: University of Nebraska Press.

Walker, Willard
1996 Native Writing Systems. In Handbook of North American Indians vol. 17: Languages. Ives Goddard, ed. William C. Sturtevant, gen. ed. Pp. 158–187. Washington: Smithsonian Institution.

Warhus, Mark
1997 Another America: Native American Maps and the History of Our Land. New York: St. Martin's Press.

Weir, James A.
1980 Nineteenth Century Army Doctors on the Frontier and in Nebraska. Nebraska History 61(2):192–214.

Welcher, Frank J.
1989 The Union Army, 1861–1865: Organization and Operations, vol. 1: The Eastern Theater. Bloomington: Indiana University Press.

Wildhage, Wilhelm
1988 Die Winterzahlungen der Oglala. Wyk auf Föhr: Verlag für Amerikanistik.
1991 The Big Missouri–Kills Two Winter Count. Archiv für Völkerkunde 45:39–59.

Williamson, John P.
1992[1902] An English–Dakota Dictionary. St. Paul: Minnesota Historical Society. Orig. pub., New York: American Tract Society.

Wissler, Clark
1911 The Social Life of the Blackfoot Indians. American Museum of Natural History Anthropological Papers 7(1):1–64.
1914 The Influence of the Horse in the Development of the Plains Culture. American Anthropologist 16(1):1–25.
1943 The American Indian and the American Philosophical Society. Proceedings of the American Philosophical Society 86:189–204.

Wunder, John R.
1989 The Kiowa. New York: Chelsea House.

INDEX